MARTIN S. ACKERMAN

SMART MONEY AND ART

INVESTING IN FINE ART

Station Hill Press

Library of Congress Cataloging in Publication data

Ackerman, Martin S. 1932–
Smart Money and Art: Investing in Fine Art
1. Art. 2. Business. 3. Investing.
II. Title.
HF
ISBN 0–88268–045–5

Printed and bound in West Germany
by Staib + Mayer, Stuttgart

FIRST EDITION

Without the help of my wife, Diane L. Ackerman, as the willing and sympathetic sounding board, this book could not have been completed. And to Herman Cooper, my former law partner, I owe an enduring debt of gratitude for not only encouraging me, but for his abiding and infectious love of art. Of course, I alone am responsible for what follows, and I expect that many will disagree.

M. S. A.

TABLE OF CONTENTS

INTRODUCTION

This little book is something that I have been thinking about since the early 1970s, when I first became interested in becoming an art collector. The topic of collecting is not an easy one to write about. The field itself is very large, and most people who do write about collecting feel compelled to deal with everything from antiques to matchbook covers. However, this book is not about collecting generally, it is about collecting art.

There is a notion in the art world that one should never talk about money and art, or investment and art, because to associate money with art somehow cheapens it. The art dealers, the auction houses and even the "Collector Class" (the key players in this activity), want us to think that most people who collect do so solely for the love of art, not because it's a good way to invest our money. Typical of the facade of the art world was Ian Kennedy's observation in "Auction News From Christie's" (April, 1986):

> "Most good, committed dealers are not likely to have much respect for the accumulator who buys purely for investment. They may feel a distaste in selling their best stock, however, tempting the profit, to someone who sees art solely in terms of dollars and cents."

No matter how rich they are, most people who spend money to acquire costly items first carefully consider the value of a proposed investment. Big money drives the art market, and when we talk about money, we are talking about real investments, not simply an abstract affection for art. As *Business Week* put it: "Why do people collect? By far the most compelling reason is to make money." Can collecting fine art be a profitable investment?

I have been a collector of art for over fifteen years, and during this period, I have often wondered if it were possible to write a worthwhile book for art investors. However, the topic encompasses many different areas of study and interest. First, it's necessary to try to understand the art market (itself a vague concept) which is unlike other investment markets. The art market is driven by the concepts of the art historical process, which influences the monetary value of an art object. This art historical process, which partly consists of an artist's fame and his place in history, is also driven by non-investment members of the art world: artists, art historians, critics and museum directors. This group, while essential to the workings of the art marketplace, rarely, if ever, admit to the monetary value of art, but rather insist on art's aesthetic quality. The collector has to be aware of this group's prejudice against mingling money and art. The collector's job is to bring the concepts of artistic quality and investment value together.

Most of what is written about art is not aimed at the collector who wants to make a worthwhile money investment, but it is directed to other parts of the art market: the critic writes for the other critics, the art historian writes for other historians, or for the connoisseur. But it is difficult for the uninitiated to fully grasp the language used by the authorities of the art world. For this reason, I have included a dictionary of art historical terms.

11

Additionally, I'd recommend two helpful books, one on art collecting generally, by Lee Rosenbaum, *The Complete Guide to Collecting Art,* Alfred A. Knopf, New York, 1982, and the other on collecting prints, by Theodore B. Donson, *Prints and The Print Market,* Thomas Y. Crowell, 1977. There are also some very good magazines besides the art magazines, like *Art News* and *Art in America.* The best one for the collector is *Art & Antiques,* and then *Flash Art* and *The New Criterion*, and, later, the forum columns in the revised *Art Forum*. While these books and magazines cover their respective areas well, they can be confusing at the outset. Also a beginning collector needs a basic art library to be familiar with the background information before he can be successful and therefore must read as much as he can. For this reason, I have also suggested books of interest to the collector and a reading list. Knowing the market and its detailed workings is essential, but it is at best only a first step in understanding how to make money in the art market.

The successful collecting of art as an investment comes about only if one can find a way to improve his own experiences in looking. If one refuses to recognize the need to improve his visual literacy, he will surely fail, regardless of his understanding of the details of the art market. Collecting for profit is not about buying and selling fine art, but about knowing what to buy.

What to Buy and Why

If one doesn't know what to buy or why he buys a work of art, he will never make a substantial profit. The technique for the collector is simple, it is to buy at or below the current market for a given artist, and to buy the artists (or school of artists) whose works will appreciate in value over time due to artistic trends and tastes. But, in order to know what to buy, one must improve his own experiences in learning how to look. One must become a visually literate person.

The mind and the eye have to come together so that the decision to buy is based not only on the market, but on a decision about what is worthwhile to buy within that market as a long-term investment – twelve to twenty years. This concept is so foreign to most people making art-investment decisions that it is helpful to use the comparison of the stock market to make this idea clearer. Most people are familiar with that market, because most people have bought and sold stocks. In this market we buy one stock as against another stock, not because we have made a visual decision about it, but because we have been told by someone that it is a good buy. The recommendation may have come from a stock broker, or from any number of financial publications, and we have been convinced by this information. And, when we decide what make of car to buy or what kind of home to invest in, we are making similar kinds of decisions, except that at these times we tend to rely upon our visual sense as well as our business sense. We choose one over another because of what we see or like. But with art, especially painting, it is, as I will try to show, more than simply finding something visually appealing, it is an educated appreciation of it which should control the ultimate decision to buy.

An Experience of Taste

Once the mind and the eyes start to work together in practice, then one can hope to develop an experience of taste, that is, a power to discern and appreciate whatever constitutes the best. Buying alone will not generally make one a successful collector unless one buys the best one can afford. And it's not possible to buy the very best of everything because it is just too expensive. The object, then, is to select the best within a given price range, something which will compete with the very best. One must also understand the way in which the history of art (taste and fashion) affects these decisions to buy and hold for future value. The nature of this art historical process, the rise, development and decline of artistic styles, plays *the* most important part in making money in the art market.

In the end, when making art investments, unlike other money investments, artistic taste will determine success. Artistic taste is not simply a matter of what one likes or finds pleasing, it is a matter of what one appreciates as being good art. The difference between the two, as I hope will become evident in this book, is substantial. I believe that most new collectors confuse appreciation with a sense of pleasure. Why is this so? Because our system of education emphasizes verbal and quantitative skills rather than attempting to cultivate the mind and especially the eye. Aren't we literate, generally? After all, we read, and we generally understand the written and spoken word. But as one becomes a serious collector, and starts to understand the nature of the visual world, one begins to understand that there are fundamental differences between painting and even poetry, the most sophisticated written word.

In understanding language, we have been trained to make objective judgments of "good" or "bad". But when it comes to comprehending the visual, using the eye and that part of the brain that controls it, we have, really, no experience or education to fall back on so we say, "I know what I like" and not, "I know how to appreciate what I am looking at." The nonverbal arts, like painting and sculpture, may cause problems unless we seek further education in order to understand what these works can mean to us as individuals. At least at the beginning, works of art may be just forms or symbols, and we don't know what they should mean. Before the visual faculties can work, we must acquire a new language of looking to understand and use.

The concept of visual art as a language has very important cultural and educational implications. It implies that lines, shapes, colors, volume, and so on, have the potential for organized communication. This is not new: the entire history of art testifies to the communicative power of man-made images. The existence of common systems of communication makes social life possible. Without the ability to communicate – to send and receive messages – individuals could not survive. That is why education places so much importance on the learning of languages: reciting and answering, encoding and decoding, writing and reading. Unfortunately, our educational system still does not consider visual arts a viable discipline. To make matters worse, the prevailing misconceptions which exist have persuaded many intelligent persons that art, especially modern art, is "incoherent".

Figurative and Abstract Art

At first, most people see non-representational art at best as consisting of forms or symbols, which they don't know how to grasp, based upon their own limited experience or edcuation. And yet, after learning to appreciate this kind of work, most people can find in it the same exhilaration that they feel when looking for example, at the Impressionist paintings; paintings that our experience and education have taught us to begin to understand. Most people haven't been exposed to anything beyond the Impressionists, an idea that was made clear recently in a John Russel article in *The New York Times* (February 2, 1986), entitled "Is Impressionism Too Popular For Its Own Good?" As Russell said, "it is both curious and sad that meanwhile in 'The New Painting' (Impressionism, 1874–1886), the crowds were filing by, three and four deep, in admiration before paintings that, if compared with Titian, were quite inconsequential." As Russell further said:

"This movement of the Impressionist brush is by now so much a part
of our universal inheritance that we no longer think of it as something
that could present a difficultiy."

One can then imagine the difficulty people must have looking at Paul Klee or Piet Mondrian.

Our education and experience, then, has generally got us maybe as far as Pierre-Auguste Renoir, but not as far as Klee or Mondrian or Ben Nicholson. As a person's eyes and mind start to work together, he begins to understand the fantasies of a Klee, or the severe line of an abstract painting by Mondrian or Nicholson. The collector with an artistic taste is one who finds deep satisfaction in looking at abstract as well as figurative or representational work.

In 1986, *(The New Yorker*, March 10, 1986) figurative work by living artists like Gregory Gillespie, Eric Fischl and Wolf Kahn, is probably more ineresting than the 1986 abstract work of artists like Stephen Posen, Sandra Mackintosh, and Dorothea Rockburne. Without some sense of appreciation, however, it is difficult for most collectors to find significance in this contemporary figurative work because they have too long associated all representational painting with the art of the few artists that they have been exposed to before. It is crucial, then, for the collector to build his appreciation off the tracings of the history of art. To begin to understand how to look requires a reorganization of the visual part of the brain through study, written and visual, of the painters who constitute the Modern era since the early 1900s. If the collector can go back further, as John Russell suggests, to Titian, it is an advantage, but not, in my opinion, required.

A Course of Study

This course of study I recommend includes (among painters) only those I consider the very best: Cézanne, Degas, Picasso, Braque, Matisse, Kandinsky, Mondrian, Klee, Munch, Léger, the Stieglitz group, Pollock, and Rothko. One

could study other painters, but for the novice collectors, this is a worthwhile beginning. Since most of these painters fall within certain art historical periods, I have found that it's easier to understand painters by first viewing their art historical periods. For example, it is impossible to understand Picasso without understanding Cubism, or to understand Jackson Pollock and Mark Rothko without understanding the New York School. As R. B. Kitaj has said (*Art News,* March, 1986), "I'm considered School of London". By first studying the school or period, one can begin to see how a certain artist fits within his time and relates to his predecessors and peers.

The artists who were important (and those who will stay important) have been generally responsible for spectacular outbursts of innovation in the visual arts since the Renaissance. Certainly the period between the Impressionists and the Second World War was one of great growth in the visual arts, and this period is the basic foundation for all that has come after. The period after the Second World War is still in the developing phase since artists and critics are engaged in an ongoing evaluation and reevaluation, and yet it is in this present-day era, where collectors will have to make their choices, for the best of the earlier work is now priced beyond what most collectors can afford.

The Contemporary

Since contemporary artists explore their relationships with their predecessors, anytime a collector, for example, looks at a painting, he must relate that painting to an earlier period as a starting point. The collector then has to study the relationship between this artist and his predecessors, only then can the collector begin to view a work of art and its creator in a specific context.

The collector of photography also has to understand these relationships, or he can't begin to understand the use of the new techniques as they relate to the history of photography. To understand the art of Stieglitz or Cartier-Bresson, one must first learn of their experimentation and artistic goals. Without such knowledge, one could never become a real collector of photography.

The Collectors

Lately we are starting to see some information about the collector. The editors of *Art & Antiques* (March, 1986) tell us that to find America's most eminent art collectors, we have to look for a "mixture of vision and passion". "Collecting", they say, "is like a treasure hunt", and I would add looking at their list, a treasure hunt exclusively for those with "money power" as their 100 top collectors in America contain mostly the self indulgent rather than the visually literate. Robert Guccione of *Penthouse* magazine fame tells us that he has "bought three container loads of Renaissance furniture" and plans to buy more. Graham Gund of Boston

has "assembled a museum of modern art in miniature". The dealers Richard Feigen, Stuart Feld, William Hokin, Armand Hammer, Daniel Wolf, A. Alfred Taubman and Eugene Thaw, all, like Thaw, tell us that it "is part of ourself, an obsession", but they fail to add also very much a part of their business as well. Asher Edelman, wheeler dealer, sums up this group, when he says that after a tough day of corporate raiding, he can still find solace in eight Frank Stellas. Robert Pincus-Witten, critic, writing about his East Village collectors in *Arts* (February, 1986), Donald Rubell, Martin Sklar, Lenor-Shore, Elaine Dannheiser, Jerry Spiegel, Eugene Schwartz, Martin Margulies and the others, tells us that they "are a new 'Collector Class'". My fatuous label for them would be collector/dealers, hoping to make their East Village favorites historically important and more valuable. Robert Pincus-Witten (*Arts*, April, 1986) even tells us that this "Collectors Class" is now starting to germinate a "sons and daughters" "Collectors Class":

> "[Ross] Bleckner's exhibition has already been divided between the most lustrous names in The Collector's armorial including for the first time in this roster, the young Michael Schwartz (Eugene and Barbara Schwartz), the quietly dark son of grand figures in the history of contemporary collecting. From the beginning of the Neo-Conceptualis Movement, Michael has been its taciturn John The Baptist. It was he who made the first ostensive gestures that pointed the way to Bleckner, Taaffe, Koon, etc., to the newly reformulated coalition that comprises Second Wave East Village."

But it's not often that one finds much written by the collector, rather than the artist, critic, or art historian, because the collector is afraid of looking foolish if he steps out and presents his views in an area where he is not an acknowledged expert. He may know something about success in his own field, he may even be very successful in making money, or professionally successful as a lawyer, doctor, or candlestick maker, but art, that' another matter, that' left to the artistic types of which he knows he is not one. The reason he is often called a Philistine is because as a professional outside the art world he is not supposed to have an artistic or poetic temperament.

It is therefore, refreshing to see in a new magazine for artists, *Issue, A Journal for Artists,* (Winter 1986) an article entitled "Notes From A Collector". The author, in fear of being called a Philistine collector who should never venture from the "back room" of the art world, used a pseudonym. What he says is pertinent for the would-be collector's understanding of the psychology of today's art collector:

> "One has a tendency to say that the art world is not for the tenderhearted, only for the strong, the brave. I believe it to be true. The art world down through the ages has never been for the weak, whether with popes or kings or the wealthy Florentines. Reform it? No!!! We will kill it.***

Much of what I have written in this little book confirms that collecting is not for the tenderhearted, it is only for those who are prepared to spend time in educating themselves in how to invest their money intelligently. Mr. Philistine, in his "Notes From A Collector", presents quality as the ultimate criterion for the

collector; he says, "quality is quality is quality" (shades of our dear Gertrude Stein). But he doesn't tell us what or how he recognizes quality in painting, pastels, watercolors, drawings or sculpture, or those that are producing lasting, quality work. He tells us how to collect, but not what to collect:

"What it all comes down to, is that the collector who is soft, gentle, easy, or naive will most likely have a second-rate collection. A collector has to kick back, walk around the perils, trade up, run fast, maneuver when necessary! Collecting must possess the collector. It must be a love, a passion, an all-consuming obsession. The collector has to look, and look again. He has to understand the workings of the art world and be willing to enter this risky but wonderful world."

While I agree with his passionate language, I don't believe that it is enough to be consumed by the workings of the art world, unless the collector can search his own conscience to find a way to sharpen his visual instincts. To "look, and look again" is not enough, unless one truly comprehends what he is looking at. Only the mind and the eye working together make one capable of recognizing quality. The words of Sidney M. Bratherly accurately describe the zeal and resolve required in a true collector, but they fail to give us specific criteria for buying artworks:

"A dealer with an aye and a good sales approach can push you into a painting. So what if you overpay? (Within logical bounds.) As long as it's not a forgery.... As long as the artist is major.... As long as the painting is in good condition.... And most of all, as long as you have quality, then you are way ahead. The only fair deal in collecting is not the bargain purchase but the quality one. The dealer can be obnoxious, a bastard. In the final analysis this is irrelevant.

"The only solution for a collector is to learn quickly, to make mistakes, to sell off what is bad, to keep looking so as to develop an eye, to copy other collectors who know better, to ask other dealers about other dealers and about the purchase, to recognize the natural malice and jealousy of other dealers when asking their opinion, to read all the art magazines possible, to ignore the art magazines, to listen to critics, to ignore the critics; to love the dealer when he sells you a great piece, to hate the dealer when he doesn't call you. All of this is critical even if it's somewhat cynical.

"Today 'quality' and 'intuition' seem to be dirty words, considered throwbacks to Greenberg's formalism. Critics don't want to deal in absolutes. A collector has to, however. He can't bullshit around with iconography. Quality is quality is quality! Too many critics are now pandering to taste which isn't permanent. A collector has to transcend taste or fashion. He has to go for the long pull."

It is hoped that after finishing this book, the reader will have a more tangible grasp on the nature of quality or if in fact a quality standard exists at all. In fact, there really is no objective standard of quality. The quality of a work of art is essentially nothing more than an opinion, though a highly informed one. The best an individual can do is to establish his own personal standards as he collects and becomes a person with the power of discerning whatever, in his view, constitutes the "best". In the end, however, most collectors' tastes are affected by the views of other people. There are simply no easy rules governing the success or failure of a collector.

Popular acclamation for a particular artist or style cannot be discounted altogether, because if enough people agree that something is worth having there is *prima facie* evidence, as we say in law, that it is indeed worth having. But what counts even more is the testimony of persons with a thorough knowledge (not necessarily credentials) of the world of art. These experts, proponents of this art historical process, are primarily dealers, artists, critics, historians, and the important collectors. Regardless of the judgments of this designated group of aesthetic arbiters, they have been and will continue to be the major forces dictating worth. And to be a successful collector, one must make himself part of that group; one must become a connoisseur.

Why does everyone make it a mystery? You do not dislose the game that makes money for you. Leslie Singer, economist and art historian, tells us that in reality collecting art today is about investment:

> "Every collector will tell you that he buys art because he likes it. That's baloney. Art is not bought as a consumer's item. The art dealer is nothing more than a good stockbroker who advises his clients. His understanding is related to potential capital gains."

Summary

In summary, then, it is hoped that this book will serve as a short and simple approach to becoming a collector of fine art. After a discussion of the art market, and the way it works, conceptually and technically, I will attempt to introduce the reader to this art historical process. Also included will be a dictionary of art historical terms and a reading list, which will have to be studied and mastered, and can be kept handy for future reference. Finally, I will not suggest which artists to buy, since the goal here is to develop a strong personal instinct. At the end of this course of study, the reader should have at the very least the confidence to become a smart art collector, as long as he has the desire.

<div align="right">Martin S. Ackerman</div>

"And so I know what it is. That is natural enough. What is it?"

Gertrude Stein

I

The Art and Stock Markets – A Comparison

Professor William J. Baumol in his paper "What Price Art?" compares the art market to the stock market to demonstrate the perils of investing successfully in art. Baumol says that both the stock market and the art market are "random walks" and therefore it doesn't matter which stock or painting one picks to buy in that neither offers a supply-response mechanism of comparable flexibility, speed or reliability. His states that "the investor's decision to act on the premise that price will not soon return to its equilibrium virtually assures failure to attain that equilibrium value." It is pure and simple, according to the professor, nothing but a beauty contest: art prices are subject to the same strokes of fortune as stock prices and approximate a "random walk" given a long enough period of time.

According to Baumol's analysis, it doesn't make any difference which stock or painting one picks to buy. Luck determines one's chances for profit. So, even if one is able to differentiate between good and bad stocks or paintings, it will not help him anticipate future prices in the marketplace. As Baumol argues, "even those critics who claim to know the value of everything may know the true price of nothing." He claims that one can't make rational, profitable investment decisions about stocks or art. In Baumol's view, predicting stock prices and art prices is always a losing game. He thinks that we are powerless in face of the unpredictable nature of prices in the art and stock markets. To the professor, both seem to be mysteries. Could it be in part that in both the art market and the stock market the practitioners don't want to disclose the game that makes money for them?

Baumol further believes this is so even when knowledge is applied to the buying equation, or what is known in stock-market parlance as the efficient market theory. He says "the main lesson ... imparted by the test of time is the fickleness of taste, whose meanderings defy prediction." He would rather recommend a visit to the neighborhood fortune-telling parlor than advise us to seek the advice of an authority on matters of aesthetics. Baumol's theory, although a strong one, is in my opinion incorrect with respect to the art market because he mistakenly believes that both markets are alike. Both are to some extent unpredictable, but Baumol fails to see that they are unpredictable in different ways. In the art market the serious investor is dealing with different kinds of market forces and a market which is driven by the art historical process, a different kind of market phenomenon.

While it is true that, as Baumol points out, we can only talk about art as an investment within a certain time frame, the period I am talking about is between twelve and twenty years, a period short enough to be both predictable and

understandable to the knowledgeable collector. Baumol cites a time period at least four or five times that length. The professor furthermore is wrong with respect to his statistics, because published sales, the basis for his calculations, represent only a small part of what is actually sold, since only auction sales are published; private sales are never published. Also, I believe that reported historical auction sales, the thesis used by the professor, depended in different times on market factors which were different than the factors which drive the market today and will drive the market over the next twenty years. The artistic bureaucracy operating in the professor's time frame, or as set forth in Gerald Reitlinger's *The Economics of Taste,* unlike today, were less knowledgeable and less influenced by the artists, dealers and critics. Since the middle of the 1950s the market has had a public and a market substantially different from any prior historical period. Also, especially in the last fifteen years and since the 1980s, the nature of patronage has changed, as well as the distribution method. In the end, I don't believe that these investments will do fantastically well in absolute terms, but very well compared to the collector's other investments. Also, aesthetic pleasure is a real number which has to be added to one's actual return.

The key to my disagreement with Baumol's idea that it doesn't make any difference which painting one buys is that, first, I believe that an individual who decides to become a collector can, within this relatively short historical period, make money, if he becomes visually literate and learns to tell good painting from bad painting. Second, he will be successful if he educates himself so that he can predict where taste or fashion will be at the end of that period – no matter how fickle it may be. The third and most important trait that a collector interested in profit must have is an acute understanding of how the art market works today so he can at least buy intelligently with regard to price against the general market.

For example, let's say that a collector decides to buy into the market for second generation New York School painters. You will hear more about this group later, but it was a group of painters who became active after the first generation of the New York School, between 1950 to 1960. He first decides which of these painters have in the past or are now producing good work, compared to their competitors. He next takes the list, for example, at the back of Irving Sandlers's book, *The New York School, The Painters and Sculptors of the Fifties*, Harper & Row, 1978 (paperback, 1986), and decides to buy across the board. Or maybe he decides only to collect some of the artists on this list. To take as an example, let's look at just one of the artists on this list, Jack Youngerman.

First the collector goes to a directory of artists to get the basic information. Jack Youngerman was born in 1926 in America and is a painter and sculptor. His paintings are abstract. He is sixty years old, and we know that he has been working at being an artist for over thirty years. John Russell tells us in *The New York Times* (March 7, 1986) that he makes pictures and sculptures which are "full of forthright contrasts of color that swings to and fro like bells in a belfry and forked, explosive, somersaulting imagery that never quite turns representational." From the catalogue of his recent show at the Guggenheim (April, 1986) we also know that he

went to Paris after his 21st birthday on a G. I. scholarship and enrolled in the Ecole des Beaux-Arts. He stayed in Paris for almost ten years and "became integrated into French life to a degree not common among young Americans in Paris at that time." He came to know both the senior artists like Brancusi and Arp, and the junior artists like Alexander Calder and Ellsworth Kelly, who were working in Paris at that time. He returned to the United States in the middle of the fifties, and by 1954 was at work "on the freely rendered but often strongly emotional imagery and the reversible figure-ground positive-negative compositional schemes that were to serve him well for many years." How good is he as an artist? As John Russell tells us in his review of the Youngerman show at the Guggenheim, he at least considers it good but not indispensible work:

> "All these spoke for a nimble and well-stocked mind, but when seen in succession at the Guggenheim, the paintings, the reliefs and the sculptures do not cohere very well. There is a genuine artist at work, and a genuine human being, and an animated, questing presence. A 30-year period in the history of art is evoked in an honorable way. If the gasp of astonishment and the stopped heartbeat do not present themselves, it is perhaps because there is a difference between good art and indispensable art, and Jack Youngerman's falls into the former category."

All collectors, I believe, operate in a world of diminished horizons, and are limited by their pocketbook. Good work, not indispensable work is, therefore, what you may have to settle for.

Youngerman has two distinct markets, the dealer market and the auction market. Therefore, the prospective buyer has a choice of marketplace. He can purchase earlier work of this artist from the dealer or newer work. From the auctions he probably can only acquire earlier work. Certainly one of the aesthetic judgments he must make is whether the work from the 1950 to 1960 period is better than the later work, or vice versa. Let's assume for the sake of this example, that it does not make any difference. In this situation it would be my contention that a collector substantially improves his luck by buying at the auctions rather than buying from the dealer. This, of course, is not a rule that will work for all painting. First, particular works may not be available at the auction and the dealer may have a better selection of work. In that case the collector has to decide if the difference in price is worth the difference in quality. The point is that to make an investment in art that will be more insightful than selecting a work the way one might judge a beauty contest and wiser than taking a random walk through the art market, each decision will have to involve three distinct elements:

(1) Is this painter the kind of painter whose work will be recognized as being more valuable in twelve to twenty years than he is now? Are his aesthetic prospects promising, with respect to his current price?

(2) Within the range of work available, what is the best medium, year, and size to purchase, and

(3) Where can the best buy in the market be made for the work you wish to acquire?

23

If all of these decisions come together then the chances of making a profit from collecting are better.

Exactly how much can be made as a comparative rate of return is not possible to say. My own practical experience has told me that the rate of return is always relative, and most individuals, even those with the best advice, do not, overall, make much on their investments. The art investor also has two other advantages over other investors: he has the capital gain advantage on sale, and the substantial tax shelter gain from the charitable deduction system of appreciated property, as I will later discuss.

The point is, theoretically and even statistically, Professor William J. Baumol may be correct in the long run, but in the short term of twelve to twenty years, an individual can make money from collecting paintings. Of course, as I will further show, he may have to do more than just purchase the investments. He has to become a visually literate person and be an active participant in the collecting game.

"One cannot come back too often to the question what is knowledge and to the answer knowledge is what one knows."

Gertrude Stein

II

The Modern Day Collector – Do You Really Want To Be One?

I never thought I would see the day, but there it was, the staid and conservative American Bar Association Journal, with an article on art collecting. Could it be that the editors really believed that those lawyers were really interested in art? Hard to believe, but there it was. A fluke, I thought, until one day I got a call from the producers of the television program, "Wall Street Week". The producers were interested in airing a show on art collecting, and asked me to be a guest. I thought to myself, "First the lawyers, and now the market speculators.

WALL STREET WEEK WITH LOUIS RUKEYSER – FOR ART'S – OR INVESTING'S SAKE, December 20, 1985.

LOUIS RUKEYSER: Now before we meet tonight's special guest, let's take a look at his area of investment expertise, art, as we focus on the always palatable and occasionally profitable state of the arts. Well, many observers, including the nice folks at Sotheby's who supplied us with the visuals, do not believe in art as an investment, actual appreciations for some lucky owners have been astounding.

This oil painting, „Summer's Burst" by Hans Hofmann went for a mere five grand in 1968. This year, it brought $ 132,000 at auction in New York. And another contemporary work, Cy Twombly's painting titled "Unititled", which sold for $ 40,000 in 1973, recently sold for more than ten times that amount. Lately, some photographs, too, have begun to produce substantial profits – with this black and white Alfred Stieglitz photo nearly tripling in value over the past six years.

And, it sometimes even pays to go by the book. This illustrated book, *The Lilies* by Pierre Joseph Redouté, specially bound for Empress Josephine of France, fetched about $ 16,000 back at auction in 1935. Last month, it went for five and one-half million dollars. And Shakespeare's first folio, which brought nearly $ 56,000 twenty years ago, recently sold for more than eleven times that sum.

Meanwhile, many fine Impressionist paintings continue to appreciate handsomely. This Renoir, "The Bather", sold this year for 1.65 million dollars, or more than three and one-half times its 1969 price, thereby, giving new meaning to the phrase "taking a bath". And, though many of these are, indeed, extraordinary

examples, it's worth noting that of the fourteen major kinds of investments tracked regularly by Salomon Brothers, Old Masters's paintings last year registered the third best price increase – topped only by bonds and stocks.

Will the trend remain beautiful? For some thoughts on that, let's go over now and meet tonight's special guest, Martin S. Ackerman. Marty, welcome. Very nice of you to come here.

MARTIN ACKERMAN: Thank you.

LOUIS RUKEYSER: Seventeen (Sic. Fifteen) years ago at the age of 36, Martin Ackerman gained national attention by winning control of The Curtis Publishing Company. Ten years ago, the flamboyant wheeler dealer traded in his New York law pracitce, his Lear jet, and various other baubles for life in the not-so-fast lane and a chance to pursue his growing interest in art. Today, he's a world renowned authority on the subject, a legal advisor to both artists and dealers, and a noted patron of the arts. Marty, you were rich. That made it a heck of a lot easier. But can the rest of us make any money in art?

MARTIN ACKERMAN: Yes, I think you can. I think the important thing is to understand some very basic rules. The first question is how much do you want to spend? Now, I've broken things down into three basic categories. Up to a thousand dollars, I think you're talking about entertainment. Forget it. Buy what you like. Don't worry about it, it will have no value. A thousand to five thousand dollars, now, you're kind of like speculating. It's almost like the over-the-counter market, not quite the penny stock market, but it's pure speculation. You can buy very little for $ 5,000. Now, once you get to $ 5,000, you're in what I call the "art market". Now, interestingly, when you talk to most people about buying in the art market, they never want to talk about money. It's not supposed to be or have anything to do with money. It's art.

LOUIS RUKEYSER: We feel the same way here. We think it's vulgar.

MARTIN ACKERMAN: Exactly. So, in the end, however, it is money, and you'll have to be very, very careful.

LOUIS RUKEYSER: Okay. Let's, for the sake of argument, say people have had a great year, they've made some money in stocks, and they want to spring for the $ 5,000. Where do they start?

MARTIN ACKERMAN: Okay. Well, the first thing is you have to understand, Lou, that we have a very basic problem. Probably you and most of our panelists here are visually illiterate. We grow up. We know how to read. We know how to write. But we don't know how to look. We're visually illiterate people. So what we have to do is, we have to go back to school. We have to learn to use our eyes, and we have to become visually literate people. How do you do that? You've got to start by educating yourself. You've got to know things in order to make money in the art market. The first, you have to know the market. And, second, you have to know how the system works"

Why, I asked myself, has the market started to look at art as a place to put one's hard-earned dollars? I had always believed that art collecting was a hobby for eccentrics rather than an activity suited for those interested in investing their

money. But, it seems that I was wrong since even *The New York Times* printed an article about art and money, called "New Art, New Money". The subtitle of this piece was "The Marketing of an American Artist." The article dealt with America's new moneyelite and the marketing of an American artist.

Recently publications ranging from *Insight (The Washington Times), House and Garden* and *Connoisseur* to *The Wall Street Journal* have run pieces on this anticipated coming collecting boom. What are the reasons behind this new interest? Dealers like Leo Castelli and André Emmerich believe that "there has been a spectacular growth of the art market as a percent of the population interested in art." According to others it is not that the art market has changed, it is that what used to happen in ten years now happens in ten days. As Jane Addams Allen, "Speculating: A Fine Art" *(Insight*, March, 1986), sees it the art market follows the same patterns as the economy at large:

"A more substantial reason for the continued expansion of the art market is the large-scale entrance of international funds. Singer suggests that the art market follows the same patterns as the economy at large. 'As global income rises, more art is purchased' he explains. 'More European and Oriental money has been flowing into the art market.'

"One of the major factors loosening the relatively tight fabric of the New York art community has been the rise of affluence in Europe and the concomitant rise in the numbers of European artists, dealers and collectors."

" 'The internationalization of the art market was an enormous change,' says Castelli. 'It was unforeseen, unpredicted, unpredictable.' "

There have also been recent profiles of famous collectors, like the de Menil family (the Medicis of Modern Art) and those two maiden ladies, the Cone sisters, from Baltimore, the great Matisse collectors, to a profile of Douglas Cramer, a successful television producer, entitled "One of the Most Powerful Producers in Hollywood Talks About his Collection of Contemporary Art". We even have a list now of "the top 100 collectors in America." The recent articles on the rich and famous, like Saul Steinberg, and Asher Edelman are full of information about obsessive collectors; Edelman says of his $10 million art collection, "It's an integral part of my life."

And even professors of economics are, for the first time, like Professor William J. Baumol of Princeton and New York Universities, delivering papers on "What Price Art?" We havent't had this much activity in the art world since the early days of the 1970s.

Not only are the collections of both old and new work making headlines, but now we are seeing articles on how to value art, speculating, gifts for collectors, where to buy and how to sell and even articles about art and taxes, everything you have to know to buy, sell, swap, give away or have fun with your art and antiques prior to April 15, that deadly date for all Americans. It may be that we are at the beginning of another collecting boom or bust – depending on the the rate of inflation and interest rates over the next few years. As Jane Addams Allen tells us

in *Insight*:

> "This year at least, falling oil prices, falling interest rates and a soaring stock market are almost guaranteed to drive art prices up."

An experienced accountant who has guided for over thirty years the finances of one of the most important American antique furniture dealers states that his client's sales did not follow the market for securities but anticipated people's needs to feel more secure with their money, once speculation and the availability for big investment returns die down. He sees the collectible market as being more psychological than financial.

The Psychology of the Investor

Most wealthy people have all of their general needs met at a given period of time: their homes are purchased, the tuition is paid, the clothes and cars purchased, their trusts are established, their portfolios of stocks, bonds or tax-frees are established. And yet, as their income increases each year, instead of accumulating more and more traditional investments, they crave for the physical ownership of great or near great objects. They want some security; they believe the acquisition of objects can bring this about. They want what is available at the Metropolitan Museum, not more of what is available in liquid investments from Shearson/ American Express. In a sense they crave for security and a desire to own the object in order to enjoy its exclusive possession, or a vicarious sensual satisfaction. In an interview *(ICA, The Literary Review)*, Rosalind Krauss, an editor of *October*, analyzed current tastes and movements as being within what she labelled "an international art boom". Art, to her, is certainly now big business – but it is more, in that it also seems to be a kind of hysteria for luxury:

> "One of the things buyers in the big luxury department stores tell you is that they're selling $ 5000 – $ 8000 dresses, not $ 500 dresses. There's a kind of hysteria about luxury at the moment which I don't, as a moral feminist, altogether understand. There's demand for luxury goods. In this context, it's interesting that a lot of these new paintings are large. What these new artists are doing is recycling a blue chip modernist image in oil, large scale. Somehow it has a certain kind of fashionableness."

Is Wealth a Prerequisite?

Does one have to be wealthy to be a collector? The answer is an unqualified yes. No one, with common sense, would begin the acquisition of art unless he has first satisfied his basic needs.

Joseph Alsop, in *The Rare Art Traditions*, tells us that collecting is a cultural-behavioral phenomenon. Certainly it has always, at least in recent centuries, been predicated upon the power of money. Collecting, says Alsop, is a type of behavior

that has been taken for granted. He says that it is an activity that is actually "highly idiosyncratic, exceedingly complex and, in some degree, quite [an] irrational cultural-behavioral development." While the psychological motives for collecting are still based in issues of class and power, today's economy and art world are unprecedented, as are the behavioral patterns of the wealthy.

Of course, the meaning of the term "basic need" differs from person to person. Someone may feel that having not one but two residences is basic to his way of life. But if he were to consider the alternatives – less cash down payments, less payments on the mortgages, and less upkeep – he might see that he would do well to satisfy another need. Maybe that urge for something else can be satisfied by building a great collection.

For most, however, unless, you have extra funds after satisfying your basic needs, collecting is a bad idea because, and I speak from long years of experience, it's very easy to become addicted (and we all know about addictions, whether to cigarettes or cocaine). This addiction is all the more serious because collectibles are illiquid and not available to be turned into cash without a twelve to twenty year holding period.

The Collecting Urge

The collecting urge is a rare combination of human elements that has to be controlled or, like any addiction, it will get out of hand.

For example, the famous Cone sisters from Baltimore were addict acquirers of the first order. They were shoppers with a vengeance, but today they would be called connoisseurs and patrons of the arts. Moving from collector to connoisseur status is of course the goal of all collectors. These women had a drive to possess objects above all else. They acquired not only art, but laces, shawls, saris and jewelry. They bought art because they had the money and also the psychological urge to own what they considered worthwhile. Fortunately for them (and us, and art history) they met Gertrude Stein and her brother Leo, acquaintances from Baltimore who believed in paintings and painters.

"So", they may have said, "why not add to our acquisitions something to hang on the walls?" They did, and came to understand, as most real collectors do, the value of these acquisitions. Then they became obsessed with the works of Matisse, Picasso, Renoir, Cézanne and Gauguin, not a shabby obsession to have, given the tremendous value we now attribute to these artists. The Cones may have been lucky, but there were others who had precisely the same opportunity but did not choose as wisely or as successfully.

As collectors, they were ordinary for their era, and not particularly rich. But with the help of Gertrude Stein, they became real collectors. This is not uncommon: a good advisor or dealer can make all the difference. When one collects, as they did, art by living artists, it's crucial to get all the help possible. The Cones alone could not have amassed such a wonderful collection without the aid of

experts whose advice helped them anticipate the vagaries of art history. How much was Cone and how much was Stein, will have to be left to the art historians.

Ann Tyler, writing in a 1985 issue of *Art & Antiques* on the Cone sisters, says, "and without Gertrude's zest and audacity – which perhaps inspired the sisters with a little edge of competitiveness – they might not have bought such vast amounts," and such basically good pictures. Who knows who influenced who in building this collection? The fact of the matter is that the Cone sisters retained almost all of what they collected and it can be seen today at the Baltimore Museum of Art. Gertrude and Leo Stein, on the other hand, sold all of what they collected long before the artists were well established.

One group was successful in investing in and collecting art, the other group was not. Fortunately for the world, these sisters died without any heirs. And while the debates may continue in heaven, here on earth we honor the Cone sisters for their brilliance and daring in recognizing genius. Not a bad way to spend money, if one has it to spend.

The End of a Collecting Era

With the 1930s advent of tough inheritance taxes, it seemed that private collecting was dead. During the Depression, many huge fortunes that seemed solid cracked, and even the wealthy were unable to pay inheritance taxes and still keep their collections intact. Some sold them, others gave them away, but few kept them for their heirs.

Did the great collector, P. A. B. Widener, have it right in 1930s, when he said:
"The days of America's privately owned treasure houses are over. They are gone with the wind as inevitably as the great Southern plantations of before the Civil War... Such a gift is more than a mere disposition of beloved treasures. It signifies the end of private art collections in the grand style. . . Few can any longer afford to buy a half-million-dollar Rembrandt or Van Dyck merely for their own personal pleasure, far less a gallery of them. Today there is a general and salutary leveling of extravagance to safeguard this great heritage of ours, America."
Obviously, Widener did not take into account a period of such prosperity, since the 1930s as the world has ever seen since the Renaissance.

The era of the great historical collections was led by William Randolph Hearst. The demolition of his vast collection began in the late nineteen-thirties with orthodox auctions in England and America. Conventional auction sales, however, could never dispose of Mr. Hearst's possessions in the remainder of the life-span allotted to him, so more forceful means were used. First at Marshall Field's in Chicago in December, 1939, then a few months later in St. Louis.

They were followed, early in 1941, by the first "blockbuster." A large portion of the Hearst collection was installed in two New York department stores at rock-bottom prices ranging from thirty-five cents to hundreds of thousands of dollars. It

was part carnival, part shocking, and everyone knew about it. Had the stores made a mistake? Would the public buy? And if it did, would it not ruin the antique and art markets? What actually happened was a surprise even to the promoters, considering the Barnumesque atmosphere.

Prior to the sale, one hundred thousand engraved invitations found their way into the homes of society and suburbanites, members of patriotic organizations, foreign ambassadors and the department store charge-account customers. The hundred thousand "elect" were invited to three formal nights of previews. Many came out of curiosity to see the Hearst collection, many to view the first-night celebrities. If this description sounds all-too-familiar to the collector of the 1980s, it's because the "blockbuster" continues as the mainstay of the auction business.

There were thousands upon thousands of *objets d'art*, each with odd-price tags affixed, ranging from tiny Egyptian scarabs and little carved cats "from the tomb of Cleopatra," to seventy paneled rooms taken from English, Dutch and French castles. The experiment succeeded on such a scale that its repercussions are felt even today in the collecting world.

However, the Depression also seriously threatened other collections, including the telegraph millions of Clarence H. Mackay. Just four months after the opening of the Hearst sale, Gimbels took over four thousand items from the Mackay Collection.

The Gimbels advertising was classic. Take these, for example:

"Gimbels is selling acres of art to museums and millionaires – but Gimbels is also selling acres of art to Flatbush, Montclair, Peoria and points west.

"Who does buy art? Everybody! You don't have to be the Countess G . . . to cherish an exquisite little Ch'ien-lung jade Kuan-Yin. You don't have to have a family tree going back to William the Conqueror's great-uncle to prize a gadroon-bordered Georgian silver soup tureen. You don't need a Mayflower ancestor to linger over a pine hutch table. You don't even need a fat checkbook, because we'll extend your payments for your treasure over months if you like, just as we should if you bought a refrigerator. You can live in Flatbush and love Reynolds. You can live in Montclair and worship Ingres. You can live in Peoria and have a passion for Hitchcock chairs. You can pay $50 for your apartment and put your dollars instead into the possession of one perfect, slender Sheraton table. Or you can pay $3 for a blue glaze faience Egyptian scarab. You can ride the 7th Avenue subway and carry home a pair of dainty ear-rings that belonged to Martha Washington. You can live in Racine or Galesburg or Tucson or Butte or Denver or Sacramento. Where you live and what you do and how much money you have has nothing to do with your love for incunabula, your interest in Byzantine madonnas, your devotion to Corot.

Few who read the advertisements knew just what a Ch'lien-lung Kuan-Yin was, jade or otherwise, but there was a subtle element of flattery in the assumption

31

that they did. Equally breezy was the suggestion concerning the ancestral portrait –
"who's to care, or to know. . ." – a suggestion of exquisite discretion. Particularly
significant were the last three sentences:

> "Beautiful precious old things aren't only for museums and art
> galleries and great hushed private collections. Artists never made them
> for museums and art galleries. They made them to be worn, to be used,
> to be looked at, to be appreciated, to be loved."

Imagine what would happen if our current dealers, or auctions, were so bold.

Glen O'Brien, writing about art advertising today in *Artforum* describes the
new image of the gallery as reflected in its public relations campaigns:

> " 'What graphic design can do for a gallery is to create a sense of a
> confident identity. Most people come into contact with a gallery through
> the advertising and what they read about it. Most people don't actually
> go to galleries. Graphic design is actually a small part of creating a
> gallery's image; however, it does represent the gallery to most people.
> Graphic design creates a personality. . . . But what's really important is
> the adherence over a period of time to a set of rules that you create.
> Those must be followed consistently – which requires a great deal of
> discipline on the part of the gallery – from the facade of the gallery, to the
> announcements, to the catalogue, to the name of the artist on the wall.
> That consistency is very important in giving a sense of confidence.
> Sometimes a gallery wonders if it's being seen anymore because it's doing
> the same thing over and over again. Actually, the consumer of the image,
> which is the whole art superstructure, sees the print representation of the
> image of the gallery in an ocean of others. If that image keeps changing
> it's indistinct."

But back in the 1930s, after the Great Depression they were asking:

> "In the era lying ahead, will the average citizen be expected to
> become more familiar with his own and other cultures and to inherit the
> collecting mantle of the tycoons?"

Anyone who's actually been part of the art business will confirm that this 1930s
idealism was really nonsense; there never was and never will be an average citizen
interested in art.

As Nelson Rockefeller learned in the 1970s with his Rockefeller Collection,
there is no great public interested in art or collecting. Despite unlimited funds, the
project was a dismal failure. The Book-of-the-Month Club's buying of the Print
Collectors' Club also marked a great failure in an attempt to make "up market" art
available to the public. The Franklin Mint on the other hand has been modestly
successful, but its limited edition fare can hardly be considered art.

In fact, the number of people (as opposed to the dollars spent) really
interested in art is quite small in relation to the total population. If you took the art
magazines, eliminated the institutional buyers who don't collect art, the remaining
group consists of less than seventy-five thousand people who are really interested
in contemporary and Modern paintings. Of these, probably less than fifteen
thousand are really buyers. The average art gallery mailing list does not include
more than fifteen hundred people.

But these few people spend probably close to a billion dollars in the market-place each year on fine art. Sales at Christie's have risen to 475.9 million dollars in 1985. Sotheby's has put their worldwide sales at 642 million dollars. I would be surprised if the auction houses send out more than two thousand catalogues for any category. Yet they do a lot of business every year. And of this group, very few make the market.

The fact of the matter is that in our society, collecting is a game which has so far no public market, and yet it produces hundreds of millions of dollars of revenue. For several hundred years it has been this way, and will probably remain so.

History is with the Collectors Who want Recognition

These days art and money go together as in the old saying, like love and marriage. The life styles of our age demand satisfaction of our growing need for recognition. The structure of our society is such that few rise to fame. Our democratic ways do not allow too many to be singled out for their achievements. However, one can achieve greatness in this country through ownership.

In every city in America collectors are courted in the hope that they will leave their possessions to the local museum. Our entire museum system rests on bequests and donations. Fortunately, tax deductions are also available to encourage the collectors.

It's ordinary to be rich in America, or at least affluent, and possess all of the things that money can buy. It's quite another thing to separate oneself from the other rich by building an art collection.

Art collecting exists in this country largely as an attempt to imitate the practices of the European aristocracy. Extensive collecting became fashionable in America as a way to move ahead of the rest of the affluent population. For reasons of pride and ambition the wealthy turned from amassing a fortune in mines, railroads, or corporations, to collecting rare books and paintings. The goal of the collector was to be singled out in his own lifetime and in ages to come. The ability to make money is still for most Americans, the greatest of all abilities, and in collecting, a man or woman who has won "money-power" has the chance to demonstrate that power through his or her collection.

The tycoon of yesterday, whose nature was keyed to financial success always turned to collecting with the same driving desire for pre-eminence. In this campaign most often dealers and experts constituted the general staff, for the tycoon soon found out how easily his judgments could cost a regiment of money. In this era collectors played the game as cautiously as possible, buying only old masters, which commanded fairly stable market prices, a fact which appealed to his business sense. To insure against big dealer flim-flamming, purchases were often made contingent on the exchange of other items. Despite this precaution many millionaires were victims of greedy advisers. Others fared better simply through luck or shrewdness.

Wealthy collectors were notoriously ruthless, a characteristic they shared with the rest of the industrial age in which they lived. Even the best of them were accused of being "people of enormous wealth with little taste, who accumulated masterpieces of art without appreciating them." Names were what they wanted, and had the industrious Corot been a magician he never could have produced the number of "Corots" sold.

At the time, vulgar rich Americans were being accused of robbing the "art loving" Europeans of their cultural treasures. One is reminded of Italy during the Renaissance when Roman noblemen detested the rich bankers and wool merchants of Florence for buying up the choicest antiquities unearthed in their ancient city. Later still, Romans and Florentines bitterly watched the departure of great numbers of Italian masterpieces to the "barbarian" French court. France, in turn, saw the upstart Englishmen marching off with art objects purchased wholesale in Paris.

The game is old, and though the Americans are the newest players, it hasn't varied much from culture to culture.

The classic examples of the American period and the great collectors, were Morgan, Vanderbilt, Frick, Whitney, Stillman, Havemeyer, Mellon, Widener, Barnes, and the rest of the names we see on museums or on plaques in them. But it is probably John Pierpont Morgan who will be remembered as the greatest of them all. Interestingly, here was a man who in 1895 saved the U.S. Treasury from collapse; he put together U.S. Steel in 1901, built the first billion-dollar trust. In 1907, at the age of seventy, he halted, through personal intervention, a Wall Street panic so severe that it might have precipitated a Great Depression twenty years early. And yet today we remember him for his Morgan Library, and its great exhibitions. Like most of his contemporaries, J. P. Morgan (1837–1913) had an excellent background for serious collecting – a lot of money. But, he was just one among many.

Philadelphia's Widener family, the founder of which was Peter Arrell Brown Widener (1834–1915), succeeded in establishing one of America's plutocratic dynasties. Widener started out by selling mutton to the Federal troops located around Philadelphia during the Civil War. Next he opened a chain of meat stores, and invested in street railways. Like other powerful men of his time he soon became the owner of many corporations as well. Although he made many mistakes (rectified in later years, when he weeded out the fakes) he eventually succeeded in assembling two great collections – of paintings, and Chinese porcelains – which have come to be considered some of the finest in America.

Andrew W. Mellon, who died in 1937, is another memorable figure. He bought paintings for forty years and brought together a collection which was the starting point for the National Gallery of Art in Washington, D.C.

In 1939 the National Gallery also got the important Kress Collection and after that the Widener Collection. Interestingly, at the time of Mellon's gift, the government sued Mellon, charging him with falsification of his income tax returns. The Federal prosecutor intimated that Mellon was trying to create what we now

call a tax shelter. Times certainly have not changed. By the way, Mellon fought like a true taxpayer and won his art tax shelter, which formed the basis of what now is known as charitable contributions in kind.

Near Philadelphia at Merion is the Barnes Collection, a tribute to the most eccentric art collector in the world. The fact that this museum contains the finest collection of modern French painting in the world is, of course, no accident. Doctor Barnes was a true collector. His attitude was to buy what he wished and "to hell with the critics." Has it changed? Is it different today? Who are the next eccentrics?

Saul Steinberg and Asher Edelman – The New Tycoons

Suddenly the New York business journal, *Manhattan, Inc.*, began carrying articles on Asher Edelman and Saul Steinberg, the big wheeler-dealers of the 1980s. And both seemed to be art collectors of sorts. Are these men the prototypes of the new art collector? Here are two men with different kinds of collections – one very contemporary, the other filled with Old Masters – but both eager and eccentric participants, and I emphasize that they are participants, in the selection of their works of art. Both collections seems to reflect the individual personalities of these wealthy businessman. The collections also, reveal the psychological motivations of the new collector.

The American tycoon Saul Steinberg actually is "old money". Steinberg's reputation, as I said in *Money, Ego, Power*, A Manual for Would-be Wheeler-Dealers, co-author Diane Ackerman, Playboy Press, 1976, was made in the late 1960s, the era of the Davids (Steinberg) and Goliaths (Chemical Bank). Few of the entrepreneurs of that era are remembered today, but Steinberg's impact is still a vivid memory.

Having received his degree from Wharton at the age of twenty, Steinberg was precocious and brash. With that unmistakable baby face, Steinberg has since the early 60s adapted his quest for glory in the world of business and finance to the changing tides of the business. If there is a new game, it's likely that Steinberg is one of the players.

With his breathtaking "greenmail" deals like Disney, and his varied investments, Steinberg has firmly installed himself at the top of the wheeler-dealer list. If a history of deal-making is ever compiled, Saul Phillip Steinberg (no relation to the celebrated Roumanian-born American artist) will stand foremost among the first generation of deal-makers extraordinaire. His career represents the rise, development, and inimitable style of a new race of deal-makers.

Steinberg's collecting habits reflect his personality. It would be easy for a man of his wealth to acquire rich man's toys, like jet airplanes, homes around the world, large cooperative apartments in New York City and so on. He could certainly afford to fill his walls with pretty pictures, that match the colors of the draperies or rugs. If he had no imagination, he might buy the popular and decorative works of

the Impressionists. But Steinberg, always a man with his own ideas, has opted to spend his riches differently by collecting Old Master paintings. And not minor league Old Masters, but art works that the great museums of the world would like to buy, if they had Steinberg's access to money.

No one can match Steinberg's wealth, acumen and audacity. No one collects Old Master paintings anymore – not Norton Simon (who has his own museum), not even Baron von Thyssen (whose collection begins with the Impressionists). Steinberg's style of collecting is reminiscent of the Italian Renaissance when the first great patrons and collectors of art made their marks.

Saul Steinberg adopted the style of his newest mentor, Lord Jacob Rothschild in England. Jacob Rothschild had the status that Steinberg believed he should share, and this was not the class staked out by the "new money" Asher Edelmans of the world. Surely Jacob Rothschild, English businessman to the core, was only too happy to initiate Steinberg into the pursuit of the ultimate of self-indulgence. If Steinberg didn't have ready cash, that was no problem since he had the next best thing, the power to borrow for the possessions to accommodate his lifestyle. To emulate his mentor, Steinberg looked not to the New York art dealers, or to the East Village, but to the London house of Colnaghi's, last of the great picture dealers in the Old Master field.

Asher Edelman is "new money", as *Manhattan, Inc.,* recently described him. He is on the cutting edge of the business world. He has moved from trading securities to arbitrage, then to risk arbitrage, and then to takeovers – each field is more daring and less conventional than the previous one. Asher Edelman is of a different sort. He socializes with underground film stars, frequents the parties at art impresario Steve Reichard's loft, and snaps up the works of the East Village artists, like Jean-Michel Basquiat. Edelman is at the forefront of the "new rich".

A newcomer to this high-paced world, he had neither the confidence of Steinberg, nor, one suspects, the contacts in that world of the Rothschilds. His notion of what the wealthy do with their money was to buy the best and the most current of contemporary art. Unable or unwilling to pay ten million dollars for a fashionable Park Avenue address (where one finds the Steinberg collection), he chose instead a twenty-three-room apartment on East End Avenue. He hired an architect to turn the apartment into a showcase for his self-indulgence, the exhibition of the newest of new, the biggest of the big, which meant big walls to house his art, with a warehouse so he could circulate what he hangs on his walls to keep current and at the cutting edge of the market.

As with Steinberg's, any museum director would view Edelman's collection as nirvana. Of course, Edelman's collection is an unabashed display of wealth and is designed to show himself as being in step with the avant-garde. His sense of style seems to be a few rungs up the social ladder from where Steinberg's attitude toward collecting was in the mid-1970s: imitating what he perceives to be the behavior of the class above him and to distance himself from those many other rich below. This is not a simple feat. It takes a lot of energy and time away from the primary activity of making more money. But as we see in the pictures on his walls, Asher Edelman is certainly trying.

Compared to the holdings of the European and American aristocracies, the Steinberg and Edelman collections are admittedly vulgar, but how else is the world to civilize the rich? If one hopes to provide a living for the artists of the world, in the hope of finding a genius, then the Edelmans are doing their small part to enhance the cultural life of this country. If one can overlook the egotism and self-indulgence of these two men, one can view them as current emphatic examples of what has long been the tradition of collecting in the world, from which we all benefit in our museums, each and every day, and probably in the future.

Since the days of the great patrons, self-made men like Steinberg and Edelman have been collecting. The world may be better off if their zeal is infused with a sense of style, skill and taste, but even if it's not, it's better to have some collectors than none at all. The complex relationships among wealth, knowledge, taste, patterns of support for certain artists, all contribute to the often intangible art historical system.

Collecting has always served to civilize the rich, and given them the opportunity to outdo one another. In the end, no matter how much one has or can spend on art, to survive competition on such a grand scale requires skill, taste and passion. In a strange way, this competition also adds a certain spirit to the whole art system, which deflates the notion that to be money-rich alone is enough to guarantee greatness.

The vulgarity of some of our present-day collectors may just be the price that has to be paid, in order for the world-wide art system to continue to function. The rich have the money and are often generous in how they spend it. Look at the names – Guggenheim, Whitney, and Hirshhorn, to name a few. I don't believe the government would or could support the arts to that extent. The price for our society is not too great if in the end we have to call such collectors "enlightened." And, furthermore, the artists all benefit, as does the art-viewing population, the dealers, the collectors, and the auction houses. It's good business when the hundreds of millions of dollars are spent on a product that has no value, except that someone wants to own it. It may be argued that the purpose of art should be re-thought in non-cash terms, but so far no one has suggested a better way. We have plenty of cynics but no solutions.

Looking at Other Collectors

Some collectors try to keep abreast of whatever is "the newest of the new." This is not an easy game. Some collectors are always looking for what is called "the new sensibility" or simply the next popular trend for market exploitation. The cynical view of this collecting activity is that new art is constantly needed to keep the art-distribution system going, since there are really very few new players in the collecting game at any one time. These new players, in a role once restricted to dealers but now open to collectors as well, try to create reasons why the collectors should spend their money. The rent gets paid, and the expenses of the galleries are

provided for only if the dealers and the commercial market for art have a new product to sell. The last big movement was neoexpressionism but, after five years, this movement has run out of steam and the search is one for a new group of artists to promote in the 1986s. How is this being done, and who are these new collectors?

Gene Schwartz is unique among collectors in that he has now made it his full-time business to be an integral part of the art historical process. Schwartz used to be a publisher of mail order "How To" books. He was, and continues to be, an outstanding copywriter who seems to be able to put together packages of material in book form that appeal to the interests of a great many people. Gene Schwartz, of course, right from the beginning, joined the neo-expressionist bandwagon, with his big Schnabels. Today, he has become an art impresario in building new and hopefully big, saleable art movements. Clearly, his goal is to identify new artists and build new tendencies into a consensus which can be promoted into a new art movement. His play is to buy at a low price at the beginning, hype the market into getting excited about his new discoveries, cause a rise in the prices of his selections through promotion and thus make a lot of money from his astuteness. Schwartz is trying to manipulate the art historical process. He wants to influence the working methods of the distribution system as well as who rises and develops as an artist, and which styles in the marketplace become important in the future. How this is being done, specifically, is clear from an interview with Jeffrey Deitch which appeared in *Artscribe International* (April/May 1986):

"Well, a bandwagon starts and in today's artworld the bandwagon gets rolling quickly and is immediately international and influential in every corner of the artworld. Taking this new tendency as a model, before last spring there were only a few disparate collectors buying the whole range of the tendency and putting it all together. Nobody was writing articles that grouped these artists together and certainly there hadn't been any significant group shows – there were just a lot of little things happening. And then last spring and through the fall one family of collectors – Barbara and Eugene Schwartz and their son, Michael – caught on, and began buying the whole group. They gave a party in November where they displayed the whole body of work they'd acquired and they invited most of the artists who were involved. I remember it was startling to see this work all put together in one place for the first time when previously there hadn't even been a group show in a gallery. So here were the artists. Most of them were already known to each other but some of the juxtapositions of works were unexpected.

"How were the Schwartzes drawn to this new work in the first place?

"They're among a small group of collectors who are very familiar with what's going on and are always looking. There are other collectors too, who are really close to the ground and very much part of the scene. So people like that begin to buy. . . the first groups of buyers are always very adventurous. They know what they're buying, they talk to the artists and they understand the work. But soon the momentum starts and it gets

in the air that this is the next hot thing and a different sort of audience starts getting in on the act; people who want to buy cheap before the really big money comes in, a more commercial approach where they want to make sure they have works by the hot new artists. So then, because these artists don't necessarily have a large output, and six people asking for a work, or for several, will quickly take up the supply, very soon the information gets out that so-and-so has a waiting list.

"But still you have a situation where the art may not have been reviewed by *The New York Times*, say, and which, in terms of museum people knowing about it, is still completely underground.

"The influence of collectors in launching a movement is a new development. . .

"Correct. The situation is radically different from ten, fifteen years ago.

"It's interesting that during this period they have moved into such a vital position.

"I had a good chance to observe the artworld at close range about ten to fifteen years ago when I was secretary at the John Weber gallery, at a time when it was one of the most exciting places on earth for art, showing LeWitt, Haacke, Ryman, Smithson. . . ant then the situation was quite different. The writers and curators, and maybe a small group of pioneer dealers, were much more important in shaping things. There were actually very few collectors – Count Panza and a few others basically supported the gallery. There were a number of interesting collectors who would come in and look at things but it was really a circle of artists, curators and writers who were spreading the meassage."

Charles Saatchi

No book on collecting in the 1980s would be complete without a few words about Charles Saatchi. Saatchi is one of the founding partners in Saatchi and Saatchi, a British advertising firm that has become famous for, among other things, its work with the Conservative Party. I first met Saatchi when he was just starting out as a collector in the mid-1970s when I lived in London. He was an early supporter of English artists and, I believe, influenced early on by Edward Lucie-Smith, a British critic and art writer.

Lucie-Smith is a prolific writer on art as well as being a fine poet. Lucie-Smith writes about everything and anything that he can get a publisher to publish, and has closely followed contemporary art since the early 1960s. His "Thinking about Art", a series of essays which were originally published in *The Times*, is still a great source book for a collector, although it's difficult to find a copy. One night after having dinner at Edward Lucie-Smith's flat in Fulham, he called: "Marty, Kenneth Dingwall is having a show and Charles Saatchi has bought ten pictures. I think you

should go around and see them." I did, and bought one big oil and two small works on paper.

Times have not changed at all. The fact that Saatchi is buying has been a key password in the international world of art for the past fifteen years. Once, I was in London in James Mayor's Gallery, and Mayor was looking at a Cy Twombly painting that had just arrived. In walked Charles Saatchi, and Mayor, a normally shy and quiet man, became flustered. His eyes lit up, and he had a look in his eyes which told the whole story. "God" himself was making one of his regular visits to the dealer's premises, and anything could happen.

Who is Charles Saatchi? He is forty-two years of age, very, very shy, and married to Doris, an American who writes about art. *Art and Auction* has called him a moody perfectionist, a man of many paradoxes, an art impresario, a recluse, and an incarnation of the ghosts of Lorenzo de' Medici and Howard Hughes combined. This reputation is derived not from the fact that he is as rich as Saul Steinberg (or Asher Edelman or any one of a hundred collectors in the U.S. who are probably richer than he is), but from the fact that he has made it his business in the most quiet way to say to the art world, "If I like it, and buy it, it's the best." I think Saatchi would have liked the good Doctor Barnes and his collection in Pennsylvania. He certainly is a new eccentric and the kind that the art world seems to develop every five or ten years. Larry Aldrich, a man of quiet passion, also comes to mind, another eccentric, with his Aldrich Museum in Ridgefield, Connecticut.

Saatchi has recently opened his own museum, in the tradition of the Russian princes, Norton Simon, and the good Doctor Barnes. It is located in a vast, renovated paint warehouse that lies behind an anonymous gate on a side road in Maida Vale, an obscure corner of London. Saatchi, whether you love or hate his numerous Warhols, Twomblys, Salles, Longos, Shermans, Polkes, Chias, Schnabels, Baselitzes, Kiefers and Clementes, has made a statement about himself: "I don't talk about my art or discuss it with anyone but a small troup, but if you want to see how great I am, you can come and look."

In his very clever way – and Charles Saatchi is very clever – he has understood the 1980s art world from the perspective of the collector better than most. Emulating the attitudes of the Minimalists, whom he first supported, he says, "I will deny all that we have understood about the collector and his ego in the Western world. I will give you my viewpoint but not myself or my emotions. Make your own decisions about me, but I am nothing, the art is everything." Attitudes like this turned out to be the most clear and immediate way to make Charles Saatchi one of the most important collectors in the world today of contemporary art. Until now, it has never occurred to any collectors that if they really want to be a force, as Saatchi wants to be, an arbiter of ideas and values, the best way is to let the purchases speak for themselves.

The Creative Collector

The creative collector, then, is that collector whose money alone does not make him great. Rather, it's the combination of buying power, experience in the market, discipline, knowledge, and subtlety, which elevates the acquirer into the select breed of those honored for their collections; we call this person a connoisseur.

One would be surprised at how little money is actually needed as long as one has the right knowledge, subtlety and ability to network. Our astute and pseudonymous collector has said: "Discipline is what a collector needs and sometimes a tight budget confers it." As I hope to make plain, collecting can be done by those other than the big rich. The point is that success is not judged on the basis of one's spending power alone but on what one spends it on. This rule applies to those who wish to become successful collectors, no matter how much one spends. Let's look, as an example, at the Russian merchant princes, who influenced the course of abstract art in the world.

The Russian Merchant Princes

When the Russian merchant princes were banished from the elite of Russian society at the end of the nineteenth century, they distinguished themselves by taking their newly acquired wealth and taught us how to see anew.

Sergey Ivanovich Shchukin, a Moscow businessman at the end of the nineteenth century, was no different from Malcolm Forbes, Edward Downe, Pat and Phil Frost, Ruth and Marvin Sackner, Douglas Cramer, or a host of others that I could list. While they all were successful in their given professions or business, that was obviously not enough. These collectors all put more than their own money into their collections, they put their intelligence into their acquisitions to make an impact on a certain specific area of art. The Sackners, for example, certainly made an impact on concrete and visual poetry, and today are that area's connoisseurs. What Shchukin did to distance himself from his competitors was to apply discipline and knowledge to his collecting to become the collector extraordinaire. As such a collector, he created the Museum of Matisse and Picasso in Moscow and introduced Cubism and radical art into Russia, an art which exposed young Russian artists to the masterpieces of the twentieth century, forever altering the course of abstract art.

What was the psychological need for Shchukin and his friend, Ivan Morozov, to amass this collection? Probably at first, it was no different than those of a host of other wealthy people, and businessmen in general. They sought, bought, negotiated, traded, bargained for what they thought would make them important collectors in a specific area of art. As I have said, collecting sometimes gives the impression of being vulgar, but the important thing to ask is, whether each collector brought something other than the ability to spend to his collection.

Collecting in the East Village

The East Village in New York, and East Village Art, is where it "is" for many collectors today. As a relatively new phenomenon, it is a process which continues to renew itself in New York, and has now spread to the rest of the United States, and even to Europe.

Years ago, there was Aegis, at 70 East Twelfth Street, showing Leonard Kirschenbaum, Ralph Wehrenberg and William E. Krollman, artists for whom I can no longer find a record. There were also the dealers like Art Directions, Carmel, Contemporaries, Diarcy, Downtown, Fleischman, James, and a host of others, all gone and most of them, with the exception of the Downtown, totally forgotten. Today in the East Village we have Gracie Mansion, Jus De Pomme, M-13, Mokotoff, Ninth Precinct, No Se No, Phenix City, Piezo Electric, and a host of others. Will any of these be remembered?

Robert Pincus-Witten, writing in *East Village, A Guide – A Documentary*, calls the story "The Green are Gone," but it hasn't changed:

"This drift, for East Village Art, registered shifts in class character, from the Lumpenprol to that of a proletarian consciousness and, as it shuttled back and forth between the East Village and Soho, brandishing those letters of patent, finally achieving the bourgeois commodity status of 'real art'. But it was along Ridge and Rivington, Norfolk and Suffolk Streets, where the Eastern European pushcart gave way to the hispanic shaved ices vendor, that the earliest generation of East Village artist first emerged from the primordial grunge.

"Next came the astute curator who grasped that an historical overview of the East Village would provide an occasion for the 'scientific' study of a closed model while it vouchsafed the host institution all the glamour accruing to so novel an enthusiasm. Indeed, in this respect, the museological effort has been preeminent in validating the East Village. The catalogues, say, of the overview held at the Institute of Contemporary Art at the University of Pennsylvania (in 1984) of 'Neo York", the survey presented at the Santa Barbara Museum the same year are central reference works – all the dates are there, the firsts, the bios, the bibliography.

"Hard upon the museum survey came the brief group exhibitions of established dealers who, sensing the displacement of excitement from conventional spheres of influence, reinvigorated their polite turf through the presentations of smaller versions of the museum survey. As icing came the commercial flip book and hip guide – ready reference, fast info, like the columns of East Village newspapers such as New York Talk of the *East Village Eye* – and the notion of the East Village as citadel of art was flyingly buttressed.

"Truth is, walls are crumbling and what we have now are mounds of fallen stones; the original matrix has not held. Well, that is overstated.

Rather what we have now is another level, another mesh, another scene built on the earlier foundation. Archaeology. But the mastic whereby early work was experienced as talisman of a set of commonly held aspirations, that period is over. The sweet, the idealistic, the green are gone."

I asked a friend of mine to give me a list of the better known East Village collectors, and what they collect. I must admit that I don't know one single artist on the list, but here it is:

The Collectors	*The Artists*
Elaine & Werner Dannheiser	Rodney Greenblatt
	David Wojnarowicz
	Rhonda Zwilinger
	Peter Schuyff
	Milan Kunc
Robert & Adrian Mnuchin	Peter Drake
	Will Mentor
	David Wojnarowicz
	Peter Schuyff
Maggie & Eddo A. Bult	Stephen Lack
	Rodney Greenblatt
	Jonathan Ellis
	Ted Rosenthal
	Rhonda Zwillinger
	Peter Schuyff
	Paul Benney
	Guy Augeri
	David Sandlin
	Claude DeMonte
	David Wojnarowicz
Don & Myra Rubell	Rodney Greenblatt
	David Wojnarowicz
	Judith Glantzman
	Rhonda Zwillinger
	Peter Schuyff
	Stephen Lack
	Mike Howard
Herb & Leonor Shore	Rodney Greenblatt
	David Wojnarowicz
	Peter Schuyff
	Thierry Cheverney

Regina Trapp	Paul Benney
	Rhonda Zwillinger
	Rodney Greenblatt
	Judy Glantzman
	Jonathan Ellis
Emily Spiegel	Milan Kunc
	Peter Schuyff
	Rodney Greenblatt
	David Wojnarowicz
	Philippe Taafe
Jerry Speyer	David Wojnarowicz
	Buster Cleveland
	Ed McGowen
	Rodney Greenblatt
	Mike Howard
Stanley & Margaret Schenker	Rodney Greenblatt
	Buster Cleveland
	Stephen Lack
	Rhonda Zwillinger
Carolyn Newhouse	Guy Augeri
	Stephen Lack
	Rodney Greenblatt
	Judith Glantzman
	Peter Schuyff
	Paul Benney
Joshua Smith	Rhonda Zwillinger
	Jonathan Ellis
	Stephen Lack
	Guy Augeri
	Claudia DeMonte
Eugene and Barbara Schwartz	Peter Schuyff
	Philip Taafe
	David Wojnarowicz
Laura & Saul Skoler	Stephen Lack
	Rodney Greenblatt
	Rhonda Zwillinger
	Mark Dean
	Ted Rosenthal
	Guy Augeri

Bert Minskoff

David Sandlin
Judy Glantzman
Rodney Greenblatt

It's too early for my questions about these collectors and their collections to be answered, and my point is that I don't have enough knowledge to make any judgments. It's for the collector to decide why he has made the decision to become a collector of this particular kind of work. In the end, it will be their own taste, and their own ideas of who is good and who is bad that will be the deciding factor when tested by posterity.

Standards by Which to be Guided

I think I know the standard by which a collector's decision to collect specific kinds of work will be tested. What did each collector contribute to each item of his own tastes, his own ideas about quality and his personal speculation about the object's future value? Collectors in a sense must challenge themselves against the unknown future and (whether we like it or not) this is conceived of in investment terms, since there is really no other practical method. Having made their decisions, they will have to wait for the results of the ultimate sale or gift. And while they will probably not know the ultimate results of their decisions for some time, they must have faith in their intellect. The successful collector's acquired knowledge enables him to anticipate the future marketplace, when the objects will be valued. Can collectors be more than mere money makers? Can they become great connoisseurs as well? Will the system validate their purchase? Will what they own withstand the test of time?

Clearly collectors have a desire to possess these objects, to see them when they came home at night, to test the work against their continuing passion for the object. They also want to own and invest in something that reflects some part of themselves. They are also "good to look at," labeled by Jacques Maquet in *The Aesthetic Experience* as attention, nondiscursiveness, and disinterestedness, or "nice" and "beautiful": words that suggest the absence of material interests.

They are not creators, but they can at least own the works of the artists. The painters or artists they collect can become part of the collector's personality and even his soul. As a result, it is hoped that the objects they surround themselves with will also expand their intellects, if they purchased the right works of art.

45

"And then having gotten so far I began often to think a great deal about oil paintings. They were familiar to me they were never really a bother to me but sometimes they were an annoyance to me."

<div align="right">Gertrude Stein</div>

III

The Market Makers

The Dealer

The world of business, as Karl Marx forcefully showed over a century ago, provides little room for altruists. And yet the art business is still and industry populated by very few people who are in it just for the money. Few, if any, art dealers make the kind of money that could be made with the same expenditure of time and capital invested in another enterprise. Dealers are in this business for many reasons, but foremost among these is ego gratification.

From the Nineteenth Century to the Present

The art world in the nineteenth century operated pretty much as it operates today. Then, as now, it was a business dominated by strong personalities, and these personalities were more important than the products for sale. The premises on which the nineteenth century dealers operated were simple. Generally they had a few rooms at most, located in an area that would attract the rich and affluent. Today, those few rooms are more elaborate, more modern, and more spacious, but the game is the same: to attract the rich and affluent. The system (notwithstanding the more modern structures within which they operate) harkens back to the beginning of the art world. It's a system by which the most fashionable people of the day are associated with objects that mirror the production and consumption of works of art.

In the nineteenth century, every gallery was dominated by a personality, and this personality was generally synonymous with the name of the business. Names such as Vollard, Wildenstein, M. Knoedler, Duveen, Gimpel, and Agnew, come to mind. All names of the person who owned and ran the business. Today, we have the same structure, only the names have changed: Fourcade, Weintraub, Acquavella, Graham, Hutton, Hirschl and Adler, Willard, Deutsch, Kraushaar and Tatischeff. Art galleries are not like other businesses. We find, for example, no elaborate organizational charts mapping the relations among top management, no

dealers-in-chief, senior associates, or heads of sales, marketing, production or manufacturing. We find, instead, a simple line of authority, the owner, whose name is on the business, who calls all the shots and one or two people who work for the owner. There are no lines of authority, just one boss who runs the entire business, no matter its size or complexity. To the best of my knowledge, there is only one art dealer that could ever be remotely called a corporate entity, and that corporate entity is dominated by and reflects the personality of its largest stock-holder.

There is little possibility that large public corporations will ever take over the art business. This prospect does not exist because even the largest of the art dealers could not be run without the dominance of its owner or owners. When it comes to the art business, " going public" and selling stock, the few times it has been tried, has failed.

An Art Dealer is One Who Gets Rich by What He Doesn't Sell

At a dinner, Claus Perls, the preeminent Madison Avenue dealer of the great names of the 1920s, 1930s and 1940s, was asked to define an art dealer. He said, An art dealer is one who breaks even on the operation of his gallery from sales to the public, and may get *very* rich on what he does not sell to the public, but keeps for his own stock. Of course, one would have to add that to follow this path to success, the dealer would have to have a lot of capital, not to mention a great aesthetic sense. The dealer Leo Castelli, although he has represented some of the best names of the art world, was limited by his capital which allowed him to purchase for his own collection only two of the stars of this earlier period, Jasper Johns and Robert Rauschenberg. He may own work by others like Roy Lichtenstein, Frank Stella, Robert Morris and Bruce Nauman, but this is where his fortune lies.

Is the Art Business Changing?

For the first time since the art business really started to grow, I see an indication of a coming change in the business, concerning contemporary art. This change has been brought about because of two elements. The number of artists produced each year by the university art schools coupled with the over five hundred galleries now operating to market their work creates a situation where art dealers are fighting for the same share of the market. Also, the uncontrollable costs of such things as rent, salaries, catalogues, advertising, shipping and maintenance has now made it a business, rather than an altruistic endeavor.

Not much more than five years ago, the business was dominated by fewer big-name artists, fewer galleries, fewer personalities, lower rents, lower expenses and consequently lots of time to gain the confidence of the art-buying public, with

respect to the artists who had survived the art historical system. It wasn't just that there was less exceptional art produced before. It was that there was a filtering process wherein the art works took a long time to find even a minor market.

Most of the artists who claimed to be professional as well as the dealers who sold their work, expected little from the marketplace until the artists were very old, or in most cases, long after they died. If an artist could live a modest life from his art, he was considered quite successful.

It wasn't until the early 1960s that even the giants of today could even contemplate living off their art without some other job. Hans Hofmann, one of the greatest of the abstract painters, ran a school until he was well into his seventies. Almost all of his best work is from his latter years, when he stopped teaching and started painting full-time. Of course, by that time, he was reputed to be very rich. Of all the artists of that period, it is probably only Robert Motherwell and Willem de Kooning who have become very rich from sales of their art while still alive, although it is rumored that Adolph Gottlieb was rich when he died. Mark Rothko was probably quite comfortable financially, as was Milton Avery. Stuart Davis was never in his lifetime very far above the poverty line. Some claim that Mark Rothko committed suicide because he could not cope with his financial success after so many years of struggling to stay alive. And that so-called financial success would be scoffed at by any of the "yuppies" who live and work in New York City today.

Little has been written about the economic situations of the artists, compared to what has been written about the art of this period, and less is really understood. In the 1970s, during the emergence of SoHo and the Fifty-seventh Street galleries, the artist and his expectations were quite different from what they might be today, because his market was different and the relationship his dealer had to that market was different.

Market Categories

Contemporary

In the past, all dealers would always agree on one thing: "the only good artist is a dead artist." The reason was the constant clash of strong personalities. In most other businesses, it is the product that dominates the marketplace. It would seem logical that the artist or the product he produces would drive the business. But no, in the art business, it is the personality of the dealer that makes the market, not the product. The dealer, and not the artist, was supreme because the dealer had the only means of exposure to the marketplace. Art works, then, came to be what the art world's distribution system could handle, because for the most part, work that could not be distributed would never be known.

Historically, the problem for the artist has always been to find a way to sell his product. Distribution has also had a crucial effect on artists' reputations. What is not distributed will not be known and will not be reviewed by critics or have

historical importance. Most artists realize, the system relies upon a Catch-22: without a reputation, one cannot be sold, and one cannot get a reputation if he is not distributed.

In the early nineteenth century, artists' associations, like the academies, would hold exhibitions which served as the primary distribution method. Through a selective process, those who were recognized by their fellows as being worthy would be allowed some exhibition space at the annual exhibition and be allowed the chance to sell. This did not mean that the work sold, for most did not, but at least it provided an opportunity for seeking recognition in this very limited marketplace. If you accept the theory that an artwork's value is created by art history, the problem for the artist was always how to break into this system of critics, scholars and collectors.

Under the old system there was no marketing means between exhibitions, and therefore no chance for potential sales. A few dealers started to bridge the gap between the annual exhibitions by offering the artist an opportunity to place his work with a dealer on consignment or sell it to him outright. Ultimately, the artists abandoned the old system, and with the dealers created a new distribution method. The system changed to accommodate the artists, and the artists also changed to accommodate the new system.

The practice of annual exhibitions has almost completely died out, although they do exist as a matter of form. However, few artists take them seriously as a means to sell paintings or make reputations. There were always two different kinds of dealers and distribution systems, those who dealt in the art of the past, artists who were long dead, and those who dealt in new art, the contemporary art of the time.

Those galleries that dealt in the art of the past needed lots of capital to compete. They bought at low prices and sold at much higher prices to cover their costs and operating expenses. The also had to pay for the opportunity to get a chance to bid for the art.

These dealers needed to know above all else where the art was located and when it might become available. They therefore needed a system of surveillance. Men like Bernard Berenson became of the utmost importance to the dealers because as a critic he had access to the collectors and knew their collections. In a sense, the history of Bernard Berenson is a history not only of the sage, the host, and the critic, but also of the *francstireurs*, or runner, as he is now called. A *francstireur* is the person who hunts out paintings for dealers. The New York collector John Quinn used the poets as well as the artists as his runners, to buy from and became acquainted with Picasso, Matisse, Braque and the other great names of his time.

In the older art category, the focus is not on the marketing or the selling of the work, but on being able to acquire it. Selling has always been the easiest part of a dealer's business with dead artists, as long as he has what is recognized as historically important art.

There was also a real need to be social, to be part of the collector's world, in

order to be able to acquire and to know what the collector needed. For the dealer in older art, even today, to sit in his gallery and hope that customers will wander into the gallery off the street, is not how the business ever operated.

The dealer's gallery was for display, comfort, and was intended to create an atmosphere in which even the worst work would look good. Most of these dealers did hold exhibitions from time to time but these were not exhibitions in which they hoped to sell work. These were scholarly exhibitions, for the purpose of building historical value and to meet potential clients. The real role for this type of dealer was a sort of match-making game, to know who in the world collected what kind of art and to try to find the art which he might buy if available.

It also was an asset if the dealer was of the same social class as his clients. This kind of game was one of nuance, diplomacy, and above all of seeming not to be in the game of selling.

The dealer of contemporary art, on the other hand, has always had an altogether different personality. The typical contemporary dealer probably started out as an artist himself. Julien Levy, the Surrealist dealer, and Betty Parsons, a famous early contemporary dealer, were both once professional artists, or if they weren't artists, they still shared the esthete's notion that the art world was separate from the world of commerce. The dealer of contemporary art might come from any background: rich families, successful business people or, like the late John Lefebre, from a career in the movie industry.

In Europe, being an art dealer has always been a profession for the son or daughter of a rich family. It's similar to the bookstore business today in New York, where the Loebs, the Ochs, and the IBM heirs all own bookshops in and around Madison Avenue. It's a business, but a business that can be participated in by the heirs of rich families without embarrassment, or by people who don't want to be engaged in the normal work-a-day world.

In recent times, since the 1950s, the field has also attracted a number of American oddballs like Richard Feigen, Thomas Segal, Aladar Marberger, Charles Cowles, Donald McKinney, David Findlay, Jr., André Emmerich, Rosa Esman, Leo Castelli, Larry Rubin, Maxwell Davidson, Robert Schoelkopf, Betty Cunningham, Ivan Karp, Arnold Glimcher, Richard Gray, and Ronald Feldman, all obviously intelligent people, who could not find their way in the more staid and conservative world of commerce. Women like Grace Borgenicht and Betty Parsons, were and are former artists, who sought to help their contemporaries in this difficult distribution process. All, of course, were well-off to begin with. There are many others, but all think of themselves as being artistic. Joan Washburn, Grace Hokin, Irma Rudin and Virginia Zabriskie are part art historians, part saleswomen, but they are attracted to art above all else.

The textile business has also been the source of some of our most prominent dealers, like Sidney Janis and Ben Heller. These were men who made a success in their own businesses, started as collectors and then became private dealers, and then went public as art dealers, primarily because they had that visual sensitivity, which is a part of the fashion business.

Basic Business Distinctions

The basic business distinction between these two types of dealers remains the need and use of capital. The business of contemporary art is all, or almost all, consignment. The most analogous system of distribution is the publishing business, where books are not sold but consigned to the bookstores by the publishers. Even today, and in a business that is modern and corporate in almost all other respects, it would still be considered revolutionary to suggest an outright rather than a returnable sales basis.

In the contemporary art business, like the book business, control of the market lies at the retail level, and with those who control the retail selling establishment.

The art world and the publishing business developed in this way because there is so little demand and capital is not readily available to the retailer. In effect, both the publisher (and his author) and the dealer (and his artist), believed that to sell an intellectual product requires a system of collective participation with the creator putting his capital at the disposal of the retailer. There really are no other commercial distribution systems which work on this exact kind of basis.

Because of the demand, the small number of people interested and the product's intellectual appeal, it seems reasonable that the product would have to be sold rather than purchased. So, the retailer is assigned the task of selling since he would not generally put his capital into the product. Confidence in the product is what distinguishes accepted, established art from contemporary art.

The dealer in non-contemporary art has no way to obtain the art other than to buy it, and has no alternative but to own it if he wants to sell it. However, like any other businessmen, if he did not think he could sell it, he would not buy it in the first place. The dealer in contemporary art for the most part feels he is dealing with an art product that has not yet established itself, therefore he buys only in those instances where he has confidence in his ability to sell or is willing to own what he does not sell. Certainly, the great fortunes that have been made by some of the art dealers, like Eric and Sal Estorick, Ernst Beyler, Sidney Janis, Frank Lloyd, are based upon their decisions to buy before artists had received consistent critical or popular acclaim.

Interestingly, this arrangement has existed in the contemporary art sales field from its inception. Of course, as a contemporary dealer becomes more established and more confident, he starts to be more of a buyer, buying what he considers the best, as well as taking consignments, if he can get them. In today's market, older, however, does not necessarily mean the work of just dead artists, but also art of the artists which the dealer believes will be recognized over a period of time as important.

As the dealer becomes more of a buyer over a period of years, he tries to take advantage of his superior knowledge and market position in his area of expertise. When a collector buys from a dealer, rather than at an auction, he pays a higher price because of the gallery commission. In return, however, the buyer can then feel secure of his investment since the dealer has already shown his confidence in the work of art by agreeing to buy it in the first place.

The nature of the process of getting rich off art is the most difficult for the straight businessman to understand because it is contrary to everything he has learned. On the one hand, it seems that the dealer, with his superior knowledge, is prepared to put his gallery, his reputation, and his overhead into the work. On the other hand, he doesn't know if he has a salable product. He is not sure that these pictures will sell, or he would buy them outright for cash and at a greater discount. Between exhibitions artists always need money, and would be happy to sell works each month, rather than wait until exhibition time or consign. But the contemporary dealer is not prepared to put his capital into buying. He seems to have no faith in the product, and therefore always prefers the consignment sale. Difficult for the businessman to understand? Definitely. It is the elusive nature of the object and the marketplace that makes the art market so exciting, especially for the collector with an eye toward investment.

The critic Carter Ratcliff, says, and rightly so, that

"We're reluctant to take a work of art seriously unless it leads a double life. On the one hand, we require it to register protests against comodification, reification, alienation – all the evil spells cast by the marketplace. On the other, we expect a work of art to sell well, or at least respectably. Marketplace hits get the most critical ink, especially from the writers who complain the loudest about hype, and the art-loving public accords star status to few artists with reliably sluggish sales records."

Just as in our society which has no standards for judging the worth of the individual except by his standing in "Forbes Four Hundred," it is so that even the dealer can't tell a good artist from a bad artist, or good work from bad work, without standards of the marketplace. The marketplace reinforces a reputation, and reputation is what makes the market. We pay more for a work of art by an artist we respect, and we respect an artist we pay more for. This is, of course, the Veblen Phenomenon. As prices for an artist's work increase, Veblen claimed, the more important he becomes, the more revered by dealers, critics, curators, collectors, and, of course, by posterity. It is no wonder the businessman becomes confused when asked to put his money into art!

If we could resurrect Degas or Renoir, they would say that times have not changed much since the nineteenth century. Today, as in the past, neither the contemporary art dealer, nor the expert or the market maker can explain why some art and artists become "hot commodities" while others do not. Ratcliff's explanation of this phenomenon is art history at its best:

"No one-sided view can comprehend a work of art that leads the life of a double agent. We don't condemn this doubleness. We don't praise it. We intuit its presence, often unconsciously, and feel comforted. It reflects the doubleness of our lives: we too give our public selves an aura of private protest, of objections on behalf of inwardness; and, conversely, we let the stratagems of public life invade our privacy."

What is the dealer, and then the collector, to think if even the critics and the

experts are not sure? The dealer hedges his bet, and takes the work on consignment, sending it back if it doesn't sell and trying again. Asking again how a dealer gets rich is to see that he has to have a bit of the collector in his blood, for he must buy or he will find that prices move so fast in the contemporary field that he may be left behind even though it was supposedly the dealer who initiated the process in the first place. The contemporary art dealer is not in a business to be looked on with envy. Unless he has the guts to put his money where his eye is, his career as an art tycoon will probably at most give him old-fashioned ego gratification, rather than make him a *very* rich collector.

Image

In today's art business, the newer dealers have other problems; the product, the art, is certainly now more secondary than ever before to the image of the gallery itself. With the clutter of so many galleries and so many artists, times have changed. Unless he or she is the strongest of personalities, like our Mary Boone, the gallery and its image is the strongest selling point. Confidence, today, is the main image that the gallery hopes to sell. The gallery wants the customer to create the demand and feel lucky at having the opportunity to make a purchase. If the dealer believes the gallery to be reliable, the work will look strong, safe and secure. The logic behind it is that the collector has such insecurity in purchasing new work that his only hope is to rely on the security offered by the gallery.

Modern Art Selling

Modern art selling in the 1986s has also taken on new kinds of marketing techniques. For example, in early 1986, we started to see the cumulative effect of the Nancy Graves marketing strategy at work. Graves has always received good coverage in the art magazines, but now she is moving into the more general press, with a recent article in *Connoisseur* (February 1986):

"As for other forms of recognition, the collectors are flocking to M. Knoedler & Company, Graves' dealer. Ann Freedman, director of contemporary art at the gallery, confirms: 'A great deal of enthusiasm for the sculptures, which sell for $ 75,000 and up for large-scale pieces.' "

Advertising is considered essential and promotion deserved, but it can't look like either. The idea, Glenn O'Brien tells us, is not to advertise, or hawk the artist, but to announce. It should not say "buy it now", but rather "it is here to be purchased". O'Brien says:

"To me, the ultimate art ad is a black page with the artist's name in big white Helvetica type and the gallery name in somewhat smaller white Helvetica type. If I were a painter, I certainly wouldn't want to have a picture of myself in the ad. That's too much like hawking. My name should be enough. And the gallery should feel that their name is enough."

It is also generally agreed today that even with these new marketing techniques, there is still no substitute for the exhibition. There never was, although for a while people believed that art could be sold through other means. Ironically, most people who buy paintings don't actually go into the galleries. That is why a piece, for example, in *Connoisseur* is considered such a coup.

The way many galleries today get sales from a new exhibition is as follows: A catalogue is prepared, or a poster is sent out, followed by reviews or promotion articles. The client or customer list is kept up-to-date, and this mailing serves to renew the customer's interest in the artist or the gallery. If the client is interested, he calls the gallery and asks the price of the pictures illustrated in the catalogue or on the card or poster. If it looks good, even if it's very expensive, he might ask that it be sent over for approval. Of course, once out on approval, the work seldom comes back. Almost all galleries report that the works reproduced on the posters or cards sell first. All of this costs a lot of money, but just one sale can sometimes make an exhibition successful. Rather than a steady sales volume, most contemporary galleries experience periodic spurts of sales from a stream of customers. Once these customers fill up their walls they stop buying and the gallery solicits a new batch of customers.

Recently an experienced art dealer asked me whether I thought collectors bought big pictures by new artists for speculation rather than for displaying in their homes. Despite years of experience in the gallery business, he had been puzzled by a recent experience at his gallery during an exhibition of a young Neo-Expressionist where canvases were all too big to fit into East Side New York apartments. The pictures were cheap by Fifty-seventh Street standards – five to ten thousand dollars each, and the artist was considered "hot" by the critics. The show got a lot of press and was a sell-out. The question is, where did the pictures go, if not on the walls of the collectors' homes? What were those collectors really buying? Art, or a chance to speculate in the possible fame and fortune of the artist? Probably they were buying not the artist, but betting on this gallery's winning reputation. At those prices it probably looked to the buyers as if the gallery had confidence in this artist, so why shouldn't they take a chance and buy the work, even if the size of the canvases was going to pose problems. Confidence is inspired by the name of the gallery, its location, its reliability and its track record. The attitude shown in this example is that, at five to ten thousand dollars, why not take a chance?

Collectors really have to be cautious of this speculation phenomenon; in the long run, it doesn't pay to speculate. At first glimpse, it looks easy for what seems to be "hot" from a good gallery, wait for prices to increase, and then sell for a big profit. I hope to make it clear that this rarely happens.

The Auction: A Guide

I had never been to an art auction until about 1974, when I was living in London. Sotheby's in London is art history at its best. The atmosphere then was all quite casual. It seemed a place that was very special, with a sort of faded elegance where one could wander into a room hung with breathtaking pictures. Without being stopped or asked questions, one was allowed to wander freely. If one had questions. it was easy to find a courteous guard or clerk to help you. It had the ambience of a hobby-house for eccentrics. I wondered what this place was – a million dollar junk shop, an art gallery, or what?

I soon found that the key to knowing what was going on at Sotheby's was the place where the catalogues were sold. There one could learn all there was to know about auctions in London. There were catalogues, exhibits, and sales but no labels, no identifications of each picture, and certainly no estimated prices. One simply attended a sale, there was no registration, one raised his hand, and bought a picture; it was assumed that the buyer could pay for it.

Christie's by contrast was much more elegant and business-like. Here was a group of very knowledgeable and energetic people who seemed to know exactly what was going on. As at Sotheby's one found the exhibit, waited for the sale, and bought what he wanted. It was simply expected that anyone who came there was already familiar with auction protocol. No one tried to sell anyone anything. Cassandra Jardine, in an article, "Christie⁵ Stands At The Crossroads," (*Business*, May 1986) summarizes the auction as a business:

> "Public image is vital to a business that is regarded by many as a 'confidence trick.' The art dealers who love to attack in the hopes of attracting more business point out that the auction rooms make 'money for old rope.' In exchange for a 10 per cent commission from the seller and 8 per cent from the buyer at King Street in London, for instance, Christie's takes in the goods, stores them (insurance paid by the owner), gets an 'expert' to catalogue them (photographs at the owner's expense) and puts them in a sale. The buyer must pay within a week; the vendor gets paid after four, giving Christie's the opportunity to invest it for three weeks."

As a business enterprise, auction houses have two distinct purposes: they must get their hands constantly on new items or objects to sell, since they are by law (and custom) never owners but agents; and they must package the consignments in an attractive way for sale. Auction-going used to be the single greatest pleasure of the collector, before the auctions became the equivalent of Harry's Bar at the Sherry-Netherland, a place to be seen. For many years, the auction houses were, for the most part, the backbone of the art business.

Since auction houses are all run in virtually identical fashions, their worldwide offices can act as depots through which goods can be channeled. They can therefore facilitate the buying and selling of art works on an orderly basis.

The Experts

Auction houses are organized by departments – paintings, furniture, and so on. Each department is headed by an expert, and each expert works with specialists in various fields, like 19th Century, Victorian, 20th Century, etc. Every department and each category within that department has its own catalogues and its own sales.

Each of these experts has two distinct functions. First, he seeks to fill his department's sale (usually two per year) with the best he can find to be offered at the lowest price. He also provides the information for the catalogue. Once the catalogue is prepared and the sale announced, he transforms himself into an art dealer, making certain that what is in the catalogue is promoted as being the best goods available. His pitch is "Buy now, or you will never get another chance."

The people who work for the auction houses are in the "fast track" of the art business. They must perform their utmost on the day of the sale, or all is lost. Some auction house empoyees are, or are aspiring to be, art historians. Some consider it socially advantageous to work there. Some aim ultimately to become private art dealers, or lately sometimes former art dealers who are fed up with the gallery business go to work for an auction house. In London, many of the better dealers in older art and objects all have a Christie's or Sotheby's background. In New York, where Sotheby's was American-run for many years, some of the best dealers started at the Parke-Bernet auction house when it was on Madison Avenue.

London and the Continent have not changed their auction proceedings or their staff for many years (except at Sotheby's in London, since its sale to Alfred Taubman, which caused a revolution in the staid "old-boy" setup). In both America and England people who work for the London-dominated auction houses have become expendable, since the Taubman Revolution because now the business with its new competitiveness, is plentiful in prestige and excitement but not generous on pay or providing personnel assistance for the experts. The gross margins at the auction houses don't allow for good pay *and* for profits to pay for Taubman's interest, *and* Christie's dividends, if it wants to remain independent. For a long time, however, positions at these two houses were considered to be great opportunities to learn art and the art business, so much so that people stayed despite the low pay. But, in England and America this is changing rapidly, and this change will forever affect the auction house as a wholesale source for collectors. In a few years it will be impossible to tell the difference between Bloomingdale's and Sotheby's. Both will be dominated by marketing, rather than by connoisseurship.

Types of Auctions

The English and Continental European type of auction house operates on the spread, or the commission. Therefore as a business, its gross margin is seldom more than sixteen precent, not a very impressive figure when compared to the book business even, which is at forty percent, or retail at fifty percent, or cosmetics at sixty percent. The auction house consignor seldom pays more than a six to ten

percent commission on a single item or a small number of items, and because of the competition on big consignments, the fee is three to four percent. Except in France and Germany, the purchaser today almost always pays a ten percent buyer's commission, except in London at Christie's (King Street) the commission is 8%. The English auction system dominates the international market, although Germany has challenged that preeminence. The French system, in contrast to the English system, is a cooperative network of a group of experts or art dealers at wholesale, in the auction business. To be an expert, one must become a *commissaire-priseur* and be licensed by the State to act as an auctioneer. These licenses are handed down from family to family, and very few newcomers are allowed. Each *commissaire* handles everything from paintings to ceramics, and seeks his own sources of consignments from his social and business contacts. If he holds a sale, it is rarely specialized, unless he has gathered together enough of one kind of an object to do so. But, generally, the sales are more like the sales at Manhattan Galleries in New York, or at a country auction, than any of the auctions at Sotheby's or Christie's.

The French auction is the greatest challenge for a collector, since the merchandise has not gone though the expert filtering process so prized by the big English auction houses. In this kind of sale, the client is the expert, and he has to know value, provenance, and be able to historically locate each object within its category. Catalogues are not illustrated and are usually nothing more than checklists.

In France, especially in Paris at the Druout, the main auction house, on rare occasions one does find specialty sales of paintings by groups. These are quite interesting and exciting, since the work presented is often not the best or the most expensive, but what the consignors have accumulated in their months of acquisitions since their last sale. The best of this work, bought by other dealers, sometimes ends up in the Christie's Sotheby's sales in London or the United States.

The main difference between the auction sales in France and the big U.S. sales, is their local character rather than their international flavor. First, the system is designed so that nobody keeps many records of who sells and who buys. It is strictly cash and carry, there is no credit. I have attended many of these sales, and I am always struck by the way the French collector or dealer whips out a wad of cash, sometimes as much as the equivalent of fifty to one hundred thousand dollars, and pays on the spot, right after his successful bid, scoops up the object and then disappears. One has to pay, at the end of his bid, not at the end of the sale, as in England or America. In France, especially with its new wealth tax, nobody wants anybody – especially the Government – to know who buys or sells what. The system is designed to meet the French need for utmost secrecy and confusion.

There is also heavy buying by foreign dealers or by dealers who deal with foreigners. These dealers, more knowledgeable than the collectors, have a distinct advantage because they know the comparative price of the object in London or New York and can therefore act as arbitragers of merchandise, buying in France at auction, and selling in London or New York. Much of the material of certain types,

especially small portable items like glassware, prints, and books find their way into the London auctions through this arbitrage method.

However, be warned: getting a work of art out of France is not an easy process unless it's put into a suitcase. All work with a value of over approximately one thousand U.S. dollars must be cleared by the French Government for export, which is not a difficult process, but a slow and expensive one, requiring the assistance of a French dealer.

Buying at a French auction house is not easy, but it can be quite rewarding, if one knows comparative values. It helps to have a French companion to make it easier to understand the fastmoving proceedings. One needs lots of cash, and it's best to restrict oneself to portable items that can fit into a suitcase. Finally, the commissions and taxes are higher in France than at the English-type auction houses, but with the value of the franc down, there have been many good buys in the last few years.

Buying in Austria at the Dorotheum is an experience. The Dorotheum is a unique auction house because it is first and foremost a pawn shop for those who need cash. The Dorotheum is state-run and serves as a means to borrow money at low rates against your art objects. If the material is not redeemed, then it goes to auction. Since the Hapsburgs once dominated Europe, one can just imagine what is available. This is a system unique to the auction world, but with Alfred Taubman's business sense for new opportunities at Sotheby's in New York, I would not be surprised to see the Dorotheum system on York Avenue in New York within five years. One needs the help of an expert if he wants to buy at the Dorotheum.

The German auction houses are closer to the English system, except everything is very efficient and well-organized. Each house reflects the personality of the auctioneer or his listed assistant. The houses maintain offices in New York, make buying easy by telephone, extend credit, pack and ship for you, and offer good merchandise, but of a special character, usually German or Swiss, with a few contemporary American paintings and prints.

If one needs to sell something German, they certainly have the best audiences for those interested in this work. Commissions are high, about fifteen percent, but the helpfulness and expertise of people who run these houses makes it worthwhile. If an American attends a German auction to buy, he is treated as a guest of the auction house and invited to a great dinner after the sales.

There are other auction houses, the most interesting of these are the secondary locations of the major houses: Christie's East in New York; the Arcade at Sotheby's at York Avenue; Christie's South Kensington in London; Phillips in New York; also noteworthy are the small auction houses like Swann in New York which specialize in books and photographs; the Manhattan Galleries on Third Avenue, which specializes in good junk; and the country auctions in New England. There are auction houses in other cities, some good, some bad, but they are always interesting.

The Concept of the Auction Market

Knowing how an auction house works is essential for a collector, otherwise he might make serious mistakes. First, auction houses are the ultimate exhibition places. Primarily through its catalogue, the auction exhibition renders the object almost public for the first time, and gives it its money value. In enters the stream of art commerce, it is recorded, first in a specialized catalogue by an expert who attests to its authenticity and it is photographed. After the sale, its selling price is entered in the auction records digests. These digests set the market value for dealers and collectors and become the standard for subsequent valuations. Dealers, generally set prices based on the latest auction prices, especially in an up market.

Demographics

Although the catalogue produced by each department has a very small print run it reaches most of those clients who are potential buyers or sellers. A collector or dealer would be severely handicapped without his catalogue subscriptions.

The catalogue is also an indispensable tool for the auction house. The auction houses' very survival is based upon a demographic marketing strategy. It is essential that the houses meet the specific needs of their customers because their customers have specific interests. Books and manuscripts are sold to book collectors, not to collectors of Impressionist or Modern paintings. People who buy Chinese works of art generally do not buy Russian or Islamic works of art or carpets.

Targeting the collector is the main goal of the auction house. Their demographic statistical information is the best available. The average gallery, however, cannot afford a system to provide full, illustrated catalogues of everything for sale in every show. In contrast to the auction house, the gallery dealer advertises a much subtler message than the auction's hard sell. To survive, the auction house must sell in a different fashion. It must communicate through its catalogues, mailings, and advertisements a once-in-a-lifetime urgency to its clients. Because of the way the auction house is set up, it cannot afford to be reserved and laid back and wait for the collector to come in, or have it sent out for approval to see if it doesn't clash with the carpets or the drapes. The auction house must sell on the spot at the auction or it loses the sale forever.

While there are never any bargains at the big auctions any more, there are smaller auctions around the world that still offer bargains to the collector. To participate in these bargains, one needs to be well-educated, both by keeping up-to-date with the auction catalogues, by consulting a copy of *Mayer International Auction Records* and also by spending plenty of time shopping, looking, and listening to what is also available at comparable prices at the dealers. If one is familiar with the prices, and knows how to buy and what he can afford to pay, he becomes an expert, and therefore can participate in the auction game.

The following appeared recently in *The Encounter*:

"Few of us, I guess, are rich enough to know. Even as citizens paying through taxes for museum purchases, we'd find it hard to quantify our personal quota of the public satisfaction at some masterpiece on display. And so we're forced back to a crude, objective answer. Auctions, in numerous metropolitan sale-rooms or in someone's garage, are neither more nor less than laboratory examples of the market – the liberal economy in an observation tank. Supply and demand alone make the price. Ours not to reason why: ours but to sell or buy. And if there are ripples on the surface of a more-or-less transparent price system, write them down to excitement, vanity, impulse buying, competitive malice. Those too are attributes of Economic Man."

This writer's estimation of the business is certainly accurate: as he said, it's partly the drama of being there. Making quick decisions, respecting one's limits, keeping cool when the stakes are high. Great dramas unfold each time the bidding begins. It's a great game for those with a strong heart and a hefty pocketbook.

Avarice plays a part in this drama as does a frequently vicious competitiveness, not to mention ordinary egotism. The auction buyer strives to undercut the dealers. He believes he can because the dealer thinks in resale rather than collecting terms. But today, it is often not the dealer who buys, but another collector, so that the sale is the worst kind of retail sale – one based upon suspense and emotion, not knowledge and forethought.

The following description perfectly sums up this collector's feelings about auctions:

"Sitting in some London sales had resembled going to church: it was simply a little more comfortable. All around sat the prosperous patrons, women in hats, men in descreet fur collars. In front was a rosewood pulpit, ceremoniously mounted by the auctioneer. Even his voice had an elocutionist's ecclesiastical ring. Thousands – when the bidding reached such heights – were always 'thaousands', pronounced thus, and with Jeeves-like imperturbable nonchalance, as if to say, 'This is small beer to us: those who worry about the price can't afford to be here.'"

"Cowed by such loftiness, I once again played possum. Now and then, if an item looked like selling for what I could afford, I sneaked in a bid just before the hammer fell. Was it, I wondered, the best tactic? If I bid early, would a show of determination discourage the opposition? But it seemed foolish to bid up something one wanted to buy: so I stuck to my ratlike tactics. I came away, over the years, with some plausible-looking near-junk."

I have pursued a similar habit, and if you look carefully, at the secondary auction in New York, or the country auction in New England, you will still find me, looking for a bargain, and still sometimes buying something I didn't want, because I thought it was such a good buy.

Famous Dealers of Today and Yesterday

The art dealers of today, and in fact art dealing in general, follows the psychological profile of its most famous alumni, Ambroise Vollard and Joseph Duveen.

Ambroise Vollard

While it is my own belief that Ambroise Vollard (1865–1939) would probably be considered the greatest of all art dealers, so little has been written about him independent of the artists with whom he was associated that it is difficult to know him as a practical down-to-earth merchant. He came to Paris as a young man from his native island of Reunion, and began as a clerk in a small art gallery. When he became a dealer himself in 1893, it wasn't long before he became involved in the contemporary art of his time. He started with Cézanne in 1895, and organized his first great Cézanne exhibition in December 1895, with one hundred and fifty paintings. The show scandalized critics and the art public. Since a great dealer is one who recognizes genius in living painters this single move put Vollard into a class all by himself.

Since Impressionism was the most radical of painting styles at the time, Cézanne appeared to be outrageous. The realism of Cézanne's work was a reaction against the optical system of Impressionism and his art seemed to repudiate in its entirety the central innovation of the Impressionists, which was their claim that the visual world is made up of colored surfaces animated by constantly changing light.

When confronted with Cézanne's work, the art-viewing public was outraged: Were they to understand that nature was to be perceived as a physical reality composed of solid, tangible objects existing in three-dimensional space? Can we perceive more than we see? Vollard, to his credit, answered yes, and the collectors who followed his advice chose very well.

Vollard's commitment to Cézanne attracted real admirers, and as a result his shop became the most brilliant artistic center in Paris during the first forty years of the century.

This is evidenced by a drawing by Bonnard, dated 1895, which depicts Vollard in the midst of the well-known disorder of his shop, surrounded by Rodin, Pissarro, Renoir, Degas and Bonnard himself. Vollard started a tradition that continues up to this day with Leo Castelli, and his famous image by Andy Warhol: the artist paints the dealer. It is undoubtedly every collector's dream to be so immortalized. Vollard was painted by Bonnard in 1905, and 1915. Cézanne did him in 1894, in a painting which now hangs in the Petit Palais in Paris, and which, it is said, took no fewer than one hundred and fifteen sittings. Vollard also sat for Renoir, Picasso, Rouault and even Dufy.

Vollard himself can in a sense be collected, at very reasonable prices, as a result of the illustrated books he produced, which ultimately became his chief concern.

In 1905, he published a collection of lithographs by Lautrec, Bonnard and Vallotton. From then on publishing was an activity that never abated until his death. There appeared successively the *Parallèlement* of Verlaine (1900, *Daphnis and Chloe* (1902) illustrated by Bonnard; *The Imitation of Christ (1903) by Rouault,* the *Sagesse* of Verlaine (1911) by Maurice Denis; a Ronsard (1925), by Villon (1918), the *Fleurs du Mal* (1916), the *Little Flowers of St. Francis* (1928), the *Odyssey* (1930) by Emile Bernard; the *Jardin des Supplices* of Mirbeau, by Rodin; the *Chef-d'Oeuvre Inconnu* of Balzac (1931), the *Histoire Naturelle* of Buffon (1947) by Picasso; *La Maison Tellier* of Maupassant (1933) and the *Mimes des Courtisanes*, translated by Pierre Loüys (1935) with illustrations by Degas; *La Tentation de Saint-Antoine of Flaubert* by Odilon Redon (1938); the *Reincarnations du Père Ubu* (1932) by Rouault; finally works by Vollard himself with engravings or drawings by Renoir, Puy, Bonnard *(Sainte Monique)* and Rouault, and other books such as the *Dead Souls* of Gogol and the *Fables* of La Fontaine by Chagall that was unfinished at the publisher's death.

To read Vollard is a treat, and those books by Vollard on Cézanne, Degas, and Renoir, available at stores that deal with out-of-print art books, are the best introduction to the works of these painters because they are written by a contemporary critic. A good book for the collector to read on this period is *Recollections of a Picture Dealer*, published in 1936 and reprinted by Hacker Art Books and by Dover Books, which remains an important source for the art and art criticism of our time.

Duveen, The Money Art Dealer

Joseph Duveen was the first modern day "money" art dealer. Duveen, with art galleries in Paris, New York and London, was considered the most spectacular art dealer of modern times. Again, as with dealers today, it was a personal business. If Duveen was in the gallery, the gallery did business; if Duveen was somewhere else, there was no business.

Recently, I was talking to an employee of a major Fuller Building gallery (*the* building in New York for uptown galleries), and I asked, how business was. He replied that it was slow, until the boss decided it was time to sell. Once the boss was on the phone, however, the boss could sell a lot of work in one afternoon. This story is important because it demonstrates that collectors jump to attention when the owner of the gallery calls because it is this personal business relationship between the dealer and the collector that sells paintings.

Joseph Duveen had a philosophy that art should be sold to people with money, and that the place to sell them was not necessarily in the gallery, but at the then-popular health resort. The art dealer in New York is a fixture in the New York dinner party circuit, but that is hardly equivalent to Duveen's exhorbitant catering to his clients. Our prototype collector has these words of advice on the subject:

"The collector had better know that when he enters the art world he
is subject to slaughter. You see the lambs marching up 57th Street or in
SoHo, feeling so important. . . so rich, so vulnerable. . . . Inevitably, the

house will soon be in *Architectural Digest* or *House and Garden* in a 'How Rich I Am' spread. That was me 15 years ago."

If Duveen, for example, was in Paris and Andrew Mellon or Jules Bache was on his way to Paris, then Duveen would remain a bit longer than usual in Paris, to assist Mellon or Bache with his art education. Duveen, like the good dealers today, saw himself as a teacher of the rich and the less sophisticated. It's disputed that Duveen's knowledge of his subject matter matched his enthusiasm for selling. Present-day art dealers are no different. They are fluent in the art world banter, but they are substantially less than scholars.

Duveen's solicitousness is legendary. One day, the story goes, Jules Bache was leaving his hotel in Paris for his boat train to New York when he realized that he didn't have enough cigars to last him for his Atlantic crossing. He made a quick detour to Duveen's to replenish his stock, as Duveen stored Bache's favorite cigars in the vaults of his establishments in Paris and London. Duveen was not in Paris, and Bache was greeted by Bertram Boggis, Duveen's chief assistant. While Bache was waiting for the cigars to appear, Boggis showed him a Van Dyck and told him Duveen had earmarked it for him. Bache, of course, bought the picture, and took both the picture and the cigars home to America. There was no charge for the cigars, but the Van Dyck cost Bache two hundred and seventy-five thousand dollars. Duveen would, like art dealers today, do almost anything to please an important client, in order to sell more pictures. Also, in order to sell a client a painting, one must get the client to want to own a lot of paintings. The best way to do that is to set the client in the world of the sophisticated. Receiving media coverage and attention from the elite world of the museum are two ways of giving the client more confidence in his dealer.

Networking

The idea of networking is also essential to the success of an art dealer. Meeting people at the homes of rich and important clients may lead to new and important business.

Duveen was the master at this kind of socializing. Duveen was invited to the great country homes of the nobility in France and England. Apparently the fact that most of the art were ancestral portraits did not deter him. He bought houses for his clients in the appropriate winter and summer hot spots and even provided architects who naturally planned the interiors with wall space that demanded plenty of pictures. He also acted as marriage broker for Americans who were shopping for titled husbands for their daughters. Duveen always maintained a high level of diplomacy and propriety. This kind of social manipulation is not far from what one reads in today's up-market magazines like *House and Garden, Architectural Digest* and *Connoisseur*.

Successful dealers (like Duveen) have to exercise great finesse with unsophisticated clients who, despite their wealth, are wary of dealing in art and are basically ignorant about art. Duveen's acute social awareness is exemplified by the following anecdote: For a great many years, Duveen' secretary was an Englishman named H.

W. Morgan. Some said that Duveen hired him simply because his name was Morgan, others have suggested that he made his secretary adopt the name. In any case the point was that Duveen wanted to feel he was sending for Morgan instead of Morgan sending for him.

Richard Feigen

Back in the 1970s, I had a personal experience that sheds some light on the personality of today's dealers. I had decided that I was going to spend about one million dollars on artwork. I made a list of galleries that handled the pictures I was interested in to visit. My first stop was the Richard Feigen Gallery. I was dressed, as I usually am when looking at pictures, much more like a bum than a collector. When I entered the gallery, Richard Feigen, art dealer with a Harvard M.B.A., was on the telephone, where he spends most of his time. I sat down in his office, and was asked if I could wait a few minutes. I said yes, and started to look around. He had a pair of Monet single water lillies, which were quite beautiful and I thought well-priced. I also looked at a group of other pictures. There was a wonderful Beckmann, and it looked as though he had some other interesting pictures, as well. I was excited and ready to start negotiating, but I could not get him off the phone. I gathered that he was giving an interview to a magazine about how great he was, and what he thought the art market was going to do in the 1970s. (Feigen loves to be quoted in any article about art and the art market.) I suppose I didn't look too important and he certainly didn't know me, so he kept talking. After about forty-five minutes, I became so embarrassed and angry that I left the gallery and proceeded on my rounds. At the end of the day, I had spent slightly over a million dollars on paintings, none of it with Richard Feigen.

Bryan Robertson in *Three Decades of Contemporary Art* (Twenty Five Years, Annely Juda Fine Art/Juda Rowan Gallery, London 1985) tells a wonderful story about the telephone and the American art dealer which confirms my own experinces:

"Arriving at Leo Castelli's gallery in New York with an appointment to see Leo, doubtless on behalf of a Rowan artist, Wonky [Diana Kingsmill] was told that Leo was on the 'phone – his favourite place. She waited, and was told after some time that Leo had been summoned by another urgent 'phone call. This happened yet again, lengthily; and Wonky, smiling imperturbably left the gallery, walked across Madison Avenue to the Carlisle Hotel, still dressed in her plastic leopard-skin raincoat – for this was the era of pop art – and rang him up. She had grasped the fact that this was how Leo worked best."

A few months later, Feigen was present for a charity affair at my home for the Brooklyn Academy of Music. As he and his wife came up the stairs, I could see a look of recognition cross his face, and then a certain sadness around the mouth and eyes. "Yes", he said to himself, "I missed that one", as he looked at the pictures and calculated the prices his commissions would have been. Lord Duveen of Milbank, or even Ambroise Vollard would never have missed that opportunity.

Most dealers learn from their mistakes, and one hopes, that Feigen did as well.

In the end, the dealer is really in the driver's seat, because clients who collect paintings are aware that no matter what the dealer's personality may be, if he has unique access to great art, his business will thrive. What the dealer has to do (and what Feigen was doing in his telephone interview) is to keep his name in front of the collecting public, and to constantly inform the people who are interested in the work he sells that he has the best, and the better access to the best, than his competitors or the auction houses.

Duveen, and most other good dealers, are masters in turning clients' doubts about prices into doubts about whether the dealer will let them buy a certain work. This is an old sales technique but it can be used with hot new artists, or with artists like Richard Diebenkorn and Frank Stella. The dealer offers the prospective buyer a chance to enter the privileged world of high art. The dealer stands at the gate of this world and deems to grant admittance to his clients. Why should the simple matter of price stand in the way? If a collector wants a Stella, Johns or Diebenkorn, or work by a painter of that caliber, he has to enlist the aid of a dealer, since these names are in such demand and buying one means putting one's name on a waiting list or trying one's luck at auction. In this kind of situation the dealer is very powerful. He can make an artwork seem more desirable by hesitating to do the client the favor of letting him buy it.

Duveen invented the classic system of using "caller's books" and it has been adopted by almost all art dealers today. Wherever Duveen was he received daily lists of those who visited his galleries and he was sure to "call back." The system is still very much in vogue with galleries today, but is used in a different way. If one goes into a gallery, he always sees a "caller's book." If one signs the book, he is put on the gallery's mailing list. By receiving mailings one can become acquainted with what is going on in the galleries in a relatively short time.

I have never had a dealer call me or try to sell me a painting because I am on their list. Duveen, of course, unlike today's dealers (who are either too lazy or too busy), used his sources to build his business. Today, dealers rarely rely on this list for direct new business, hoping that the mailed announcements will stimulate a visit to the gallery. Of course, Duveen was not only looking for customers, but for major collections to buy.

Bernard Dannenberg

Bernard Dannenberg, a major dealer in the early 1970s was a master of digging out works for sale. Most dealers of older art rely on the French system of *francstireurs*, that I mentioned in connection with Bernard Berenson. These are private dealers (also called "runners) who don't own their galleries but hunt out paintings for sale from collectors or other dealers. While Bernie Dannenberg used runners, he also printed ads in *The New York Times* and in specialized magazines. He offered good prices for artists who were little known at that time.

He concentrated on Twentieth Century American art, assuming there was a lot of it in private collections in this country and guessing that the owner didn't

realize its true value. Dannenberg capitalized on the fact that much of the American Art of the twentieth century was purchased by collectors at a time when it cost little, and art from this period was not considered to be terribly valuable.

The major artists of the early twentieth century in America were poor, and sold their work for whatever they could get. Most of them sold their paintings while summering at the famous art enclaves between 1890 and 1920, like MacDowell Colony, Provincetown, Old Lyme, Woodstock, Saratoga and Taos. Until the end of World War II these towns were popular vacation spots for the wealthy. Artists who worked in these communities included William Merritt Chase, Childe Hassam, and William Metcalf. The names that passed through these colonies are today legendary, and much of this work from all over these areas flowed for a while into Dannenberg's gallery. The results of his advertising were surprising to most other dealers. This was a new 1970s technique for tracking down art to sell. Dannenberg never paid the prices he advertised, and seldom bought the pictures unless he couldn't "steal" them. He out-"Duveened" Duveen in finding good work to sell. His scheme worked for a while, but in the end Dannenberg ran out of sources and other dealers caught on to him and began competing with him. The Bernard Dannenberg Galleries disappeared, his gallery building was sold, and he went off to France. He is now a dealer in glass.

The "buy" side of the business takes brashness and an ability to talk prices. But most people who own art have already done their homework and know the true worth of what they own. Bernard Dannenberg probably rid the market in American pictures of naivete.

A dealer by the name of Daniel Grossman, is attempting the same thing today, with big ads for Nineteenth Century pictures, but it's hard to believe he finds many sellers who don't know the value of what they own. Of course, to be a Duveen takes lots of money to put into pictures for stock, and even Duveen used to get frantic calls from his comptroller in New York imploring him to stop buying. Duveen loved to sell but loved buying more.

The Dealer As Collector

There are many dealers today exactly like Duveen, but they are not wealthy collectors. Some would keep everything they bought if they could afford to. Today, it's syndicates of dealers and collectors who buy the big pictures. In a business filled with dealers claiming to be short of money, cash is always available when a good painting is on the market and the competition is keen. Dealers today have a tremendous respect for pictures and prices, and if they see a good picture, they reach deep into their pocketbooks to buy it, since they know that they may not get another chance.

It's a tough market, and as the supply dwindles and the auctions fight for market share, the dealers must buy at any price to replace the older inventory they have sold. Otherwise they will go out of business. And a never-before-seen picture appearing on the market is just what they need to compete with the auction houses and other dealers. This isn't to say that they don't ever get pictures on a consignment basis, but if they have to buy they will.

One of Duveen's favorite tactics was to encourage the potential buyer to take the picture home. Once with the client, it seldom reappeared in the gallery. There's a story told about John D. Rockefeller, Jr., and three famous busts from the Dreyfus Collection. Duveen wanted $1.5 million, but Rockefeller thought that was too high a price. He offered him some tapestries and one million dollars. (The year was 1934, and Rockefeller probably thought that even Duveen could use a million in cash.) Duveen told Rockefeller he had some tapestries of his own and didn't want any more. He even suggested that if Rockefeller was short on cash, he might help out a bit. At Christmas time, with a week left in which to make his decision, Rockefeller told Duveen that he was definitely not going to buy the busts. But Duveen was prepared for this response and said, "keep them in your house, they are as safe as they would be in mine." Of course, as Duveen knew, on December 31, at the eleventh hour, Rockefeller informed Duveen that he was buying the busts at one and one-half million dollars.

Many collectors probably can recount similar stories of times when they never really intended to buy a certain picture in a gallery but did. "Take it home," says the dealer, "see if your husband or wife likes it. If not, I'll pick it up." The dealer knows that in all collectors there comes a time when they fall in love with a picture. Once that happens, collectors must possess the object. The question of affording it is not relevant because the collector has fallen in love. He simply finds the money.

Prince Youssoupoff – The Self-Indulgent Collector

An important legal case in the art world, *Youssoupoff vs. Widener*, was decided in 1927 in the New York State Court of Appeals, the State's highest court. This case represents the art world at its greediest and most self-indulgent.

The case involved a Russian Prince, Felix Youssoupoff, the slayer of none other than Rasputin; Calouste S. Gulbenkian, the Armenian oil tycoon and great collector, the founder of the Gulbenkian Museum in Portugal and the famous Gulbenkian Foundation in London; Joseph E Widener, the Philadelphia collector; and Joseph Duveen. What a crowd that would make at a modern-day charity benefit!

The object of everyone's affection was a group of Rembrandts, owned by the impoverished Prince Youssoupoff. The court record describes the characters:

"The plaintiff, Prince Youssoupoff, had resided in Russia prior to the Bolshevist Revolution. He came of a noble family which until the Revolution had enjoyed wealth, which was almost without limit, and great power. In the spring of 1919 he was compelled to flee from Russia. He was able to bring along the two paintings by Rembrandt, which according to the findings are "unique and irreplaceable works of art . . . not excelled in quality by any portraits ever painted by Rembrandt." He also brought along two smaller and less important paintings by the same master, and some family jewels. All the rest of the vast possessions of the family were confiscated. Only the property he brought from Russia was available to meet his various needs. Out of his resources he was support-ing his wife and daughter as well as his mother and father, and he was

contributing to the support of many Russian refugees. He was, indeed, devoting his entire time and energy to the work of relieving the distress of these refugees. In the summer of 1921 the family jewels were in pawn, and the two great paintings by Rembrandt were pledged in London for the sum of 44,000 pounds. Prince Youssoupoff regarded these paintings as an available means of obtaining more money to meet his needs, which were then pressing."

The defendant, collector Joseph E. Widener, was, the court said:

". . . at that time traveling abroad. He was a resident of Pennsylvania, a wealthy and experienced businessman, and the owner of a great collection of paintings and other works of art. Numerous paintings by Rembrandt were already in his collection. Financial conditions generally and conditions in the art world in particular were greatly depressed. Mr. Widener, in spite of the depression in financial conditions, could raise the money for the purchase of these great paintings by Rembrandt for his collection. The paintings were heirlooms in Prince Youssoupoff's family. He was greatly attached to them. He was desirous of retaining them for his own use, but his needs were great. So the correspondence between Prince Youssoupoff and Mr. Widener began, and it was Prince Youssoupoff or his friends who sought out Mr. Widener."

Youssoupoff needed money and Widener hat it. Youssoupoff wanted a loan on the pictures, Widener replied that he was not a banker, but a collector. He said he would buy the pictures for a hundred thousand pounds, about $ 550,000. The Prince said that he would sell them for one million dollars. So a deal was struck: Widener would buy them for the one hundred thousand pounds, but the Prince had an option to buy them back, if "on or before January 1, 1924, a restoration of the old regime in Russia made it possible for the Prince again to keep and personally enjoy these wonderful works of art." The point was the Prince could buy them back, but was not obligated to, thus, there was no legal loan, but a sale, with an option – a technique which is used in the option market on Wall Street. Prince Youssoupoff signed the contract, he fully understood its terms. He had legal advice of his own choosing, the record reads, "he did not like to accept its terms; indeed, he protested against it." Nevertheless, he took the 100,000 pounds.

Along came Joseph Duveen, art dealer, and told Gulbenkian about the value of the paintings, and the greatness of the Rembrandts, and the fact that Widener bought them. Like the helpful, gossipy, art dealers of today, Duveen and Gulbenkian protested on the grounds that they "were indignant that a man of Rembrandt's talent should sell for less than he was worth". Gulbenkian found the Prince in Paris, and struck a new deal for two hundred thousand pounds. The Prince wanted his pictures back, so he could sell them to Gulbenkian at a higher price, and was, therefore, ready to repay the one hundred thousand pounds with the stated eight percent interest. Widener wanted to know what revolution had taken place in Russia that he hadn't heard of that made it possible for the Prince again to keep and personally enjoy these wonderful works of art.

Youssoupoff said that he just wanted his pictures back. He reminded him that it was not a sale, but only a loan, therefore he was free to pay it back and get the collateral – the pictures – back. Widener refused to return the pictures and Prince Youssoupoff sued in the New York Courts. The Prince called Widener a "pawn-broker," a sharp trader who had taken him to the cleaners.

Duveen was the star witness. He testified that Widener had in the past few years bought over six hundred thousand dollars worth of art from him alone. The trial was the highlight of the art season. Widener won the case. The decision is classic:

> "As we have pointed out, the defendant was never willing to make a loan. The plaintiff understood that the defendant entered into the transaction only with a view to becoming the owner of the pictures. The defendant indeed refused to make a loan, and by the contract which was made the plaintiff was under no personal obligation to repay to the defendant the amount received upon the transfer of the pictures. The parties never intended that the pictures should be transferred in order to secure the defendant for money advanced if the plaintiff should not repay it. The purpose of the agreement was to transfer to the defendant the full ownership and enjoyment of the pictures unless the plaintiff repurchased them within the stipulated time and *upon the stipulated terms*. The right of the plaintiff to repurchase was not a right of complete defeasance of the transaction. If the plaintiff repaid to the defendant the amount he had received, the defendant would still retain some rights to the pictures, in case the plaintiff decided to resell them thereafter. These considerations collectively distinguish this case from those where the courts have construed the contract, in accordance with the intention of the parties, as a loan and mortgage. Here actual intention coincides with the form and terms of the contract, and according to the law of England, where the contract was made and dated, and where the pictures were situated at the time of their transfer, the contract of sale, subject to a limited right of repurchase, must be enforced according to its terms and actual intent."

Duveen let it be known, after the case ended, that the Rembrandts were not, after all, as great as they had been purported to be and that there were better ones than the Prince's. He even claimed to have sold one himself to Widener. This is consistent with the art dealer's attitude that what he has is the best and what anyone else has is of poor quality. A year before Widener's death, the Rembrandts went to the National Gallery in Washington, D.C., where they now hang.

Dimitry Jodidio

Dimitry Jodidio is no match for Joseph Duveen, but he may rival Joseph E. Widener. I met Jodidio, who was reputed to have a great collection of Impressionist pictures, in the south of France at his villa in Castellaras. Nobody seemed to know who Dimitry Jodidio was. Was he a collector, a dealer or what? He had pictures, lived a great lifestyle, and at one time owned and ran the art magazine

Réalités in Paris. Did his wealth stem from big business, did he inherit it? To this day, nobody seems to know the source of his wealth, a fact that became a problem.

In 1981 Jodidio wanted to sell some of his paintings. Enter David Bathurst, the president of the acution house Christie, Manson and Woods. At a meeting, Jodidio informed Bathurst that he wanted to raise $10 million through the sale of several paintings owned by his company, Cristallina. Bathurst looked over eleven Impressionist paintings and chose eight for sale. As the court proceedings explain:

"Bathurst examined the paintings and gave Jodidio estimates of their value in three possible contexts: a private sale; a low bid at public auction; and a high bid at public auction."

The parties chose eight pictures to be sold. Bathurst estimated that they could be sold privately for approximately 8 million dollars and that at public auction they could be sold for between 8.5 million and 12.6 million dollars. Christie's agreed to pay the expenses and Jodidio agreed to pay a commission of four percent, unless the eight paintings did not bring in at least 9.4 million dollars. In that case Christie's would get no commission.

This court action provides one of the great windows on the world of art in the 1980s. Until now, it was always assumed that the highest price (retail) could be obtained in the private sale market. No longer so, according to David Bathurst. If one wants retail, go to an auction. The point of this exercise was to show that in the 1980s the best place to sell Impressionist paintings in America is at auction and not in a private sale through the dealer market. Times have certainly changed from the days when it was assumed that auctions were wholesale markets, and the retail prices for fine Impressionist painters received at least a twenty-five per cent markup by the dealers.

The difference in price at the low side of the auction was 9.4 million dollars, as opposed to 8 million dollars in a private sale. At the up side, at auction, it was 8 million dollars in contrast to 12.6 million dollars, less a commission of four percent ($ 12,096,000). Clearly there's a substantial difference between the best private market and the best auction retail market.

It's assumed that Dimitry Jodidio was no novice to the art of buying and selling pictures and knew the differences in the marketplace. He owned Impressionist pictures at least since the late 1960s or early 1970s, over sixteen years. Did David Bathurst know what he was talking about? If Bathurst doesn't know about markets for good Impressionist pictures, both private and public, then no one does. This market is the most sophisticated art market in the world. While it is true that there are few dealers who can handle a five million to ten million dollar deal, these dealers have plenty of customers and are always on the lookout for valuable pictures.

Although it's hard to verify what Bathurst's plan was, one can suppose his idea was that when presented to the new American rich, these pictures would find buyers at auction faster and at better prices than at a private sale. The auction was held during a big auction week in New York on May 19, 1981. It was a disaster. Only one painting sold, bringing in a price of $ 2.2 million. The remaining seven were bought in since no bid reached the reserve price.

Dimitry Jodidio sued Christie's, alleging that Bathurst and Christie's misrepresented their abilities to accurately estimate value and current conditions in the market. Jodidio's complaint is summarized as follows:

"Apparently immediately preceding the auction, stories and questions began to circulate with respect to ownership and legal title to the paintings. Plaintiff alleges that Christie's should have taken measures to minimize the effect of these rumors."

In what will go down in history as the classic art case of the 1980s, the court sized up the art market as follows:

"The misrepresentations at the core of the instant matter involve the estimate of value given by Bathurst for each painting and the subsequent reserve prices set by Bathurst. Misrepresentations as to value are not ordinarily to be treated as constituting fraud. Rather they are to be regarded as mere expressions of opinion involving a matter of judgment and an estimation about which men may differ***. An exception to this general rule has been recognized for items which are capable of objective valuation***. While the components of oil and canvas may be capable of precise valuation, a finished work of art is not. The monetary value of a work of art is dependent upon the vagaries of the marketplace. The valuation of the Cristallina paintings and the establishment of reserve prices necessarily entailed a prediction of the mood and behavior of an auction crowd not yet assembled in economic conditions which could not be calucalted with precision. The estimates were Christie's best opinion as to the value of the Cristallina paintings and were merely expressions of hope dependent upon the confluence of several factors. As such they were not representations as to existing facts and cannot support an action in fraud***.

Implicit in an auction with a reserve is that an item will not be sold if a minimum bid is not received. The mere fact that a painting was not sold, without more, cannot sustain a finding of negligence.*** Nor can the court find that Christie's breached its contract with plaintiff. Christie's compiled a color catalogue featuring the Cristallina paintings, placed advertisements and arranged for media coverage. Christie's could not however control the amount of coverage given to the event by an independent news media. Nor can it be said that members of the general public would provide a pool of potential bidders for the Cristallina paintings. Realistically only a few can successfully bid at such auctions. The Cristallina auction was sold out and one painting sold for in excess of $2 million. Without any evidence to the contrary, the court must find that the auction of the Cristallina paintings was sufficiently publicized. As to the "May rumors", the court cannot discern what duty defendants owed to plaintiff or given some duty what defendants were expected to do to

quash nebulous rumors emanating from an unknown source. These allegations are purely speculative and plaintiff has failed to establish any triable issue of this theory.

With respect to the allegations of breach of fiduciary duty and failure to warn plaintiff of the risks of an auction, the court finds the affidavit of plaintiff's principal officer Dimitry Jodidio completely incredible. In that affidavit Jodidio states that he was and is totally unfamiliar with the procedures of an auction and that he has no knowledge of the value of the works of art bought and sold by Cristallina. It is admitted that the sole business of Cristallina is the purchase and sale of works of art. The Cristallina paintings involved in this matter are clearly major pieces and highly valuable. The self-serving affidavit of Jodidio simply cannot be credited by the court. In addition it is plaintiff's theory that once a painting has been bought in from an auction, its value is diminished and it becomes virtually unsalable. However, Jodidio concedes that subsequent to the auction, Cristallina sold four (4) of the remaining seven (7) paintings. Identity and sale price of the painting has not been revealed by plaintiff. Equally incredible are Jodidio's allegations that Christie's intended to sabotage its own auction and thus deprive itself of substantial commissions.

"Finally the court finds that any damages suffered by Cristallina are entirely speculative. Plaintiff seeks the difference between what it actually received from the sale of one painting and the $10 million which was projected when Jodidio first met with Bathurst. As indicated above an auctioneer is not a guarantor as to what price an item will fetch or even that an item will be sold at all. The conditions in the marketplace determine the monetary value of the item offered for sale. Whatever their artistic merit, the conditions in the marketplace on May 19, 1981, indicated that the Cristallina paintings had a lower monetary value than that estimated by Christie's and anticipated by plaintiff. The paintings were then returned to Cristallina.*** The monetary value of the paintings can only be established by responsible persons actually bidding for the paintings not by jurors engaging in a fantasy auction."

Just when it looked like Justice Wolin had set the standards for auctions in the 1980s, a New York appeals court, on May 13, 1986, Justice Sullivan writing the opinion, reinstated the case against Christie's. As *The New York Times* reported, Dimitry Jodidio will now have a trial to see if he can prove his charges against Christie's and David Bathurst, its president at the time:

"In ruling that the suit should not have been dismissed, the decision, written by Justice Joseph P. Sullivan, states that while an auctioneer, 'is not required to guarantee the results of a sale or, for that matter, even

predict the price that a particular item will bring, he is nonetheless held to a standard of care commensurate with the special skill which is the norm in the locality for that kind of work.'

The court said there was a 'factual question as to whether Christie's and Bathurst acted in a manner commensurate with their skill and expertise.'

In addition, the ruling said that if Christie's officials knew that appraisals were inflated – something which has not been determined by any court – fraud statutes might apply."

Until the trial is completed and Cristallina puts forward its evidence, the art world will have to wait to see if Christie's and Bathurst acted in a manner commensurate with their skill and expertise. At issue is the responsibility, if any, of an acution house to the consignor of works of art at public auction.

Blame The Collectors

In 1973 Sophie Burnham wrote a very engaging book entitled *The Art Crowd*. "The art trade is no worse," she said, "than any other industry." The fault lies with the collectors, not the dealers. The collectors are to blame because they set the market's tone, the price. In her view, they are either naive or greedy or both. The naive ones, she says, are most often to blame, because they believe that since art is the highest form of visual expression, it is governed by the highest moral code. She goes on to say that these frequently inexperienced customers confuse aesthetic judgment with commercial values. They have no other qualifications than the two eyes in their heads and the bankrolls in their pockets. This, she says, "appalls" the dealers.

However, the dealers see themselves differently than others do. In my opinion, most of them lost long ago any sense of prudence. They, not the collectors, set the tone of the market. They will do almost anything to sell works of art, especially the newer ones. Of course there are exceptions, but it seems in most cases to be true. They also think of and treat the collector as if he were an idiot. This same attitude is evident at most auction houses, as well. The sheer arrogance of the auction house personnel is frightful. The first-time collector is more likely to be confounded than respected by these so-called experts. The system does not breed naivete among collectors, but cultivates a feverish impatience in anyone who works there.

The auction houses employ the young and inexperienced, or the arrogant old-timers, both of whose goals seem to be the opposite of satisfying the customer. They entice the collector into putting a work into the auction, promising a high reserve. The collector, believing that English accents indicate superior knowledge, falls for the come-on. In an article about Christie's *(Manhattan, Inc.,* April, 1986), John Taylor reported:

"To attract the American Anglophiles, it was essential to have an Englishman represent this most English firm. (Amusing how so many of these colonials, especially the women, still swooned at the sound of an Oxford accent.)"

Then, the night before the auction, he gets a call from the auction expert. "It looks like we may have problems with your picture. Once we saw it, we determined that it's not quite up to the quality we expected. What we suggest is that you lower the reserve (the minimum price) so that we can sell it."

This is all very confusing to the collector. Previously they assured him that his painting was the best example, and sure to bring a high price. Suddenly, it does not meet their expectations. This is standard operating procedure used by auction houses throughout the world. After all, they *only* get paid a commission if they sell it. And while legally they profess to be the customer's agent, they are in reality working for their six and ten percent commissions. They will tell the buyer that they are the experts as to authenticity, and they even tell you in the smallest of small print that they stand behind some (but not all) of their statements in the catalogue. The codes used in the catalogues are practically inscrutable.

If a painting has been described as a Caravaggio, that's precisely what it isn't. If a painting is by Caravaggio, it will be attributed to "Michael Angelo Amerighi (or Morigi) Caravaggio." "M.A.A. (or M.) Caravaggio" is not authentic; that simply indicates his studio. And in any case the auction house only "considers" it to be genuine, even with a signature. "Signed" means that it is signed but not necessarily authentic. "Bears signature" implies the worst, that the work is a forgery. Each auction house also uses different terms of descriptions, and the so-called warranty is different for each auction house. I have never bought an old master painting because I know that it's too often the case that one buys something that is not what he thinks.

In the field of Modern works, the problem is less severe, because the history of the work is easier to trace and there are often *catalogue raisonnés,* a catalogue by an expert covering the entire output of an artist. But even in the case of work produced in this century, auction houses will rarely stand behind their guarantee or warranty.

But the real problem is not the authenticity, the problem is that the art trade (contrary to what Sophie Burnham tells us) is different from any other trade, partly because it employs the most haughty people in the world. These auction people (and a lot of dealers, too) dislike collectors, think them uncouth, without education, and inferior to themselves and, moreover, resent the fact that they have the money to spend. As John Taylor said:

> "The auctioneers believed their primary obligation was to protect the interests of the seller. After all, the houses had traditionally perpetrated deceptions of a sort on bidders. If an item did not reach its reserve at Christie's auction houses in London, the auctioneer announced that it had been sold to a "Carruthers" or a "Carew" – though no one with any such name was in the room. It had always been thus. Bathurst's claim to have sold three pictures when he sold only one was in the same vein. You protected the seller. *Caveat emptor!*"

What has now developed at the auction houses, especially since Sotheby's has gone retail, is a completely new marketing style. Christie's in New York has

unfortunately followed Sotheby's example. In the past Christie's may have been gentlemen trying to act as businessmen, and Sothebys' businessmen trying to act as gentlemen, but now, unfortunately, neither are gentlemen. Phillips in New York, the fading English-type auction house, is so badly-managed that it simply can't compete. The German houses are no competition for the American houses, so the two big houses have the auction field all to themselves.

The recent David Bathurst fiasco, in which he lied to the press in order to save the reputation of a sale of Dimitry Jodidio's paintings in May of 1981, was only symptomatic of a bigger problem. The problem is the appearance of a new super "hype". Each sale at the auction houses has to be bigger than those of their competitors, and marketing people have replaced art staff.

Bloomingdale's at York Avenue

Auction houses have become the Bloomingdale's of the art world. The old days are gone. Smaller items are not even welcome at Sotheby's Arcade sales anymore, and the days when a collector could look around for a bargain or two are gone. At one time attending an art auction and viewing the merchandise was rather like going to an art gallery where the labels had been removed.

Today, it's all very Bloomingdale's with labels galore, prices out front, and the merchandise presented in department store fashion. One can barely get in to some sales without an invitation. Sotheby's now holds auctions on Saturdays so retail customers can spend their money there rather than at Bloomingdale's. Most bona fide collectors stay away from the crowds who only attend so that they can be seen by the "in" crowd. Bidding by telephone and mail has replaced attending the auction itself. A big auction in New York is now purely social.

I used to go to these auctions, if not to buy, to learn to identify the artists and see the pictures. I would sit in the audience and compare the estimates and the bidding. The surprising results, what sold and did not sell, and my own estimates, all gave me a clue to how the system really works. I soon became acquainted with an old-fashioned system that for generations supplied dealers with their stock.

Auctions used to be a wholesale market, a chance for the dealer to restock his inventory. They gave the collector a chance to beat out the dealer, because he could afford to spend a little more, since he wasn't paying the dealer's marked-up prices.

But now it seems that even at the secondary auctions in 1986, we find pictures that keep circulating, clean-outs from dealer's old stock, or liquidations in bulk, rather than pictures that missed the dealers for some reason or another. Can you still find bargains at these secondary sales? I believe so, but it's much more difficult than it was in the past. Phillips has now picked up some of the slack in New York, and maybe now the auctions out-of-town will be able to get better goods without the competition of the big New York houses.

Retail salesmanship prevails at the big auctions, with prices that a dealer could never get, even with his mark-up. In *Sold: The Rise and Fall of the House of*

Sotheby, Nicholas Faith blames it all on the legendary Peter C. Wilson, who could coax bids by Londoners right through the roof. The dealer would never dare to put those prices on such mediocre work, since he might be confronted by the collector sometime in the future. The auction houses believe that there are always more buyers where the last group came from. But there's no limitless supply of customers in this market, as the auction houses are learning from the incredesing numbers of sales which they call "disappointing."

Michael Findlay, Christie's Impressionist expert recently discussed a case where paintings had been re-offered within two years of being purchased:

"They were re-offered, obviously prematurely. One would imagine that merely with the mild appreciation fine paintings could be resold. But once again we learn this old boring lesson – fresh paintings sell, the others do not."

This example points to a deep problem for the auction houses and that is that the collectors are neither as naive as Sophie Burnham would like to believe, nor as greedy as Joseph Duveen wished them to be. The auction houses, like Duveen, will ultimately have to survive by understanding the temperaments of the collectors and the dealers they hope to deal with. If the auctions want to be retail sales houses, good luck to them, but to survive in the retail business service sells merchandise, not a sense of superiority which manifests itself in an overbearing manner.

Cautious, secretive and deliberate, these new collectors and dealers are much like those of Duveen's age: they're not stupid when it comes to spending their money. To succeed in the retail business, if that is the new market the auction houses hope to conquer with their Bloomingdales "hype," they will have to understand the retail business in America. Quality and price determine success, and in art terms that means having pictures that the public can buy and be able to sell back into the market after a reasonable period of time. Less "hype" may put the auctions back where they belong, in a natural partnership with the art dealer.

While it is true that there exist some objects so unique that they are virtually priceless and they should sell in the millions, but that is not the case with most pictures today at auction. The auction-going public is paying high prices for mediocre or ordinary work.

Will the Auction Prices Collapse?

It is my belief that the auction houses, like the stock brokers, are pushing too hard and too fast. And, like the market for all commodities or investments, supply and demand will ultimately set the price for the work, when the collector tries to sell it back into the marketplace. The present hyped-up auction price system will collapse, and the collectors will either write down their investments to real value in a few years or hold onto the pictures for ten to twelve years and see what happens to the market. I think the author of this passage (quoted earlier) has it right:

"Our's not to reason why: our's but to sell or buy. And if there are ripples on the surface of a more-or-less transparent price system, write them down to excitement, vanity, impulse buying, competitive malice. Those too are attributes of Economic Man."

76

The thing that will save the art business in the long run is the fact that rich people don't like to take losses on pictures. In a down market, or when prices collapse from what they paid, collectors simply keep the paintings on their walls, and sell other things if they need the money. Joe Duveen is quoted in his biography as having said:

> "Do you realize that the only thing you can spend a hundred thousand dollars on without incurring an obligation to spend a great deal more for its upkeep is a picture? Once you've bought it, it costs you only a few hundred dollars every fifteen years for cleaning."

This argument made great economic sense then, and still does today. Pictures are the last things sold by collectors when they need money, part of the reason is that giving them up is a blow to the ego. But the more important factor is that collectors are embarrassed by their stupidity. Works of art are so difficult to sell anytime that they usually remain as a long term asset of the collector. In the end, the market catches up with the value, both as a result of inflation and of supply and demand. At that time the family, if not the collector, reaps substantial longterm benefits.

Three Famous Art Dealers

I will deal with Sidney Janis and Leo Castelli in a brief fashion, and spend more time on Frank Lloyd, because a collector can learn more from studying Mr. Lloyd as an art dealer, than from studying the other two.

Sidney Janis is important for the collector to know about, but more as a historical phenomenon than as a gallery unless he can afford the very best (like Brancusi, Mondrian, and other bluest of blue chips in the art market). Leo Castelli, with his part-time association with Mary Boone, is not only still at it, but his gallery is a place where one can continue to buy the very best of the older names who haven't quite made it, like Nassos Daphnis, Paul Waldman, and Ron Davis. Or, one can at least look at some of the big names, such as Roy Lichtenstein, Jasper Johns and Frank Stella, or consider the future potential of people like Dan Flavin, Donald Judd, Robert Morris, James Rosenquist and Edward Ruscha. As long as Castelli is with us, his gallery will continue to be a place for collectors to go to learn about artists and their way of seeing.

Sidney Janis

The spry Sidney Janis was a power in his day. Active as a collector since 1926, and acquainted with the European artists who came to the United States after the fall of Paris in 1939, Sidney Janis had made enough money, first in shirt manufacturing, to have built a three-million-dollar collection before he became an art dealer.

According to his interview in a recent book entitled *The Art Dealers*, Janis knew Duchamp in Paris, and "spent many wonderful evenings together exchanging

opinions." He was an intimate of Mondrian, and rumor has it that he owns more Mondrians than any museum in the world. He published a book in 1944 called *Abstract and Surrealist Art* and is also a great benefactor to the Museum of Modern Art.

Before the Lloyd/Rothko case, Janis was the first modern art dealer litigant. His law suit against de Kooning in 1965 for $ 500,000 was the talk of the art world. Janis lost his law suit, and had to return the pictures he had withheld from de Kooning but it did not really hurt his reputation since by then he was too well-established in the world of big art and big collectors.

What makes Sidney Janis so important was his early confidence in Pollock and de Kooning, from the early 1950s, and his exhibitions of all of the Abstract Expressionist artists, which he showed side by side with the Picasso generation. Because he had both Pollock and de Kooning in the gallery at the same time, he was the dealer whom all of the younger artists of that era looked to as the dealer with the best artistic taste. He had all of the New York School greats at one time or another: Franz Kline, Arshile Gorky, Mark Rothko, and Robert Motherwell. As he tells it:

"We put on consecutive exhibitions of American artists which were real knockouts, but sales were slow. Out of the exhibition of de Kooning's 'Women' only one or two sold, and those for around $ 1,800. Pollock never enjoyed the sweet smell of success; an eighteen-foot painting called 'One' was sold in 1952 for $ 8,000, which was to stand as the greatest amount we received for a Pollock during his lifetime. Twenty years later I bought it back for $ 350,000 and gave it to The Museum of Modern Art. We sold 'Blue Poles', a somewhat smaller picture, for $ 6,000, and eventually it was sold to the Canberra Museum in Australia for a reputed $ 2 million."

In the end, all of the artists left him. Rothko left, says Janis, to handle his own sales. Janis says, "he was difficult even before he was recognized." Mark Rothko was typical of the artists of his period. According to the dealer John Bernard Myers (*The New Criterion*, February 1983), he distrusted the art world in general. He was then, says Myers, "street smart":

"With Mark the anger is more pronounced. He is convinced that collectors are exploiters, that they buy works of art to enrich their pocketbooks and social position, that they have the instinct of vultures, and that their deepest feelings are based on the joy of mere possession. He believes that their most dangerous attribute is caprice; the capricious need to be *au courant*. If all this is so, then the artists had best be wary of them and make it as difficult as possible for them to acquire serious work. 'Who knows', he asked, 'when, at what moment, any one of them is apt to become bored with single painting? Usually the miserable embarrassment of the auction block, the hellish fumes of Parke-Bernet.' Mark shuddered, then added: 'I particularly lothe people like' – he mentioned two well-known collectors of contemporary art. 'Both of them think they

are greater than artists,' he said. 'Both of them are self-satisfied because they are so rich, and neither of them knows anything about art."

The artists also all saw the art world and the dealer differently. As Sophie Burnham tells us in *The Art Crowd:*

"It was not an easy time for artists. They found a quality of meanness in their relationships. Naum Gabo, close to eighty years old, is quoted by his lawyer, Lee Eastman, as saying: 'New York has not been good to me.' And another, savagely: 'We haven't received any gifts.' De Kooning's impression of his dealer, Janis comes out in his lawsuit, as we shall see; and while it is true that most artists have inflated egos, requiring constant stroking, petting, continual reassurance (Franz Kline had a recurring nightmare of Janis standing over his work shouting, 'Get that junk out of here!'), on the face of it, dealers seem unnecessarily ruthless at times with the artists they are supposed to serve."

The artists believed the dealers were not selling enough, and the dealers believed that work by living artists could not be sold. The situation might have remained the same, but for the entrance of Mr. Frank Lloyd and Marlborough Fine Arts, Ltd.

A close friend and an artist, disagreed violently with my analysis of the situation in the middle of the 1960s when Marlborough moved onto the scene. "No," he told me, "you have it all wrong. Sidney Janis made the Abstract Expressionists, not Marlborough. Marlborough just skimmed off the cream. Janis was the dealer who really made these artists the stars they became." Why then, if they had it so good, did the artists leave Janis, to go with Lloyd and Marlborough? "Greed," he said, "the artists were just greedy."

Marlborough was an international gallery and Frank Lloyd understood that the art business was, after all, a business. Even the artists knew that they had a better chance to be successful with a dealer who put his money behind them. On the other hand, dealers like Sidney Janis, no matter what they said, were not prepared to put their capital behind the artists, and treated the artists as nuisances to be tolerated. Artists wanted what Frank Lloyd had to offer – a business approach to the selling of new art – not a family relationship of pats and encouragements, but no sales. They were tired of the patronage of dealers like Sidney Janis and believed they were ready for the big time. Marlborough seemed to offer just that. If they were to make it big, they had reputations to build, and if it was greed that drove them, so be it, that seems to be the American way. Today, they are recognized as the best of their generation.

Frank Lloyd

One of the most controversial art dealers of the twentieth century is Frank Lloyd of Marlborough Fine Arts, Ltd. – the man people in the art world love to hate. Frank Lloyd, still active in New York, London and Tokyo, is barely known today to the new breed of art dealers in SoHo and the East Village. The older collectors remember him well. But for new collectors, while Marlborough is still

very important, it is the astute Frenchman Pierre Levai, the gallery director, they know; not Frank Lloyd. Exactly what kind of art dealer was Mr. Frank Lloyd, and what can the collector learn from him?

Many older dealers on Fifty-seventh Street and Madison Avenue in New York who remember him and dealt with him, believe that Frank Lloyd was in the art business only for the money. He was a businessman, they say, who happened to be in the art business and therefore he was clearly disqualified from being a true art dealer. However, they fail to understand that dealers in art have several functions. Can an art dealer be a good businessman as well? The answer, in my opinion, is clearly yes. Behind the facade of most dealers usually looms a poor businessman. What the older dealers really disliked about Lloyd (putting the Rothko case aside) was the fact that he did not discover the artists he sold and promoted, but took other people's discoveries and made a huge profit from them.

Frank Lloyd has had a great talent for seizing an opportunity when it is available. Until the days of the Rothko case, the Marlborough Galleries were under Frank Lloyd second to none in acquiring and promoting the best of the new art available. They are still one of the top ten dealers in New York. In London, while they no longer dominate as they once did, they share top honors with Waddington as the most active dealers in the United Kingdom.

Lloyd started in England with his partner Harry Fischer. He moved there after World War II to fill the vacuum in Modern and contemporary art in England. The Marlborough Galleries were an extension of an earlier rare book business that both men began as refugees from Europe once they were free from internment as foreign nationals in England. Lloyd's family were antique dealers, and as a young man, he had always been around the business of buying and selling art objects. Books, and then paintings, were a natural extension of his own background. Art world gossip said that Harry Fisher had the eye and Lloyd had the brains. I'm not sure that this was really the case, at least with respect to American art.

Certainly Fisher brought to the English branch of the business a great feel for the Germans and the Viennese, artists which Marlborough was first to inter-nationalize. Gilbert Lloyd, trained at the Courtald Institute in London and David Somerset, an English aristocrat, set the tone for the Impressionists and the big Moderns in England and Europe. Barbra Lloyd in London stayed with limited edition prints, and made a sustained impact on that area as well. And Pierre Levai, a nephew, ran the American end of the business, and continues to do so today, introducing a whole host of new and revitalized artist, including Botero, Bravo, and the Mexican, Tamayo.

As a group, it clearly dominated the world-wide art business from the 1950s, until the Rothko case. But when it came to new art, both in England and in the U.S., it was clearly Frank Lloyd who decided who was to become a Marlborough artist. Lloyd had a businessman's understanding of the art which gave him an edge on his competitors.

In the early 1960s, the dealer David Gibbs introduced to England the large-canvas work of Barnett Newman, Jackson Pollock, Morris Louis and Lee Krasner.

Gibbs was the advisor to England's most important contemporary collector, E. J. Power, the head of Pye-Murphy. Power's collection was almost visionary for its time, with its broad range of contemporary art of the 1950s and 60s. In 1962 Diana Kingsmill and Alex Gregory-Hood opened the Rowan Gallery, specializing in young English artists, and surviving on contemporary sales. After five years the gallery was just barely paying its way. Since England had no contemporary art market, this was considered an exceptional achievement. While great efforts were made to find new English collectors, and build a supportive domestic art market, this market never developed, and, without help from the government (The Tate Gallery and the Arts Council), young English artists would not have survived. Most of the English artists of the period from 1960 to 1970 were forgotten in the shift to Minimalism. Painters like Paul Huxley, Bridget Riley, Jeremy Moon, Robyn Denny, Brian Fielding, Antony Donaldson, John Edwards, Bernard Cohen and Anthony Green are barely remembered today, even in England. The sculptors (probably because of the international impact of Henry Moore), Tony Caro, Isaac Witkin, William Tucker, Phillip King and Barry Flanagan, however, have maintained reputations in the 1980s.

In England, the only art dealer who tried to compete with Marlborough were Freddie Mayer, the father of James Mayer (the current proprietor of American art in England), Annely Juda, (Russian Moderism – 1912–1924) and Leslie Waddington of the Waddington Galleries, the current king of English art. Freddie Mayer was an exciting and innovative art dealer, but his interests were more in early English and European art and his capital was limited. Waddington was just starting to make an impact, when Marlborough was at its heigth in England.

Henry Moore, Graham Sutherland, Ceri Richards, Ben Nicholson, and Barbara Hepworth were but a few of the first generation of English artists supported and promoted by Marlborough in its English Gallery. Francis Bacon (probably Lloyd's greatest discovery) was critically recognized, but unable to make a living from his art. Artists like Frank Auerbach were surviving on teaching, and others, like R. B. Kitaj, were only just surviving. But English artists like these were were only regionally promising until Lloyd came along. The system that Lloyd adopted in England became the model for what we know today in the world as the contemporary art business.

As a very perceptive English dealer named Alan Cristea has said, and as Frank Lloyd understood, English artists are at a distinctive disadvantage to American artists:

> "It seems to me that [American artists] always start off with the
> advantage of having been born in the only country where there is a huge
> market for contemporary art"

Before Lloyd, all art dealers in both the U.S. and Europe, with few exceptions in both the U.S. and Europe, dealt with contemporary artists as if they were a nuisance, to be tolerated at best. Those with reputations established prior to the Second World War (the Moderns) were treated with slightly more respect especially the French. But the Americans in both the Stieglitz and Halpert groups were

certainly struggling. The motto then and now is "the only good artist is a dead one".

Before the appearance of Frank Lloyd, dealers and auction houses believed that it was impossible to sell the work of living artists without pre-World War II reputations, or in the case of the French artists, without at least good contemporary reputations. According to this theory, only the work of dead artists appreciates in monetary and aesthetic value over time. In America, the Pierre Matisse Gallery represented the renowned French artists like Miro, Chagall and Giacometti and helped develop their reputations in this country, while John Lefebre struggled for years with lesser-known artists like Hans Hartung, Pierre Alechinsky, Asger Jorn, Horst Antes, and Julius Bissier.

Lloyd believed that this attitude toward living American artists was old-fashioned. One had to apply the same merchandising methods to the art business which had been successful with other products outside the art market. Not only did he profess this belief to his private clients but, what is worse, he said it publicly as well. His competitors in Europe and England were shocked by Lloyd's audacity in proclaiming the art business to be a business like any other.

The setting of the Marlborough Galleries in London and Zurich were museum-like. They didn't have the small rooms of all the other contemporary art dealers but boasted real premises, where the work could be exhibited as if it were in a museum. Marlborough even had special rooms where the salesman and the client could view works. And not only did Lloyd's sales staff know the works in that exhibition, but they also had ready access to all of the stock then under offer. They were always ready to show the client almost anything else he was interested in.

What's so revolutionary about this method of selling, one might ask, it's been used by retailers for generations. The point is that contemporary dealers, and even dealers of older art, have tended to carefully guard their inventory. This was a radical notion for the contemporary gallery, and even for galleries which specialized in Twentieth Century art. It's hard to believe that once it was different. In those days, dealers never spent money on their artists. If an artist wanted an ad, or a catalogue, he paid for it, not the dealer.

Lloyd's stock was always mind-boggling. I remember once going in to look at Egon Schiele drawings and watercolors and Marlborough's inventory at the time was exceeded only by the famous Doctor Leopold in Vienna, which were not for sale. No matter what one's interest was – any period, any price, any movement, no matter how scarce or rare – Marlborough had the goods. Lloyd bought and sold constantly. Unlike other dealers, like Pierre Matisse, Stuart Feld, Lawrence Fleischman, Helen Serger, Serge Sabarsky, or Claus Perls, who tried to keep the best works for their own collections, or to hold onto them until they matured in value, everything at Marlborough had a price. One wonders how rich Frank Lloyd would have been, had he kept the best works for himself, rather than selling them.

Although the retail prices in the 1960s were not bargains, the selection available was unsurpassed. If a collector wanted to choose, rather than have the work chosen for him by the dealer, Marlborough, in London and subsequently in

the U.S. branch, was the place to shop and buy. Marlborough's sales were at least ten times their competitors or more.

Another innovation, the modern dealer catalogue, originated at Marlborough. Periodically, there were other dealers who would put out catalogues, but not as consistently as Marlborough did. If a show was important enough to be hung in a Marlborough Gallery, then it was important enough to receive the full art historical treatment with a catalogue essay and colored reproductions. The Marlborough catalogues were better than the auction catalogues of their day. These catalogues are valuable records of their periods, and are still the major documents available for some artists.

Advertising, another mainstay of today's gallery system, was unheard of until Lloyd came along. A simple ad or a line or two was good enough for most dealers, but not Marlborough. It had very full advertising schedules in the art magazines. The art magazines, in the tradition of Hearst, expressed loyalty to their advertisers with *quid pro quo* coverage of their exhibitions.

What Leo Castelli, Mary Boone, and all the art dealers of contemporary art have learned from Frank Lloyd, is that work being produced by living artists has to be actively sold, or it will not sell at all. To move an artist out from the pack of his or her contemporaries, one must get the collector's attention, and this can only be done with old-fashioned retail promotion, the kind that sells merchandise in retail stores. The market for new art is a very insecure group, unsure of its tastes, and lacking any sense of appreciation. What is the difference between promotion and hype? Hype is the promotion without value; Frank Lloyd promised value at retail, and the best selection of an artist's work available.

A collector must be told that an artist is important and that he is being exhibited and sold. Art reviews help a little, more so today then when Hilton Kramer was at *The New York Times*, but in Lloyd's time, it was impossible to get even a review for a new artist in a general circulation publication like a newspaper.

Lloyd provided his own reviews in his own catalogues, by the best writers he could buy. He had the line on the art criticism of his era. He understood the critic's function, as publicity agent, teacher, and culture maven. And he understood that the critic, who was in sympathy with a given artist, could also use a few extra pounds or dollars for a catalogue introduction. Was this a bad thing for the artist or the public? Not if one is as cynical as I am about the imperfections of the art historical system. The art historical system works for the artist, but only if he can get into it. Should an artist stay out of the system and wait for something to happen? "No," said Frank Lloyd, "I'll make you part of art history."

Those dealers who complain about the Lloyd revolution in art marketing would have liked to have done it themselves, but they were either too lazy to undertake all the work and organization, or were just too cheap to put any money into the art or the artists they hoped to sell to the public. Those old-style dealers were good at publicity, but publicity for themselves, not for artists.

To understand why Lloyd was able to get the most important artists of both Europe and America into his gallery in the 1950s, 1960s, and 1970s, is to

understand the artists. The artists, up to then, were second-class citizens in the dealer-collector relationship. Artists were desperate to get exhibited at all. Many dealers even charged them to rent their exhibition spaces. Artists were at the mercy of the access that the dealer had to the public. Rarely would a dealer support an artist betwen shows. The artists protested for what they knew to be true – that the dealers controlled the exhibition process. The public is also a part of the art process, and without an exhibition, it is frozen out of the system.

To paint and stack their pictures until they died, like Clayfford Still did, even if they were well off enough to get by, was not what contemporary artists wanted. Clayfford Still, that most difficult of artists, had his only gallery show with Frank Lloyd. The artists needed the public's input. Yes, they also would have loved to have the critics communicate to the world their originality, charm and brilliance as artists, but as a first step, they needed an exhibition, and if it was in a gallery that looked like a museum, so much the better. The starting point and the great breakthrough for most living artists is showing with any dealer ideally on a continuous basis. Without these steps, nothing happens to the artist or the work. Artists who have lost their galleries are out in the cold, the system has shut them out, and it's almost impossible to re-enter it.

Some dealers like Betty Parsons, Grace Borgenicht, Sam Kootz and Tibor de Nagy would not adopt Lloyd's marketing methods, but they were after all loyal to the artists they believed in. Year after year they would continue to exhibit artists in their so-called stables, and never sell a picture. Most of these dealers supported their galleries either from back-room sales, or they had one or two artists whose success carried the gallery, or perhaps an artist's estate was entering the reevaluation process. They may have been loyal, but were they serving the best interests of the artist? Interestingly, all of the galleries that still exist have now adopted Lloyd's marketing methods.

Lloyd In America

When Frank Lloyd arrived in America, fresh from his European successes with Francis Bacon, Henry Moore, and Graham Sutherland, the art world in New York started to take notice. Lloyd just didn't open a new gallery, he found and bought into the Gerson Gallery, an old established gallery that specialized in twentieth century sculpture. Some cynics say he did this so he could have instant respectability, as Gerson was part of the then-famous Ralph Colin mafia. Colin was a passionate collector and a lawyer to the art world. He was the organizer of the "reputable" art dealers into the Art Dealers Association of America. It was no surprise that Frank Lloyd chose Ralph Colin to be his lawyer.

Almost instantly, the Marlborough-Gerson Galleries in New York, in lavish premises on the corner of Fifty-seventh Street and Madison Avenue, became the hub of the new art world. Most of the artists that Frank Lloyd took into his gallery are now legendary. He had most of the important Abstract Expressionists: Pollock, Motherwell, Still, Kline, Rothko, Reinhardt, Gottlieb and David Smith and many of the second generation artists who were tied to this group, like Alex Katz, Red

Grooms, Larry Rivers, Lee Krasner and Richard Diebenkorn. He also had his powerful English and European artists, like Henry Moore, Ben Nicholson, and above all Francis Bacon. If we define a great art dealer as that person who recognizes genius in a painter, then Lloyd does not qualify, as all of these artists, maybe with the exception of Richard Diebenkorn, were recognized first by other dealers – Peggy Guggenheim, Sidney Janis, Tibor de Nagy Gallery, Betty Parsons Gallery, Greene Street, Sam Kootz Gallery and others.

But, certainly, discovering new talent is not the sole criterion for being a good dealer. I would add that if Ambroise Vollard is the modern day standard by which all art dealers of the twentieth century are judged, then we have to look to him as the art merchant of his time as well as the person who recognized genius in a painter. By limiting discovery to a reasonable time period, then one could say that it was Ambroise Vollard as the promoter of Matisse, Cézanne and Picasso, who earns the title of *the* dealer of the Modern era.

The artists promoted by Vollard, including Degas, Monet, Renoir, Rédon, Rodin and others would not be where they are today without the help of Vollard. Would the artists promoted by Frank Lloyd be where they are today without his help as an art merchant is a question which I am sure will continue to be argued whenever and wherever art dealers are discussed.

Art Dealers and Morality

The real anti-Frank Lloyd group in New York base their criticism of the man on his moral character, not his art-merchandising powers. But it has long been my contention that Frank Lloyd is no more immoral than the next man in business. Frank Lloyd in the Rothko case was applying the standards of the day as to the behavior of art dealers generally. Those standards were not enough, given the obvious conflicts of interest. I'm not even sure that the standards of the day as set in the Rothko case have caught up with the art business.

Stanford Professors John Henry Merryman and Albert E. Elsen, have published a two-volume book entitled *Law, Ethics and The Visual Arts*. These volumes give evidence of the fact that the art world, with all of its supposed righteousness is no more ethical than any other business. The authors' comments on dealers confirm my own experience:

> *"Author's Note: Dealers.* In the art world the most controversial figures are not always artists, but art dealers. Stories of art dealers who have unfairly treated artists and collectors abound, not only because they are numerous, but because the art world, like the public at large, is more interested in news of devious practice than honesty. No profession is better than the quality of its practitioners, and art dealing, which has not required licensing, advanced degrees, or special credentials in this country has attracted men and women of widely different backgrounds, competence, and ethical awareness. In our experience, most art dealers are honest. Rare is the young person who in college determines to be a dealer in art and accordingly prepares by taking extensive courses in art

history as well as economics and business. Few art dealers, but they include some of the very best, are trained art historians. Some are in the profession by ancestry, others have been collectors Most come from other callings, notably previous careers in business. Being an art merchant is largely a matter of on the job training, often begun by working with an older dealer and just as often done on one's own. The ideal dealer has above all a great eye for quality, the conscience and skill to research and document the authenticity and history of his finds, a broad, up to date knowledge of where good art is, a keen instinct for when to buy and sell and to whom, and is scrupulously honest in his transactions. All of these traits can be trained if the apprentice dealer chooses excellent models and disciplines himself intellectually and morally like and athlete heading for the Olympics."

If the test for honesty is the Olympics, then Frank Lloyd passes, the scathing rebuke he received from Millard L. Midonick (Surrogate, New York State) notwithstanding.

There is plenty of evidence of both good and bad art dealing, from museums, to auctions, to dealers, to collectors, to artists. But the point is how does Frank Lloyd rate as an art dealer? Aside from Rothko, his dealings with artists and collectors have been scrupulously honest. Frank Lloyd was wrong in not settling the case, and giving the Rothko pictures back and rescinding the contract from the outset. The Rothko case was not a test of Lloyd's honesty. It was a test of his good business judgment. And he failed in that test, and it cost him dearly. Is Lloyd the type of dealer and Marlborough the type of gallery one should look to as a model of long-term values in contemporary art? Yes, because basically it's the Marlboroughs of the world that end up better serving the collector as a guide or advisor, given the confusion and competition of art collecting today. Galleries in New York which serve the collector better because they understand the merchandising of a contemporary artist are those that understand the nature of the art world and that it is necessary to back their artists with long-term and lasting support.

Once one is around the contemporary art field for a while he starts to understand the meanings behind descriptive terms associated with artists and their work. Opinions of artistic merit are only opinions, but when it comes to buying new and highly promoted work, price determined by opinion plays an important part. Heavily promoted works are accompanied by extraordinary prices. For example, Elizabeth Frank, in her article on Nancy Graves in *Connoisseur* may be right when she says, that Nancy Graves is producing some of the most daring and original work of our time, but at $75,000 and up, one has to be very careful of such a price, especially at this stage of her career. As Merryman and Elsen have said, a good art dealer is one who discourages as well as encourages collectors to buy.

Leo Castelli

In Leo Castelli's case, we have good documentation of his status as an art dealer. His reputation is without a doubt the very best. His most profitable artists

were Cy Twombly, Jasper Johns, Roy Lichtenstein and Frank Stella. Robert Rauschenberg and Andy Warhol have been successes for Castelli only for their early work. All of Castelli's other artists have been mediocre performers at best, in market price terms. The second ten years of Castelli (1967 to 1977) were, in terms of recognizing artistic genius, aesthetically very good, but not profitable in market terms.

What has kept him and his gallery going has been the early "winners". It's often true that a gallery can establish its success on just one artist. Castelli may be right in placing his confidence in the rest of the artists he represents (like John Chamberlain, James Rosenquist, Donald Judd, Christo, Larry Poons, Robert Morris, Bruce Nauman, Dan Flavin, Edward Ruscha, Claes Oldenberg, Ellsworth Kelly, and Richard Serra); we will have to wait for the future for the art market to tell us.

While Castelli has never had cheap prices, his prices have always been more than fair, especially if one was a good client. As an former banker, he also understands how to use credit as a marketing method. If a collector can latch onto someone like Leo Castelli, the odds for success are greater because someone who buys from him is buying what a man of considerable expertise and experience believes in. One can't ask for much more than that.

How do the dealers see themselves today?

It used to be that artists were the "stars", or the collectors, the engine that pulled the dealers, but in today's market, it is the dealer who dominates the market. Frank Lloyd, Sidney Janis, and Leo Castelli, are the dealers of yesterday. Mary Boone, Pierre Levai, Brooke Alexander and Donald McKinney are the dealers of tomorrow, if they last. But in between, we have the old timers and the new comers mixed together.

Serge Sabarsky is now less of a dealer than he is a professor of art history. Helen Serger laughs all the way to the bank, with her stock of great German and Viennese Expressionists. The prototype of the middle-range dealer is Arnold Glimcher of the Pace Gallery in New York. Glimcher in an interview with Olive Green in *Issue, A Journal for Artists,* (Spring/Summer 1985) gives us an insight into the thinking of a man who has seen it all and survived:

"OG: Does an artist have a chance to get into Pace today, who is not already there?

AG: The situation with a gallery that has some age, as mine does, is that you make commitments, and you make friends. Your artists become, hopefully, international figures, and eventually, part of the history of art. There's a choice that has to be made. Either you say to them, 'All right, you're famous, I don't want to handle you any more,' and you go on to the next generation of artists or you stay with them. I'm interested in the idea of an evolving career. I like very much what Monet said, 'painting is an old man's game.' The cult of the youth – the idea of disposable moments or issues – is not interesting to me.

OG: Does Pace Gallery promote its artists?

AG: Surely every gallery, promotes its artists but you have to have

something you can promote. That's critical. I could put up an exhibition of any artist for the first time and probably sell the entire exhibition because the collectors have a great deal of faith in the gallery. But I couldn't do that repeatedly unless the art had merit and value. You can't promote just anything; a lot of people don't understand that. They may think that all you have to do is come to the Pace Gallery and you're a star. But I'm not a magician... just a very good manager.

OG: Does he help the art historical process – a little?

AG: I can't do anything for them in terms of history. History judges artists for their personal contributions to the ongoing history of art, for their personal perceptions. What I would like to do is remove all extraneous activity so the artist can just work. That's really my role. I don't think the mechanics of selling art in order to live should be the artist's responsibility. We each have independent and interdependent roles. They make the art – I sell the art.

OG: How does he see the collector?

AG: Well, I think one has to be conscionable in pricing the works. My responsibility to the collector and my responsibility to the artists intersect at some point. It's very important that key works be placed in the right collections.

OG: The right homes?

AG: Exactly. Places where the works will eventually find their way into museums, where there is concern about the artist in general. I'm not as interested in the collections that are sort of a Whitman's Sampler of the art world. I like collectors who are involved with the artist's work and who have many works by an individual artist. They take a stand on a specific artist and are involved in the development of that career... and they learn much more.

OG: So you're not interested in the eclectic collector?

AG: It depends on the collection. If a collection is being made for the purpose of going to a museum to represent the period, sure. I'm interested in collectors who want to know about the art. In some ways, a gallery is a teaching institution as well.

OG: Like a museum?

AG: Yes. I think of my gallery as a small, private museum."

Well, as you will see, you have to make up your own mind about each dealer, but clearly Arnold Glimcher and I see the art world of today very differently.

Dealers of Non-Contemporary Art

A few words should be said about dealers of Modernist painting, and of American painting – not work by living artists. It is not possible for any gallery in the world to "hype" an artist in these fields. One has to be careful not to be swayed

by a hard sell, but if it is a reputable dealer (and here I mean recognized as being reputable), then one should be able to make an informed decision. If one makes a simple review of the facts, with a little bit of reading and studying, one can decide what the approximate present market price should be. Also, unlike new artists, most of these artists have auction histories. These auction histories give one the best overall look at present market conditions, and what one buys from a dealer is generally priced at or near the auction price. The gallery price might be one hundred percent more than what would be paid at auction, but the availability and quality of what one can buy in a gallery is better, which accounts for the higher price and the price differential.

As the Serge Sabarskys and the Kennedy Galleries and Hirschl and Adler people will tell you, "when you have top quality works, you never have to sell a painting. You sell it when you buy it." Most of these Modern pictures, both American and European, are difficult to find. As soon as a dealer gets hold of one he can sell it as long as its not from auction.

The best paintings need no promotion because the market demand is always greater than the supply. Here, the collector never gets a bargain, because there are none. He pays market prices and is happy just to have the chance to buy. The bargain is recognizing the quality of the picture, that is, the content or subject, medium, size and signature. A great painting is generally a bargain at any price. Most dealers in this end of the business price within the limits of their market overhead costs. Obviously, a good private dealer can mark the picture lower for sale, because his overhead is lower. But on the other hand, the private dealer doesn't always have access to the best art works.

The market below is more or less a decorative one. Works by these artists, especially if they're European, follow the prices of the first-tier market. As prices of premium quality works go up, the prices of lesser works are sure to rise as well – as long as good market conditions prevail. In a bad market, the lower-quality works fall in price or can't be sold at all.

Many collectors are confined to the lesser-work market because buying the best works would put them out of business. Their entire budget may buy them one good small painting in today's market, if they aim to buy the very best of what they want. For example, School of Paris painters like Vlaminck and Dufy in their best ranges have never been cheap. The best of them sell at high prices: the lesser-quality sell at substantial discounts. If one can discern the difference, and believe that, for example, Dufy is as great as any, then this is the field for that enterprising collector. It's impossible to say whether spending a fortune on a painting by a so-called second-tier artist is worth the risk, especially if one loves the work. As Leo Castelli has said:

> "Although I knew already that Jasper Johns and Rauschenberg would be the stars of my gallery, I did not imagine that they would be the ones who appeared at the very beginning and would still be with me. There are no others, except those two."

If Castelli doesn't know, then it's very hard for the collector to know.

"It is natural that I should tell about pictures, that is, about paintings. Every-body must like something and I like seeing painted pictures."

Gertrude Stein

IV

The Collecting Game:
The Market Determines Value

Some will say that collecting is a game only for the rich, and maybe it is. Collecting as an avocation, for those other than the super rich, seems to be spreading, if not in numbers of people, certainly in the money spent. As *Business Week* put it, "Of all the phenomena fueled by prosperity and inflation in the last few decades, the international art market is perhaps the most eye-popping." What is the reason for this expanded interest in collecting, and how should an individual, if he wants to, be able to participate in it?

The point worth repeating over and over again, is the knowledge or informa-tion a person brings to the activity of collecting is essential to answering the question as to why and how he should collect. If one generalizes from insufficient data or information, then one is bound to miss the real benefits of putting some of his capital into art.

The reasons people collect are as varied as the people themselves. For those other than the super or reckless rich, motives should generally be both aesthetic as well as investment oriented. The best course should be a blend of these sacred and profane motives in each acquisition. The amount of money involved and the personal circumstances of the individual should also determine the specific blend in each case.

As Thomas E. Norton has said in his article in the *American Bar Association Journal:*

"Certainly for Americans, it is comforting to have, as a security blanket, the knowledge that art purchases may turn out to be worthwhile investments: most of us feel much better if what we do for pleasure turns out to pay practical dividends as well."

While some can spend anything they want for their self-indulgent pleasure, most people are not in that category. Those of us in that category have a better chance to succeed, although nothing is guaranteed, if we arm ourselves with information sufficient for the task.

To be successful as a collector one must understand some very basic rules as to the nature of the collectible market. Nothing operates in a vacuum. All activities are determined with reference to the market in which that activity is operative. The market and the marketplace in the fifteenth century, the nineteenth century, and today are different. A collector is limited whether he likes it or not by the marketplace, both with respect to his purchases and future sales. One can under-stand why Joseph Alsop labelled this market complex and irrational.

90

The Market

In effect, the art market is a commercial distribution system which integrates artists into their society's economy, bringing art works to a public which can appreciate them, and can purchase them. These distribution systems, like other systems, are run by middlemen who want to regularize the relatively unstable and erratic production of the artists, or circulate the artwork back through the system. Basically, we call them dealers, and we call the distribution system the art market. By now, the reader should have a pretty good feel as to how the dealers and the auctions operate. Are auctions dealers? For purposes of the distribution system, they certainly are.

If one wants to get good value for his money, and not to be taken for a fool, then he must start by understanding the parameters of the marketplace and the concept of value within the market.

Bargain Purchases

First, no one sells something for less than its worth, unless there are extreme circumstances. We call these extreme circumstances, bargain purchases. For example, buying ten pictures by the same artist, rather than one, can be a real bargain at the current market price, because of this bulk purchase. Sales at less than the current market are rare but not unheard of.

The market for art, once again, has different characteristics from the market for other kinds of investments at retail. The major difference is the lack of liquidity in the marketplace. Bargains at current market price (retail) mostly come about now because of the lack of a constant and substantial demand. While it may be possible to sell one or two of a kind of a certain object at a price, if a large number of these items was offered at one time, the market could not absorb them.

This phenomenon is recognized in the tax law as "blockage", where value is determined on a one-by-one basis, as if theoretically each art object was sold in a single sale, although, in fact, it was a bulk sale. Where this comes into effect for the artist is in the valuation of paintings in an estate for death taxes, where the government allows a volume (blockage) discount upon an artist's death for valuation purposes. For the collector, it proves th illiquidity of the marketplace. As a general rule, even the U.S. taxing authorities recognized that to get fair market value in the art market, a collectible has to be held for a long period of time.

If we had no stock exchanges, or over-the-counter markets for securities, this market would be like the collectible market, it would be longer-term because of the difficulty of finding buyers and sellers in the market-place. The difference between these two markets is the size and the scope of the market and the opportunity to buy and sell in a market that has liquidity compared to one that does not. Since current market price is determined by a willing buyer and a willing seller, in order to get a fair market value, both must be present to create a real market. Artworks as commodities bear the marks of the system in which they are distributed, and liquidity is a key element in this system.

91

Value

What is value? Recently, this notice came in the mail from John L. Marion, Chairman of Sotheby's:

"Dear Client,

"I have often been asked by new collectors – and even experienced collectors – how do you determine the value of an object? There are obviously *many factors involved,* but now we have made it easier to find the *current market values* for thousands of decorative works of art.

"Sotheby's experts world-wide have worked with me in putting together a comprehensive guide, which is the first collectors' price guide that is truly international in scope."

Therefore, simply, value is current market price, at least according to Sotheby's. There are, as Marion says, obviously many other factors.

If one defines current market value as the combined effects of what a willing buyer and willing seller will pay for an object, both having knowledge of the facts, and neither being under any compulsion to buy or sell, then in order to have a market which determines this value, there must be market makers.

The Market Makers

The Market Makers are the dealers, which include the auction houses. By now it should be apparent that these market makers are as different as the products which they hope to sell.

The important point to understand is that in any category, a lack or scarcity of market makers can affect the market for any given object, whether it be painting, works on paper, sculpture, or prints. This scope of the market makers affects each and every value decision a buyer will be called upon to make. It becomes obvious that the more regular the market makers are, the more value an object will have.

This can be seen clearly in the market for sculpture. The fact that there are fewer dealers for sculpture than painting or prints will always affect the price of sculpture, and thus it is easy to buy sculpture, but very difficult to sell. The breadth and scope of the willing buyers and willing sellers helps to create part of its value.

Other Value Factors

How about the "many (other) factors" involved, as John Marion puts it? Well, here is where the trouble starts. We know that the object itself has little or no value. Canvas is worth the price of canvas, and paper is worth the price of paper, and yet it has a different value if it is designated a work of art. Also, the utility of the work doesn't help, because in most instances, the object has no real utility, other than as decoration.

In market terms works of art – unlike stocks, bonds, and other investments which have underlying monetary value – are good for nothing except the value created because someone wants to own it, and believes it is valuable. These other factors (which Marion talks about in his "Dear Client" letter) are several in number and will be dealt with in greater detail later in this book.

Quality, Medium, and Subject

But, for now, I will talk about three of these factors. First and foremost is the quality of the object. Quality, in the end, probably means how we value the status of the object in relation to our sense of what will be demanded by others, and how art criticism in its broadest sense functions to affect this demand. This, in its simplest fashion, is manifested in the fame or reputation of the artist or the work of art.

The theory of fame or reputation goes like this. The artist creates a work of art (which has no monetary value) that expresses his intentions and has a certain cultural value. These special qualities (intention and culture) testify to its maker's special gifts, and the quality of the work. Since the works reveal the maker's essential qualities and worth, all the works that an artist makes, but no others, should be included in the corpus on which his reputation is based. In effect, this reputation or fame criteria says that we value more a work done by an artist we respect, just as we respect more an artist whose work we have admired. Since the art market involves the exchange of money, reputational value is translated into financial value.

The next factor is the medium of the object, such as painting, pastel, watercolor, or print, and then subject, size, signature and condition. To see how these other value factors come together let's look at the work of James Tissot, an Anglo-French artist of the Victorian era. In an article in *Art & Antiques* on value judgments, the difference in value between objects by the same artists in different media is pointed out as follows:

"Like all Victoriana, the work of James Tissot, the Anglo-French artist, has enjoyed a recent reevaluation. Fifty years ago, his work sold for pennies in French department stores; now he's again in the spotlight he held in the London society of the 1870s, his paintings often fetching six figures. But it's only the *paintings* that command these high prices. His prints, drawings, and watercolors, which evoke the same frilly women and elegant soirées, cost much less.

"Tissot's prints rarely exceed $ 2,000. He recognized the medium's commercial possibilities and executed some ninety etchings, drypoints, and mezzotints in small editions. Perhaps half of Tissot's graphic works are based directly on his oils, and though they remain secondary to the paintings, they are nonetheless beautiful works of art in themselves. In fact, many have a softness and texture his meticulous paintings lack.

"For an artist who labored so intensely on his paintings, Tissot made very few preliminary drawings or water colors. Such studies are rare finds but offer a happy compromise – in price and technique – between the prints and the oils ...

"To recognize the printmaker and watercolorist in Tissot is not to detract from his indisputable talents as a painter. But, like many other artists, Tissot worked successfully in many media, and the creative collector would do well to examine the possibilities offered by the total *oeuvre*."

In summary, then, it is generally true that between mediums there exists an

approximate traditional relationship between prices. This system is loosely based on an old European system, and suggests that an artist's prints are worth twenty to twentyfive percent of the price of his drawings or works on paper, and that his works on paper are worth ten to twenty percent of the value of his oil paintings. Taking the price of the most important painting, it is possible to gauge the price of his drawings or works on paper and his prints. For example, if an artist's oils on canvas sell for $ 20,000 each, his works on paper would be in the range of $ 2,000 to $ 4,000 each, and his prints should be in the range of $ 400 to $ 600 each. This is, of course, a very general rule.

So we have value, by medium, such as paintings, pastels, watercolors, drawings, and prints, and value within the medium, first by quality and then by subject, size, signature and condition.

Of all these value prospects, the quality criterion is the most elusive, and most important, and the most difficult to understand by everyone, the professional or amateur collector, and it is often said that that separates the collector of genius from the ordinary collector.

The Collector's Quality Criteria

As collectors without the help of the critic or the art historical process, the best thing to do is try to understand how close the object comes to achieving its aim. If it is close to its mark, then it is probably of good quality. As Harold Rosenberg, the critic, has said, "Yes, absolutely. There is no objective measure of a work of art." Beware of those among the judges who claim to be passionate about an object, because most people do actually feel what they think they feel. Clearly, the quality of a work of art is an opinion, and don't forget what an opinion is worth the next day, the next year or ten or fifty years hence.

Brooke Alexander, a dealer who shows mainly young painters like some of the budding "stars" such as Ken Goodman and Judy Rifka, told an interviewer *(ICA, The Literary Review)* what he looks for in an artist's work:

"I try to look for what I call a genuine impulse. It has to do with someone making an image which is really part of his or her character, what they're about.

So the 'genuine impulse' has to do with consistency.

I think so. People are about what they're about. It's curious when you find someone who will do one kind of work for two or three years and then do a totally different kind. Then you suspect that that person is watching other developments rather than what he's about. What I look for is what each particular artist is about, whether it's fashionable at the moment or not."

There can be no final judgments in art, said Rainer Maria Rilke, the poet and critic, "where would the best of us be, if justly judged,"

The best advice I can recommend is that suggested by Jed Perl in the *The New Criterion*, February 1986, in a piece called "Houses, Fields, Gardens, Hills":

"When one goes to a couple of dozen gallery shows a week as I have

been doing over the past months, the rush of images and the effort to adjust one's eyes and mind to very different kinds of art can be overwhelming. Sometimes I'm not sure I'm actually responding to the work and suspect my general mood is getting in the way of what I see in front of me. Some days all sorts of things look good; other days, when the first few shows are a downer, I start to approach everything skeptically. Often I leave a gallery feeling uncertain about what I've seen, and in these cases I find that one of the most useful tests is whether the work holds in my mind's eye. Some art feels intriguing when I'm in front of it, but ten minutes after I leave the gallery it's gone from my mind – I can barely recall what it looked like. Other shows ... make me feel uneasy when I'm in the gallery, but stay with me afterwards. The shows I remember and play over three hours or three days after I've seen them are the ones I'm interested in. They're the shows that make me feel I've been opened up to a new experience."

Very often one hears that so-and-so has a "good eye", but what is meant by that expression is that that person has an ability to judge good from bad. This area of quality is in itself an area that has its own theories and practices, which we will deal with in greater detail later in this book. But for now the collector must know that if he can conquer this world of quality and use his instincts and knowledge to direct his purchases, he becomes a collector who can be successful in every way, beyond his wildest imagination, both on the passionate and monetary level.

Just like the successful analysts in the securities field, the dealer who can successfully direct his knowledge to the quality of an object, deserves, in my opinion, to inherit the earth. If a collector find such an astute dealer, my advice would be don't buy the object, buy the dealer.

The Scope of the Market

The experts have told us that the art market approximates the stock market. While the analogy is not perfect, it is a good point of comparison. Both, we are told, are random walks. Despite the record sales of the auction houses, and the fact that more art dealers are operating across America than ever before, the art market doesn't come close to approximating the stock market in total size or activity. But the two seem, at least to most people, to be linked because affluent people are investors in both markets. A big problem for anyone who looks at the scope of the art market is a definition of affluence. In America wealth usually means an annual income of $ 50,000 per year. However, to be an art investor and spend a lot of money on art, no one earning less than $ 100,000 a year should consider it, unless they are prepared to spend the time and energy.

To this observer, at the top end of the market there seems to be some correlation between the scope of the art market in any one year and the economy in general. When things are on the whole good economically, and people are spending more they also tend to spend more on art than they do when things are less stable.

When other sectors of the economy are down the art market tends to follow with some lag time. But because of the nature of the art market – its smallness, its specialization, and the lack of detailed information – the answer is almost impossible to pin down. Unlike other markets, even used cars, fluctuations in the prices of art go pretty much unrecorded. Auction prices provide the only public record of the cash value of a piece of art, and even there, elaborate evasive action is taken to conceal the fact that a work of art is actually being bought in or bought at all. There is no way to know if galleries are doing good business or none at all, and the nature of the business is not to disclose what is going on with their customers.

The price at which art is sold in the galleries is kept secret. Most of the big sales by the dealers take place without a public trace of evidence that a work of art has changed hands. If Baumol in "What Price Art?" is correct in his analogy that investing in art is a floating crap game, then it might be helpful, because the art market is so secretive, to know one of the key rules of the stock market and see if it applies to the art world.

Never Buy "Puff" or "Hype"

In a recent issue of *Barron's,* I found an article by Rodone Fadem, entitled "Three Golden Rules, or How Not To Get Poor In The Market." Since I am a great believer in experience rather than theory, I was impressed by the author's having been a stockbroker for twenty-five years, and I assume a rich one because he followed his own advice. That is the kind of advice which may make the collector's "random walk" somewhat less random.

Mr. Fadem tells us that he has concluded from his twentyfive years of experience that people who lose money in the stock market have certain common behavior patterns. Again, my own experience tells me the same thing about the art market. The point is that if one plans to spend hard-earned money on buying art, following some of these general rules might help beat the odds, since almost everyone feels more comfortable with stock market terms than art terms. Mr. Fadem tells us to never buy a "puff" stock. He says, "one of the worst mistakes is to chase what everyone else is chasing. Everyone from childhood on," he says, "wants to be popular". To apply this to the art market, we first might substitute the word "puff" for the word "hype".

In today's art market, we have to be very careful of the categories – for example, I would break these down basically into contemporary painting, Modern painting, and old masters. The market that is the most "hyped" is the contemporary field in paintings, works on paper, and prints. The other markets do not receive the same highly commercialized attention or "puff," that is familiar in the stock market.

What is a "puffed" painting? It's by an artist or group of artists who shoot onto the market quickly. I have called this new art because the artists have been at work professionally for less than ten years. They are contemporary artists, rather than professional contemporary artists. Usually behind this phenomenon is a group of new and sometimes older dealers who combine with the new dealers to present to

the art public what is described as the "cutting edge of the hottest of hot trends", The newest of the new.

Brooke Alexander, a dealer at the cutting edge of the kind of promotion I would call "hype," thinks it's a change in tempo, back to the days of the 60s, "the atmosphere is the same," he says, "there's a kind of excitement." Collectors get together to try to figure out what's going on. People, he tells us in a recent interview, are back into collecting paintings again *(ICA, The Literary Review)*:

"What do you think is at the root of this?

I think people simply go starved. Or it may be the natural swing of things.

One of the swings and roundabouts in fashion?

Yes, well, no, you can't quite say that. Pop art, if you look at it in terms of Lichtenstein, say, was a clear anti-abstract expressionist statement, or a parody. It looked great after all that sloppy paint and emotion on the canvas. Now people seem to want that again. So rather than fashion, I'd say it was a change in tempo. I don't like the word fashion. Though, on the other hand, the way some of the painters are being promoted, it makes you think of rock stars.

Do you think this kind of promotion to stardom is a good thing for the art world?

I don't know. I think I'm more conservative than some of the leading examples of promotion. Though it is necessary to garner serious attention for artists.

Has this hit-parade phenomenon affected the painters in any particular way?

Well, they're all intensely aware of who's being hyped. They're involved in the art world and they see it happen. They're ambitious and they wonder if that's the right way of going about things. After all, you only have one shot, more or less, it's very confusing."

The most important recent example of this was Mary Boone, a very young art dealer. With the help of Leo Castelli, one of the most established art dealers, she opened a gallery in 1981 representing eleven painters who had literally never been heard of before. Among them was Julian Schnabel, David Salle, Rainer Fetting, Gary Stephan, Ross Bleckner and several others.

The paintings being promoted are never cheap, and the "hype" generally follows the same pattern with each new group. The dealer is said to have a good eye in being able to dig into the great reserve of new artists always available in New York and the world, and know how to pick those that will be successful in the marketplace. "Successful" means that the prices for their work will increase dramatically over the next few years. Mary Boone, with the help of others, started a movement that is now called Neo-Expressionism. Foremost in the movement was the artist Julian Schnabel, who is the prototype of what I am talking about, but the are others who could be used as examples as well.

Schnabel is a dealer's dream: he seems to know market forces instinctively.

From his first show, he was an "art star," moving into the marketplace with all of the "hype" reserved for the Hollywood stars of yesteryear. He seems to understand the system to the core, and is the master of the interview, where he is both controversial and outrageous. Pictures of himself in the magazines and newspapers, stripped to the waist, with his own pictures as back-drops, are the ultimate in "Expressionism." "They wanted a pseudo Pollock – the art world equivalent of Rocky Balboya," wrote the art critic Robert Hughes of the painter Julian Schnabel. When he wasn't relieving himself in the Guggenheim fireplace, Pollock was picking fist fights among the competition at the Cedar Tavern in Greenwich Village.

Schnabel epitomizes our idea of the modern-day painter. He is more Kirk Douglas than Douglas playing Gauguin in *Lust for Life*. If one wants to believe in the artist as being a celebrity, then he is perfect for the role, and Mary Boone was the merchant providing collectors the golden opportunity to invest in a star.

Can this discovery be credited to Leo Castelli, the modern day Ambroise Vollard, art mover and shaker, or to the thirty-year-old neophyte, Mary Boone. Castelli is widely known for his uncanny ability to recognize genius in some artists. In a fascinating catalogue Castelli tells his story. He is not only the present-day Vollard, but also the Daniel-Henry Kahnweiler, the Alfred Stieglitz, the Peggy Guggenheim and the Julien Levy of the Eighties. People were asking: if these are Leo's artists, they are something; if they are Mary Boone's, can anyone be confident of an upstart's discovery? As it turned out, they were Mary Boone's, at least for a while.

Here was a collector's dream come true for those who could get into this market at $10,000 to $50,000 a painting. This was modern day art world "hype" at its best.

This Julian Schnabel and David Salle discovery brought with it a whole new group of painters from Germany and Italy. The names are all very much with us today: Georg Baselitz, Anselm Kiefer, Rainer Fetting, Helmut Middendorff, Francesco Clemente, Enzo Cucchi, Mario Merz, Mimmo Paladino, and Sandro Chia. These all now make up a group, together with Julian Schnabel and David Salle, called Neo-Expressionism.

In 1986, Michael Brenson of *The New York Times* told us that an "artistic moment has now passed." What Brenson was writing about had been recognized by most collectors and dealers for the previous six or eight months, but to see it full-page in the Sunday section of *The New York Times,* confirmed the passing of a most interesting and singular period in the art historical process.

As he said,

"the passing of a moment can be felt in many ways. Although with the most widely respected of the artists, there may be no trailing off in prices or gallery attendance, there is far less sense of expectation and excitement, and far less interest in the artist as a whole."

I don't totally agree. What this movement does represent is the most current example of "hype," and we have had that before. But, I am afraid that this

movement represents, as well, a new method of art marketing which has never quite worked before and the understanding of which is critical to the collector. The question for most collectors is: What does one do, jump on this bandwagon or not?

The problem for most collectors who wanted a Schnabel early, was how to even get into this game, prices notwithstanding. As in the days of Joseph Duveen, the collectors were hearing that old refrain, "We can't get enough Julian Schnabels to satisfy the demand. As soon as we get them, we sell them." Unless one was a favorite of either Mary Boone or Leo Castelli, or if either of them thought the picture was "going into an important collection" (read "where it would help future sales"), he was told "I'm sorry, but other collectors have been waiting a year or more for the paintings in the show." Of course, you're certainly welcome to come by the gallery when you're downtown."

In this well-staged World's Greatest "Puff" very few collectors ever got paintings. There were exceptions, Barbara and Eugene Schwartz, the collectors who were first in the Color Field phenomenon of Morris Louis and Company, had the proper connections to buy both Julian Schnabel and David Salle right at the beginning. Asher Edelman was there as well, as were a host of others in the "Collector's Class." Leo Castelli, with his twenty-nine years of experience in the art business, is the master of placement, rather than selling. Most, I believe, of the earliest quantity buyers of the Neo-Expressionist works were smart newer dealers, especially European ones. These dealers were buying for resale, rather than to hang in their homes or offices.

It usually takes a long time for the other older dealers to chase what another dealer perceives to be popular. However, in the market of the early 1980s, there were a lot of rich "private" dealers, many former collectors who were really wired into the downtown/Soho art scene, and on the lookout for the newest trend. Minimalism, the last big art movement, just could not find a real market.

The Minimalist work, with all of its attempted "hype," was just not for the collectors or the popular press, in contrast to the art press. It is at best very difficult work for a collector to get hold of. The "Neo's", on the other hand, were producing work which had world-wide impact, it was not just American work, although Schnabel and Salle were Americans, it was German and Italian as well. It has been a long time since before the Second World War, that the American art market has taken notice of European painters. This international underpinning helped get European money into this movement. Of course, it didn't take long for the Kiefers and the Clementes to see that to really make it, they had to be seen as New York artists, and this meant living and working in New York, at least part-time, and not in Europe, They, however, brought with them a good deal of European dealer support, something the Minimalists never enjoyed. These were commercially-oriented artists who were mostly young and knew the system as well as or better than the dealers. Also, because of the original high prices, a new and clever technique (the Thorstein Veblen Phenomenon – if it cost a lot, it has to be good!), the work developed a certain market stability, which caused an after-market to develop from dealer to dealer and then on to the collector or the museums.

The auctions also changed their policy with respect to contemporary work in order to accommodate this new group of "Master" painters. Until this time they never would have even considered selling work that was two or three years old at big important auctions. But the auction houses with their new retail sense, jumped into the market as well, and the Neo-Expressionists have been appearing at auctions on a regular basis ever since. The prices are comparably higher than they would have been at auction under the pre-1980 auction system, because no one ever made really good buys. Collectors who wanted to get into this game were paying up to $50,000 for a decent Schnabel. Now approximately five years later, we can begin to see what has happened to this market. The collector has to be on guard because this is likely to happen again.

Schnabel and Salle were then slammed by the critics, as were most of the others. The consensus seems to be that one or two will survive, probably Baselitz, Kiefer, and maybe one of the Italians, Clemente or Chia. Most of the community of art professionals refused to take them seriously. Typical are the comments on Schnabel which went like this:

"But the more Schnabel tries to convince us, the more fetishizing his relation to his means of expression becomes."

"The gallery space dwarfed even the biggest and heaviest of the paintings, and their numbers only diminished their impact."

"In his restless quest for power and legitimacy, he builds to such a frenzied pitch that it appears the battle being waged is not with painting or a vision of the world, but with the self lashing out at its own impotence."

Schnabel has now left Mary Boone *and* Leo Castelli and taken cover quickly. We know that he has done all right financially from the pictures in the magazines, and the other up-market publications like *Vogue*. He now has a grand loft/apartment, probably a home in the country, and, I hope for his sake, at least a half million dollars in the bank. Julian Schnabel is now with the Pace Gallery on Fifty-seventh Street, where the owners re-made the gallery space into his image.

Now the test really comes, the "puff" is over, the critics have spoken and Julian Schnabel is with a gallery, that, if you believe the other dealers (which I don't, since they are all the same when it comes to promotion), has buried more contemporaries than any other gallery in town. Julian's hope is to fit nicely into the concept of the "Pace Collection"; make more of his broken plate pictures, on which he made his reputation so that the "new rich," who want the biggest and the most outrageous to decorate their new and most expensive houses, can be convinced to own a Schnabel. Like the stock market with the new issues that caught on quickly, in a few years people will be saying, "Do you remember Julian Schnabel paintings?" It's like the days of Panacolor which was to replace Polaroid, and went from sixty to zero. I can remember some of them, the names were always exotic, like Xonics or Braintech. Will some of these artists make it in the long term? Probably.

The Georg Baselitz market started in Germany in 1963 at about $1,200 per painting. These same paintings in the dealer market today could bring up to $100,000 each, according to Philippe de L'Estang writing in *Galeries Magazine,* an interesting French art magazine wherein all the articles are paid for by the art dealers. As de L'Estang says, "It is important to distinguish two types of markets for Baselitz works: the primary market and the secondary one."

This primary market is controlled by Michael Werner, who is not only a West German art dealer and the power behind the German and European Neo-Expressionist market, but also the new husband of fellow dealer, Mary Boone. As one wag commented, the alliance might bring stability to the Neo-Expressionist market.

Since 1963, first in Berlin and now in Cologne, Werner is the exclusive representative of Baselitz. It is he, who, with the artist, sets the prices. Waddington in London, Mary Boone in New York and Gillespie-Lange-Salomon in Paris follow. As Philippe de L'Estang says, those dealers, with Werner's agreement, have access to the artist's studio and list their official prices under one condition: to sell the works only to collectors and museums, not to other dealers. This is the primary retail market and it is well controlled and stabilized. The dealer market is fed by Werner, who subcontracts the Baselitz paintings to other dealers who can then sell to collectors.

The only leak in the system is the possibility of resale at less than the normal dealer mark-up, and this can take place at auction or with dealers who are content to take a small profit. This system has in the past always been based on the fact that few pictures were available, as in the example of Jasper Johns, where demand drove the sales. But the reverse is true of Baselitz who turns out hundreds of pictures per year for sale into the marketplace.

In the old days, before our new private marketing-dealers came on the scene, the theory of marketing artists was based upon the stock market equivalent of an efficient-market theory. As the world got to know that Jasper Johns was the best, the demand, not the supply, would create the market and the price. Of course, as in Johns' case, it could take twenty to thirty years for the art historical process to determine the greatness of the artist sufficiently to create the demand and the price.

In the Baselitz case, the German collectors were there early in the 1960s, and they seldom sold or now sell their works, thus giving the newer work a stable base price as determined by the supply, and an unbelievable demand because of the extent to which the Neo-Expressionists have become popular in the last five years. In this controlled fashion the market will probably quintuple in price every four years, according to de L'Estang. One must remember that Baselitz has been active since the 1960s, whereas most of the other American "Neo's" came on the scene late in the 1970s. However, it was not until the 1980s, when this market started to move up, that Baselitz's work began to appreciate. The important pictures at auction are in the $70–$80,000 range, with a strong market for drawings and

prints for those who can't afford paintings. These works on paper range from $3,000 to to $7,000, depending on the completeness of the image and quality.

Will this market and the prices continue to move up as the work matures? If one looks at the time frame, one can see that the market has been growing for twenty years (1965 to 1985), with most of the appreciation occurring in the last five years. If supply slows, and if demand slacks off (and here Werner seems to control the output, and is, of course, very knowledgeable about the market) then it is possible for the most important paintings to move into the quarter-of-a-million-dollar range over the next five years, as long as Baselitz's reputation can survive the downfall of the Neo-Expressionist group. It presently looks as though he will, since he has distanced himself from the Americans, and furthermore has the support of the best of the European dealer group. While the Europeans are slower to invest in an artist, once they do, they seldom sell back into the marketplace, even if they can make a large profit. If a work goes into a good collection, it stays put for generations, unlike the American collectors who always seem to take a big profit when they can and are less interested in logn-term collection building.

If Baselitz continues to be labelled the best of the group, by the critics and writers, and continues to get attention, then this legacy becomes self-fulfilling as time goes by. Other artists in the group get less and less attention, and Baselitz more and more. As the literature builds up, and the exhibitions continue, his position vis-á-vis the market will probably get stronger, if supply is controlled to keep demand high. If the early and middle 1970s pictures were well-placed, then the older pictures – if they come to market at all – will stimulate the demand, rather than depress it for the new pictures.

Also, by now the artist and his dealer must be established financially, and thus able to hold back new work. I would suppose that Baselitz and Werner have, by now, begun adopting the old European custom of never keeping one's money or paying taxes in the country in which one lives or works. Although I can't verify it, my guess is that both are familiar with Lichtenstein and Switzerland by now.

How about the Italians, the other part of the Neo-Expressionist group? There the big names, as I have said, are Sandro Chia and Francesco Clemente. But there are others as well, Enzo Cucchi, Mario Merz, and Mimmo Paladino. Chia has made it into the big-name collections like the Lewis and Susan Manilow Collection in Chicago, and Paine, Webber, Inc., in New York. Clemente, Cucchi, Merz and Paladino are well taken care of by Sperone Westwater in New York. But the question remains, are they and their dealers as well organized, financed, and as sophisticated as Baselitz and his promoters?

The Germans have always been good at organization, and always have capital and backings. The same, however, can't be said of the Italians. There have been no famous Italian artists in recent times. The Germans also have the Swiss collectors, and dealers like Ernst Beyeler in Basel, who sell and support Baselitz in both the gallery and at auction.

If asked to bet on one of this group, I would take Baselitz. But if I could bet on two, I would pick Sandro Chia as the possible survivor among the Italians, but it's difficult for me to predict without more knowledge of this market.

102

The art market for the "Neo's", generally, like the new issue market, is more than a passing of a moment, as Michael Brenson says in *The New York Times*. Most of this group has soared upwards since the 1980s on a puff of hot air and will, in my opinion, be blown away by that phenomenon called the art historical process.

Since supply is a factor in the art market, and since there are hundreds, if not thousands of paintings out there, unlike the big three, Jasper Johns, Frank Stella and Richard Diebenkorn, the investment potential of the Neo-Expressionists is much more likely to drop. There also seems to be a picture to fit every color scheme and then some, and this might stabilize the market for a few years at least.

The museum curators who jumped on this bandwagon, and most did, may in the end help to stabilize the marketplace. Whether we like it or not, this group of Neo's will be with us for a very long time, because there are many vested interests involved at this stage, and they can't just dump the pictures or they may lose their jobs. I was interested to see the opening exhibition at the Whitney's new space at the Equitable Building. There they were, the big American Neo's in full splendor. Certainly, the Whitney Museum of American Art has a lot at stake in this marketplace. We will have to wait and see whether these vested interests will tip the scales of "historical importance" of these artists, so that prices can at least stabilize from their soaring rate. The lesson here is never buy a "puff" picture, unless you are part of the "hype" and can sell before the collapse.

What a collector has to learn from this story is that, even with this "hype," the art market is not mysterious at all. Art history is no more a "mystery" than the stock market is; it depends on what a person is familiar with. The stock market is unfamiliar to some, but not an unfathomable mystery. In the stock market there are secure and very predictable ways to invest and that is why it seems safer to spend your money there than in the art market. But if the art market is de-mystified, it can be as familiar as the stock market and become a secure way to invest.

I am sure that from here on out we will see each year a new attempt to "hype" the market. Before 1980, it was much more difficult to promote new talent because, while the artists would have loved to play the game, the old-time dealers were not interested. The "safety valve", so to speak, was the reluctance of dealers, who were cautious and careful with new art. They didn't believe it would sell and pay the rent, therefore, they stayed with the professionals. Now we have a group of new public dealers, new private dealers, and more "backers" in the art market than ever before. This means more power and money to suddenly make new art into great art. Collectors, therefore, have to be more careful than ever when buying into the contemporary art market. The East Village market is the latest and most current example. Art galleries – joined with night clubs, boutiques and eateries – have transformed the East Village in New York into a new aesthetic. This is going on in every city in America. Will the publicity and "hype" for the artists promoted by the Few Gallery, Gracie Mansion and others withstand the test of time and art history? Will the new entrepreneurism, typified by Patty Hamilton and Karen Amiel, a "new category of art world professional", be able to promote and "hype"

the careers of artists, like the agents who have for many years promoted careers in the movie, music and publishing industries? These are all questions that the collector will have to ask himself when purchasing new art in today's market.

This doesn't mean that one shouldn't look at new art, one should. The collector should also buy if he can, but it's the price that will indicate what's going on. When one invests between one thousand and two thousand dollars, he stands to lose very little, if he really thinks he's discovered something. Above five thousand dollars, one must be very careful. At this level the investor must know exactly what's behind the artists, the dealer, and the so-called new genius. The artist's success story may turn out to be a fairy tale of the worst order and at five thousand or more, it's a very expensive "story" on which to base an investment decision. In most cases, the collector is probably better off waiting to see if the artist's current popularity is shattered by the critics and marketplace.

In most cases, the price will drop fast in real terms because there will be no market at all in which to sell. Since the market for contemporary painting is generally a single-dealer market, the asking price may remain high but that doesn't mean much, because the dealer will never, or almost never, buy it back. Also, it's very difficult to detect downward price movements, except by the lack of activity. After awhile one becomes familiar with prices and their fluctuations. Once I returned to a gallery to confirm my feeling that a particular painter had bombed. The picture I had remembered was still there. I asked the price and it was half of what it had been. I asked about the previous prices and the dealer told me I must be mistaken.

If one is going to invest in this market, he must know his prices, and follow the dealers. If he's on the list of most of the contemporary galleries, he will get the invitations, posters and catalogues as well. Also *The New Yorker* magazine has the best listings each week, which is a good overview of the New York art scene. For a week in March, 1986, these little reviews told the whole story:

Bill Jensen – A two-gallery showing of new, thickly brushed works *by this influential artist who has a reputation as a painter's painter.* Through March 29. (Paintings alone at Washburn, 42 E. 57th St., and paintings and drawings at 113 Greene St.)

Wolf Kahn – A diverting collection of drawings and pastels *from the past forty years by an artist whose work seems as energetic and perceptive as ever.* Through March 29. (Borgenicht, 724 Fifth Ave. at 57th St.)

Dorothea Rockburne – A selection (by the artist) of paintings *dating from 1968 on – a group that shows the infinite possibilities inherent in folding a simple rectangle.* Through March 28. (Fourcade, 36 E. 75th St.)

Each major city has a similar system, it's only a question of figuring out how it works. Chicago has a lot of action, and is a New York in miniature. Los Angeles is some of New York with a lot of original West Coast activity. Also, Atlanta, Charlotte, Detroit, San Francisco, are all tied into the New York gallery system for new work. Usually cities outside of New York are slower in getting work by new artists, although New Jersey is almost as up-to-date as New York.

The aspiring art investor needs to see as many of the exhibitions as possible, and should mark his catalogue, or make notes about prices. The first thing to realize is that one has to ask the price, no one will ever voluteer it. This is part of the game. A good system is to select the best picture, and the worst in your opinion, and ask their prices and then to make a record of them. Also, to really get a feel of what's going on with the artist, it's necessary to engage one of the art dealer's personnel in a discussion. One shouldn't be put off by the red dots on the pictures, which are supposed to indicate what is sold, or a half-red dot for what is on reserve. These are generally for merchandising purposes only and mean very little. But to get the "story," as I call it, it's a matter of pretending to be a buyer. If the story is, "I am sorry, everything has been sold," or, "there is a six-month or two-year waiting list," things become clearer. Of course, it always helps to give the impression of being a pivotal tastemaker, or to arrive in a limousine or be accompanied by a museum curator.

If one is a known collector, he will be treated better than I am in my old jeans. It also pays to know the dealers history, his track record. The dealer's taste is still crucial because they really try to exhibit what they think is the best. Being observant at the gallery will reveal a great deal about a dealer's opinions and why it's important.

Until one can make decisions for himself in this marketplace, he should assume the price is fair – not cheap; contemporary art is never cheap. The buyer is, however, essentially at the mercy of the dealer's aesthetic values, and he must rely on his judgment as to whether or not it will have *any* value in the future. One must ask if this dealer is the kind who has both the ability and the endurance to make this new artist into a star. Does he or she have the drive to be around ten years from today and does she or he have the ability to be an art deal-maker?

When dealing with new artists, dealers have to be a real presence to survive in this tough field. How long the new galleries will last is anybody's guess. Of course, the uptown galleries, like Marlborough, Grace Borgenicht, Fishbach, Robert Miller, Hirschl and Adler Modern, etc., have been there for a while, but these are not the places to find the newest trend. These uptown galleries by and large sell established art by living artists. This is again a different game from the future Mary Boones of the world, uptown or downtown in any major city across the United States.

As may be evident, it's easier to study the art dealers rather than the artists at the beginning, but finding the next Leo Castelli is not easy. Even then, if one eliminates the Neo-Expressionists, Leo's record will prove how hard it really is to move into the great-art-dealer category of Duveen, Vollard or Daniel-Henry Kahnweiler. As the saying goes, "many are called, but few are chosen."

Julius Westheimer, on the Wall Street Week Show asked me:

"Let's say a young couple gets married and wants to decorate their home with art, and they go to New York. Are they better advised to go to some of the well advertised, well known galleries that you read in the Sunday papers or to scrounge around among the side streets, the remote ones, and take their chances there?"

My answer, which I will repeat, was:

"If they're going to spend $ 5,000 or more, then you're spending real money, then go to someone who's been in business a long time. That person, who has been around for a long time, generally, will be there; and, therefore, that person will not overcharge you. So I would go with the established operator. I think your investment is as good as the reputation of the person from whom you bought it, and that's especially so in the art business."

Rating galleries is not an easy business, but if I had to, on the contemporary/consignment side, as my top ten in New York, I would list: (James Corcoran, Los Angeles; Thomas Segal, Boston; Kornblatt, District of Columbia; John Berggruen, San Francisco; Jerald Melberg, Charlotte; L. A. Louver, Venice; Meredith Long, Houston; Kurnbluth, New Jersey; and Richard Gray, Chicago)

André Emmerich	M. Knoedler & Company
Blum Hellman	Pace Gallery
Grace Borgenicht	Robert Miller
Hirschl & Adler Modern	Xavier Fourcade
Leo Castelli	Mary Boone
Marlborough Galleries	

In the family of stock/dealers, I would list the following:

Acquavella	V. Eugene Thaw
Barbara Mathes	Marisa del Re
Berry-Hill	Perls Galleries
Coe-Kerr	Pierre Matisse Gallery
Galerie St. Etienne	Serge Sabarsky
Hirschl & Adler	Sidney Janis
Kennedy Galleries	Washburn
Kraushaar	Zabriskie

Others that are well-established and have good reputations include Alex Rosenberg, Allan Stone, Allen Frumkin, Annina Nosei, Blue Mountain, Brooke Alexander, CDS, Charles Cowles, David Findlay, Jr., David Mackee, Davis and Langdale, Edward Thorp, Fishbach, Forum, Getler Pall, Gruenebaum Gallery, Hammer, Holly Solomon, Ingber Gallery, John Weber, Lefebre, Leonard Hutton, Louis K. Meisel, Marian Goodman, Max Protech, Maxwell Davidson, Metro Pictures, Milliken, Monique Knowlton, Nancy Hoffman, O. K. Harris, Paula Cooper, Phyllis Kind, Richard York, Robert Schoelkopf, Ronald Feldman, Rosa Esman, Sonnabend, Sperone Westwater Fisher, Susan Caldwell, Tannenbaum, Tatistcheff, Tibor De Nagy, Vanderwoude, Weintraub, and Williard. I have not dealt with Tribeca, most of SoHo, or the East Village, because these are out of my own experience. There are also very good galleries in Boston, Philadelphia, Charlotte, North Carolina, Texas, Washington, D. C., Chicago, New Orleans, Houston, and Florida, but I don't know them well, or in some cases at all.

Jed Perl, one of the new critics who has taken on the task of reviewing contemporary artists in the 1986s (for Hilton Kramer's *The New Criterion"* – a

"must read" for anyone interested in this field) summed up the current SoHo gallery scene:

> "There are very few galleries in SoHo where one can have any expectation of seeing art of quality on a regular basis. I can think of fewer than a dozen: Washburn, Ingber, and the cooperatives at 121 Wooster Street come quickly to mind. But in general in SoHo the *mise-en-scéne* surpasses in interest any of the art hanging on the walls."

Recently, *Town and Country* (May 1986) printed an article on art in Los Angeles. According to the author, "the stigma or regionalism no longer applied to those world-class artists of all ages and 'isms' now working in Los Angeles." Has the art world shifted from New York to L. A.? The answer is no. While it is true that there is a boom in the Southern California museum scene and even a few new collectors, one can't expect the California museums to come into their own any sooner than the New York museums. It will take at least fifty years for the California museums, with all of their good intentions and the money of Marcia Weisman and El Broad, the big names in California collecting, to become really established. Look at the Guggenheim, with probably the best museum director in the country, and it still after all of these years has no identity. It is still true even in New York that if one wants to see what is going on in current art, one goes to a collector's apartment or visits the New York art dealers. Is it possible for museums to guide or advise future collectors? I doubt it, because why would a collector have confidence in the opinion of our current museum directors or staff as to what to buy of quality.

New York is the art world, like it or not, and as Stuart Davis (in his sometimes ungrammatical language) tells us, it's because it is "crawling with entrepreneurs in the field of art":

> "Where else could the Armory Show of 1913 originate? In Chicago they thought it was a rodeo. Or what other city Lincoln Arcade group produced an Independent Show in 1910 such as that at 29–31 West 35th Street? New York is a place of origins in Art, whether as consumer or producer. People increasingly talk today about the Meaning of American Art; its Social Use; College Credits for Art; Cultural Funds, Foundations and Scholarships; Art as a Currency for International Good Will; and latterly, even about American Art as Investment. But the substance of this gossip has validity only in the fact that New York nurtures the subject of its excitement.
>
> I wish to note in passing, without revealing any trade secrets, that the Artist is a Foundling, an Orphan, whose miserable foster parents consist of Dealer, Museum, Critic, Collector and the like. From that status as given, his actuarial potential improves relative to the availability of these vultures. He can lay-off some of his bets. That is what makes New York so great. The place is crawling with entrepreneurs in the field of Art whose motivations cover the entire range of human ingenuity. The rate of their voracity complements the voltage of the artist's vector. Of course, it's a fight to the finish, but that's the way it is.

It is only proper to add that New York itself has a powerful visual and psychological presence which is favorable to the awareness. If you can get past the first round, there is statistical opportunity to reach the semifinal. Secret pretensions to the elegance of hope can be ventured in New York without patent absurdity. When better Art becomes necessary, New York will get the contract."

The problem of the stigma of regionalism and the art market has been with us for some time. Can an artist who has made a reputation outside of New York (for example artists who are famous in their own cities, like Herb Jackson in Charlotte, North Carolina; Ida Kohlmeyer in New Orleans; or John Alexander in Houston) make it big in the New York or in the international art market today? Generally, the answer is no; they are too far from the real art market, the collectors and the critics. The New York art press is also too hostile to regional artists and their work. Obviously, not everyone would agree with me. The critic Barbara Rose, who has spent time in Houston as a curator, believes that a least the Houston artists may have benefitted, not suffered, from not being at the center of things:

"The great advantage of making art in Houston was that Houston was too far from the art market and too hostile to the New York art press to appreciate the fact, first demonstrated by Duchamp, then by Judd and Warhol, that painting, solidly rooted in the fine art tradition, established by a pioneer generation of dedicated artists like Dorothy Hood, Richard Stout, John Biggers, Charles Schorre, Dick Wray, Atanacio Davila, Jack Boynton, and Bob Camblin, was not disrupted. Younger Houston-based painters continued to believe that painting was a viable and valid form of expression even during the novelty-oriented sixties. Thus, the isolation of Houston from the mainstream – its lack of connection to the art business and the conceptually oriented art magazines, promoting every New Wave to hit the Manhattan shore as the absolute *dernier cri* – turned out, in the long run, to be a major advantage."

Barbara Rose, for one, would have us look to Houston and some other cities and outlying areas because, as she says, "there are artists who still hold such old-fashioned and naive beliefs. Could it be that this anti-media, humanistic art is the new avant-garde?" Some of the artists she would have us consider (many of whom also have New York galleries) are John Alexander, Derek Boshier, Jack Boynton, Bob Cambin, Joseph Glasco and Dorothy Hood.

The Market and the Contemporary Artist

Art has always been a catalyst. That is, it has always promoted the interaction between people or between people and things. Of course, the nature of the desired interaction is usually determined in advance by whoever it is that employs the artist. Historically, artists have been like the fabled "hired gun" of American Westerns: they serve the master who can pay their wages.

In the past it never occurred to artists to set themselves up as arbiters of ideas or values; that work was left to writers, philosophers, and priests. But two hundred

years ago – around the time of the French and American revolutions – artists came into their own. As kingdoms toppled and aristocrats emigrated, the formerly subservient artists began to think of themselves as free intellectuals, crators of ideas and images that would change the course of politics and history. We have only to think of Goya, David, Daumier, and Courbet.

Of course, they paid a price for their independence: without this patronage artists were now free to starve. Some were romantic enough to think that they starved for their ideas; some believed they starved because their genius was too original to be understood by the masses. Other artists found creative freedom a burden. It was better, they felt, to concentrate on making things well; they would have preferred to return to the pre-democratic age when there was a neat division of labor between those who commissioned works on the basis of what they thought painting or carving was worth and those who simply executed the technical work.

It would seem that artists are always caught on the horns of a dilemma. Liberated by the democratic revolutions of the eighteenth century, they had to find new patrons to replace the kings, nobles, and popes who had been their prinicipal supporters. In other words, they sought new masters. The Bohemian lifestyle associated with freedom from academic standards and aristocratic patronage was mainly attractive to young men living off their parents. Once they grew up, their lifestyles had to change because of their family responsibilities. To some extent, the emancipated artists of the nineteenth century were able to find patrons in the new businesses and industries that were then emerging.

As capitalism matured in western Europe and the United States, the mass-manufacture and distribution of goods created new occupations for artists. They became product designers, illustrators, and creators of visual and graphic displays. By the middle of the twentieth century no company or corporation could sell its goods or services without first engaging teams of design and graphic specialists. So at least some of the artists displaced by the political and industrial revolutions of the eighteenth and nineteenth centuries were re-introduced into society under the auspices of twentieth-century business. Those who did not choose to become disgners for industry continued to practice their arts according to the traditional patterns. A few of these – very few – prospered as "fine artists," selling their work through galleries to wealthy manufacturers, bankers, professionals, and businessmen.

Thus a new class, the upper bourgeoisie, began to function modestly as a replacement for the pre-revolutionary ecclesiastical and courtly circles that used to patronize artists. Today these are suppelemented to some extent by national and state bureaucracies that support artists through commissions of one kind or another. Private foundations, museums and corporations, too, are important patrons of artists. Business patronage is important as well, but different in that it is justified as an exercise in public relations and corporate imagebuilding. But because of the conservative nature of most corporations, they make little impact on the art historical process even though they spend a lot of money. The DIA Foundation, it is said, was supporting not only projects, but artists as well. John

Chamberlain, the sculptor, was getting $20,000 a month, before the collapse of DIA. But the most startling new development and market activity in the history of artistic patronage since the 1970s is the emergence of schools, colleges, and universities as the largest producer of artists for the market system. What will happen as a result of this emergence is that these artists will (and have already) change the nature of the whole process. Will these artists start to produce work with an eye to what the system demands?

Reading the *The New Criterion,* and the article by Joseph Epstein, "Is it all right to read Somerset Maugham?," I was struck by the similarity of Maugham as described by Epstein to most of the visual artists I have met or really known. The world for Somerset Maugham, according to Epstein, was professional as contrasted with amateur. The difference, however, between the literary artist and the visual artist is that while the former's audience may be fickle, it is still exposed to enough writing to recognize talent while the latter's public has few visual standards by which to gauge superiority. If the market demands an increase, will producers give it the kind of work demanded, or will the quality of the work bear the marks of the low expectations of the inexperienced system?

The visual artist is at his best when dealing with a range of expression based on human emotion, realized through form and color. To discover the superior artist (quality), it's necessary to have an audience who can at least understand what the artist is about, and there are few of those in this visually illiterate world. With the emergence of so many artists, artworks may come to be what the system can handle, rather than what won't circulate in the system.

Comparing and understanding the artists of our recent past is important because of the part played by the audience or the viewer without the proper knowledge. The best quotation on this subject that I have found, is from a recent book on Franz Kline, *The Vital Gesture,* by Harry F. Gaugh. Kline was asked to explain his abstraction, and replied: "I'll answer you the same way Louis Armstrong does when they ask him what it means when he blows his trumpet. Louie says, 'Brother, if you don't get it, there is no way I can tell you.'"

Unfortunately, for most good (quality) artists, many people do not get it at all. Their interest in quality art is negligible. They either are not moved, just don't care, or can't understand the subtleties of structure, light, form or color. If they care at all, and I am talking about most collectors, it's because of the artist's rank in historical importance with those of his fellow artists, both past and contemporary.

The problem for the artist, in relation to the market, is to decide what he wants to accomplish with his art. I have interviewed a number of artists in the course of my associations in the art business, and in each case their problems are different. At the beginning, their problem is how to make a living from their art. At first, they are content if they can survive in this workaday world by working as an artist. After that is accomplished, just making a living from their art is not enough. They want recognition for themselves as an important artist.

Many of them can get by for a while, because the support system for the artist in America and Europe today is quite extensive. In England, the art schools offer

teaching jobs, which allow the artist to earn a living if he lives modestly. In Canada, there is the Art Bank, wherein the state purchases enough art each year in order to provide the artist with the necessities of life.

The United States is in a class all by itself. The older artists of the generation of Avery, de Kooning, Pollock, Newman, Rothko, and Davis, were different. They were generally poor, and received only informal art education. They travelled to England or Paris to get educated, worked at peripheral art jobs as illustrators or designers and finally settled in New York, hoping to make it.

As James Brooks said in an interview on Franz Kline, like many other New York artists, Kline produced for years what were disparagingly called "Buckeye paintings" which helped pay the rent. Those who were lucky had one or two early patrons, or a family that could help them literally stay alive, until they could get into a gallery and start to sell pictures. From then on, they found support in the changing times, which, from the end of the Second World War, found a proliferation of art galleries, and an increased interest in contemporary art, which created a situation that allowed artists to live, if barely, off their art. This era ended with the big names of the Abstract Expressionists, but it was too late for many of the others, like Earl Kirkham, Ludwig Sander, Lee Gatch, Morton Schamberg, Gabe Kohn, Paul Burlin and Ben Benn.

The group in America, the Abstract Expressionists, like de Kooning, Pollock, Newman, Gottlieb, Hofmann, Rothko, and Still were the first artists of this era who achieved fame and money within their lifetimes. The heirs of this group were and will be quite rich from the art they inherit.

One of the most interesting characters of this 1950s period was an accountant by the name of Bernard J. Reis. Reis was in a sense the person who sought to bring this first generation of American abstract artists into the mainstream of the art business world. Later in his career he also became the accountant for Marlborough. Until the 1950s, artists didn't need accountants because they had no income. As John Bernard Myers tells the story, in the 1940s few American artists "of the so-called avantgarde made their living from their work, and few needed accountants to take care of their affairs." As the American art market grew, artists for the first time became big money makers. Some of the artists, like Willem de Kooning and Josef Albers, chose lawyers to help them cope with tax problems, like Lee Eastman or Ralph F. Colin (who by far represented more artists and did more wills for artists than anyone else). But it was Bernard Reis who became the most celebrated accountant in the art world. The Bernard Reis story, as told in a fascinating article by Myers in *The New Criterion* (February 1983) is important in understanding the emotional attitudes of the artists who, up to middle 1950s, felt that they were the "unwanted" in the artist-dealer-collector arrangement. While Myers talks about Mark Rothko, the same story applied to Franz Kline, Naum Gabo, Willem de Kooning and José de Rivera, and a host of others, only each had a different person to rely on. Some depended on lawyers, some on other professionals like writers, musicians or dancers, and some on dealers or a single loyal patron. The names appear in the index in a most interesting book on the period, John Gruen's, *The Party's Over Now,* Viking, 1972:

111

"Did the artists seek out the company of Bernard and Becky Reis because they were rich collectors and hosts? Did they seek out Bernard because they needed his professional services? Or did at least some of them rely heavily on the advice and friendship of two people who were both worldly and affectionate? In the case of Rothko, the reliance was largely of an emotional nature, even more than was his relationship with Stamos. If he hated museums, Mark hated lawyers even more, and in his mind what he needed most was an intimate friend who could also manage his financial, legal, and domestic affairs. Bernard thus became the central person in Rothko's life."

This period is best summed up by Gruen's interview with Adolph Gottlieb:

"I may not have liked some of the artists of the fifties, but I never had any fights with them. I always had my fights with dealers. Dealers, as long as I've been associated with them, have had the idea that *they* are the employers and that the artist is an employee.

Unfortunately, most artists – because of the situation – have accepted this and are psychologically geared toward acting like employees. They forget that they are paying a dealer a commission. When the dealer gets his commission and gives the artist his share, the artist thinks the dealer is his benefactor. The dealer is nobody's benefactor – although there are some cases where dealers have not been just mercenary or venal. Too often, dealers act as though they were the artists. That is why it was so refreshing when Frank Lloyd of Marlborough came to me and told me that he considers himself just a businessman and that he'd like to work for me. And that's just the point. Artists don't realize that the dealer is supposed to be working for him. Of course, I was always aware of this, but I pretended with the dealers that I was dumb. When artists lose a gallery they act as though they lost a job."

Someone like William Gropper never made it financially, and the story of Ben Benn is almost pathetic. Ben Benn was so poor that in his old age he had to be supported by his relatives just to survive. Neither William Gropper nor Ben Benn ever really supported themselves from their art. The Stieglitz group, including Sheeler, O'Keeffe, Demuth, and Hartley, had of course great help from Alfred Stieglitz and his gallery. It certainly helped in the 1920s, 1930s and 1940s if you came from a rich family. The source of an artist's income certainly had to play a big part in his art. The market for his product was limited by those old rules of supply and demand, and there was always plenty of supply but very little demand. Probably the greatest benefit for the poor artists without family money to fall back on was the make-work projects, which constituted the legacy of government patronage in the arts in America, and continued through the end of the Work Projects Administration art programs. But collectors for other than the European works, or some of the Impressionist paintings, were rare, and demand for the artists' work in America was quite limited.

By the late 1950s, things really started to change for some artists when the so-

called second generation of artists came on the scene late in that decade. This next and second generation were different from the previous generation, and included names from Leland Bell to Robert Whitman.

Certainly for this second generation, the important factor was New York City: the excitement of the 1950s, the advent of more galleries (both independent and cooperative), the beginning of real demand for paintings of the artists of the first generation. Additionally, more university positions were opening up as U.S. schools began emulating British art schools. Schools like the Art Students League, and above all the famous art schools run by Hans Hofmann and Stuart Davis and the others helped to attract young people to the profession and create jobs for working professionals.

As Stuart Davis said in the late 1950s:

"It is well known that New York City is the only locus in the Western Hemisphere where Art can properly incubate. However the thing may be shushed, dissimulated, whatever masquerades may be set up elsewhere, cultural cellars, poetry, etc., the fact remains that New York has the peculiar climate for Art."

The art school in New York as a place to go, be seen, meet friends and associates, and be taught by and rub elbows with the people who were called geniuses – all very heady stuff for all of those young potential artists who were coming from everywhere in the U.S. and Europe. Some like Sam Francis, Norman Bluhm and Michael Goldberg chose Paris in the '50s rather than New York, but few stayed as the center of activity was in New York City. Those who attended the hot schools, like Hofmann and the Art Students League, were where the action was. To get a show in the mid-50s at the Hansa Gallery, Tibor de Nagy Gallery, the Stable Gallery, the Egan Gallery or the Borgenicht Gallery, was the beginning of real professionalism, even if one did not sell much at all.

There were also artists like Larry Rivers, Grace Hartigan, Alex Katz, Elaine de Kooning, Helen Frankenthaler, Jane Freilicher and Jane Wilson, who were part of the Cedar Bar and Hamptons pack.

To be included in an article written by Clement Greenberg, Thomas Hess, or Frank O'Hara, was like going to heaven, even if it was just a line or two and a black and white photograph. Artists helped promote other artists, and Elaine de Kooning and Fairfield Porter, worked with the pen as well as the paint. Most were not rich, unless, like Fairfield Porter, they came from a rich family, but none were in poverty, either, as Wolf Kahn has told me. Everyone seemed to get by, even if it meant painting on old boards like Jan Muller or Gandy Brodie. Felix Pasilis, however, did not get to make it.

I own a painting by Felix Pasilis because I became interested in his work after having seen it on West Twelfth Street, hanging all over the walls in a stationery store. The painting I own is quite outstanding. The story goes that Pasilis, born in 1922 in Batavia, Illinois, was at the Hans Hofmann School with his friends Wolf Kahn and Lester Johnson and considered a very talented figurative painter. He was

included in important young talent shows at the Hansa Gallery in 1953, the Urban Gallery in 1954, the Tibor de Nagy Gallery and Zabriskie Gallery in 1957, and was last heard of sometime in the 1960s. The paintings he left in New York are not figurative, but abstract and, as the story goes, he left the paintings with the stationery store, got into a taxicab, headed west, and has not been heard of since.

The period from 1950 to 1960 was a good time to be a talented young artist in New York as it looked like that historic struggle for recognition, and ability to live off of one's work, was changing from the days of the 1930s and 1940s. But it was for this generation of artists in America, and even for those in Paris, a time of false security. As my friend, the artist Francois Arnal, tells me, from 1960 to 1980 no one in Paris even remembered that he was an artist. Supply continued, but the demand dried up, with the advent of a new fashion, generally called Pop Art, and a whole new crop of young artists – Andy Warhol, Robert Rauschenberg, Jasper Johns, and Roy Lichtenstein.

Interestingly, most of these second generation artists, unlike Felix Pasilis, adjusted to the new requirements to make a living by different means, some became art teachers and moved to the midwest, California, and upstate New York. Some of the women found husbands who were not artists, and some of the men found women who were willing to work to provide the income for them to continue to paint without working. The younger artists of the period, like Emily Mason and Ruth Miller, never even got into the distribution system. They were just too late. Those that were rich, like Fairfield Porter, just continued to work, some left New York either for the country or Europe or California.

However, things did change substantially for those of the second generation who were not included in the Pop onslaught of Warhol, Lichtenstein, Claes Oldenburg and Robert Rauschenberg. Some like Larry Rivers, Alex Katz, Wolf Kahn, Philip Pearlstein, and Al Held, continued selling and living off their work because of their solid reputations and their strong dealer connections. But for many of the rest like Lee Bell, Louisa Matthiasdottir, Nell Blaine, Norman Bluhm, Warren Brandt, Ernest Briggs, Gandy Brodie, Robert De Niro, Grace Hartigan, and Jan Muller, it was back to survival tactics.

In the early 1960s, of course, there was a spurt of Color Field painters, like Morris Louis, Kenneth Noland and Helen Frankenthaler, who were very popular also, and made a living off their work.

The next group of artists to come on the scene in New York were different from the previous two groups, and this is the group that has dominated the contemporary art business from the middle of the '70s to the middle of the 1980s. This group can be distinguished by their formal training, instead of being self-taught, or Hofmann students, the two prevalent educational means of the earlier contemporary artists. These artists started to sport degrees after their names. The initials BFA or MFA started to dominate in the artists' biographies. The Bachelor of Fine Arts or the Master of Fine Arts signified a trend, which is continuing today. These artists are the product of the university art school, rather than the Hofmann School or the Art Students League or its equivalent in the United States. "Ten

years ago," says John Weber, you could read an artist's biography and guess within a few thousand what his prices were."

The great schools like the Yale Art School or the universities in California began to take art education seriously. Staffed with both big and small names as teachers, the university wanted part of the art education game. Before these schools, it was Bennington and the Rhode Island School of Design, or the California School of Fine Arts, which were the out-of-town equivalents of the Hofmann School or the Art Students League. These were degree-granting institutions, but also old-fashioned art schools. The new university art schools appealed to a different kind of student, either he had to be wealthy enough to afford both the tuition and the room and board, or he had to be a good enough prospect to get a scholarship. The bridge for the best was the Yale Summer School at Norfolk, which tried to take the best of the students from all over the country for at least a summer.

The point of this is that the artist today and since the middle of the 1970s is a different kind of artist than those from the First and Second Generations of the New York School or even from the Pop Art era. They are knowledgeable in the mechanics of the art trade and the art market. They are much more sophisticated in how to promote both themselves and their work. They know how the art system works; the galleries are part of their network, as are the museums, the exhibition coordinators, and how to get started and how to survive.

Robert Hughes gives us its history and forecasts the future of this phenomenon as follows:

"One was the postwar baby boom, whose mass, having moved through the art schools like an antelope through a python, arrived in the art world at the end of the '70s. American art teaching swelled in the '60s and '70s. Every university had to have its art department, and that department had to be full. The National Association of Schools of Art and Design guesses that about 900 institutions offer fine-arts degree programs; its own 138 member schools had 45,000 students in the fall of 1982, of whom some 8,500 graduated with B.F.A. degrees in the spring of '83. So the annual output of all American art schools is probably around 35,000 graduates. Significantly, no one seems to know the exact figures entailed in this unprecedented glut of artists.

The impact of the '60s and '70s on American art training has yet to be fully assessed, and when it is, the results will not be reassuring. They will show a pattern of indifferent teachers (painters doing it for survival) serving institutions that, for fear of a drop in enrollments, disliked failing anyone and were none too picky about the students' motives for being there in the first place ***"

"So the art world is overcrowded, and overcrowding means competition. It reaches extremes in Manhattan, where perhaps 90,000 artists live and work, providing the art dealing system with a large proletariat from which trends can be condensed at will. But the struggle for visibility is

intense from Maine to Albuquerque, and careerism, once a guilty secret,
has become one of the art world's main texts..."

Looking at a recent catalogue exemplifies my point. Sharpe Gallery (a wonderful name – are they sharp?) at 175 Avenue B, in full color, and at great expense, offers for your consideration the following:

James Albertson, B. F. A., M. F. A.

Mark Deal, B. F. A., M. I. A.

Arthur Gonzalez, B. A., M. A., M. F. A.

Jane Irish, B. F. A., M. F. A.

Cheryl Laemmle, B. A., M. F. A.

Poor Milton Resnick, a fine Second Generation New York School artist, tells us his problems in this status-conscious world of ours, in a wonderful interview in *4 Issue, A Journal for Artists* as follows:

"In my day, artists were self-made people. They never went to school. Most of them never went to college. In 1954, when I was invited to San Francisco to teach, I asked myself, where do artists live around here? So I walked around until I passed a store and peeked in and saw some guy stretching a canvas. Well, he must be an artist, I thought. On the door was a name. Underneath the name was 'Master of Fine Arts'. I'd never heard of someone calling himself a 'master of fine arts'. I didn't understand that it was a degree, something that came from a school. I thought this person had just given himself that title. I couldn't believe it! How wonderful, I thought, to be a master of fine arts. So I walked in and said, 'Excuse me...'"

Next, I expect, that the art schools will move to offering Doctors of Fine Arts degrees (D. F. A.), so that it will be easier for the artists to get restaurant reserertions in Solfo and uptown, and the poor collector in America will have *another* doctor of something to worry about in our status-conscious world of one-up-manship.

Although I don't know many of these degree-carrying artists, I suspect that in most cases they come from good middle class families, and in many cases from what we would call rich families. For the middle class and the rich both, the son or daughter who is an artist is no longer the outcast or the ne'er-do-well, but someone to be proud of who they think potentially has great talent. And these great talents can get very rich as artists, at least that's what their parents have heard or read of the world of artists and art prizes.

These artists, compared to the Second Generation of New York School painters, Lee Bell, Hyde Solomon, Warren Brandt, or Joan Mitchell, are very sophisticated in the art business, at least, as I have found, in dealing personally with both groups. None of course is a sophisticated as that Second Generation artist Frank Stella, but after all he was graduated from Princeton University and is very, very smart. The only artist who, in my opinion, can compare with Frank Stella in sophistication is Christo, and he has a very, very smart wife. For *real* sophistication, no one compares to Helen Frankenthaler.

Why are Stella and Christo so smart? They know and understand the game and the players. They are not afraid to spend their own money on their careers.

Why should anyone else be interested? They understand that art is business, and to be in the art business you have to be a businessman, as well as an artist.

This new group, at least in New York, and up at least to 1985, has radically changed the contemporary market, as far as the collector is concerned. These artists are masters at those essential marketing skills which were never the strong suit for the earlier artists: the pricing and allocation of their work. The old artists, operating within what is known as the efficient market theory, would sell low to stay alive. Not this group, they know how to price to meet the demand, and if there is no demand, they don't sell, but support themselves by other means, or through the public or private support system, like grants or commissions.

Keeping low-priced work out of the marketplace allows them to maintain a stability of price structure, so that when and if they sell, or if a museum or institution, or corporation, or even a collector wants the work, they pay up or they don't get the work. Even the auctions, who would not normally be able to get high prices for most of the second generation artists of the New York School, can get prices reasonable in comparison to retail prices for these new artists. Of course, resale prices are a different matter because demand is still quite limited. In market terms, this has created a new generation of artists with cooperative apartments, studios both in New York and in the country, money for travel, and funds to participate in the art world networking games – all essential for keeping their name and their art before both the collecting and institutional public.

With five to seven hundred galleries pumping out this work, most of the good ones are placed in the market system, at least to the point of having regular exhibitions. Artists also have an opportunity to keep old collectors happy, and they hope to attract new interest from the corporate and museum field, all at higher prices, or at least at stable prices. For those who have not broken into the present-day system unless they are very new, like the Neo-Expressionists, they are out of the system forever.

There are now six major areas in New York, in which these galleries or the system works. There are (1) the Tribeca/Washington Market area with about twenty-five galleries, (2) the SoHo area with approximately one hundred twenty galleries, (3) the East Village with about fifty galleries, (4) the Downtown/ Houston/NoHo area with about at least twenty-five galleries, (5) the Uptown galleries beginning in the '50s, where you find at least one hundred galleries, and (6) the Madison Avenue area which has approximately one hundred galleries. The gallery system in New York has at least four hundred galleries, and this doesn't include Brooklyn, Bronx, Queens, Long Island and the New York City suburbs. New Jersey also has at least fifteen galleries, not to mention Connecticut, California, Florida, Chicago, Boston, New Orleans and Texas.

To survive, the artist must, above all, be affiliated with a gallery, or he is out of luck. It's not like the old days, when you had to work at least ten years to get into a gallery. Today, if you make the right connections as an artist, you can within three to five years contemplate purchasing a studio loft apartment, and probably a house in the country. Not bad, for a business that is "not really" a business. When asked

117

(which is not very often), I tell artists that they are really in the best business I know, they can turn paper and canvas into money, and not even Paul Volker at the Federal Reserve can do that anymore.

Rediscovery and the Fallen Angel

There is another part of the collecting game which the collector has to be aware of, and this is the game of rediscovery. This game is played by the collector at the auction houses, the uptown galleries, and at the Madison Avenue galleries. Some of the galleries at which you might find what I have called the fallen angel, that is, the artist whose reputation has fallen over time, or is stalled at a certain level, are Grace Borgenicht, Armstrong, Aaron Berman, Sylvan Cole, Tibor De Nagy, Sid Deutsch (who specializes in fallen angels), Hammer, Sidney Janis, Kennedy, Kraushaar, Midtown, Spencer A. Samuels, Robert Schoelkopf, ACA, Davis and Langdale, Schlesinger-Boisanté (who also features many such artists), Forum, Graham, Harriet Griffin Fine Arts, Achim Moeller Fine Art, Solomon & Company, Allan Stone (who is in a class by himself), and a host of others, both public and private dealers in the United States.

Should one buy a fallen angel? It has long been good advice in the stock market that if there is one thing worse than buying a "hyped" stock, it is buying last year's winners after they have fallen on bad times. When a stock has gone straight up and suddenly starts dropping, according to the experts, too many people make the mistake of being attracted by the sudden bargain price. Looking for the bottom, it is said, is a game for the amateurs, not the professionals. I am not sure that everyone who invests in stocks would agree, but here again is where the two markets have different rules.

Rodone Fadem in *Barrons* says that it is not safe to purchase stocks on the way down or undervalued stocks. As *Barrons* says, "looking for lows is called 'button fishing." Every pro knows that the quickest way to wind up with a million is to put ten million into last year's fallen stars."

Does the same rule apply to the art market? Yes and no. I would agree that one has to stay away from "hyped" or fallen stars, unless he can discover why they have fallen, and he believes that in the short term the critics have been wrong. Again, here it is also very important to differentiate between the kind of work we are talking about. Most of these fallen angels will be in the Old Master or Modern field, but they are sometimes in the contemporary arena. In contemporary painting it's not so much that reputations have fallen but that the critics and the market have not yet gotten around to a full consideration of the artist or his period. The question is: how will the history of art eventually answer the riddle of these artists in awarding value to which one of them as opposed to their contemporaries?

However, the collector who wants to get into this game, must wait for the angels to fall in price or for the work to find its lowest level within each artist category. In the end, once he has made his own judgement of which of the artists to buy, it's possible to enter this market.

Is it easy? No. There was, for example, a group of conceptual artists. Among

them were Kossuth, Venet, Viener, and Beuys, and Agnette, among others. At the time, all had top rankings and were being discussed by the critics. There was "narrative art," "conceptual art," "art and language," etc., but the only one who has made it from this group of stars of the period is Joseph Beuys, who died in January of 1986. The rest have suffered serious declines in their prices. Part of the problem (and this is even true in the case of Beuys) is that they were artists who were producing art intellectually inaccessible to the general art public. But nevertheless, to purchase Joseph Beuys after the fall means the collector made a profitable choice, *if* he bought the work not at the original prices, but at their so-called bargain prices.

Another fallen angel example is some of the artists in the Leo Castelli group. There were Lee Bontecou, who has disappeared from the market. Richard Artschwager is available today at lower and lower prices. James Rosenquist is again on the rise after a great fall in price. For a while in London, Frank Stella was a bargain at auction. Today, he is in great demand at great prices. People like Roy Lichtenstein, Jasper Johns and Cy Twombly have never fallen in price value; each year, the dealers who get them can sell them. Artists like Jim Dine, Anthony Caro, Howard Hodgkin, Richard Pousette-Dart, Sam Francis, Helen Frankenthaler, Jane Freilicher, Louisa Matthiasdottir, Duane Hanson, Red Grooms, Leonard McComb, Al Held, Romare Bearden, David Hockney, Wolf Kahn and Alex Katz are all in great demand at higher and higher prices. In these cases reputations have already been made at certain price levels. The point is that money can be made from the fallen stars of the contemporary art world with work and study, even if the same doesn't hold true for the stock market.

Some of the fallen angels of the contemporary art world who appeared on the market between the 1960s and early 1980s that one might consider looking at (at the right price) are:

Pat Adams	John Heliker
François Arnal	Patrick Heron
Peter Bailey	Roger Hilton
Walter Darby Bannard	Dorothy Hood
Leland Bell	John Hoyland
Billy Al Bengston	Alice Hutchins
Nell Blaine	Herb Jackson
Norman Bluhm	Lester Johnson
Lee Bontecou	Norman Ives
Stanley Boxer	Gerome Kamrowski
Mark Boyle	Alan Kaprow
Paul Brach	Michael Kidner
Warren Brandt	Ronald King
Ernst Briggs	Ida Kohlmeyer
Seymour Broadman	Alison Knowles
Gandy Brodie	Albert Kresch
Henri Chopin	John Latham

Dan Christensen
John Christie
John Clem Clarke
Pierre Clerk
Bernard Cohen
William Copley
Edward Corbett
José Luis Cuevas
Allan D'Arcangelo
Nassos Daphnis
Gene Davis
Olivier Debré
Peter DeFrancia
Jean Degottex
Tony DeLap
Robert DeNiro
Robyn Denny
Guy DeRougemont
David Diao
Jan Dibbets
Laddie John Dill
Sherman Drexler
René Duvillier
Jimmy Ernst
Ian Hamilton Finlay
Gordon Onslow-Ford
Andrew Forge
Mary Frank
Terry Frost
John Furnival
Paul Georges
Joseph Glasco
Michael Goldberg
John Golding
Maurice Golubov
Robert Goodnough
Ron Gorchov
Ken Greenleaf
John Grillo
Grace Hartigan
Stanley William Hayter

Emily Mason
Jean Messagier
Ruth Miller
Robert Moskowitz
Rodrigo Moynihan
Jan Muller
Lee Mullican
Victor Newsome
Kenzo Okada
Jules Olitski
Eduardo Paolozzi
Raymond Parker
Gabor Peterdi
Irving Petlin
Tom Phillips
Larry Poons
Paul Resika
Milton Resnick
Robert Richenburg
Bridget Riley
Dieter Roth
Santomaso
Gerard Schneider
Tim Scott
Charles Seliger
Joe Shannon
Leon Polk Smith
Jack Smith
Hyde Solomon
Michael Steiner
Marina Stern
Myron Stout
George Sugarman
Barbara Thacher
Joe Tilson
Euan Uglow
Elbert Weinberg
Allan Hacklin
Grace Hartigan
Larry Zox

Each of these artists, while offering interesting future prospects, have yet to be fully judged by the art historical process. For other lists, one could examine *American Realism* (Abrams, 1986), *Still Life,* "1945–1983" (Harper & Row, 1984), *Beyond the Canvas,* Artists of the Seventies and Eighties (Rizzoli, 1986). The collector has to decide which of them the history of art will accord value (medium within each *oeuvre*). Once the collector has made his own judgment, it's possible to enter this market, at a price of course.

In the older painting field, like twentieth century Modern or American painting, there exists an entirely different set of rules. Here reputations have already been made and are relatively fixed. Here we are clearly dealing with legend, myth and magic in the image of the artists and his place in the art historical value system. For the collector to participate in this field he has to rely upon the theory of rediscovery.

Jay Cantor, a Senior Vice President, American Paintings at Christie's, in the auction house's February/March 1986 Newsletter says:

"In the eight years since Christie's established its department of American Paintings & Sculpture, the volume of sales has grown enormously. This growth reflects a widely expanded interest in American art and a corresponding increase in private collectors.

"Looking back over the top lots in the major sales of the last eight years provides a fascinating index of taste and trends. Although many developments can be seen in all ends of the market from our innovative drawing and watercolor sales, a strong middle market, and a vast increase in works selling in excess of $500,000, shifts in taste are also visible.

"Most obvious is the rise of interest in American Impressionism spurred by new publications and significant national and international exhibitions. With this has come sensitivity to the international roots of American painting and sculpture. Buyers more willingly accept European subject matter in American painting and study the important dialogue between American artists and their foreign confreres. Similarly, modernist painting, with direct roots in European avant-garde innovations, has an increasingly broad audience. Regionalism and social realism of the '30s have profited from the expansion of collecting interest across the country."

Many of the artists that are now bringing big money in the American paintings field fell from stardom but still enjoy a high level of popularity. For example, Childe Hassam, Thomas Moran, and Maurice Prendergast have all risen from the ashes of the art historical process. Artists, like Joseph Decker, William Michael Harnet, John F. Peto, and Martin Johnson Heade, had dropped so low that they were very cheap for a time. A client of mine, a dealer in fine glass, bought a Martin J. Heade, for virtually nothing, not so long ago, and now has it for sale at a very high price. Could Edward Bruce, Marjorie Phillips, Harold Weston, Gifford Beal, Bernard Karfiol or James McLaughlin be next?

This is not an easy path, but certainly the most exciting. My own experience tells me that as fixed as the art historical system is, it does change as it goes forward. New people, new ideas, museum curators, art writers, are all looking and searching out fresh ideas to inject into current concerns and values. The art historical views of the past are constantly being modified to take into account current trends.

For example, the Cobra group operated right after the Second World War, and were basically Neo-Expressionists. One of the painters in this group was Karel Appel, another in the group was Asger Jorn. Both of these artists in the early 1970s were very cheap. Today they are very expensive. When the art historians started to look at Julian Schnabel, David Salle, Francesco Clemente and Sandro Chia, they started again to look at and rediscover Appel and Jorn and the Cobras. Their older work is now at premium prices. The work of these artists was reevaluated within the framework of contemporary trends.

The case of Stuart Davis is another interesting example of the re-evaluation process. In 1973, at Sotheby Parke-Bernet, there was a sale of twentieth century American paintings, drawings, watercolors, and sculpture from the estate of the late Edith Gregor Halpert, an important dealer of early twentieth century American art. Halpert was for a long time, before Grace Borgenicht got the estate, the dealer for Stuart Davis, who died in 1964. There were no less than ten Stuart Davises for sale in this auction. Beginning in 1964, at the time Davis died, the reevaluation was just starting. (By the way, to this day there is no monograph on the work of Stuart Davis which takes into account the revival his work has undergone.) At the time of Stuart Davis' death in 1964, the family was so poor that they sold the best works at relatively low prices to stay alive. Edith Halpert had some of the very best, having bought them over the years to keep Davis alive and working. Also, Stuart Davis was not an artist who produced a lot of pictures, since he also had to teach to make a living.

Almost any of Stuart Davis' work purchased by collectors in 1973, either at the auction or from dealers, have been real rediscoveries for collectors. I would say that any purchases prior to 1979 can be considered good deals in relation to his current market. The prices for the best can go as high as three million, small ordinary pictures are in the $250,000 range.

There were other painters in this sale who became reconstituted angels. Ralston Crawford, who died after the 1971 sale, is one. Charles Demuth, who died in 1935, is still a bargain if a good one can be found. Single sheets of watercolors are in the $100,000 to $150,000 range. This artist is, in my opinion, just starting to be rediscovered. The "sleeper" in 1971, and even today, is Arthur Dove, who died in 1946; in the Halpert sale, there were eleven pictures to choose from.

In that very same sale there were still others that represented astute buys; Charles Sheeler, for example, who died in 1965, and, of course, Georgia O'Keeffe, who died in 1986, of which there were nine items under offer. It's hard to believe that there was recently a Georgia O'Keeffe sold, not the best I have sen, at around $1.6 million.

But if one chose Mark Tobey, Max Weber, William Zorach or Samuel Halpert, he would still be in a waiting pattern after fifteen years. Will they become art market leaders? Certainly with the best of Tobey and Weber, the answer is yes. As to Zorach and Halpert, I don't know. Since this is not meant to be a tip sheet, let me emphasize the point I am making is that all of these artists, if not fallen angels, were angels, but their light has been hidden by the art historical process.

The collector who can bridge the time gap between availability and future prospects is a collector that can make a lot of money in the art market. One thing that is sure is that because of the way the system works, more and more art historians have an increased interest in discovering undervalued artists.

The question is, however, that even if these artists are rediscovered in an art historical sense, does the market respond in prices to such rediscovery? Sometimes yes, and sometimes no. Since, as I have tried to show, value in market terms is a very elusive matter, the mere fact that there is an exhibition, a catalogue, or a monograph on the artist, does not automatically create an increase in the price of the object. I do believe that if this process continues on a cumulative basis over a number of years (art history has a way of eventually justifying its own redis-coveries), ultimately, there is a good chance that values will be created in fundamental market and price terms.

Another rule for the collector is the same for stocks and art: admit one's mistakes. Once one has bought a "puff" story or a work of art that has no real chance for rediscovery, sell it. Take the loss, if there is one, and forget it. The key to making money in the art market is to continually refine one's collection as one's judgments improve.

Many collectors trade up, by that I mean swapping with dealers for better pictures by adding to the cash cost of the new work. Dealers love this system, because they want collectors to improve their taste and recognize why an item costs more money. This game can also be played at the auction houses. One can sell a work by an artist, in order to buy a better work by the same artist.

If one believes the doctrine laid down by Kenworth Moffett, in *Partisan Review/2* (1983), "Abstract Art and Middlebrow Modern," that the audience must attain a distance to be able to tell the really new from the merely fashionable, then one believes that the audience for the best of contemporary art is always lagging behind the newest of the work which will endure. Moffett, like most art historians, speaks in terms of periods of hundreds of years. Whether this applies to periods of twelve years, or twenty years, I am not sure.

Moffett uses Henry Moore instead of David Smith as one of his examples to demonstrate his thesis that distance in time sometimes equals value. I have owned both, I still have my David Smiths, but I have sold my Henry Moores. I think I made a mistake. In the ten-year period of 1975–1985, I would have done just as well with Moore as David Smith in market price terms. For anything other than the best David Smith sculptures, like drawings and watercolors, any investor would have done substantially better with Henry Moore. Here again, it's apparent how it's not just the name of the artist, that plays a part but the particular medium within each artist's *oeuvre*.

The case of Willem de Kooning versus Jackson Pollock is a much more interesting case. Moffett tells us that de Kooning was the magnetic center, but Pollock was the artistic center. Depending upon when, certainly from 1975 to 1985, if one bought Pollock, it might have been more profitable than buying de Kooning. But the best of the de Koonings in 1985/86 are starting to move into the Jackson Pollock price range. Of course, Pollock's early death accelerated the valuation process of his works.

If one was following critics rather than artists, the man certainly to have paid attention to for this early period was Clement Greenberg. Greenberg has proven to be right more times than not.

How about de Kooning and Fairfield Porter – not entirely similar artists, but close in age and time. It's too early to really tell the Fairfield Porter market story as he only recently died. But certainly those who bought at the first Fairfield Porter show at Hirschl & Adler have done very well indeed. The point again are the factors, which are variable and can range from an untimely death to art historical re-evaluations.

Jack Bush, the Canadian Color Field painter and Kenneth Noland, the comparative American, are an interesting question. There really is no question between Kenneth Noland and Morris Louis, the acknowledged best of the Color Field painters. Darryl Hughto is another great example. He was to be *the* next generation of Color Field painting. When I asked Anthony Caro for the name of the best new artist, he said Darryl Hughto. So far this advice has not proven true, but it's still very early to tell.

Moffett nicely summarizes the problem:

"As earlier Modern art became popular, so did American Contem-
porary. Thirty years ago New York had only five or six galleries that
regularly showed contemporary art; today it has nearly two hundred. The
number of museum exhibitions, periodicals and college courses devoted
to contemporary art increased geometrically during this same period.
The huge new audience is very broad and unsophisticated. It wants easy
excitement and obvious kinds of activity and diversity. Serious Modern
art (art that takes itself quite seriously) comes in relatively small quan-
tities and develops over generations; it can't hope to satisfy an audience
that wants so much so fast."

For him it all is very depressing. But the game continues for the collector, and it is, to me at least, a very exciting one.

"That the oil painting once it is made has its own existence this is a thing that can of course be said of anything. Anything once it is made has its own existence and it is because of that that anything holds somebody's attention. The question always is about that anything, how much vitality has it and do you happen to like to look at it."

<div align="right">Gertrude Stein</div>

<div align="center">V</div>

Appreciation

So far we have been talking about market information and market knowledge, but is that enough? The collector has to develop two separate and distinct attitudes. The first I have called market knowledge and the second appreciation. Both of these attitudes must move together in one individual to the point where the collector feels comfortable in both worlds. When the collector has the necessary skills displaying taste in his acquisitions and astuteness in his buying and selling, then he has a chance to make money from his art collecting.

For most people, art is unnatural, and they believe that the world populated by the artist is a world of the eccentric. As a basic proposition, art is merely one method of human expression. It is also an affair of emotion, intuition and intelligence. Art is not something that comes to us without work and study.

Most of what has been discussed so far is about technique, rules of the game, and the kind of people who play it. But remember my basic proposition; why buy a given work of art? On the contemporary side, one will always be faced with names of artists like Josef Albers, Pierre Alechinsky, Jean-Michel Basquiat, Irving Petlin, Willem de Kooning, Jules Olitski, Richard Pousette-Dart, Marina Stern, Emily Mason, Mark Tobey, and literally a thousand other names, all names of people who are considered creators of a product that is called art.

Why one, and not another, that is the basic course of study for the collector. To start, it's important to first understand that this study is rooted in a tradition that goes back to the beginning of man's appreciation of the visual, and the collector has to begin with that which forms the basis of this tradition, the history of art. Next the collector has to understand the history of taste with its many contradictions between that which is trend setting and that which is truly innovative and can stand the test of time. In the end, one's own taste is at least in part established by others, through a combination of these traditions.

In all of this there is an obvious pendulum swinging from art style to art style, from the Impressionists, to the Surrealists, to the Minimalists, etc., etc. Just because a particular style preoccupied the art market of one period does not necessarily mean that it will preoccupy the art market of another period. But each

<div align="center">125</div>

of these styles, at best, becomes an anchor for the next period. The collector in his aesthetic attitude must understand the basis for each of these styles by responding to work of each period and by carrying away in his consciousness something which he didn't know or understand before.

Once the collector understands the style, or the period, he then moves to the next step, understanding the nature of the object with the period, or simply what the artist was trying to accomplish and what the collector can respond to as an individual. It's either the object or the artist or the two considered together that he is trying to understand through the training of art history. Until a person feels comfortable and secure with what he is looking at, he can't be a real collector. In the long run, most of us must have something in mind to look for before we see anything. And for most of us also, habit is also our guide, as I have tried to indicate. In looking at works of art – especially painting – we are asked to dig deeper into a world of the less-familiar. Some people love novelty; others are much more comfortable with the old and established. For the collector who truly wants to advance his knowledge, he must in the end have a willingness to go deep and look and try to understand what he is looking at, even if at first it seems unfamiliar and outside his present understanding.

No one can deny that the first contact with a picture, poem or a musical composition stimulates what we have called liking or disliking. "I know what I like," says the collector. But does he know what he is looking at? True, this minimal appreciation of a work of art is a necessary first step toward a fuller understanding, but that's all it is, a first step. Liking a work of art at first glimpse is not the same as knowing what there is to like in it.

It's my view, and again it's not original, that each picture one looks at builds on something that went before. Therefore, we become better spectators of the creative act of the artist, if we understand, at least in basic terms, where the artist is going. Unless one is aware of the essential difference between abstract and figurative work, it's impossible to tell where the artist is coming from. If one doesn't know the basics of Cubist and Surrealist paintings, he can't even begin to talk about originality or even conformity to traditional patterns in that area of painting. The only point of uniformity is that most painting (and there are exceptions like Ron Gorchov or the new Frank Stellas) deals more or less with flat surfaces and color or black and white patches. But once past that, the question has to be where does it fit historically in its resemblance to other paintings. This, at least for me, is the starting point, and one therefore must, whether he wants to or not, be able to make this category-by-category interpretation or he will never really advance his understanding as a spectator.

I believe the reason people find it difficult to appreciate a work of art is that appreciation involves judgments or conclusions: judgments and conclusions are logical matters, requiring evidence for their support. And most people are generally too lazy to make enough of a study of the subject to arrive at a judgment. To appreciate a work of art, in the end, is to have made a decision about it. And here, art history and criticism play *the* most important parts.

126

Herbert Read, that master critic, has said "art" and "society" are two of the vaguest concepts in the modern language. The word 'art' is so ambiguous that no two people will define it the same way.

The word 'aesthetics' is also ambiguous, but for our simple purposes, we use it to mean appreciation of, or responsiveness to, the best in art. To me, a person who manifests taste is an aesthete. The person with taste is a person with the power of discerning and appreciating whatever constitutes the best. Taste, to me, means quality as judged by a person who knows what he is talking about.

How does the collector educate himself to be receptive as an aesthetic? He must be able to look and try to understand why such an object has been created. The artist helps him with a series of clues. Roughly, there are four kinds. First, there are the sensory qualities of the materials he works with, the color, line, movement, etc. Second, he pays special attention to the formal properties or the way the sensory materials are organized, the theme and variation, balances and the varieties.

Much of the art produced, especially today, is said to be formalist. What this means in simple terms, is that the elements of the picture or sculpture alone constitute the proper aesthetic response, the formal elements of design, composition, or arrangement are the means to seek the artist's perception.

The third clue to look for is the artist's sensitivity to the technical problems associated with the creation of the work of art.

The fourth and most important clue is artistic perception of the properties of the object. For most objects it is the image's impact that makes the work significant as art. Without the viewer's perception, art loses its magic and becomes a literal representation of some sort or a conventional symbol or signal.

Are there any simple rules, a guide for the collector to follow? It's a very difficult and at times a confusing question, but, if I had to, I would say that the world of aesthetics leads back to the search for art's unique function and that is the object itself. It's a circular argument, I know, but to simplify it, I would say:

1. Does the aesthetic enjoyment of the object (by definition) provide parts that are unified into something of a whole that has a character of its own?

2. Aesthetic value is then (by definition) the capacity to provide, under suitable conditions, aesthetic enjoyment, and this is brought about by;

3. Positive critical criteria that are (by definition) properties that are grounds of aesthetic value.

Let's see if we can summarize this for the collector, in simple terms.

When one looks at a painting, one looks for unity, complexity, and intensity. If it works, then these parts of the painting become unified into something that has a character of its own and provides aesthetic enjoyment. If it does, then these positive critical criteria should create aesthetic value.

How do we establish that aesthetic experience that manifests itself in the collector as taste? Or, how does a person acquire the power of discerning and

appreciating whatever constitutes the best? He learns it from others. And, as I have said before, popular acclamation is not to be discounted altogether, for if enough people say something is worth having it is in fact worth having. We therefore must look to the testimony of persons with impressive knowledge in the world of art, to see what their opinions may be. They can be wrong, and they may change their minds, but nevertheless, it is primarily our critics, historians, and connoisseurs, with all of their biases, who will continue to determine aestehtic worth. In brief, like it or not, it is determined by the judgments of professionals.

Art History as the Basic Foundation for Aesthetic Worth

The debate begins on the issue of how an object and the artist are placed within history. Some will tell you that the history of art is a science requiring background and knowledge. Others will say that the issue is really a matter of intuition and guesswork. The issue for a collector is what value is created and how.

For the non-owner, pleasure may be limited to merely looking at the work of art. For the collector, that pleasure is not enough, because down deep, his motivation for moving from spectator to owner is the pleasure of owning something that will increase in value.

Estimating whether an art work will increase in value consists in large part in understanding how and why the series of opinions and judgments made by certain individuals affects that value.

If the artist is long since dead, it is generally the work itself (what I have called older work) which has to be judged as to its aesthetic value. For example, let's assume we have discovered an artist who was very famous in his time, but now is out of fashion and in little demand. We start, in effect, with mystery, an artist who cannot tell us what his intentions are. The only evidence available to us is the work, the history of the time in which he painted, his position vis-á-vis his contemporaries, the opinions of those who were writing about him then and the general opinion of his work today.

Depending upon the time frame, changes of labels on works of art of this kind, affect the fundamental nature of the opinion placed on the work itself. Its value is affected by the way in which it is seen, by how the experts rate it, and also by what else is known besides the standard, accepted view of an artist. Now if any of this is to change between the time of the artist's death and the time when the collector acquires it, it will affect its place in art history.

Unless it is a universally acknowledged great discovery, or rediscovery, the secrets of the artist and his work, assuming there are some, have to be brought out into the open by the art historian. The way in which these new interpretations are arrived at in modern art history is always slow and excessively intricate. But without this process there can be no fuller appreciation and no added value. The process by which the art historian puts together the facts that led to their conclusion is the basis of their discipline.

This process of constant re-evaluation goes on in every museum in the world and in every category of work. Although the visitor to a gallery may not realize he

is a witness to it, this demonstration does constitute instruction for the collector in art history.

The nature and character of each exhibition, the way they are grouped or classified is the director's and his staff's way of educating the public. In the end, his discrimination and knowledge is presented to us, not only for our enjoyment, but to help increase our knowledge of the place of this artist or group of artists in the history of art. All that he does goes to explaining the fundamentals of a particular artist's value at the current time.

When it comes to contemporary work, where we have the artist and his intensions to deal with, the art historian has an additional problem. Here he has not only art history to deal with, but he also has a living artist, who is trying through his work, to enter the stream of historical development. It is obvious that taste and fashion are always in a state of change. One style, as we have said, develops a new style, which puts the artist into a historical movement. As this style develops, art historians, critics, dealers, collectors, the press, both the popular and art press, all come into action, in what I have called the developmental stage of the art historical process. All of this criticism, in the broad sense, is directed to determining the importance of the artist and his contribution to this developing process. If the artist, and the style, can survive the selection process of this development, and not be replaced by other artistic styles, then he enters the history of art. This is not, of course, the rule for most contemporary artists, for them it is not as concrete as being "in" or "out" of art history. For them it is rather a system of gradation, whereby he may be a full-fledged member of a style which stays historically important, but his part is minor and only a footnote to the trend itself which is responsible for an outburst of spectacular innovation in the visual arts, and continues to be recognized by art history. It is more likely, for the successful contemporary, a rise, development, and then a decline.

Clearly, also, works of art are part of the society from which they spring, and one can't learn about one without learning about the other. Questions of intellectual and social background are also part of the process again to be learned and determined. All of these understandings are therefore part of the history of art.

Art history is not only an illuminating discipline, it is also a field of professionals with different skills and methods. The range of the techniques employed by these scholars are the same tools of the trade used by art dealers, museum curators, critics, writers, and a host of others whose jobs depend on their being right about the questions raised by a work of art. In addition to value or aesthetic questions, there are questions of attribution, dating, authenticity and rarity that must be addressed, and these are mainly the responsibility of the art history scholar.

Art history as a discipline is always overlapping with other creative study. For example, if someone is interested in ancient art, he has to know something about archaeology. If someone wants to understand popular art forms, the basis of, say, Pop Art, he has to have some background in sociology. The study of the ideas communicated in the art of any given period leads across to and links up with the literature, music and philosophy of the same periods. The study of aesthetics acts

as a bridge between art history and other disciplines. And the study of human perception and art overlaps with psychology.

The art-dealer as an art historian is a combination of businessman, critic and curator. The museum professional, in a different way, combines two different disciplines since he is trained as an art historian but works as a curator. The strict art historian is normally either a teacher or an independent scholar. The critic is the person on the spot, for he is the historian who combines his talents to become a reporter or journalist, and may end up as publicity agent, teacher, or cultural arbiter. All of these art historians, the dealer, the curator, the critic, and the pure art historian, try to publish with a view to sorting out their interpretation of the artists or the events, as they see them.

Ideally the result is the development of a point of view, encompassing the broad subjects of style, subject matter, technique, and so on. If successful, this discussion will demonstrate how the artist developed and evaluate his achievement within this development. Criticism's ultimate goal is to provide a fresh viewpoint concerning the artist and his work, predicting movements, tastes, and necessary changes and in this capacity the critic acts as instructor. The unsuccessful critic simply describes and surveys the subject, or at worst, is a publicity agent for the artist.

Art Criticism

A good critic compares and relates large numbers and groups of works to each other. What he should try to do is provide the basis for insight into the work. The knowledge that is provided, and the circumstances surrounding it should enrich and deepen the insights of the spectator. Fresh insights and current concerns, which evaluate are the real stuff of the art historian. In effect, these views should constantly modify our own way of looking.

Does it happen? Rarely, as we will also see, because most art writing encourages flippant value-judgments, puff or hype pieces, thoughtless dismissals and – most prevalent of all – a breathless superficiality which is more concerned with the childish concept of who's "in" this season than with the crucial considerations of how and why artists go about translating what they have to say about the world into works of art.

Good criticism exists but it is not easy to find. David Park Curry, the curator of American art at the Denver Art Museum (*Arts Quarterly*, New Orleans Museum of Art, April/May/Juni 1986) writing about the American pictures owned by Baron Hans Heinrich Thyssen-Bornemisza, produced just such a piece of criticism. First, the critic set the standards to guide his readers. Look to the clues offered us by the artist and the work, Curry tells us, and we will have a better understanding of what we are looking at:

"In creating a work, the artist makes choices. Subject, medium, formal elements of color, shape, line, texture, and style comprise the artist's tools for shaping a unique vision of the world. Choices depend on purpose. An artist may paint for the sheer joy of manipulating his

materials or his audience. He may seek some special kind of beauty. He may wish to make a political or social statement. He may want to record or question ideals valued by his society. Seeing is selective. By choosing what to show and how to show it, the artist controls what the viewed sees. Reality depends on the amount of information given by the artist and apprehended by the viewed. The artist may or may not choose to make his visual statement easily accessible. And the viewer may or may not have the time, energy, knowledge, or desire to respond. One hundred thirteen paintings spread over two centuries are rather a lot to contemplate. It is *not* necessary to scrutinize every painting."

Are all of these pictures masterpieces? The word "masterpiece," says the author, "is a nearly bankrupt term beloved by the public relations specialists in promoting a collector's pictures exhibited at museums around the world." "Here," says Curry, "the museum visitor can exercise his own tastes and become more aware of factors that govern the collecting and presentation of artworks in a public form":

"What was available in the marketplace? What trends did the collector follow? How has a given museum decided to arrange its display of the work? What hangs next to what?

How good is this collector's eye? "Not bad," says the critic, "you'll find it well worth your time."

From Ruskin up to our own times, the most provocative and fruitful criticism has come from people who are capable of locating and articulating a direction for art to pursue. The critic must play the role of the middleman, in that they act as mediators between the artist and the public. But they can, at best, be something more than a species of broker as well – actively bringing about a new awareness and sometimes prompting artists to see themselves as part of a larger purpose.

Harold Rosenberg, the long-time art critic for *The New Yorker* and a professor at the University of Chicago, in an interview conducted in 1978 (just before his death) was asked if he could explain the difference between good and bad work. The answer, after much ado, was that Rosenberg could not, and would not, tell us the difference. The most he would say was that he was more interested in the painting of one artist than he was in another. In general, that's the problem for the collector with all criticism. There are no black and white answers.

In the end, as Sally Avery, the charming doyenne of the New York art scene, once said to me, it's an opinion or belief backed by popular acclamation, with all of the biases, which we have come to expect from opinions, rather than knowledge based upon positive facts or criteria. Maybe, as we will see, there are no pat answers when it comes to art.

The Art Critic is Many Things to Many People

Publicity Agent

Gregory Battcock, in the October, 1979, *Journal of Theory and Criticism* (T & C) tells us what he thinks the art critic is:

"Publicity agent? Teacher? Defender of the culture? The art critic is many things to many people. Let us consider what some of these things are and then let us consider what, in fact, is the situation of the art critic.

"For many artists the art critic is a publicity agent in a glorified sense. The critic interprets and explains and evaluates, producing a type of public relations copy that publicizes the merchandise of the artist and that makes it attractive and understandable and desirable to the public. Thus the critic helps the artist to sell the art object. These artists expect art critics to 'write up' their art, their ideas, techniques and life styles. These artists write notes to critics, such as 'Please come. I know you won't be disappointed.' 'I think you will like my work, and hope to see you at the opening.' 'I have been following your writing for years, and think you will find my exhibition of interest.' 'I hope you will come to my new show. I'm very interested to know what you think about the painting.'

"All the above means one thing. The artist wants free publicity and the art critic is the one to provide it. The art critic has the connections with the press and is the one to communicate to the world the originality, charm and brilliance of the artist's work. There is no question as to what is wanted, expected, from our critic. A glorifying review. Nothing less is accepted. Nothing less will be recognized. Such artists will consider anything as high praise."

Defender of the Culture

While Battcock's view may be shocking to some, in practical terms, it is probably correct; publicity agent, teacher and defender of the culture. So that I am not accused of being onesided, let's hear from a defender of our culture as to the nature of criticism. Suzi Gablik, writing in the "Letters" column of *Art in America* in January, 1986, in response to her being called "pan art world Cassandra" by Carter Ratcliff, tells us:

"It is not the subjects of money and decadence, then, that hold me in thrall, but my desire for art to become culturally resonant again. I am not content merely to describe (and redescribe) the emptiness in our values; I wish to empower people with a sense of renewed vision and possibility. In order for this to be, however, we must come to see ourselves as impresarios of change, as orchestrators of culture and consciousness. Each of us must realize our own responsibility to change first, and not wait for others to do so. 'There are no excuses for anything,' Agnes Whistling Elk tells Lynn Andrews in *Jaguar Woman*. 'You change things

or you don't. Excuses rob you of power and induce apathy.' The key is to do things differently, to break old patterns; replace negative criticism with positive action. To reframe means to change the way we look at things.***"

Teacher

James Faure Walker, painter, writer and publisher, tells us, as our teacher, that the relationship between observers and artworks is crucial to any discussion of art criticism. In his view it is absurd to talk about artworks without including the observer because it is only human consciousness that is capable of seeing objects as artworks, (assuming that the observer in question belongs to a culture which acknowledges the category "art"). He says that in order to extract any meaning from an artwork the observer must bring some knowledge with him; the artist provides the signifier while the observer fills in the signified. Therefore the observer may be said to complete the artwork; he is an accomplice, a collaborator, of the artist and the work. Since it is the observer who completes the work the term "artwork" should properly refer to the whole system of interaction between observer and object. (The term "observer" is perhaps inappropriate because it suggests detachment rather than participation.)

This view, he tells us, is not particularly original: Ernst Gombrich has written extensively on what he calls 'the beholder's share' and Marcel Duchamp said in 1957 that "the creative act is not performed by the artist alone; the spectator brings the work in contact with the external world by deciphering and interpreting its inner qualifiactions and thus adds his contribution to the creative act, " Roland Barthes remarks "the goal of literary work (of literature as work) is to make the reader no longer a consumer, but a producer of the text." To summarize Walker's view: the observer completes the artwork; he participates in the creative act; therefore critics are, to a degree, artists.

Now I think some of the problems facing the collector are becoming clearer; he must understand what part the critic is playing as the collector's advisor.

What distinguishes the critic, then, from other observers is the greater knowledge of art and its codes which he brings to his encounter with the art object. This then enables the critic to contribute more to an understanding of the artwork than the layman. Furthermore, his contribution should be his commitment to his product, his writing, or his knowledge as a curator to the presentation of the artist and the art.

Criticism and the Value System

What part does criticism play in the practical world of the art market? To see this interrelationship, let's look at Jack Flam's criticism in *The Wall Street Journal*. First, he tells us that "things happen quickly in the art world these days." It was only five years ago that, for example, Eric Fischl had his first solo show in New York. Now "he has an international reputation." First there was no value for

Fischl's work in 1980, and apparently substantial value by 1985. Why? Because he now has an international reputation. He has become famous as an artist in just five years. We have our first label; Eric Fischl, contemporary artist, of international reknown.

Next, we have to see what is behind that label. We are told that Mr. Fischl is a controversial painter. Critical opinions about his work run from enthusiastic praise to outright disdain. What is it that causes this disagreement by the critics? For some, he is a ruthlessly honest realist; to others, he is a cheap sensationalist. But whatever he is, a great deal of attention is now being given to what he does, and a great deal is being written about him; he has started the development process which creates value for his work.

Fischl's picture appeared in *Time* magazine, captioned "Fischl in his studio: set for the long haul." In just five years Fischl has had exhibitions in Saskatoon, Saskatchewan, Eindhoven, Basel, London, Toronto, and then the big time, the Whitney Museum in New York. He is on his way through that so-called mysterious system, by which the history of art will ultimately validate his position. And how is this done? Art criticism in its broad sense, is the answer. It is that combination of publicity, education about the artist and, as Suzi Gablik sees it, manipulations of culture and consciousness by the critics and educators. If one wants to play in this Eric Fischl game with the critics and curators, the price is probably over one hundred thousand dollars per picture.

The Eric Fischl story is the story of contemporary art in these days of the late 1980s. Fischl is a young, bright man, born in 1948 in New York City. Because of his name, and his association with Mary Boone, many have thought that he was somehow part of the German contingent of the Neo-Expressionist movement. He is not, he is clearly a New Yorker. In 1972, Fischl received his degree (B. F. A.) from the California Institute of Arts, and moved out of New York, to teach in Nova Scotia, where he stayed until 1978. There was not much happening with his work until 1980, when he had his first major gallery show in New York at the Edward Thorp Gallery. He was up and around, establishing his reputation from 1980 to 1984, even having a show in England, at Nigel Greenwood Gallery in London. (I wonder if that is where Charles Saatchi first saw his work.) Then he showed at Mary Boone in 1984, and that was the big, big time. Today, Eric Fischl would be more than welcome at any gallery in New York uptown or downton.

I recently attended the Fischl opening at the Whitney, and from what I saw there I could deduce what was going on in terms of this artist's career and the stage of his art historical development. I went first not to the pictures, but to read the labels. The labels tell the story: "Sleepwalker," 1979, owned by Edward Downe, that mover and shaker in contemporary art, "Barbeque," 1987, Douglas S. Cramer, the co-producer of such shows as "Dynasty," "Hotel" and "The Love Boat." Then we see "The Old Man's Boat and the Old Man's Dog," 1982, a picture that has been reproduced so often that it has now become the Eric Fischl trademark. This, of course, is in the Saatchi Collection and that alone confirms Fischl's success to some. Saatchi and Downe never buy just one picture, so we have one or two more labels with their names affixed.

All collectors and dealers have to be careful with museums, especially at the Whitney; when it comes to overpowering the curatorial staff. Curators don't want to appear to be part of thy hype process, so they make sure a variety of owners' names appear as lenders to an exhibition even if they have to sacrifice quality to achieve that end. Other interesting labels show the dealers: Sable-Castelli Gallery, Ltd., in Toronto, with a 1981 "A Woman Possessed" which could have come from an exhibition that they had in their gallery in 1981 and was probably an unsold painting that they had to buy to get the show from Thorp. Mary Boone put her money up for "Sisters," a 1984 large oil, certainly one of the best in the show, and a painting that would, in my opinion, be worth at least $200,000, if it was for sale by Ms. Boone. I could go on, but, I hope it's obvious that the big-time collectors are in front of and certainly behind Erich Fischl escorting his entry into the art historical system.

Just one more thing has to be said about the process and the museum world. I have said that art history works through the museum world, and that the visitor to a museum has to be aware of the biases reflected in what museums choose to exhibit. It's important to remember that there are literally a hundred good American artists who have been at work for thirty years or more (as opposed to five years like Fischl) who would consider their artistic life complete if they could have a large show at Mr. Tom Armstrong's Whitney Museum of American Art. But the Whitney has told us that exhibition space is in such short supply that they must build a large extension. But what do we find? Existing exhibition space used instead by the Whitney staff to instruct and educate the public to assure Mr. Fischl's place in the annals of the history of art. Could it be that this exhibition and this handsome catalogue is supported by collectors and galleries that have the most to gain by the success of an artist they've invested in, or is it that I am just too cynical to suppose otherwise? Interestingly, the Fischl and the Alex Katz exhibitions were running simultaneously at the Whitney. Katz, born in 1927, has been exhibiting since 1954 and is certainly considered important as an American figurative artist. It has taken Katz thirty-two years to get an exhibition at the Whitney, not five as in the case of Fischl. A viewer with taste who viewed both exhibitions should get a good idea of the part museums play in instructing and educating the public as to the art historical process. In any event, to see criticism work in a practical way, one should watch Eric Fischl's career over the next few years.

The museums in New York, caught in an upsurge of art activity, often contribute to a confusion of values by an indiscriminate use of their influence. The collector has to be careful as never before of this formidable shadow when visiting these institutions today. For a long time the Museum of Modern Art has been exclusively a place to see Modern art, but certainly not contemporary art. This museum is interested in the completeness and quality of its own collection. It may very well be an institution that has lost its nerve, and gone historical, but it is the best of its kind. This museum is always a good starting place for the collector, a place to go back to, to rethink his own ideas. As for the Guggenheim, its staff – with the exception of the director – is second rate, and no one there seems to know

135

what it's identity is. The Whitney often generates angry disappointment because it is certainly not a museum of American art. This particular weakness is not especially hard on New Yorkers because they can see American art better every day in the private galleries. Most of our current dealers, like Arnold Glimcher, think of their galleries as teaching institutions. As Glimcher has said, "yes, I think of my gallery as a small private museum." But it is now apparent that we also have to be very careful even at the prestigious Metropolitan Museum of Art. I remember the contempt of the critics at the exhibition of Andrew Wyeth's paintings at the Metropolitan because this exhibition was funded, supported, and executed to hype the prices of the Wyeths in Joseph Levine's collection. But we have never seen anything quite like the current situation of B. Gerald Cantor's Rodins at the Metropolitan. Vivien Raynor (*The New York Times*, April 25, 1986) called this exhibition unusual. As she tells us:

> "The niceties are observed, the sculptor gets star billing; but make no mistake, this is a collectionneur show, the nearest thing in art to an auteur movie. As the Met's director, Philippe de Montebello, puts it, the selection is meant to 'illustrate the depth and seriousness of Mr. and Mrs. Cantor's interests.'"

As I add the numbers it's at least a $7 million interest, going from Cantor to Montebello's Metropolitan. This is to me, at least, a deep and serious interest. But an interest in what? Reading carefully between the lines, we are told that these so-called Rodins are not by the sculptor Auguste Rodin (1840–1917) at all, but made and produced by B. Gerald Cantor. These are clearly *posthumous* casts. As Rainer Maria Rilke, in his study of Rodin, has told us, Auguste Rodin's great talent as an artist was his obsession with tiny details from which his work sprang. How could the Cantor-produced Rodins then be considered as the original work of Auguste Rodin? How many collectors or visitors to the Metropolitan Museum of Art will understand that this exhibition exists solely to raise the value of the rest of Mr. Cantor's collection of posthumous Rodins. Mr. Cantor is described as a "financier by profession" so one would suppose that he knows how to spend $7 million to provide capital to enhance future value:

> "Whether the Paris museum still destroys molds after making a certain number of casts is unclear; editions of sculpture are, in any case, in as gray an area as those of prints. Nevertheless, disinterested observers have questioned the abundance of Rodin casts and their quality, which is considered to have deteriorated since Jean Limet, a craftsman who worked with the master, retired from the Georges Rudier Foundry in the late 1960s.

> And, to judge from the general appearance of some pieces in the show, with good reason. Most of the early casts in the Met's permanent collection are black: those in the exhibition can be anything from silvery gray to a disagreable light brown to oxidized chocolate. Some have too high a sheen and the grand model for Ustache de Saint-Pierre, one of the burghers, looks as if it was made of green plastic. Badgered by this new-

and-improved Rodin, the viewer looks for the old version, which naturally is best represented by the plasters."

I remember a time in the past (remember what happened to Tom Hoving, the Metropolitan's former director?) when the critics would burn a museum director at the stake for such an exhibition, but I have seen Cantor's Rodins in every museum coast to coast, and the vested interests are now so great that even the great Metropolitan is prepared to play the game "if the price is right." I guess I am getting too cynical in my old age to believe that poor Auguste Rodin needed Mr. Cantor ro revive enthusiasm for his art. Certainly the art historical process has not broken down to that extent.

Issues of value, the market and criticism permeate the entire art world and the art historical process. If one accepts this system, then he must ask himself in each instance why is this article being written or why is this exhibition being presented and reviewed, and what value can it be to the collector?

As Battcock tells us:

"Art dealers, foundation officials and granting agencies view art critics somewhat differently. For these dignitaries and institutions, art critics are service personnel. Not to be allowed to meddle in administrative work or to make decisions of import, the critics are nevertheless called upon to give the stamp of approval to programs, schemes, proposals and policies that have been designed to correspond to administrative efficiency and order. Critics are, of course, pre-screened. Those called upon to serve can be counted upon in advance to give the correct opinions and the required approval."

When a dealer or a museum accepts certain art as worthy of display and when a public institution makes a purchase for its collection, these are also acts of criticism. Indeed, by the time the critic appears on the scene to write his article, the key critical decisions have often already been taken.

Eminent critics also strike up friendships or make alliances with artists and in this way they contribute directly to artistic decision making. For example, in the early 1950s Clement Greenberg advised several Washington artists about their painting. In particular he advised Morris Louis on the cropping of his canvases and Kenneth Noland on the shape of his.

In contrast, Harold Rosenberg's decision that "art should be left to artists" commits him to an external, passive role: the critic waits expectantly at home for the next wave of exhibition openings so that he can make his response. Rosenberg discounts the idea that criticism might function internally, that it might have a role to play in the creation of artworks, rather than existing as a separate force.

Given the confusion inherent in the system of criticism when reading an art critic or an article written about an artist, or when going to an exhibition, I ask myself the following questions:

(1) Who is the writer and why should I take advice from him? Or why is the exhibition being done, and does it mean anything as an act of criticism?

(2) Does the writer set forth his reasons for his criticism, or is he an advocate for a certain kind of work to the exclusion of all others? Can I expect more from this dealer or this museum, or are they advocating what is their recognized position?

(3) Does the writer or the curator of the exhibition set forth the bases for their value judgments, and what place do their tastes play in this judgement?

(4) Is the writer, or the curator, or the dealer, a kind of art historical instructor, who gives me the facts from which I can formulate my own conclusion? and,

(5) Is he the kind of writer or curator who will make a judgment and offend the artist, the dealer, and the system if he thinks it is warranted, or is he the kind of writer or curator who never makes a judgment and never offends?

The Source of Art Criticism

The most basic kind of publication produced by the art historian or art critic are monographs on particular artists. Other typical sources are catalogues on a particular subject or group of artists a part of ongoing exhibitions at a museum or a museum-like setting. These exhibitions are the foundations on which the markets for works of art are built. They may take place in a museum, or alternative space, like PS-1, or Artists' Space, or in a dealer's art gallery. All deal with the presentation of information, which the curator believes is relevant to an understanding of the artists who make up the exhibition, or the work which is presented in it.

This system of gathering related objects together and hanging them has been the same for generations. Many times a catalogue is published which may range from a simple checklist of the works to a book-size publication. If the show is in a museum, then there will also be lectures or guides to help the viewer understand the information presented.

The artists' monograph is a sort of phantom exhibition on an artist in particular or a group of artists which make up a segment of a historical period. Like the museum exhibition, the work is sorted out and catalogued, with reproductions to substitute for the walls or space at an actual museum or gallery. Here the information is generally presented by the writer in an essay or a series of essays using the illustrations.

Hopefully all this informations is dealt with from points of view of style, subject matter, technique and so on. The historian deals with how the artist or a group of artists developed and evaluates his or their achievements, incorporating into the discussion his own criticism of the subject matter. If he is a good critic, he arrives at a conclusion as a result of the fresh viewpoints he hopefully brings to the artists or the group which make up the subject of this phantom exhibition. Unfortunately, most writers simply describe and survey the subject, rather than bringing new insights into the work.

Dealers often promote artists by telling clients that so-and-so artist is about to be included in an exhibition at a museum, or a museum is about to have a

retrospective exhibition of the artist's work and therefore, the time to buy is now. Exhibitions are now such a big part of the marketing process that a critic recently told me that it is the collector who now wants to know before he buys if the artist's work is likely to be included in the next big exhibition. If not, he doesn't buy.

This system of establishing a foundation either through an exhibition at a museum or through an artist's monograph is how all value is created at the outset in the art market. If one is dealing with established artists, then it is the continuing nature of the information presented which is important. When considering new or neglected artists, it is the initial exhibition that forms the foundation on which all value is built.

The collector, with his lack of confidence in his own judgment, needs a security blanket, and this security is created not just by having an exhibition, but by the documents which are created; such as catalogues from the exhibition. These documents, in our time, serve to circulate over and over again.

The entire system, especially in the area of new art and rediscovered art, is one which is so subtle that it almost defies description. Eliminating the blockbuster exhibition of the established big-name artists, most exhibitions of the new and the rediscovered take place, with few potential future collectors even being aware of it. If one is a collector of the artist's work, then it is likely that he follows the artist's work, and might even be asked to lend works to the exhibition. In such a case that collector is then part of a group of collectors who are invited to the opening of the exhibitions and receive a copy of the catalogue.

It all starts with a collector's purchase through a dealer. The dealer, whether for older potentially rediscovered artists or for new artists, keeps abreast of exactly what is going on in the art world in terms of planned exhibitions and publications. He knows what is going on, because the curator or critic or writer has as his first step to find the source of the work which he wants to include in the monograph or exhibition. And this first source is, for practical reasons, the dealer rather than the artist. The dealer represents an easy central starting point for the accumulation of the work, the beginning of all exhibitions, and in photographs of work to be reproduced in mongraphs. The older the art, the more established the artists or the subject matter, and consequently the less need for the dealer because the museums are the repository of the work.

The fascination of this procedure is how long a catalogue or monograph can last. These are usually conceived in very limited terms not more than 1,000 or 2,000 printed for a catalogue, and not more than 5,000 for a monograph. However, they have a very long life considering the number produced. The distribution of the catalogue takes place at the outset of the exhibition, then to the better museum donors as part of their membership benefits. The catalogues for blockbuster shows have an altogether different distribution life.

The artist's monograph has a more difficult time of distribution. Here there are five or six publishing houses that specialize in the artist's monograph. If they are part of a major book publishing operation, they are sold to normal book distribution channels by its salesmen. If it is a small publisher who specializes in art

books only, distribution takes place through a larger house on a commission basis, or through a series of specialist bookstores, like Hacker Art Books, and Wittenborn.

A new phenomenon of the last five years is the museum catalogue-as-artbook. This new phenomenon provides the museum with a wider distribution of the catalogue which it can't sell because of its limited local audience, and the need for the book publishers of product, which they could never afford to produce, because of the relative high cost of an art book and a generally very small audience.

Most of the art books which one sees today in the bookstores are the latter type, created as part of an exhibition, and not created as an independent book project for the publishing house. The museum acts as a modern-day packager for the publishing company, like the independent producer in the movie business.

The publisher is a distributor, not a creator. He adds the art book to his list to enhance his list by the publication of a prestigious book (as the art category is called in the publishing industry). This new development is a result of the publishers' access to the bookstore chains, to which they can now sell centrally rather than by selling the private bookstore one book at a time. In effect, although the audience is still very small in the bookstore chains, the publisher's dollar volume is higher as a result of this more efficient distribution system. If there are even a few potential customers for a catalogue repackaged as a book, or a monograph in Denver, these chains will handle the book, because with their new computers and distribution system, they can add to their own dollar volume and profit; even if they just sell one or two in a store.

Even though the U.S. is large and diverse, with a lot of educated people, the actual number of art-oriented books sold (unless by a very popular artist), is still comparably very small. Most books of this kind seldom sell more than five thousand and usually an average of two thousand copies sell. If that doesn't say something about people's general interest in art, I don't know what does.

Also, many of these titles actually get sold by the chains like B. Dalton and Walden's and the discount book chains like Crown, as remainders. That is, the price is substantially discounted from its supposed list price at the time of publication. If an art book strikes it rich, by actually being able to be sold in quantities, like books on Georgia O'Keeffe or Norman Rockwell, then art and commerce converge and the publishers gets very rich off the artist's book. This rarely happens for new or rediscovered artists.

Almost all art books, whether catalogues or monographs, lose money. They are in effect paid for by the museum, the dealers, or the artist or a group who support an artist's work. This system is in reality a system of vanity publishing, although people hate to hear that word. It is the vanity of the museum, the vanity of the dealer, the artist, the art historian or critic that makes art books possible and at such good value. There is obviously no other way for the publisher to finance this, given the general public's lack of interest in art. For the collector, the system works quite well, as he can build a wonderful library of art books and catalogues, which are subsidized by the system, and in themselves represent great value. As a

museum member, he generally receives the catalogues at no (or lowered) cost, and as an art book buyer, he can find books on his interest at good prices.

The point I'm driving toward is that as part of this elite audience, the collector benefits by having information available to him, at a good price, which he can use to educate himself.

Is art becoming more popular? The answer is probably yes. But, are these the kinds of people who buy or collect art or big art books or catalogues, other than for the biggest of the bigname artists? Or are these the people who support the artists, the answer is no. The museum programs, the corporate collector and the blockbuster exhibitions are not about collecting contemporary art, but about entertainment.

It is true that in the 1980s, the public is not as elitist about art as it was ten or twenty years ago, but ask a typical well-educated museum-goer if he would spend five to thirty-five thousand for a painting by a good contemporary artist (the range today for a decent contemporary painting), and he would say no. Popular belief still holds that contemporary art is difficult to understand and not worth buying.

This same individual would not hesitate to spend fifteen to thirty-five thousand dollars for a new automobile, but art is something out of his normal experience and expectations for a painting by a contemporary artist. For him, art is still so ambiguous a concept that he couldn't begin to understand it, much less invest his money in it.

Therefore, we are back again to the market. Art books demonstrate that this is a market for the rich, maybe the sophisticated, maybe the knowledgeable and maybe the intellectual, but certainly not for the common man. So we see that the curator, the historian, or the critic, whether writing a monograph or organizing an exhibition is generally doing so for the very few who have an interest in art. Again, I make the point that this limited audience has a disproportionate-sized influence on the market for without the exhibition, the catalogue, the monograph, the great majority of us would have no reference or basis upon which we can endow a work of art with value.

This value system (when it works) in which the critic, dealer and the connoisseur are engaged is based upon an information system so subtle that a collector can miss it, unless he understands how it works. The system never starts from scratch, but consists of sources on which an artist drew, the influences upon him and his influence upon others, and why this artist's work is more valuable than some other artist's work. In its most basic terms, it is demonstrated by popular acclamation for the artist and his work.

No information system, subtle or otherwise, however, is universal and without biases, therefore we have to be careful of the details. We start by looking ourselves and checking the critic as to the sources on which the artist depended for his ideas. Next, we check the critic as to how he deals with the age or time in which the artist painted or produced the work, and the part the past played with respect to the artist's own ideas. We ask how the medium was used, or the possibilities the artist saw for putting different elements together. And, finally, we look to see how the artist develops them into the the concept into which he put them. In effect, we rely

on the information supplied by the critic, but we check him as to his application of this information and the details he supplies. Interpretations of these facts is the ultimate goal and if we find a critic whom we can rely upon, so be it. If not, we try to do it ourselves. Many will say it's a mystery, but remember that insiders do not disclose a system that makes money for them. This is not an easy game as most people who read catalogues or art books know. The problem for the lay reader or collector is the degree to which this writing is vague or abstract and not within his usual comprehension skills.

The Adequacy of What is Available

For most new collectors, they just can't do it themselves. They need help. And help is usually found in reading art criticism, probably in the local newspapers as a first step, and then in the more specialized art magazines and books. Very little has been written about the adequacy of the material available, there have been some, mostly out of London by the English critics.

In 1976, I attended a conference in London on Art and Criticism, which was an open discussion of the role which art writing plays in the public reception of art.

England, in the 1970s, like America in the late 1980s, suffered from a lack of confidence in the artistic community, the public, and critics themselves had lost faith in the way art criticism was being practiced. As the chairman of the conference said:

"Any survey will show that, specialist magazines apart, visual art receives significantly less coverage in the newspapers and periodicals than either drama, music, or television and radio. The amount of space devoted to visual art by the weekly and monthly magazines in particular is not only low but, I think, decreasing. At least, it is not increasing. What is more, there is to my knowledge not a single educational establishment in the country in which the recent history, theory or practice of criticism can be studied systematically or thoroughly. And there are no regular workshops, discussions, meetings or symposia of any kind in which this important activity has a central place.

"Another remarkable fact about the practice of serious criticism in the postwar world is that critics themselves, whether they are employed by a newspaper or magazine or whether they contribute material from time to time on a free-lance basis, find themselves in possession of a platform of opinion which is such that the extent of the dialogue between themselves and artists, or between themselves and each other, is at an absolute minimum. A member of the public, with or without a professional interest in art, is more or less forced into a position of having to agree or disagree in private by himself, rather than being able to challenge the published judgment in a way that would itself produce a response."

In the U.S. in 1986, there is only one general form for any art criticism whatsoever, and that is in *The New York Times*, on Fridays and Sundays. If an

exhibition doesn't get reviewed in *The New York Times*, it doesn't get reviewed as far as the public is concerned.

Reviews in the specialist art magazines or other magazines are reviews which carry no weight at all with the public. Most are so-called trade magazine reviews, that is, reviews by people in the business for the people in the business. These reviews are generally expected to be good or at least neutral or the magazines will lose their advertising. Some of the reviews or articles, are so obviously paid advertising, that it is an embarrassment to even read them and believe that anyone will be convinced of anything written about the artist.

Some of the magazines, like *Arts*, don't even try to be colorably independent, packing the advertisements between the articles on new art and academic papers on the most esoteric subjects, prepared by would-be future art historians for their course work. This magazine is a trade journal for the art trade. *Art in America, Art Forum* and *Art News* do a little better on general topic subjects, by way of an introduction to past or future exhibitions, imparting general art-historical information, but don't even try to be a forum for serious criticism of artists or art subjects.

The New York Times, while Hilton Kramer was its chief art critic, tried to be a forum for serious day-to-day criticism. But even there the job was almost impossible because of the large amount of art activity going on in New York, not to mention the rest of the U. S. With just one forum, and the limited space that any newspaper can give to the visual arts even Kramer, the most controversial of our art critics, was handicapped in what he could do.

In the rest of America, there is not one forum that even attempts serious criticism. Instead, all follow that type of criticism that has been called "a gallery guide." The best of that type of one- or two-line information source still remains *The New Yorker*, where one can find out at least what is going on in the New York City area. Since Hilton Kramer left *The New York Times*, it has moved almost completely into the realm of exhibition news reporting, covering the major exhibitions going on around the U. S. and Europe, and serving as a souped-up gallery guide.

As Robert Hughes (*The New Republic*, April 14, 1986) has said of Hilton Kramer:

> "Kramer wrote clearly. Few read him for pleasure, but none could deny his intelligence, his tenacity, or his imperviousness to art fashions. Over the years Kramer earned a name for incorruptibility in a field much afflicted by mutual back-scratching. He did not take freebies, as both Clement Greenberg and Harold Rosenberg had so conspicuously done. He did not deal, as several of new York's star museum personnel in the sixties and seventies unabashedly did. He was a moralizer (albeit a somewhat erratic one) in a field whose ethical sense, secured by a loony American belief that art is the fluoride of the soul, is no better (and in some ways much worse) than the rag trade's. Thus he was widely respected and narrowly loathed. *Oderint dum timent* – no dishonorable motto for a critic. The American art market, which in the early eighties

was entering the most bloated, fashion-ridden, and image-infatuated phase in its whole history, was not sorry to see him quit the pulpit of the *Times*."

Michael Brenson, the new man at *The New York Times*, is now just starting to find his way, and has a lot of potential, if he gets the space. He writes across the board from the contemporary to Boucher, French, Rococo, *et al*. His writing is clear and concise, but yet he doesn't have the confidence of Hilton Kramer, to go for the kill and call or make a judgment. He is still trying to be fair and not offend anyone, like his boss, John Russell. John Russell is a very good writer, and I have been following him forever, ever since his days in London. But he just will not offend anyone. If one reads him often, his reviews are quite literary and are real art history at its best. In *The New York Times* of Friday, February 21, 1986, Russell writes on Eric Fischl (itself a phenomenon, as he usually gives Brenson the contemporary world). But, as we have said, this just indicates how important Eric Fischl is at the Whitney. Does Russell make a judgment? First, he tells us, this is a remarkable exhibition at the Whitney. Next, he talks about the pictures:

"And what actually happens? Nothing much. It is what might be going to happen, or what may have happened already, that disturbs people. Incest, bestiality and other forbidden pastimes are never spelled out. It could, in fact, be that we ourselves read them into a perfectly innocent situation as a result of inclinations long repressed. How galling, if so, and what an intolerable fellow is Fischl to bring us face to face with our hidden selves! And what a happy day for paint, if this is so! Reading 'Lolita', or watching Joe Orton's play 'Loot', now revived at the City Center, we can distance ourselves from the proceedings. It is paint alone that has still not been defused."

John Russell, however, may be changing: (*The New York Times*, May 18, 1986)

"So, this year, I have broken the habit of a lifetime and given my inquirers a short, private and doubtless fallible list. In the only sense that matters, these artists are all young, though one of them has been around on the international scene for several years and another, though more than ever young in his vision, is not far off 50. Two of them show in midtown, three in SoHo, one in the East Village. Three are women, three are men. As it happens, all except one are represneted in current exhibitions."

I remember a review by Kramer, in the Friday Section of *The New York Times* in connection with an exhibition of Neil Welliver's work in the early 1980s. The piece was so strong that it forced me to drop everything else I had planned for the day and go to the gallery at 10 : 00 on a Saturday morning to see what was going on. What could cause Kramer to be so positive about the greatness of this artist?

When I arrived, the gallery was jammed with people. I remember seeing a number of people whose opinions I admired, movers and shakers in the art world who were also brought to the gallery by the power of this Friday article. The point

is that Kramer, unlike almost every other critic, except Robert Hughes, writes in a language which people who are not in the art business can understand. I can barely read *Art Forum*. Lately, I have noticed a new group of sections labelled "Forum", and here is writing which I can at least understand.

Should serious criticism serve the function of the potential collector, as well as the productive activities of the artist and the art world? I believe that it should.

Let's look at some different critics to see what we can get out of them. First, John Berger. For those unfamiliar with the name John Berger, the name is one to remember, and a critic who certainly qualifies as important for the collector to understand. Berger is an art critic as well as a Marxist. If one eliminates the Marxism, then John Berger is that rare phenomenon in journalism who seems to look at art and stimulate thought in a field where normally there is none at all. John Berger is not for everyone, certainly not up to the standards set by Donald Kuspit, a New York critic. Kuspit says of Berger's latest book, "this book is not analysis, but an exercise in opinionation". But, I like opinion, so I guess I like Berger. I can't read Kuspit, incidentally, although I try.

The first step, John Berger tells us, is to see, to feel and to absorb the work presented. To begin with, he is different from most other critics. Most critics do not sense the specific work, but rather generalize on the basis of an automatic and usually commonplace reaction. What I think should be provided, and I find this in the writing of John Berger, is proof that something particular in the artist's work has actually been perceived by the critic, which causes the critic to complain or to praise. Why does something happen in the work to be examined or not?

Next, Berger sets the clear criteria for judgment or evaluation. He seems to possess ideas of his own, some personal or some traditional, but all values which he enunciates, elucidates and then defends. What emerges is a clear evaluation of the work.

Berger also observes sharply and specifically. His findings are expressed in terse and lucid summations not designed to display his erudition, but to illuminate the object of his examination and to define what he feels about it. The writer in America who comes the closest is Robert Hughes who uses his wit to define his feelings.

In *The Moment of Cubism and Other Essays*, Berger discusses Cubism – apart from what he says about individual exemplars. In reading this one is instructed in Cubism's technical aim and its relevance to modern expression in general, its origins and its direction, its source in our society and its value for the future. In *The Look of Things: Selected Essays and Articles*, and *Ways of Seeing*, Berger's characterizations of artists are quite precise and in detail. Art, for Berger, is not simply the expression of the isolated individual, but the graph of a relationship between an individual and his fellows. The individual and society constitute a continuum. Art in Berger's view is therefore personal as well as historical.

What can the collector learn from this critic? John Berger tells us, in *Toward Reality, Essays in Seeing*, that:

"After we have responded to a work of art, we leave it, carrying

away in our consciousness something which we didn't have before. This something amounts to more than our memory of the incident represented, and also more than our memory of the shapes and colours and spaces which the artist has used and arranged. What we take away with us – on the most profound level – is the memory of the artist's way of looking at the world. The representation of a recognizable incident (an incident here can simply mean a tree or a head) offers us the chance of relating the artist's way of looking to our own. The forms he uses are the means by which he expresses his way of looking. The truth of this is confirmed by the fact that we can often recall the experience of a work though we have forgotten both its precise subject and its precise formal arrangement.

"Yet why should an artist's way of looking at the world have any meaning for us? Why does it give us pleasure? Because, I believe, it increases our awareness of our own potentiality. Not, of course, our awareness of our potentiality as artists ourselves. But a way of looking at the world implies a certain relationship with the world, and every relationship implies action. The kinds of action implied vary a great deal. A classical Greek sculpture increases our awareness of our own potential physical dignity; a Rembrandt, of our potential moral courage; a Matisse, of our potential sensual awareness. Yet each of these examples is too personal and too narrow to contain the whole truth of the matter. A work can, to some extent, increase an awareness of different potentialities in different people. The important point is that a valid work of art promises in some way or another the possibility of an increase, an improvement. Nor need the work be optimistic to achieve this; indee, its subject may be tragic. For it is not the subject that makes the promise, it is the artist's way of viewing his subject. Goya's way of looking at a massacre amounts to the contention that we ought to be able to do without massacres."

For some, as Waldemar Januszczak, the art critic for the *Guardian* in London tells us:

"Berger's way of seeing takes an eternity. I would not wish to go round a museum with him for he would surely be several rooms behind all the time, looking at objects from all angles, running his hands and his thoughts over them, super-glued to them in contemplation. Only when he has affected a communion with the maker does Berger emerge with a point of view."

But, if I had to choose a guide for the collector, I would certainly trail John Berger through a museum, even if it took an eternity. Let's see what he would tell us about Jackson Pollock:

"Pollock was highly talented. Some may be surprised by this. We have seen the consequences of Pollock's now famous innovations – thousands of Tachist and Action canvases crudely and arbitrarily covered

and "attacked" with paint. We have heard the legend of Pollock's way of working: the canvas on the floor, the paint dripped and flung onto it from tins, the delirium of the artist's voyage into the unknown, and so on. We have read the pretentious incantations written around the kind of painting he fathered. How surprising it is, then, to see that he was in fact, a most fastidious, sensitive, and charming craftsman, with more affinities with an artist like Beardsley than with a raging iconoclast.

"His best canvases are large. One stands in front of them and they fill one's field of vision: great walls of silver, pink, new gold, pale blue nebulae seen through dense skeins of swift dark or light lines. It is true that these pictures are not composed in the Renaissance sense of the term; they have no focal centre for the eye to travel towards or away from. They are designed as continuous surface patterns which are perfectly unified without the use of any obvious repeating motif. Nevertheless, their colour, their consistency of gesture, the balance of their tonal weights, all testify to a natural painter's talent. The same qualities also reveal that Pollock's method of working allowed him, in relation to what he wanted to do, as much control as, say, the Impressionist method allowed the Impressionists.

"Pollock, then, was unusually talented and his paintings can delight the sophisticated eye. If they were turned into textile design or wallpapers, they might also delight the unsophisticated eye. (It is only the sophisticated who can enjoy an isolated, single quality removed from any normal context and pursued for its own sake – in this case, the quality of abstract decoration.) But can one leave the matter there?

"It is impossible. Partly because his influence as a figure standing for something more than this is now too pressing a fact to ignore, and partly because his paintings must also be seen – and were probably intended – as images. What is their content, their meaning?"

A most interesting question, and one for the collector to figure out. The point is that if one wants to understand how to look, reading John Berger is a good place to begin.

On the American side, the important critic to read is Clement Greenberg. Greenberg was born in 1909, and at age thirty-three began to write about art and culture for the *Partisan Review*, becoming the premier American tastemaker in the contemporary art field. To summarize the Greenberg philosophy is not easy. He would, I believe, advise the collector to base his judgments about art upon what he considers the facts of style of a painter. The *how* and *why* of the look of the art would dominate his judgment with respect to good and bad painting. The basis for his conclusion is that Modernism not only justifies this practice, but also explains late Nineteenth and Twentieth Century Art by situating them within a post-Enlightenment tendency to use, as Greenberg puts it, "the characteristic methods of a discipline to criticize the discipline itself."

Clement Greenberg in "The John Power Lecture In Contemporary Art" sums up some of his thoughts as follows:

"Things that purport to be art do not function, do not exist, as art until they are experienced through taste. Until then they exist only as empirical phenomena, as aesthetically arbitrary objects or facts.

"But even so, if this were the only kind of order obtaining in new art today, its situation would be as unprecedented, still as common opinion says it is. Unprecedented even if not confused. The good and the bad might differentiate themselves as clearly as ever, but there would still be a novel confusion of styles, schools, directions, tendencies. There would still be *phenomenal* if not aesthetic disorder. Well, even here experience tells me – and I have nothing else to rely on – that the phenomenal situation of art in this time is not all that new or unprecedented. Experience tells me that contemporary art, even when approached in purely descriptive terms, makes sense and falls into order in much the same way that art did in the past. Again, it is a question of getting through superficial appearances.

"In the present context I would say that the duration of an art-historical style ought to be considered the length of time during which it is a leading and dominating style, the time during which it is the vessel of the largest part of the important art being produced in a given medium within a given cultural orbit. This is also, usually, the time during which it attracts those younger artists who are most highly and seriously ambitious. With this definition as measure, it is possible to see as many as five, and maybe more, distinctly different styles or movements succeeding one another in French painting of the 19th century.

"To this extent art remains unchangeable. Its quality will always depend on inspiration, and it will never be able to take effect *as art* except through quality. The notion that the issue of quality could be evaded is one that never entered the mind of any academic artist or art person. It was left to what I call the 'popular' avant-garde to be the first to conceive it. . ."

Clement Greenberg is not only a critic, as I have said, he is also a phenomenon, and a collector who wants to understand art must ultimately come to terms with him in both respects. Peter Schjeldahl, a very fine plain-talking art critic, who used to write for the *Village Voice*, but one seldom sees around anymore, said it best in a *Voice* piece on February 10, 1981:

"Sometimes I forget about Clement Greenberg for months at a time, then suddenly I'm thinking about him again. Most of these thoughts are of the useless, compulsive, tongueexploring-a-cavity kind. As the avatar

of Authority in the art of the '60s – that parricidal decade – he was the enemy, and the critics who were not his progeny (and some who were) had it in for him. He had anathematized almost everything in new art, and to claim one's own experience it seemed necessary to battle his ideas. My own aptness for the fray was limited, since Greenberg's rhetoric so intimidated and infuriated me that I could barely read him.

"So I kept on obsessing about him intermittently through the '70s, when his visibility and influence waned drastically in New York. People knew about the informal network of his adherent curators, dealers, and academics nationwide. There were rumors of his do-this/do-that intervention in the work of his favored artists (Noland, Olitski, Poons, Bannard, et al.) and of his unique traveling salesmanship for them – Tupperware parties of collectors in Houston, Denver, Seattle, Toronto, and other country seats. But it became increasingly hard to work up polemical enthusiasm over the tasty painterly cuisine of the colorfielders, and his own writing became a routine of preachings to the converted, carpet bombings of current trends, and assaultive letters-to-the-editor. It all seemed long-ago and faraway.

"But not for me, somehow. At last I studied Greenberg's one – that's right, still his sole and solitary – book of general criticism, *Art and Culture* (Beacon, 1961), and both the wonderful and the fishy aspects of his triumphal march through modern art came into some kind of focus. I still wanted to bust him one for his damned arrogance and presumption – his total depreciation of other viewpoints – but just when I might have tried I became aware of something else, which is that almost nobody reads him any more. Anti-Greenberg rhetoric deteriorated through the '70s to a level of carefree ignorance. A whole generation of art people is emerging that is a lot dumber than it strictly has to be because convinced that it can safely discount his writing."

"It *is* pretty incredible. Radically positivist and formalist at base – 'art in a vacuum', as he complacently allows – his approach brushes aside 'content', subject matter, psychology, semiotics, politics, biography, artists' statements, *everything* except the discriminations of the practiced eye. The result is a quasi-religion of 'quality' – 'quality' down through the ages, observing an inexorable agenda of formal development – with the critics as hierorphant. (When he talks about the 'good' in art, his voice is liable to take on an evangelical tremolo.) What the audience couldn't get over was that it wasn't being asked to think. Quite the contrary. Greenberg repeatedly reffered conceptual questions to 'better minds than mine', mainly Immanuel Kant's."

149

"For Greenberg, there is only one use for art – the pure and intense arousal of what might be called the 'art emotion' – and, in practice, really only two categories of high art: the best – and everything else. No one gets into Valhalla entire, not even his paragon, Jackson Pollock."

"He is a system-maker, and his thought is all of a piece, and tinker-proof. Periodic attempts to retool his historicism – adding a little Freud or a little Duchamp or Wittgenstein or Derrida – don't last long. The option to Greenberg's system is *no* system, a willingly suffered climate of uncertainty with our permanent desire for 'standards' and 'criteria' part of the weather – always turbulent, always unallayed. Reading vintage Greenberg can be depressing because its cocksure lilt contrasts so painfully with one's own usual lack of conviction. Still, it is in just such grinding extremes of discomfort that creativity may find work to do."

The collector, has to ultimately make up his own mind, as I have said. It's clear he can find any number of advisors. Critics are part of the system, and most love to write. Can Greenberg and the other critics help the collector learn to see? I just don't know. They are all very difficult, at least for me. I am interested in understanding the artist, his intentions and the painting, but what I want to know is what is good painting and what is considered bad painting, so I can make a decision as to what to buy, sell and hold. Everyone tells me to buy quality, but is there anyone among the critics who will tell me what quality is? For me, at least, the good critic is one that helps me make that decision.

Harold Rosenberg (1906–1978) was for many years, the counter weight for Greenberg, and a critic that tried to write for that "sophisticated public." His pieces in *The New Yorker* proclaimed the importance of such major postwar figures as Barnett Newman, Arshile Gorky, Jackson Pollock, Franz Kline, Mark Rothko, and Willem de Kooning.

In an interview in January, 1978, in the *Partisan Review* (Fall 1978), he talked about "What is Art?" Clearly, this interview first tells us that few of the critics are really prepared to tell us what is good work and what is bad work. What they do seem to be prepared to do, and here Rosenberg is typical, is to deal with the aim or intention of the artist, and from that, arrive at some kind of value judgment (certainly not a monetary one):

"Tumin: Then what do you mean when you say one of the criteria you look for when you're looking at a work of art is the idea that the artist has, what he's trying to do, and one of the dimensions of that idea is how important it is?

"Rosenberg: That's right.

"Tumin: What do you mean by an important idea? Is it always relevant to the history of previous ideas in the world of art?

"Rosenberg: The phrases that you add are helpful, at least in the approach I'd like to take. The history of art, especially in the last couple

150

of hundred years, has touched on almost every conceivable form of thought, on physics, on social problems, on psychological problems and all kinds of things regarded as intellectual activitis. Now, some of these problems, or areas of thinking and imagination, are basic to human life. Some of them are much less so. For example, it's very important to consider the effects of blue in juxtaposition with red.

"Tumin: Important for whom?

"Rosenberg: Well, it's important in general. I mean it's a form of knowledge to understand the optical effects of color."

"Rosenberg:*** Let me give you an apt example of the answer to this question. If you compare the aims of Barnett Newman and the aims of Josef Albers, the first is involved with the question of the absolute in relation to man, and the second is involved with color relations. This is very clear.

"Tumin: So one is more important than the other for art, all other things being equal.

"Rosenberg: All other things can't be equal.

"Tumin: I knew I would get that. That is, all technique being equal.

"Rosenberg: They're both very good painters.

"Tumin: They're both very good painters, but let's say, if you can imagine for a moment all other things being equal, but one painted the best he could paint about the meaning of color and the other painted with an equally good quality about the meaning of absolute *angst*, would you now say that the latter was a better painter because the idea was more important?

"Rosenberg: But I wouldn't care whether he was a better painter, because you've established that as painters they are equal. What I would say is that I would be much more interested in the paintings of the one than I would in the paintings of the other.

"Tumin: I don't want your interests. Would you say that one is more important? Is one more important for art than the other?

"Rosenberg: I would say so, yes. I would be inclined to agree with Newman, by the way, who said this, that the subject matter of the artist is the most important thing to consider about his work. And if the subject matter could be conceived as having a relation to the experience of the absolute, I would regard that as more important than, shall we say, insights into the relations of blue and pink."

After all of this, we have from Harold Rosenberg a value judgment: Rosenberg says, yes, Newman is a better and more important artist than Albers. While I respect Rosenberg and his views, I would disagree. I think that Josef Albers is a better painter, but then, the market and the marketplace, agrees with Rosenberg. Newman's prices, equal size, date and media, are at least four to five times the prices of Alber's work.

What I think this critical analysis indicates to the collector is that quality, that cherished goal of all collectors, is, in the end, how the art world values the status of the object or the artist in relation to its sense of what will be demanded by others. Simply, who is more famous, Newman or Albers, and who will remain more famous in twelve to twenty years, given the workings of the art historical process?

Generally, then, let's summarize what the collector can and cannot do to find what he needs to help himself from the critic. At the most mundane level, there is the art reviewer or art journalist, someone who is concerned with a regular round-up of current exhibitions usually published in a daily newspaper. Pressure of space, combined with a fundamental inability or unwillingness to decide what are the priorities worth emphasising in any given review, often mean – in the United States, at least – that the results are distressing. Unless one does extra work and follows up on the artists, this kind of information will only state that a particular exhibition is being held, and no more. No one should consider such an article as anything other than something like a listing on the sports pages.

If critics write where they have more space within which to develop an argument then the reader has more of a chance to see if their viewpoint is worth considering. This is, with few exceptions, the only criticism worth taking seriously.

Let's see how this system of readjustment of the reputation of an artist is working in the art world of today. Jed Perl, in *The New Criterion*, February, 1986, gives us his regular round-up of current exhibitions. He obviously can't miss that most important Jennifer Bartlett Retrospective at the Brooklyn Museum. We know her "star" status is in trouble with the opening lines: "The Jennifer Bartlett Retrospective at the Brooklyn Museum left me with about as much of an impression as a soap bubble after it's burst." Now, we start to see the readjustment of the label and its rating.

Perl is certainly descriptive of the whole process:

"I always find Jennifer Bartlett's shows peculiar experiences. I have the sense that most visitors to her exhibitions are really feeling lost; you never see people locking into a painting – they just bob through, glad to be participating in a blue-chip cultural experience. I don't think Bartlett's work is meant to be looked at; it's just fodder for the art magazines and the corporate collections. Like all the recent superstars, Bartlett presents a problem for the critic. The proper job of the reviewer nowadays is to register minor reservations about the establishement heroes; critics are here to prove we don't accept the dealers' creations wholesale. It's fashionable to say Bartlett has had her ups and downs, but to return from Brooklyn and say there was nothing there is in a sense to exclude oneself from critical discourse. How can something so written about be so worthless? The writer who says this is defining himself as a kook – and I certainly don't want to get that reputation. I have a painter friend who argues that there's no point in writing about an artist like Bartlett. My friend's theory is that no matter what you say it just ends up as more copy, more square inches of glorification. I think she's got a point. To

criticize Jennifer Bartlett is to acknowledge the existence of something that, from an aesthetic point of view, doesn't really exist. And yet to ignore Bartlett is to leave yourself open to the accusation that you're living in a dream world. I'm not really sure what the answer is. But if taking Jennifer Bartlett seriously is a prerequisite to critical sanity, I'll gladly sign myself into the loony bin."

To me, Jed Perl says it all. I am not really sure either what the answer is, but that's the art market, and to play this game, one might as well understand the rules as set down by the critics. Be cautious and remember my questions:

(1) Who is the writer and why should I take advice from him?

(2) Does the writer set forth his reasons for his criticism, or is he an advocate for a certain kind of work to the exclusion of all others?

(3) Does the writer set forth the basis for his value judgments, and what place does his taste play in this judgment?

(4) Is he a kind of art historical instructor, who gives me the facts upon which I can base my own conclusion if I disagree? and,

(5) Is he the kind of writer who will make a judgment and offend the artist, the dealer, the museum, and the system if he thinks it is warranted, or is he the kind of writer who never makes a judgment and never offends?

"It is awfully important to know what is and what is not your business."

Gertrude Stein

VI

Auction Reserves

The art world was shocked at the revelation that David Bathurst of Christie's lied about the actual sales of the Impressionist pictures of Dimitry Jodidio at auction in May, 1981. "His crime," said Casandra Jardine, "was to have done what every other auctioneer does – and to get caught." The controversy soon spilled over into the auction system itself over the existence of something called the secret reserve.

Axiomatic to the concept of the auction is that the property being sold goes to the highest bidder. But is the bidder really bidding in an open auction? The centerpiece of all the talk was the practice called the reserve. Simply stated, the auction reserve is the minimum price a consignor is willing to take for a piece he is selling at auction. Without the reserve, the auction could not function because sellers would not dare consign their merchandise without some protection. The consignor is, of course, always worried about the possibility that he might get very low bids. He wants at least what the property is worth, or an amount that is equal to its fair market value. He worries about the imperfections of the system, and without the reserve he will not consign, at least that is what the auction houses argue.

The reason for the reserve, historically, is that it has long been felt that a seller should not be expected to put his art or antiques into a market as unique and as undependable as the art market without a minimum price at which it could be sold. The reserve system has been used in Europe and England on a regular basis for centuries. In America, it is relatively new. For example, when Parke-Bernet Galleries began operation it refused to sell property that had a reserve. Of course, at that time, the business was local and the customers were mostly dealers, not collectors or consumers.

When the New York auction house was bought by Sotheby's in 1964, it dropped its resistance to reserves and embraced the reserve system as practiced in other parts of the world as standard policy. Today, it is rare to find an unreserved auction, except for general merchandise country auctions.

The problem with the reserve is the way it is practiced by the auction houses. The reserve is kept secret from the public, and unless one knows the system, the bidder is generally bidding against the house until the reserve amount is reached. This secrecy has the effect of making naive and less sophisticated collectors believe that they can get a bargain on a certain item. When confronted with a bid that is

below the estimate, they bid thinking that they might actually get the item at less than the auction house estimate.

The problem is in understanding the nature of the reserve and the nature of the estimate as stated in the catalogue. The reserve is a secret, but we are told that it is usually set by the auction house at around ten percent or so below the low end of the estimate. The estimate is what the auction house believes the item is worth in today's market. This is obviously an opinion, and like all opinions, it depends on who makes it. We are not told if it is an opinion with a basis in fact, or an opinion which represents the auction house's desire to get business away from their competitors, or for some other reason.

This confusion between the secret reserve and the estimate has become more and more of a problem as the auction houses reach out for the less sophisticated collector, and go more and more retail rather than wholesale.

There is a sense of unfairness in the process because if there is competition among live bidders below the reserve, the auctioneer makes the next bid as if it is "off the wall," as it's called on behalf of a fictitious buyer. These bids are disguised, and confuse even the veterans of auctions.

Some auction veterans claim it can be detected, but I have a tough time distinguishing real bids from "off the wall bids." The less sophisticated bidders are confused, and believe they are bidding against a live buyer. With the excitement of the auction room, this potential buyer keeps bidding against the auctioneer, and the auctioneer's job is to keep this process going with as much enthusiasm as possible until the reserve is reached, and thus sell the item. Since only the consignor and the auction house know the reserve, this creates a demand that does not exist, other than by the auctioneer, with his "off the wall" bids.

In any other consumer business this situation would not be tolerated, but here most buyers know how the system really works so there are few complaints. Nobody knows how many collectors go home from an auction not understanding the reserve and the "off-the-wall" system. Certainly, at best this is manipulation of a market, and in the stock market would be illegal. If stockbrokers, in making a market, enticed the buyers to buy a stock with "off the wall bids," and not from real clients, they would soon find themselves in real trouble with the Securities and Exchange Commission.

Ralph F. Colin, a great lawyer, who recently died, was the single greatest force in cleaning up the ethics of the art dealers in the United States. He created the Art Dealers Association of America which has been fighting the secret reserve for years as being both illegal and unfair.

Auction houses and their officials, on the other hand, look on the secret reserve as an ingredient essential to the vitality of their business. They feel that the reserve system offers protection to the seller (their client) and while it may be an imprudent system, they claim that without it there would be no auctions at all and they have been doing it, at least in Europe, for generations. Their view of disclosing the reserve before the sale is that as a result people would simply not bid above the level of the reserve. The upshot of this would be that the auction

155

business would immediately become a retail business, which it is becoming in any event.

The auction houses profess that if the reserve is made public, it would not be a reserve, but rather a price tag placed on the item for sale. At the heart of the hidden reserve is a practice very dear to the auction business: tempting the bidder with the possibility of buying at less than market price. In a sense, the auction business relies upon the wholesale rule of never disclosing the rock-bottom price, in order to make the buyer think he is getting a bargain. And if reserves could be construed as price tags, then that would take the mystery out of the auction, reduce the hype, and kill the auction business as it is operated world-wide today. Auction houses do hundreds of millions of dollars of business each year, and they have a lot at stake in maintaining the existing reserve system.

The auction houses also argue that because of the global nature of a sale, reserves are variable up to the day of the sale (despite the fact that the consignor's contract requires that reserves be set three days before the sale). As a practical matter, they also say that they are unable to disclose the reserves in the catalogues. Others say that publishing reserves would serve to discourage attendance at the auctions.

This is of course nonsense. All business works best for all collectors and consignors when there's full disclosure of what is really going on. If fair market value requires an element of knowledge on both the buy and sell sides, then full disclosure is the only way to set a real market price. If, as the auction houses argue, the sophisticated know that the reserve is ten percent or so below the lowest estimate, why not advise the less sophisticated of this and merely announce at the start of the bidding on each item the lowest price that the consignor will accept.

While not going as far as I think it should, New York City's Department of Consumer Affairs has proposed a new regulation requiring auction houses to announce immediately after bidding if a work of art has not sold, thus ending the common industry practice of leaving the results of sales unclear at the end of a round of bidding. This measure still does not abolish the secret reserve system.

By going retail the auctions will in the end probably have to conform to retail consumer rules. With fair disclosure of selling methods and prices becoming commonplace among retailers, once the consumer agencies get up the courage, they will make them do it as a matter of good consumer policy. The auction houses should clean up their act before they are forced to do it. It just might give them a dose of long-overdue humility.

While there has been a lot of gossip about the use of inflated reserves to establish new price levels for works of contemporary artists, it is mostly overblown, as the auction houses are careful to ensure that the practice doesn't occur. Auction houses want the lowest price to sell the item and they have no interest in helping contemporary dealers hype their prices for new or even established contemporary artists. The competition today is too great for anyone to be fooled by this old ploy. If the auctions can get the item away from the dealers, they will generally price it at market, not some inflated market figure in order to help the dealer.

The other old piece of gossip is the belief that consignors bid for their own work to push up the price. This is illegal, and the auction houses try to police this area with a heavy hand. The auction houses' sales contracts forbid this practice, and it is not a real problem. The risk involved would be too costly with the buying commission as well as the selling commission.

In general, if a market is simply defined as an arrangement which enables interested parties to consider the possibility of exchange – art for money, and money for art – then the auctions serve a useful function as a central place for these arrangements to take place.

The auctions may have to increase the costs of operating this market since they will learn that an average mark-up of approximately twelve to twenty percent is not enough to operate a successful business. Their gross margins are too small to do what they hope to do without having the chaos of a rich man's bazaar many times a year, and without the blockbuster sales and multi-million dollar pictures. If a big sale fails to find buyers, their gross margins disappear in one evening rather than if they priced for the service they render at a reasonable cost. The costs of the catalogues alone can hardly sustain the commissions auction houses charge, if items don't sell. As they will learn the retail market is not expanding at anywhere near the rate they believe.

Their position is somewhere between being wholesale dealers to the art trade, and being a retail establishment like Bloomingdale's. Now, with all their hype, they have opted to appeal only to the rich and famous. This will prove to be a mistake in the long run, given the potential they have to bring real liquidity to a marketplace that needs a regular method for dispersing art objects.

With the sophisticated instruments available today, auction houses could operate this marketplace on all levels, offering the dealers a source to replace their stock, and collectors the liquidity to dispose of items they no longer want. However, they would have to change their attitudes toward both dealer and collector and also be less interested in setting records and in their competitors' sales figures.

The auction house is the single most important ingredient in the art market system as it exists today. Auction houses could become even more central if they were to recognize that it's to their benefit to act as a stabilizing force, rather than as a force that gears the market toward unsophisticated collectors by becoming retail dealers, thus putting the retail art dealers out of business.

Exercising a little restraint of their potential power might go a long way to ease this conflict. It's not a bad system, it stabilizes the market and is a potential force for greater liquidity, but it should operate with nuance rather than with sale after sale of mediocre pictures at higher and higher prices which they continue to advertise as major "blockbuster" sales.

"What has it had to do and what has it had not to do and how does one know one from the other, know what it has had to do from what it has had not to do."

Gertrude Stein

VII

The Burned Picture

The single most difficult problem for collectors who either buy or sell at auction is the fact that auction pictures become tainted in the eyes of the art world. When an item to be sold at auction fails to reach its reserve it has been "burned." When an item has been recently purchased in an important sale and the world knows what the purchaser paid for the item, it is also considered "burned." In the first of the two situations, the auction house needs to fill up the sale and to do so it often places unrealistically high reserves on the merchandise up for sale.

In the past, and sometimes today, if the reserve demanded is completely unrealistic, the auction house will refuse to offer the item. But today, the auction usually takes the item, hoping to get the reserve reduced the night before the sale. Or, the expert talks himself into believing that it can be sold, not being aware of what the market is really like.

The auction business of today has become like the movie business, people will believe whatever will suit their business purpose. I remember attending screening after screening of films at a laboratory I ran for the movie industry. Into the screening room would come the producer and his colleagues. In almost every case they were convinced that they had the most important picture of the year. Since they made the picture with a lot of someone else's money, were they going to admit it was a disaster? Of course not, as far as they were concerned it was going to be the greatest picture of the year.

The auction house has become like the movie business. The expert needs to fill up the sale, prices are high, dealers and collectors are in hot pursuit of good pictures, and if they have to tell the consignor it's a great picture, who knows, maybe they are wrong, maybe the market will surprise them. The auction house personnel are also under tremendous pressure to exceed the previous sale in total dollar sales, so they don't mind taking a chance on a picture. However, like the Hollywood studio that has to pay for the disaster of its so-called expert producers, the collector pays dearly in having a picture "bought in" or "burned." It usually takes a long time for anybody, even a desperate dealer, to sell this picture at any price.

The market always wants fresh and untainted pictures. A burned picture cannot have a realistic after-market, unless the price is reduced quite substantially, or it's held for at least ten years before it is put up again at auction. Maybe a dealer can move it out, if he can come up with a good enough story as to why it didn't sell.

Perhaps a truly astute collector will not be influenced by the fact that a certain work is "burned," recognize its real worth and recognize it as a bargain.

Especially with important pictures, the auctioneer will sometimes contact the underbidder or go through the dealer network to find a buyer for the picture at a price lower than the reserve. If it is a good customer who's been "burned," (an estate or lawyer or trust company that the auction house hopes to do business with again), it will waive its commissions in order to make the sale. It used to be that a burned picture could be resold in two or three years. Today, with a big name picture, it's closer to ten years, and a less noteworthy picture might reenter the auction market after two or three years.

One can only attribute the failure of certain items to sell at auction to the chemistry of the art world. Today, it often happens because the reserve is set too high. However, there are many other factors that can contribute to an item being "bought in" at an auction sale. Rumors about the item can kill even the best picture, or the condition, authenticity, the reputation of the owner, or sometimes it's just the weather on the day of the sale.

The dealers certainly don't help matters. They see themselves as the enemy of the auction house, and will do almost anything short of outright libel to hurt an auction house sale. In the market today, there are a few key dealers who make it their business to talk down a picture, as long as they can do so without creating too many problems for themselves.

Collectors also love to gossip, and they will frequently talk to their dealer about such and such a picture and what in their opinion is wrong with it. Some will even send telegrams from Switzerland, claiming something is fake, with no basis in fact. A good example of this is the Mark Tobey market in America which has been killed by a group of Swiss collectors and possibly dealers who are prepared to slander any Tobey that they don't own. Once in London I tried to get one of these mysterious experts to make a statement in writing in America, so that I could sue him, but of course, he disappeared when confronted by this threatening request. I am still waiting, and am on the lookout for this Tobey clique to surface in the United States. When it comes to other people's pictures, dealers can raise doubts about a work's authenticity and spread other vicious rumors.

If a collector really wants to sell at auction and not have a picture "burned" he must set a realistic reserve, and ignore the auction house expert, because he probably knows less about the market for your picture than you do. If one encounters art world gossip on his picture, he should consult a good lawyer fast, or his picture will be burned in the marketplace forever.

The newest type of burned picture is the case of a picture bought at auction by the collector at an unrealistic price. While it can be argued that if a knowing buyer and seller consent to engage in a transaction, whatever they agree upon is the fair market value. The point is, however, that this picture bought has been hyped to a price that is higher than it should be, were it not for today's auction marketing system. This price is artificial and not a realistic reflection of the market.

This is not to say that dealers don't do the same thing, they do. And many

collectors (myself included) could tell stories about the pictures they bought from dealers at artificially high prices. But with the dealer at least the buyer can go back to him and try to get some of his money back, or can, in any case, take his loss privately without a great deal of embarrassment. At any rate, these types of dealers don't stay in business for very long, and that at least protects the future collector.

In auctions, one has little or no recourse, except to wait it out, and hope the market will catch up with his own stupidity. The situation today is that many people will be prevented from becoming serious collectors once they've been burned by an artificially high-priced picture. Also, the art world knows about every purchase because the price is set in Mayer, and in the other numerous auction guides for that year. One has no recourse but to keep this picture for a long, long time before he can even get his money back.

If one intends to buy at auction with the hope of selling and making a profit in five years, the chances today of success are very slim unless he can recognize true bargains. And that's only if one pays a realistic price. If this all sounds depressing, then one should not spend any money, unless he spends some time understanding what he is spending it on. This is the real world of collecting.

"The painting may be good it may be bad, medium, or very bad or very good but any way I like to look at it."

Gertrude Stein

VIII

Fakes, Attributions and the Collector

The issue of authenticity in collecting can be discouraging and one must exercise great caution at all times. Given the current state of the investment market in general and the propensity for fraudulent investments in everything from mortgages to real estate, art investments don't seem so risky.

To say that the art world today is similar to the old days before the stock exchanges became regulated is an understatement. This field is populated by many who are out to take advantage of those who let their guard down for a minute, or even a second. The old master field is dominated by the word "attribution." The codes used to describe pictures in the reputable auction catalogues for old master pictures are themselves works of art requiring inside knowledge and interpretive skills.

Each catalogue from each auction house, as to warranties, is different and must be read by the collector very carefully. But generally, if a work of art is definitively *by* an artist it is listed in an auction catalogue with the artist's full name. If a little star or mark or other notation appears in front of the name it is "ascribed" to the artist, but this really means that it's probably not by that artist at all. "Attributed to" means it's positively not by the artist named. For example, a painting an auction house believes has been painted by "George Inness" must say "George Inness," and nothing else, in bold type. This is the highest category of authenticity offered by the auction house. In practical terms, that doesn't mean much. While the auction houses say that such an appraisal is their most definitive judgment, and that they will guarantee a work's authenticity for at least five years (in the case of Sotheby's, six in the case of Christie's), because of the limited nature of this guarantee, a buyer would probably have to sue to get his money back. Also, if the work is sold the guarantee may lapse.

The other exclusions are quite severe, and it would be unwise to rely solely on the auction house's guarantee. The rest of the descriptive facts given in the catalogue, such as to date, signature, size, etc., are also unreliable, and they are not even guaranteed by the auction house terms, which mean very little anyway.

For pre-1900 pictures, one must be a real expert to buy confidently at an auction house. In post-1900 paintings, the question of authenticity is for obvious reasons not nearly as complicated. Auction catalogues rarely list mistaken information as to authorship on modern works. The practice of sending auction catalogues to art historians, critics, and dealers protects the buyer since the art world grapevine usually picks up a mistake long before the sale takes place. Dealers who

specialize in certain areas love to catch the auction houses in an attribution or description error, because they consider the auction expert in their specific field to be their mortal enemy.

Recently at Sotheby's, New York, there was a work signed as "C. H. Pain," the name the owners deciphered in the corner of the canvas. Because of the work's size and subject, it was put into one of the auction house's minor sales. It was catalogued with the unknown Pain's name and estimated to sell for $2,000–$3,000. When the sales catalogue was printed and distributed, however, Sotheby's was flooded with calls about the painting. Michael Owen, a Sotheby's expert, took a closer look and recognized the work of one of America's best Pennsylvania folk painters, Charles C. Hofmann. The cryptic "C. H. Pain" was thus easily accounted for: Hofmann generally signed his works with his initials and noted his profession. The painting was immediately withdrawn from the sale, only to reappear a few months later with a new lease on life: it became a highlight of Sothebey's most important Americana sale and even its estimate of $40,000–$60,000 was far too conservative. The painting finally sold for $126,500.

But auction houses are only half the problem, the dealers are the other half. To my great embarrassment, I once bought a Dali watercolor from what I thought was a very fine English art gallery. I had it around for a while, and then put it into an auction. The piece was in what I though was a classic Dali frame. However, when the auction house cataloged it, it was taken out of the frame, and it turned out to be a well-framed reproduction.

When buying drawings and watercolors, one must take them out of the frame. If there's the slightest doubt, one shouldn't buy. If one buys from a very reputable dealer who has been around for a long time, take the piece home and unframe it so as not to embarrass him. If one is buying in Boston – the home of some of the newest notorious fakers – the piece should be taken out of the frame before it is paid for. In galleries away from one's home base, it is always necessary to unframe pieces. Otherwise one can never be sure of getting his money back. With dealers, it's always a question of reputation: well-established dealers do not sell fakes or misattributed pictures in my opinion. New galleries, and galleries off the beaten path, may or may not sell unauthentic works. The best rule is simply to be very careful.

One must be especially careful when buying prints, unless from a well-established art gallery with a good reputation. In Chicago, I ran into a gallery that gave fancy "certificates." These were promotional devices, not certificates of authenticity. If one buys from an established gallery, he is given an invoice of purchase, and full disclosure of all the facts about the object. Full disclosure can be in the form of various documents of prior purchase, establishing a chain of ownership in the current owner. The gallery generally also tells the buyer if there is anything odd about the picture. For example, even Picassos have been relined or restored, and this should be stated on the invoice of purchase. The dealer will generally be straightforward if he is reputable. If he is not, then one has no alternative but to hope that he is there when the buyer wants his money back. Most

reputable dealers stay in business only because they stand behind what they sell, with respect to everything except price.

The auction houses in this country are very helpful, all one has to do is call them and ask for the expert in charge. If a collector tells them what a work purports to be, they can generally steer him to a catalogue resource or some other helpful documentation. When it comes to fake labels or fake documents, the only protection is to carefully check some of the provenance information by making some telephone calls. Other dealers are also helpful. The art world hates fakers, most people will be cooperative in checking a work's authenticity. If one had doubts, he just shouldn't get involved at all.

One should be especially cautious of provenances on smaller items, as this seems to be a new area of faking. One should ask for the name of the previous owner, and call him. If the dealer refuses to supply proof of authenticity, then one should not buy. Reputable dealers in big cities as well as in Boston will generally have the proper documentation for anything they sell or they would not be selling it.

At secondary auction houses, or marginal dealers, it all depends on the nature of the work. They try to be as careful as they can, and the dealer system works fairly well in checking the auction houses. But most of them don't know, and don't have the expert talent to really check out an item. One should be careful, since there is often a lot of time between when the catalogue is received and the auction date, in which to do some research. Caution is the rule for buying at secondary auction houses.

If a buyer is in doubt, he should ask for documentation. If it's not available, then he shouldn't buy it. With smaller or secondary dealers today, one has to be very sure. No one should pay until he is completely satisfied with the work's authenticity.

The word provenance simply means the sale and exhibition history of the work of art. Art works take on a reputation, as they move through their sale and exhibition periods. When reading an auction catalogue, most people are startled at the beginning by the detailed exhibition and ownership records of a work of art.

In order to see what good documentation consists of, one needs to look at a lot of catalogues by auction houses or dealers. Each step in the sales or exhibition history of an object is spelled out in the catalogue. This documentation, which includes the names of previous owners, the names of the exhibitions in which the work appeared, and the location of the painting accompanied by a reference or a reproduction and even a bibliography of the period or the artist. Today, however, art historians are fighting over a chance to modify the records with additional insights into the work of named artists.

Sometimes even the best experts can be taken, or were they? In an article in *The Economist* for December 14, 1985, there appeared the following:

"Is the most expensive picture in the world a fake? The J. Paul Getty Museum in Malibu, California, is putting a brave face on it as, indeed, it must, having shelled out a record $8.1 million last April for Mantegna's 'Adoration of the Magi'.

So highly regarded was this painting that Britain's then arts minister, Lord Gowrie, delayed the issue of an export licence in order to give the National Gallery of Scotland, where the painting hangs, time to raise enough money to keep it in Britain. Mr. Timothy Clifford, the enterprising new director of the gallery, managed to raise over half the sum – but time was running out even before a new controversy erupted over the painting's authenticity.

Mr. Peter Collins, an art historian, threw a grenade in the ring on December 4th in a lecture in which he branded the painting a forgery. Mr. Collins reckons that a number of details in the painting are historically inaccurate. He is also suspicious of the fact that, apart from one of the magi in the foreground, none of the figures overlaps with another and that it is unlikely that Mantegna would have executed so unsophisticated a composition. He concludes that the painting was probably the work of Bianchi, an Italian restorer who worked on the celebrated Mantegna frescos in the Camera degli Sposi in Mantua in the 1870s.

'The Adoration of the Magi' belonged to the Baring family in the nineteenth century and was inherited by the present Lord Northampton. Its earlier history is uncertain but the painting is so well executed that other scholars, including Mr. Ronald Lightbown of the Victoria and Albert Museum, have no doubts that it is authentic. They have dismissed Mr. Collins's claims as a futile, publicity-seeking exercise.

Meanwhile, Mr. Clifford at the National Gallery of Scotland has conceded defeat in the quest to keep the painting in Britain. One question: if it is good enough to convince the V & A and the boys at Malibu, is it not worth all the brass even if it is by somebody else?"

Art historians, and some dealers, consider it the ultimate in one-up-manship to publish a *catalogue raisonné*, and list a work as being of disputed authenticity. I remember a dealer in London who had a painting he believed was by Egon Schiele, the Austrian painter. Out came the *catalogue raisonné* by Doctor Leopold, an eye doctor who had devoted his life to studying Schiele. The dealer's picture was labeled doubtful, and the picture was now basically worthless. If a collector had bought this picture from the dealer, he would have at worst a burned picture, and at best a lawsuit if he lived in the U. S. to get his money back.

Art historians, looking for the ultimate in accolades, attempt to challenge several pictures in an established *catalogue raisonné*, so that they can become the new authority in the field. It's not the competition I object to, it's their loose tongues.

The best reported example of this kind of "loose tongue" art criticism, was practiced by Joseph Duveen. Duveen was asked by a reporter of the *New York World* to give his opinion on a painting entitled "La Belle Ferroniere," which had been offered by the owner, Mrs. Hann, for sale to the Kansas City Art Institute as a Leonardo da Vinci. Duveen, although he had not seen the picture, told the world that Mrs. Hann's picture was a copy of the same picture of the same name which

hung in the Louvre. In the tradition of our current art dealers, Joseph Duveen loved to gossip. The fact that he had no reason to defame this picture did not deter him.

Our current art dealers have the same problem. They either fail to understand the nature of what they are doing to someone else's property, or they just can't resist good gossip.

Sometimes they are just incapable of restraining themselves when it comes to getting involved in someone else's business. Usually dealers are honest and helpful, as when they work with an auction house in clearing up doubts or questions about provenance and so on. Word of mouth can sometimes protect a buyer. The kind of gossip I am complaining about is like Joseph Duveen's, and arises out of little or no knowledge of the work of art in question.

Joe Duveen went further than most art dealers fo today, he confirmed his opinion in writing to the museum in 1922, and was duly sued for slander of the picture by Mrs. Hann, a case which dragged on for almost a decade.

In the end, if one has a picture which is signed, has a confirmed date, and passes the critic's stylistic standards, the painting is considered authentic. Unless substantial new documentation comes to light which changes the attribution, then that, too, is an opinion, and nothing more. Opinions change, and in the old master field, they change constantly. With old master pictures, or pictures older than 1900, the collector has to be an expert or buy from an expert or a reputable gallery.

With twentieth century work, the real potential for damage comes from gossip or dealers who spread slanderous rumors about works of which they have little or no knowledge. Authenticity is generally not a problem with twentieth century works, as the art historical system for validation works quite well. In the end, Joe Duveen paid up for slandering Mrs. Hann's picture, and if any collector is the victim of a Duveen-type slander, he should see a good lawyer, since he will probably either get a retraction or damages from the court.

"Knowledge is the thing you know and how can you know more than you do know."

<div align="right">Gertrude Stein</div>

<div align="center">IX</div>

Taxes, Taxes, and More Taxes for the Collector

Tax policies affect virtually all of our behavior when it comes to the utilization of money. Spending money to buy art is a decision that involves taxes one way or another. For the collector, this involvement manifests itself in three distinct areas. These three tax areas are: the deductibility of your expenses associated with collecting; income from sales as capital gains, and the tax shelter potential of gifts in kind to museums. The first concern I will discuss is the issue of treating his collection as an investment, and therefore deduct the expenses associated therewith. This is the famous Wrightsman case.

In this case, the court ruled that Charles B. Wrightsman and his wife, Jayne Wrightsman, were not "art investors" despite their claims to the contrary, and therefore were not entitled to the type of tax benefits given to investors in securities, real estate and other assets. This was a classic case involving wealthy, serious art collectors who claimed income tax deductions (including travel and entertainment expenses on their buying trips to Europe) based on their art purchases and collection.

The IRS claimed that the plaintiffs were entitled to deduct expenses only by showing a physical segregation of works of art that precluded personal pleasure. In a split decision, the court found that

> "the evidence does not establish investment as *the* most prominent
> purpose for plaintiffs' acquiring and holding works of art. The complete
> record *does* establish, to the contrary, personal pleasure or satisfaction as
> plaintiffs' primary purpose."

The problem, then, is of proving that one is an art investor. To do so one must demonstrate that art is not an incidental part of his net worth but rather is an essential component of his investment activities. A number of techniques could be cited as evidence of this intent: holding artworks in storage because one chooses not to show them in his house; obtaining and paying for art-investment advice; keeping up-to-date statistics on the value of whatever art is owned (just as one would for securities); and periodic buying and selling (as opposed to holding works for long periods). Also, whatever steps one takes to increase the value of one's artworks – lending to museums or traveling exhibitions, for example – might help demonstrate investment motivation to the IRS. Should a taxpayer go so far as to set up a separate investment corporation to convince the IRS of his investor status? It isn't advisable, since it would involve additional legal and accounting fees and create further tax problems. As to whether a taxpayer is an investor/collector or a

so-called hobbyist, the rules are very murky. At the one end, the courts seem to take the position that you can't be an investor/collector if the work he buys is located in his home, is used as decoration and for enjoyment. At the other end is the fact that most investor/collectors hang their pictures at home and deduct their expenses anyway. The rule is somewhere between these two extremes. In any event, this rule affects only the deduction of expenses for such things as transparencies, catalogues, and the like, which are generally of no substantial consequence to most collectors. Most collectors wouls be better off discussing these problems with their own accountats in order to get their individual situation exactly covered before they take these expenses as deductions.

For tax reasons, it's also important to consider whether the property purchased is capital gain property, that is, property which is not held in connection with a trade or business. If it's trade or business property, it's ordinary income property and not capital gain property. Furthermore, if it is capital gain property, then the taxpayer is able to take advantage of the rules relating to appreciated property. These same appreciation rules work to the collector's detriment in the case of gifts during his lifetime, or at the time the collector's estate is valued for estate tax purposes. All of these areas are complicated and the details are best left to lawyers and accountants. From the collector's point of view this means that he should understand the basic workings of this system, because it can have a lot to do with how a collector deals with his collection in practical terms.

The matter of capital gain property is quite simple. If the collector is in the business of buying and selling art as an art dealer, then he is in a trade or business and subject to ordinary income tax rates. Capital gain property is art that one buys and sells as a collector, investor, or trader, in a transaction for profit. If one holds art for sale to customers in the ordinary course of his trade or business, he is a dealer, and such property does not benefit from capital gains rates.

The topic of appreciated property or income, gift and estate taxes is one that all collectors who wish to make money in the art market must become thoroughly familiar with. It lies at the heart of a system, which from an economic point of view gives the American collector an advantage over his European competitors. The judicious use of the allowed system under the current tax laws allow one to refine his collection, poisition himself as a leader at a museum, and sometimes make more money from giving rather than selling, because not only does he get a deduction of the appreciated fair market value, but he doesn't have to pay any capital gains tax on the gift to a bonafide user museum. These gifts in kind are clearly tax shelters or tax subsidies for the collector during his lifetime or after his death.

History of the Deduction

Contributions of property to qualified charitable organizations have been deductible under Federal income tax law since the enactment of The Second Revenue Act of 1917. During the intervening years from 1917 to the present, Congress has enacted amendments to the above provision on at least twenty-six

separate occasions. As a result, Section 170 of the Internal Revenue Code of 1954, as amended (which now controls the income tax charitable deduction), bears little resemblance to the original language of the 1917 ruling.

There is a sharp contrast between the original statute and the present Section 170 in terms of sheer size and detail. In addition to the amendments since 1917, there has been a similar increase in the volume of interpretive Treasury regulations, which have burdened the statute with a degree of complexity which is more than proportional to the change in its length. While this means more business for lawyers like myself, it is bad business for everyone else.

Original Justification for the Charitable Deduction

The Second Revenue Act of 1917 sharply increased income tax rates to realize the funds needed to finance America's entry into World War I. Congress was understandably concerned that this step might curtail private support of public charities. Proponents of the deduction viewed private donations as coming from the "surplus" of an individual's income, which would be eliminated by the substantial income tax rates about to be imposed. Should the flow of private support dry up, it was argued, these worthy charitable causes would require governmental funds, generated through yet greater taxation. An adaptation of the income tax to encourage continued private support of charity was suggested as an efficient alternative to governmental support.

In addition, supporters of the charitable deduction also considered that an income tax without a charitable deduction would, in effect, impose a tax upon the charitable organizations themselves. They reasoned that if an individual voluntarily contributed "X" dollars of his income to charity, he would not have the "X" dollars from which to pay the tax on that amount of income; if the donor, aware of this problem, transferred the "X" dollars to charity, less the amount of his anticipated tax on the "X" dollars, the tax would, in effect be imposed upon the charity.

Finally, congressional supporters of a charitable deduction for income tax purposes felt that an individual should not be taxed on that portion of his income that is devoted to charity. This concept presupposes that the income tax should be imposed only upon consumable income, that is, the income left to the taxpayer following his expenses of earning the income and his contributions to charity.

Each of these original theories is referred to today as a justification for the income tax charitable deduction.

Overview of the Statutory Scheme

Today, taxpayers not electing to take the standard deduction are allowed to deduct a portion (30% of their adjusted gross income) of their gifts in kind to charity. In the case of corporations, it's 10% of their pre-tax profit. If the new tax bills is enacted, their deductions will, however, also be preference items in determining the individual's minimum tax. The threshold question controlling the deductibility of a gift to charity, by either a corporate or an individual donor, is

whether the gift is a "charitable contribution." This term is defined in Section 170(c) as a contribution "to or for the use of" any of several classes of charitable donees.

If a deductible contribution has been made, *its value* must be determined and the amount of the corresponding deduction, subject to numerous statutory restrictions, must be calculated. At this point, the process frequently becomes quite complex. The *value* of a charitable contribution is the "fair market value" of the property contributed, which is defined by the regulations as "the price at which the property would change hands between a willing buyer and a willing seller, neither being under any compulsion to buy or sell and both having reasonable knowledge of relevant facts." While theoretically sound, the application of this standard, particularly in the case of contributions of art objects, is a constant source of friction between taxpayers and the Internal Revenue Service.

Since I have recently tried a major tax court case involving such contributions, I am being generous in saying that these types of problems are a source of friction. They are in reality a source of outright hostility on the part of the Internal Revenue Service. This hostility stems from several sources:

First, the IRS believes that all contributions are overvalued. This assumption is, in my opinion, sometimes true. But not for the reasons commentators or the IRS suggest, and this is obvious when viewed by experts. Overvaluation takes place because of the complexity of the system, and the need of donors to run the risk in court of what I have called a valuation lottery. The donor starts high, the IRS starts low, and the judge comes out in the middle.

Second, the IRS also believes that the provisions governing Section 170 and the deduction are not in keeping with what it perceives to be fair tax treatment for all. Although it is hard to get anyone from the Service to admit this, it is inconceivable not to believe that this is their *real attitude*, especially in view of the history as well as testimony of the Commissioner before the Congress during its 1974 consideration of amendments to Section 170 of the Internal Revenue Code.

The Service has waged an effective public relations campaign to convince the Congress and the American public that there are serious overvaluation problems. This campaign has now taken form in the classifying of most charitable deductions of property as an abusive tax shelter. This is the new favorite tax term of the Service in order to send a message to the public to stop doing what the Service considers illegal prior to any adjudication. In the Service's perfect world, rule-making shifts from the Congress to the Service, as a collector of revenue. Everybody who reads newspapers can not help but be impressed by the IRS's public relations.

The point to be made is that notwithstanding the hostility of the IRS, charitable contributions can and will continue to be made by collectors. Now one has to be much more careful about how and where he makes them. Also with the new appraisal guidelines, which became effective January 1, 1985, one must be prepared to justify the amount claimed as fair market value.

This is good for the real collector and bad for those who have been involved in

overevaluating the work they donate. The best advice for this is that in order to participate in this tax subsidy program, one must consult with an expert in the field. An accountant, lawyer, or art dealer can recommend those who are familiar with the process, and steer the investor in the right direction. Many appraisal organizations exist to help people understand the concept of fair market value.

Also, if one wants to do some very creative estate tax planning, the tax rules on appreciated property for gifts and estates afford some interesting opportunities for collectors, that other investors don't have. Again, art as an investment offers some excellent opportunities to substantially improve one's after-tax rate of return.

The rules are no more stringent than those one has to deal with with taxes year in and year out. If one is "tax smart," he sees why few serious collectors ever talk much about charitable contributions. They are good for the collector, and the collectors rightly believe that the less they are talked about the better.

"When I look at landscape or people or flowers they do not look to me like pictures, no not at all. On the other hand pictures for me do not have to look like flowers or people or landscapes or houses nor anything else. They can, they often do, but they do not have to."

Gertrude Stein

X

What to Buy and How to Buy It?

What Can One Buy for a Thousand Dollars?

There is no question that the amount one spends plays a very important part in the collecting process. The rule I use for myself is a very simple one. If the object is under a thousand dollars, it doesn't matter if it is worth nothing in the end. If I like it, and will enjoy it, I buy it. Since the average dinner for two is now about $100.00 in any decent restaurant, this object represents ten nights of dinners out of 365 possibilities. By today's standards, it's money one can afford to spend.

The question, however, is can much good art be bought for under $1,000? I think so.

The charity auction is a good place to seek out real bargains. The reason is that very often, artists, to help the charity, will put some of their less important work, works on paper or prints, into the auction for sale, and the collector can benefit from their generosity. What I consider to be very good buys for the collector in this approximate range of up to $1,000 can be found at such auctions. The collector who is aware of these auctions has little to lose by checking them out. They happen in every city in the United States, several times a year, for many organizations.

Are bargains available there, that is, are items available at less-than-current-market prices? Usually, but not always. It depends on the type of auction and the type of charity. Charity auctions at the big auction houses, like Sotheby's and Christie's, are rarely bargain auctions. As a matter of fact, these usually have items at dealer retail, rather than at auction house prices. The reason for this is that artists, and the dealers who supply most of the work, are afraid of the publicity the low prices will receive. They don't want the work to be considered inexpensive. The offbeat auctions don't pose this publicity problem, so the artists can be more generous. Of course, the corollary is that the collector has to work harder to find these auctions. But he can, if he becomes knowledgeable about the art scene in his city. *Art in America* for March, 1986 lists some of last years' benefit art auctions and their results:

Independent Curators, Inc. held a silent auction on Nov. 18 of 288 works (price range: $75–$6,000) at New York's Puck Building in SoHo, netting $175,000. In this case the artists donated the entire sale proceeds of small works.

The *Washington Project for the Arts* held its sixth annual art auction on Nov. 16 and netted $ 80,000 with the sale of 225 works in a combined live and silent auction.

Fashion/Moda held its benefit Nov. 1–16 at Ronald Feldman Gallery, selling 45 of some 250 works (price range: $ 50 – $ 4,000), for a net of $ 45,000.

LACE auctioned 120 works (price range: $ 200 – $ 4,000) at the Park Plaza Hotel in Los Angeles, raising $ 43,000.

Creative Time's benefit auction on June 18 and Christie's New York included 70 works (price range: $ 500 – $ 20,000), netting $ 35,000.

The *Kitchen's* benefit exhibition and sale at Brooke Alexander Gallery Dec. 13–21 featured works by 30 artists (price range: $ 1,500 – $ 12,000); 10 sold, netting $ 25,000.

ABC No Rio held its benefit auction Oct. 18 at the New York City Department of Cultural Affairs City Gallery. Some 95 works were offered (price range: $ 50 – $ 4,000), raising $ 15,000.

I have taken as an example an auction which took place in New York late in 1985, for a not-for-profit organization. Taking only some of the names that were available, and those that I am familiar with, at this sale one could have found works by the artists listed below. In my opinion, these represented a good buy at or around the estimated price.

Since this was an auction, the prices listed represent the reserve, the lowest amount an item will be sold for, not necessarily what the buyer pays, especially if there is competition for the work. But this gives a good estimate of the market in the $ 1,000 range.

ABISH, Cecile. *Untitled.* 1973. Hydrocal, rubber, wood, metal wire. $ 500
2–3/4 x 19 x 3–1/2

ALLEN, Roberta. *Where A Secret Was Lost.* 1985. Ink on dendril. $ 120
4 x 5–1/2

ALONGE, Carol. *Money Totem.* 1985. Shredded currency, glitter, on $ 400
wood. 10 x 3 x 1

ANDERSON, Lurid. *Mt. Daly/U. S. IV.* 1982. Lithograph. Ed. 18/50. $ 375
22–1/2 x 30

ANTIN, Eleanor. from *The Black Ballerina* series. 1981. Ink on paper. $ 2,500
14–1/4 x 23–1/4

ANUSZKIEWICZ, Richard. *Spectral Square.* 1969. Serigraph. A/P $ 250
20. Ed. 200. 19 x 19

APPLE, Jacki. *The Mexican Tapes: Working Script/Score.* 1978. Mixed $ 150
media. 16 x 20–1/16

APPLEBROOG, Ida. *Study for "Hurry up and die".* 1985. Oil on $ 600
canvas. 6 x 8

ASHER, Elise. *The Studio*. 1983. Graphite, colored pencil, on paper. $ 350
17 x 14

ASTROM, Peter. *Exploration of Long Island*. 1978. Crayon, photo- $ 175
copy on paper. 12 x 11

AYCOCK, Alice. *The Indian World View*. 1985. Colored pencil, ink, $ 1,000
on paper. 17–3/4 x 23–1/2

BAECHLER, Donald. *Study for Schwarzwald*. 1982–85. Acrylic, var- $ 700
nish, on canvas. 18 x 18

BANDY, Gary. *Back Stage*. 1985. Acrylic on canvas, on masonite. $ 800
36 x 26

BARDON, Marcel. *Bathroom Eiffel*. 1980. Cibachrome print. Ed. 7/ $ 275
10. 14 x 14

BARRY, Robert. *Untitled*. 1985 Graphite, latex paint, on paper. 12–1/ $ 500
4 x 13

BEERY, Gene. *I Love You, Big Dummy*. 1985, Oil on canvas. $ 500
Diptych: 10–1/4 x 11–1/4, 16–1/8 x 3/8

BENES, Barton Lidice. *Green Scrub Brush*. 1984. U. S. currency. $ 200
7 x 2 x 2

BENGLIS, Lynda. *Patang Fossil Drawing #118*. 1979. Mixed media $ 1,200
on handmade paper. 27–1/2 x 34–1/2

BEUYS, Joseph. *Trace I* (d, h). 1974. Two lithographs. Ed. 27/98. d: $ 600
20–1/2 x 28; h: 28 x 20–1/2

BEUYS, Joseph. *The Meeting of Lady Rosebery – Black and White* $ 75
Conference, Edinburgh. 1974. Poster. Ed 247/400; 1 of 75 copies signed
by Joseph Beuys and R. Buckminster Fuller. 27 x 34

BIEDERMAN, James. *Josiah's Way*. 1985. Oil on gessoed wood. $ 400
11 x 6

BOSHIER, Derek. *Wake Up America – Get a Fresh Start Everyday*. $ 175
1982. Etching. Es. 1/30. 16–7/8 x 11–3/8

BOWER, Gary. *Homage to the Antique*. 1984. Handcolored litho- $ 400
graph. Ed. 11/20. 24–1/4 x 31–7/8.

BROWN, Earle. *Untitled* (Graphic Score) 1985. Ink on paper. 10 x 12 $ 250

BROWN, Joan. *Portrait of Donald II*. 1983. Lithograph. Ed. 4/20. $ 500
30 x 22–1/8

BROWN, Robert Delford. *Another Map to Nevada*. 1985. Watercolor, $ 250
paper collage. 20 x 30

BULTMAN, Fritz. *Black Grackle*. 1983. Painted paper collage. $ 1,125
14 x 15–1/2

BUTLER, Frances. *Rock Book: Domestic Archeology*. 1985. Mixed $ 75
media. 10–1/8 x 12 x 7/8

BUTTER, Tom. *Ring Bound*. 1985. Fiberglas cloth, polyester resin. $ 1,000
25 x 18 x 16

CAGE, John. *Weathered II*. 1984. Photoetching. Ed. 19/50. 26 x 16–1/2 $ 250

CANRIGHT, Sarah. *Untitled*. 1985. Oil on canvas. 10 x 10 $ 350

CASEBERE, James. *Shooting Gallery*. 1981. Silverprint. 16 x 20 $ 400

CAVALCANTE, Lito. *Untitled*. 1984. Watercolor on paper. $ 750
13 x 19–1/4

COHEN, Arthur. *Baroque Architecture*. 1984. Graphite on paper. $ 300
12–1/2 x 9–1/2

CRILE, Susan. *Pandora Awakened*. 1985. Oil on canvas. 12 x 12 $ 750

EDELSON, Mary Beth, *Movie Couple: Woodcut*. 1985. Handcolored $ 350
woodcut, watercolor. A/P. Ed. 20. 15 x 21

EGGLESTON, William. *Untitled*. 1984 Type-C color photograph. Ed. $ 400
1/3. 11 x 14

FASNACHT, Heide. *Woodpecker*. 1985. Wood. 10 x 8–3/8 x 7–3/8 $ 600

FEDERIGHI, Christine. *At the Piazza*. 1982. Terra cotta, slips, stains, $ 250
low temperature glazes. 15–1/2 x 15–1/2 x 4

FELDSTEIN, Mark. *Nero*. 1985. Silver gelatin print. Ed. 6. 16 x 20 $ 200

FERGUSSON, Claire. *Mondrian*. 1978. Color photograph. 15–1/ $ 125
2 x 10–3/4

FERRARA, Jackie. *DD61*. 1980. Ink, graphite, on graph paper. 16–1/ $ 750
4 x 45

FERRER, Rafael. *Vegetables*. 1982. Oil on canvas. 10 x 14 $ 1,200

FISHER, Joel. *Untitled Drawing (Apograph)*. 1983. Graphite, found $ 300
fiber, on handmade paper. 8 x 8

FLEMING, Linda. *Grove*. 1985. Wood, steel, paint. 20 x 11 x 11 $ 500
(maquette: 1″=1′)

FRIEDMAN, Ken. *Painter*. 1972–73. Assemblage. 9–3/4 x 9–3/4 $ 275

GARABEDIAN, Charles. *C. G. 1985*. 1985. Acrylic, ink, on paper. $ 500
10 x 8–3/8

GERLOVINA, Rimma. *Tom Thumb*. 1985. Acrylic on plywood. $ 100
8 x 6–1/2 x 5–3/4

GIANAKOS, Christos. *Drawing: Double Dutch Series*. 1982. Ink on $ 250
mylar. 8–1/2 x 10–1/2

GIBSON, Jon. *Primordial Relations Series*. 1982. Graphite, metallic $ 100
pencils, on paper. 7–1/2 x 9–1/2

GIERSBACH, William. *Plato's Book*. 1977. Mixed media. $ 150
9 x 13 x 2–1/2

GILBERT-ROLFE, Jeremy. *Untitled*. 1984. Oil stick, charcoal, on $ 700
paper. 14 x 12–1/2

GONZALEZ, Arthur. *Pan*. 1982. Clay. 20 x 16 x 8 $ 850

GRAVES, Nancy. *Equivalent*. 1980. Silkscreen. A/P 7/12. 29–3/ $ 700
8 x 40–1/4

MAYNARD, Valerie. *Hommage to Struggle*. 1985. Paper, paint, $ 150
graphite, ink, gold. 7–3/4 x 9–3/4

MAZUR, Michael. *Wakeby Island I*. 1985. Woodcut. Ed. 15. 25 x 20 $ 375

McCORMICK, Pam. *Jerusalem Gate*. 1985. Enamel, glass, stone. $ 300
12 x 10 x 6

MEYEROWITZ, Joel. *Wowana, California*. 1983. Color photograph. $ 275
Ed. 1/2. 8 x 10

MOONELIS, Judy. *Untitled*. 1984 – 85. Ceramic. 9 x 8 x 6 $ 350

MOORE, John. *House*. 1985. Oil on board. 10 x 10 $ 950

MORELLET, Francois. *Gravure sur bois no. 1*. 1985. Paint on wood. $ 700
10 x 10

MORRIS, Robert. *Liver and Heart*. 198 Watercolor on paper. 9–1/ $ 1,250
2 x 13–5/8

MOTHERWELL, Robert. *Primal Signs*. 1985. Etching. H. C. 10 x 10 $ 600

NAMUTH, Hans. *Jackson Pollack & Lee Krasner, 1950*. 1950. Silver- $ 225
print. A/P. 8–1/2 x 7–1/2

NATSOULAS, Tony. *Bub*. 1985. Ceramic, glaze, paint. 12 x 10 x 4–1/2 $ 175

NEILL, Joe. *Study*. 1985. Ink, colored pencil, on paper. 8 x 11 $ 300

NICKSON, Graham. *Bather with Turban*. 1982. Graphite on paper. $ 600
10–1/2 x 13–3/4

OJEDA, Naul. *Untitled*. 1983. Woodcut. A/P. Ed. 10. 11 x 8–1/2 $ 60

OLDENBURG, Claes. *10 x 10 for ICI icy, eyes)*. 1985. Crayon, water- $ 1,000
color, collage. 10 x 10

OPPENHEIM, Dennis. *Study for Image Intervention*. 1984. Graphite, $ 1,500
colored pencil, oil wash, oil pastel, on paper. 38–1/8 x 50–1/8

OPPENHEIM, Meret. *Agate*. 1979. China ink, gouache, crayon, on $ 2,125
paper. 8–1/4 x 10–7/16

PASCHKE, Ed. *Amano*. 1985. Ink, oil stick, on paper. 10–3/4 x 11–1/2 $ 500

PEARLSTEIN, Philip. *Seated Woman With Kimono*. 1982. Etching, $ 300
aquatint. A/P 8/12. Ed. 125. 11 x 9

POZZI, Lucio. *Bruno*. 1985. Oil on canvas. 6 x 5 $ 700

PULIDO, Guillermo. *The Devil You Say?*. 1979. Cotton, dog hair, $ 250
cloth, hummingbird. 10–1/2 x 8–1/2

RAUSCHENBERG, Robert. *Arcanum II*. 1981 Silkscreen. A/P 5/9. $ 900
Ed. 85. 22–1/2 x 15–3/4

REICH, Steve. *Clapping Music for Two Performers*. 1972; re-copied $ 250
1985. Ink on paper. 12 x 9

SLAVIN Arlene. *Swan on Georgica*. 1985 Acrylic on paper. $ 475
23 x 28–1/4

SMITH, Gregg. *Young Japanese Girl*. 1985. Acrylic on canvas. 15 x 15 $ 250

SMITH, Susan. *Grid Dissolution – Container Series*. 1985. Watercolor, $ 250
pencil, on found paper container. 9–1/2 x 12–1/2

SNELSON, Kenneth. *New York Parking Lot With Cat*. 1975. Ciba- $ 600
chrome print. A/P. Ed. 10. 4–1/4 x 30–1/4

SOLOMON, Elke. *Untitled*. 1984. Oil on paper. 30 x 22 $ 400

SONNENBERG, Jack. *Islands*. 1985. Graphite, oil stick, on paper. $ 1,000
24 x 24

SONFIST, Alan. *Earth Mapping of New York*. 1975. Wood, charcoal, $ 750
wax, on paper. Diptych: 10 x 10 each

SONNEMAN, Eve. *Fresh Fish, Chinatown* 1973. Black/white photo- $ 1,000
graph. Ed. 2/5. 4–11/16 x 13–5/16

SPERRY, Ann. *Hooray*. 1985. Welded, painted steel. $ 1,200
120 x 4 4–1/2 x 12

STALEY, Earl. *Dog on a Hill*. 1985 Acrylic on canvas. 12–1/2 x 24–1/2 $ 500

STALLER, Jan. *Mayor Moscone Park*. 1980. Ektacolor print. $ 200
9–1/2 x 9–1/2

STEIR, Pat. *Untitled*. 1977. Graphite, colored pencil, watercolor, on $ 600
paper. 19–1/4 x 19–1/4

STIKAS, Marianne. *Summer Saratoga*. 1985. Gouache, watercolor, on $ 250
paper. 10–1/4 x 7

STOLLER, Ezra. *Oakland Coliseum, Oakland, CA. Skidmore,* $ 300
Owings and Merrill, architects. 1969; printed 1980. Black/white photo-
graph. 13–1/2 x 10–1/2

STONE, Sylvia. *Summer Garden*. 1983. Ragboard, plexiglas. $ 1,250
25 x 33 x 9

STRIDER, Marjorie. *Sliced*. 1982. Painted bronze. Ed. 29/30. $ 650
11–1/4 x 3–3/4

STUART, Michelle. *Night Ship*. 1985. Encaustic on linen. 7 x 7 $ 800

SUNDQUIST, Jim. *Project IV*. 1985. Colored pencil on paper. $ 200
10 x 8–3/4

TANSEY, Mark. *The Ecstasy of Theresa* 1985. Oil on primed rag- $ 2,000
board. 5 x 6–1/2

TREMLETT, David. *Mozambique, E. Africa* 1985. Graphite on $ 250
paper. 10–1/4 x 10–1/4

UELSMANN, Jerry. *Untitled*. 1980. Silver gelatin print. 11 x 10–5/8 $ 350

UMLAUF, Lynn. *Oct 1984*. 1984. Ink, pastel, collage, on vellum. $ 200
15 x 11

VALIUNAS, Julius. *Cuba – dedicated to Anne M.*. 1985. Pastel, ink, $ 175
graphite, on paper. 19 x 20–3/4

WAITZKIN, Stella. *Ships and Sea*. 1985. Resin. 5–1/2 x 2–1/2 x 4 $ 400

WALKER, Sandy. *10 x 10 for ICI (My Night)*. 1985. Ink on paper. $ 300
10 x 120.

As we can see there were big and small names, but good prices by media. These are what I call some of the big names:

Richard Anuszkiewicz, Ida Applebroog, Alice Aycock, Joseph Beuys, Joan Brown, Fritz Bultman, Tom Butter, Rafael Ferrer, Joel Fisher, Gilbert-Rolfe, Sam Gillman, Michael Goldberg, Nancy Graves, Michael Mazur, Robert Morris, Robert Motherwell, Claes Oldenburg, Meret Oppenheim, Ed Paschke, Philip Pearlstein, Lucio Pozzi, Robert Rauschenberg, Kenneth Snelson, Pat Steir, Sylvia Stone and Mark Tansey.

A "big name" is an artist who has an established reputation. First, there is the matter of professionalism. Like all fields, art has within it beginners and profes- sionals. I define the professional as a person who makes his living from his

occupation and haas been at it long enough to bring to his profession study, time, experience, and knowledge. There is no bar examination, or qualification to pracitce as an artist or an artisan, therefore, one has to look not only at the picture but the history and experience of the creator. The prospective buyer needs to ask how long has the artist been making pictures, where did he study (if at all), how many exhibitions has he been in, and where are his works collected? All of this information serves as a guide to the professional nature of the maker and his position within his own profession. Like any professional, his value as a maker or a creator depends to a great extent upon his experience, and the critics' and spectators' views of the results achieved over a period of time. As I have said before, ten years is probably the least amount of time one has to wait before being able to evaluate the art historical worth of this kind of investment.

That does not mean that the work of a younger artist may not be a better investment than that of an older artist. The market is very sensitive to the break-out artist like Jean-Michel Basquiat who, at the tender age of twenty, without more than a few years of experience, had himself profiled in *The New York Times Magazine* on February 10, 1985. Is he an authentic genius, comparable to Matisse and Cézanne in the days of the early nineteenth century, or is he a 1980s phenomenon, where the word *caveat emptor* takes on a new meaning, that of art market hype?

We could debate that forever, but still, on November 5, and 6, 1985 Sotheby's offered two works by this artist. One of them was "Two Heads on Gold," a 1982 acrylic and oil stick on canvas, 80 x 125 inches, previously owned by two pioneering dealers, Annina Nosei in SoHo in New York, and the Larry Gagosian Gallery, in Los Angeles. Approximate purchase price was probably under $1,000 in 1982, and under $10,000 in 1983. Now these are being offered to the collectibles market at thirty to forty thousand dollars, plus ten percent; not a bad return on capital invested. This rate of return beats any kind of compounding of interest that I know of. For the poor collector, there was another Jean-Michel Basquiat, dated 1982, oil and collage on canvas, 48 x 29 inches, which was acquired from the artist by the seller, who wished to remain anonymous, for twelve to fifteen thousand dollars plus ten percent. Probable cost in 1982 under $300.00. Also not a bad return for a collector who believed in miracles.

Jean-Michel Basquiat is not alone as an art world phenomenon – a beginner, who the market labeled within two years as a genius. From *Contemporary Art Observer*, dated December, 1981, Marsha Fogel, its publisher then told us the Europeans were on their way into the market in 1981, but five years ago:

> *"On the Popular Front*
>
> The most recognized now among the Italians are of course the three C's – *Sandro Chia, Enzo Cucchi*, and *Francesco Clemente*. (The Museum of Modern Art recently purchased a Chia drawing.) The Germans who were also discussed in June's issue – *Rainer Fetting, Salomé, Bernd Zimmer*, and *K. J. Hodicke* – are also very much in the New York limelight. Among the more recognized older established German artists

in Europe, who since the Spring have gained New York gallery representation and are soon to be in evidence in solo exhibitions, are *Georg Baselitz, Anselm Kiefer, Markus Lupertz*, and *A. R. Penck.*

The European Situation in a Nutshell

Italians

* Sandro Chia	Sperone-Westwater-Fischer (April, 1981)	$ 10,000 to $ 17,000
* Francesco Clemente	Sperone-Westwater-Fischer (May, 1981)	$ 5,000 to $ 15,000
* Enzo Cucchi	Sperone-Westwater-Fischer (February, 1981)	$ 15,000 to $ 20,000
* Nicola De Maria	Unaffiliated	
Charlo Maria Mariani	Sperone-Westwater-Fischer (November, 1981)	$ 3,000 to $ 35,000
Mario Merz	Sperone-Westwater-Fischer (February, 1981)	$ 4,000 to $ 25,000
* Mimmo Paladino	Annina Nosei; Marian Goodmann (February, 1982 and May, 1982, respectively)	$ 7,000 to $ 14,000
* Ernesto Tatafiore	Annina Nosei (January, 1981)	$ 8,000

* These Italian artists are referred to as the *Italian Trans-avantgarde,* a name given to them by the Italian art critic, Achille Bonito Oliva. The three C's also exhibited at Sperone-Wesrwater-Fischer in October, 1981 with David Salle, Julian Schnabel, and Malcolm Morley.

Germans
(Established German Neo-Expressionists)

Georg Baselitz	Xavier Fourcade; Sonnabend (December, 1981 and Spring, 1982, respectively)	$ 5,000 to $ 45,000
Jorg Immendorff	Unaffiliated	
Anselm Kiefer	Marian Goodman (April, 1982)	$ 9,000 to $ 28,000
Markus Lupertz	Marian Goodman (December, 1981)	$ 14,000 to $ 16,000
A. R. Penck	Sonnabend (December, 1981)	$ 12,000 to $ 24,000

Berlin Expressionists

* K. H. Hodicke	Annina Nosei (October, 1981)	$ 8,000 to $ 12,000

* Teacher of the following young German artists knows as:

"Vehement Painters" from Berlin

Lucian Castelli	Annina Nosei (April, 1981)	$ 5,000 to $ 8,000
Rainer Fetting	Mary Boone (December, 1981)	$ 5,000 to $ 15,000
Helmut Middendorf	Unaffiliated	
Salomé	Annina Nosei (November – December, 1981)	$ 3,000 to $ 6,000
Bernd Zimmer	Barbara Gladstone (September, 1981)"	$ 6,000

If one chooses from my charity sale those who will be next from the younger group, like Jacki Apple, Peter Astrom, Claire Ferguson, or any of the others, then maybe he can find the next star, like the American artist equivalent to the Hollywood superstar, Julian Schnabel, or from the Fogel list, artists such as Sandro Chia, Francesco Clemente, Georg Baselitz or Anselm Kiefer.

In Roland Hagneben's "Untitled '84", *The Art World of the Eighties* we find a whole range of prospects for future acclamation:

John Ahearn	David Kapp
Jean-Michel Alberola	Bernard Koberling
Olivia Asafu-Adjaye	Shigeko Kubota
Elvira Bach	Barbara Kruger
Donald Baechler	Robert Kushner
Ina Barfuss	Tseng Kwong Chi
Georg Baselitz	Joe Lewis
Jean-Michel Basquiat	Robert Longo
Joseph Beuys	Markus Lupertz
Mike Bidlo	Robert Mapplethorpe
Francois Boisrond	Bruce McLean
Gregory Botts	Karl A. Meyer
David Bowes	Helmut Middendorf
James Brown	Malcom Morley
Werner Buttner	Robert Morris
Ellen Carey	Micolas Moufarrege
Peter Chevalier	Ed Paschke
Sandro Chia	Ishar Patkin
Francesco Clemente	A. R. Penck
Chema Cobo	Rammellzzee
Colette	Judy Rifka
Arch Connelly	Gerd Rohling
Chuck Connelly	Herve di Rosa
Brett de Palma	David Salle
Ero	Salome
Rainer Fetting	Kenny Scharf
Eric Fischl	Thomas Schliesser

Dan Friedman

Futura 2000

Jedd Garet

Dieter Hacker

Richard Hambleton

Keith Haring

Ter Hell

K. H. Hoedicke

Jenny Holzer

Bryan Hunt

David Humphrey

Jorg Immendorff

Ewao Kagoshima

R. L. Kaplan

Bruno Schmidt

Julian Schnabel

Hermann Spoerel

Frederick Sutherland

Stefano

Rigobarto Torres

Thomas Wachweger

Andy Warhol

Terry Winters

Louis Yamme

Bernard Zimmer

Joseph Zucker

Zush

Reasonably priced artists (for the moment) of the eighties, all over $5,000, however, include Jedd Garet, Bryan Hunt, David Kapp, Robert Kushner and Joseph Zucker. I have started to collect two from this group: Joseph Zucker, a maturing artist, and David Kapp, an artist of unlimited potential. Joseph Zucker is now at Hirschl and Adler Modern and David Kapp is at Anne Plumb Gallery.

Where do you find some of these other artists? Jus De Pomme Gallery, Inc., 338 East 11 Street, New York, NY; Salvatore Ala, 32 West 20 Street, New York, NY; Tony Shafrazi Gallery, 163 Mercer Street, New York, NY; Galerie Michael Werner (You remember him, don't you?), Köln, West Germany; Edward Thorp Gallery, 103 Prince Street, New York, NY; Holly Solomon Gallery, 724 Fifth Avenue, New York, NY; Gallery Nico Smith, 339 East 10 Street, New York, NY; Annina Nosei, 100 Prince Strett, New York, NY; Leo Castelli, 420 West Broadway, New York, NY; Phyllis Kind Gallery, 136 Green Street, New York, NY; Anne Plumb Gallery, 81 Green Street, New York, NY; or a host of others, which anyone can find in a gallery guide.

Some day, maybe twenty years hence, maybe more, we will know about these artists of the eighties. But let me say this, this choice of spending money, as little as one thousand dollars, is what has made the art market so exciting. One can't buy much older art, or even the artists of the eighties anymore, for under $5,000, so one is more or less limited to new art and younger artists, or to the secondary media used by established artists.

Back in the 1960s *Art in America* had a "market letter," if you had followed the advice of Charlotte Willard, you could be very rich today:

"Capital gains continue to be enjoyed by holders of Jackson Pollock. A widely-circulated rumor claims that a $100,000 offer for his *Blue Poles* recently exhibited at The Four Seasons restaurant in New York was rejected by its astute owner.

Gilt-edged investment picked by Wall Street stockbroker and published in *Forbes* magazine is work of Clyfford Still, avant-garde painter.

Living American painter sets new record. Andrew Wyeth's *River Bend*

went for $35,000, the highest price yet paid for the work of any living American painter. Knoedler's does not foresee any downward dip in his prices. Wyeth's superrealism which is tied to surrealist movement is a trend to watch.

Look for upswing in prices of Max Ernst, one of surrealism's founders. An exhibition of his paintings is reported scheduled for 1961 at the Museum of Modern Art.

New trends foreseen by Martha Jackson who picks Jasper Johns, one of the Museum of Modern Art choices in 'Young Americans' show, as artists to watch. Miss Jackson believes abstract expressionism has gone as far as it can go.

Wide range of market boom evidence by increasing values of both abstract expressionism and more representational art. Abstract: in recent Gottlieb show at French, five sold for prices up to $8,000 before opening. Representational: at Nordness Gallery, Milton Hebald's latest sculpture brought $6,000; Karl Zerbe, $4,700; Louis Guglielmi, $4,000.

Avant-garde Stable Gallery recalls show in Fifties including works of Pollock, deKooning, Rothko, Kline; the entire exhibition could have been bought for $10,000. Today, Pollocks are in stratosphere; paintings of the other big three hover around the $6,000 mark."

Between One Thousand and Five Thousand Dollars

Now, once we get above $1,000 per work, we are into a much more serious undertaking. We are in the realm of investing our hard-earned after/tax money, and with the compounding of interest, we are into serious stuff. Of course, it will depend on how rich or poor one is, or how he sees his lifestyle, but between $1,000 and $5,000 is the field of rank speculation. It's possible to make a lot of money from collecting or lose it all. Probably the best attitude is to assume that money spent on art will be lost forever.

If you can do some travelling, especially in England and France, there is a lot of art which can be acquired for under five thousand dollars. I am familiar with England and France, and if you stay away from the big English or French names, or the American art sold there, then there are many prospects for good future value. A very interesting publication is *The World's Art Directory, 1985*, Giancarlo Politi Editore, via Solferino 11, 20121, Milan, Italy, which lists all of the dates for the international art fairs, as well as the names, addresses and telephone numbers for artists, critics, galleries and museums around the world. Because the contemporary art markets in, for example, France and England are so small, it is impossible for dealers to ask much more than three to five thousand dollars for even the best work by a good artist. Even if he has a budding international reputation, the work is cheaper in his home country than in New York. Local conditions dominate the local artists, and in England or France today, ten thousand dollars for a major work of art is considered big money. If you buy and believe in the artist, buy the best you can afford. The artists Jean-Paul Chambas and Francois Arnal in Paris can both be

purchased in the five thousand dollar range. In England Tom Phillips, John Furnival, Patrick Heron, Mark Boyle and Peter Bailey are all good prospects in this price range.

Of course, for the bigger names, one can still buy what are generally called small works. As I have said, it's impossible to buy anything today of quality as an investment for less than five thousand dollars. Again, not as a recommendation but as an example, I have pulled from my files some recent prices from an uptown gallery show, "Small Works/Fine Works."

Here's the list under consideration:

SUSAN CRILE
Curved Cube. 1981.
Oil and gesso on canvas.
36 x 48 each panel
$ 6,000
SUSAN CRILE
Intermezzo. 1982.
Pastel on paper.
10 x 17–1/2
$ 1,200
Interior with Guitar.
1984. Watercolor on paper.
$ 1,600
ROBERT DE NIRO
Three Nudes & A Head.
1960. Charcoal on paper.
18–1/2 x 24–3/4
$ 1,200
KATHLEEN FERGUSON
Siamese Pachyderms.
1984. Painted bronze
(unique). 8–1/2 x 7 x 3
$ 1,500
CARL HOLTY
Abstraction. 1936.
Pastel on paper.
12 x 18
$ 3,500
IRVING KRIESBERG
The Scribe. 1982.
Oil on canvas.
58–1/2 x 45–1/2
$ 6,000

ROBERT DE NIRO
PAUL RESIKA
Black Cow, Blue Mountain.
1978. Pastel on paper.
5–3/4 x 8–1/4
$ 700
PAUL RESIKA
MacMillan Wharf, October.
1984. Oil on paper.
14 x 21
$ 2,200
PAUL RESIKA
Red Roof Tepotzlan.
1984. Oil on paper.
14 x 21
$ 2,200
S. PETER STEVENS
Joy of Emma.
1982–84. Painted steel.
28 x 21 x 9
$ 1,500
JOAN THORNE
Amba.
1984. Oil on canvas.
40 x 50
$ 5,000
REEVE SCHLEY
Playing in the Dunes. 1982.
Watercolor on paper.
17 x 23
$ 1,400
REEVE SCHLEY
Red Truck (Oklahoma). 1982.
Watercolor on paper.
12 x 16–1/2
$ 1,200

PAUL RESIKA
August Moonlight,
Tepotzlan. 1978.
Pastel on paper.
8–3/4 x 12–1/4
$ 850

SALINA TRIEFF
Goat In An Orange World.
1982. Oil on canvas.
48 x 48
$ 3,000

How does a collector go about deciding which to buy, if any, from this list? Let's review a few of the buying rules:

The gallery is a middleman for artists' work. Therefore, the first question is: does the gallery have this work on consignment from the artist or does it own it? In this particular case, the gallery is a seller and promoter of contemporary art, and the work is on consignment. Very often, as I have said, galleries combine the two activities. But one can generally tell whether something is in the contemporary consignment side or in the own-for-stock sale, usually hanging in the office, if not part of an exhibition.

Second, what is the gallery's mark-up? Generally these types of galleries operate on a thirty to fifty percent commission. This then gives one an idea, to ask for a discount from the stated retail price. If one asks for a ten percent reduction, he will probably get it, without much trouble. Any more is usually outside the dealer's discretion, and he would have to consult with the artist. It's probably impossible to get more of a discount unless one is a very good customer, or buys in quantity.

Third, can I buy this same or similar work at the auction house for less? The indispensible *Mayer International Auction Records* tells us whether these particular artists generally come up at auction, and what their approximate prices per medium are. *Mayer's* has auction prices listed by the name of the artist, a description of the work, date of sale and name of the auction house and it also lists by medium: prints, drawings, watercolors, paintings and sculpture.

Selecting four from the group as potential candidates for purchase, the only artist on the list that might come up at auction is Robert De Niro. The rest, Paul Resika, Susan Crile, and Joan Thorne have no active auction life. If one wants to wait until a De Niro comes to auction, he may have a chance at a lower price than in a gallery, but none of the other artists will probably be for sale at auction. Also, if one waits and takes his chances in finding a Robert De Niro at auction, he will probably see only older work from the 1960s and have less of a selection of both older and newer work.

Fourth, one next asks whether the prices are reasonable. Am I being taken advantage of? The gallery in this case is very reputable and has been around a long time. Prices are set for this kind of work both to sell and to be reasonable in relation to the artist's position vis-á-vis his status in the art historical process. These prices reflect the retail market, but the *reasonable* retail market, without "hype" or promotion. Here, experience is the best guide.

Fifth, once one has looked at the work he decides what he will or will not buy, a decision based not on emotion, but upon appreciation of the artist and the work.

This is the critical decision point who are these artists, and how good is this particular work? For our purposes, let's assume that the work represented in this show is up to the artist's best standards in this medium. What is it then, that we must know about these artists?

Susan Crile, we are told from our *Dictionary of Contemporary Artists* (1981), is an American printmaker who was born in 1942 in Cleveland, Ohio. We first encountered her work at our not-for-profit charity auction, where we found "Pandora Awakened," 1985, oil on canvas, 12 x 12 inches: quite small, with a reserve of $ 750. She studied at Bennington College, and has exhibited steadily since the 1980s. She graduated, as we know from our information, from Bennington in 1965 with a B.A. She has been at work professionally for twenty years. She is certainly not new to the market. We are offered an oil and gesso on canvas, big, at 36 x 48 inches for each panel, at $ 6,0000.

Since this exhibition was without a catalogue on each artist, and the information at the gallery was not extensive, we are forced to find other sources to get a line on this artist and her place in art history. If you accept my premises, that the fame of the artist is the key factor in determining relative price, then we have to educate ourselves as to her fame. Information on artists like Susan Crile is not generally easy to obtain, since she seems to fall into what I have called the middle category, 1970s to 1980s, born in 1942, this makes her 43 years old. She would have just come onto the scene in the late 1960s or the early 1970s, thus not in the group labeled the Second Generation New York School. She also was involved with printmaking in the 1980s, and was included in an exhibition in 1980 at the Stedelijk Museum (Print Publishing in America). I have found no general source of information on her work historically, so I looked at the most current source, which would be *Art in America, 85/86 Guide to Galleries, Museums and Artists*. Susan Crile is listed there with nine references. We are told that she exhibited in 1984 at Ivory/Kompton Gallery in California in a one person exhibition. Other artists represented by this gallery were not impressive. There was another exhibition in which she appeared in a gallery in Colorado, another in Michigan, New Jersey, Buffalo, Cleveland, Pennsylvania, and of course, our exhibition in New York uptown. My own opinion is that this artist is not particularly well-known or famous for an artist who has been working for twenty years.

If this sounds cold and hard, unfortunately it is. But, as you will learn, it is this kind of analysis which makes a successful collector.

We could go down the list and review each picture, artist by artist, with the same analysis, but I think the idea is clear. For example, I don't know the work of Joan Thorne, whose oil on canvas, from 1984, also big at 40 x 50 inches, is also available at $ 5,000 (not the six thousand dollars for the work by Susan Crile, but smaller). I would buy Thorne before I would buy the Crile, based upon the fame of the artist, at around the same price. Why Thorne? From my information, her history looks more substantial. The formal education, which doesn't necessarily mean much, is about the same. Bennington B. A. as against N. Y. U., with a B. A., with Thorne having spent some time at Hunter, where she got an M. F. A. in 1968.

Thorne has been working professionally since at least 1968, seventeen years, against Crile, twenty years. Both are professional. But it's the exhibition list which tips the scale. Joan Thorne has exhibited and been represented by better galleries than Crile, galleries with fine reputations for selecting promising artists. Galleries like Willard, Nina Freudenheim in Buffalo, Sidney Janis and Landmark have all shown her work. In 1980, she was in a paperworks exhibition in Guild Hall Museum, in East Hampton, NY. The *Art in America* guide for 85/86 shows five listings for exhibitions. All of this information is important in arriving at a decision as to the value of the work in the future. Because, at $ 5,000 one is, in my opinion, spending real money.

Well, there it is – two artists – both about the same price level, both at a fine uptown gallery, both at mid-career points, both have been working as professionals for about twenty years, both are about equally famous. Which artist and which picture to choose? Let's assume for this example, that the works themselves were about equal in quality. I choose Thorne, but I might not be right.

The other night at a party I had a chance to put this question to two different kinds of people. One person was Bill Richards, a young and accomplished artist, whose work I own and whose opinions I respect. The other a fine critic, Peter Frank, whose writing and curatorial work I have also followed, and whom I also respect. "Do you know Susan Crile?," I asked; the answer from both was yes. "How about Joan Thorne," I asked, they both answered "yes" again. "What do you think of their work?," I asked. Richards' comments were, I thought, quite interesting. "Susan Crile," he said, "has been a slow starter, especially in oils, but her work is maturing to the point where it is becoming quite substantial." Frank agreed. "Which would you buy, if you had to buy?," I asked. Crile, not Thorne, they both said, because, although Thorne had made a bigger splash at the beginning of her career, the work of Susan Crile seemed more interesting and substantial as of late.

Here are two insiders, both people who look at a lot of work, and know a lot of artists, and both came to the opposite conclusion than I did, using information, which I thought would help me decide. So, as is plain, there is no easy way to make a decision about what art to buy.

I haven't used either Robert De Niro or Paul Resika as exmaples, primarily because I know their work quite well and am therefore prejudiced. I think both of these artists are very good long-term buys at fair prices. Robert De Niro is in my category of fallen angels, and he's ready, if not overdue, for a serious reconsideration. Resika has in the last few years, just started to get the attention he deserves, with a substantial number of exhibitions, all with universally good reviews. Other artists who fall into this category of artists just starting to get attention again would include Warren Brandt, Walter Darby Bannard, Robert Richenburg, Emily Mason, Marina Stern, Milton Resnick, Frank Bowling, Paul Feely, Sherman Drexler, Frank Stout, Robert Goodnough, Michael Steiner, Frank Bowling and Ken Greenleaf: all professionals who need attention from the critics and the public.

Let's look now at some more artists, to get a better feel of prices, especially in the $ 5,000-and-up category.

How does one know what's a fair price? That's our continuing question. Knowing the psychology of artists, I thought it best to look again at my list of recent charity auctions to get an idea. Here we are looking at a charity auction at Sotheby's, and we are basically looking at dealer prices, although they are purchased at auction. Not too cheap, or his dealer or collectors will be confused. Also since this is charity, the dealer and the artist want to look generous. Here's a sampling of some of the bigger contemporary names and some older artists as well (be careful to note the media): Prints are worth approximately twenty to twenty-five percent of the price of drawings, or works on paper, and drawings are worth ten percent to twenty percent of the value of paintings.

Edward Ruscha
Very True 1973
pastel on paper 22–5/8" x 28–5/8"
Donated by Leo Castelli Gallery
$ 3,000–4,000

Louise Nevelson
Forgotten City 1985 wood, painted black
31–1/2" x 18–1/2" x 1–3/4" Donated by the artist, Courtesy Pace Gallery
$ 20,000–25,000

Robert Kushner
Untitled 1985 mixed papers, copper leaf and India ink 17–1/4" x 22–1/4" Donated by the artist, Courtesy Holly Solomon Gallery
$ 2,000–3,000

Anthony Caro
Writing Piece Friday 1983–84 steel and wood
15" x 18–1/2" x 9–1/2" Donated by the artist, Courtese Andre Emmerich Gallery $ 8,000–12,000

Louisa Chase
Untitled 1983 oil on canvas 24" x 30"
Donated by the artist, Courtesy Robert Miller Gallery
$ 3,000–4,000

David Salle
Untitled 1985 watercolor on paper 16–1/4" x 21" Donated by the artist, Courtesy Mary Boone Gallery
$ 3,000–4,000

Gary Stephan
Untitled (Study for "Eating Light") 1984 watercolor on paper 30" x 22" Donated by the artist, Courtesy Mary Boone Gallery $ 2,000–2,500

Theodoros Stamos
Infinity Field Lefkada Series 1980 acrylic on paper 30" x 22" Donated by the artist,
Courtesy Ericson Gallery
$ 3,000–4,000

Helen Frankenthaler
Cameo 1980 eight color woodcut print on paper (TGL color handmade paper), ed 48/51 42" x 32" Donated by Baskerville & Watson
$ 4,000–5,000

Keith Haring
Untitled 1985 acrylic on canvas 5' x 5'
Donated by the artist, Courtesy Tony Shafrazi Gallery
$ 8,000–10,000

Jim Nutt
Slight Adjustments ("for me?") 1985
colored pencil on paper 12" x 14"
Donated by the artist,
Courtesy Phyllis Kind Gallery
$ 2,500–3,500

Bill Jensen
Study for Big Painting 1971–72 oil and
mixed media on paper 30" x 22"
Donated by the artist,
Courtesy Washburn Gallery
$ 4.000–6,000

Joan Mitchell
Petit Matin 1982 oil on canvas 39–1/
2" x 32" Donated by the artist,
Courtesy Xavier Fourcade, Inc.
$ 14,000–18,000

Ellsworth Kelly
Nine Colors 1976
colored pulp laminated to handmade
paper, a/p 4/7, ed. of 10 30" x 30"
Donated by the artist, Courtesy Blum
Helman Gallery
$ 2,500–3,500

Wolf Kahn
Barn Against the Morning Sun 1984
pastel on paper 22" x 30"
Donated by the artist, Courtesy Grace
Borgenicht Gallery
$ 2,500–3,500

Jennifer Bartlett
*At Sands Point #25 (House for Jay
Rogers)* 1985 oil on canvas 48" x 48"
Donated by the artist, Courtesy Paula
Cooper Gallery
$ 10,000–15,000

Sam Francis
Untitled 1980 acrylic on paper
19–1/4" x 13–3/4" Donated by the
artist, Courtesy Andre Emmerich
Gallery
$ 5,000–7,000

Cy Twombly
Untitled 1981–82 oil stick on paper
39–1/4" x 27–1/2" Donated by the
artist, Courtesy Hirschl & Adler
Modern
$ 18,000–24,000

Jim Dine
Untitled 1985 mixed media on paper
45" x 36" Donated by the
artist, Courtesy Pace Gallery
$ 18,000–22,000

Kim MacConnel
Foocat 1985 acrylic on canvas 18" x 24"
Donated by the artist, Courtesy Holly
Solomon Gallery
$ 2,500–3,500

R. B. Kitaj
Portrait of Robert Duncan n. d. pastel
and oil on paper 24–3/4" x 19–3/4"
Donated by the artist,
$ 3,000–4,000

Gaston Lachaise
Ogunquit Torso c. 1928 polished
bronze ht. 10" Donated by Hirschl &
Adler Galleries, Nex York
$ 15,000–20,000

Philip Pearlstein
*Two Models With Green Bench and
Standing Mirror* 1983 watercolor on
paper
60–1/4" x 40–1/4" Donated by the
artist, Courtesy Hirschl & Adler
Modern
$ 12,000–16,000

Piero Dorazio
Centofiori 1971 oil on canvas 18" x 72"
Donated by Kasmin Ltd., London
$ 3,000–5,000

James Brown
Woman in Hat 1983 oil, enamel on
wood and canvas 54" x 48" Donated by
Egret
$ 9,000–12,000

187

Beverly Pepper
Volterra Regina Wedge 1979–80 forged
steel and cast iron 25–1/2″ x 12–1/
2″ x 6–1/2″ Donated by the artist,
Courtesy Andre Emmerich Gallery
$ 4,000–6,000

Cindy Sherman
Untitled (#104) 1982 color photo-
graph, ed. 3/10 30″ x 20″ Donated by
the artist, Courtesy Metro Pictures
$ 2,000–3,000

Joel Shapiro
Untitled 1985 charcoal on paper
19″ x 26″ Donated by the artist,
Courtesy Paula Cooper Gallery
$ 4,000–6,000

Robert S. Zakanitch
The Ogre Series 1985 acrylic on paper
40″ x 50″
Donated by the artist, Courtesy
Robert Miller Gallery
$ 4,000–6,000

Paul Jenkins
Phenomena: Lode Stone for Salter
1981 watercolor 43″ x 31″ Donated by
Katherine Komaroff Goodman
$ 3,000–4,000

Janet Fish
Map and Flowers 1984 oil pastel on
paper 19″ x 24–1/2″ Donated by the
artist, Courtesy Robert Miller Gallery
$ 4,000–5,000

Nancy Graves
Whyalla 1985 gouache, pencil and
acrylic on paper 30″ x 40″ Donated by
the artist, Courtesy
Knoedler Gallery
$ 4,000–6,000

Robert Rauschenberg
Untitled 1982 solvent transfer, acrylic
and collage on mounted wooden panel
84–1/2″ x 37–1/8″ Donated by the
artist, Courtesy Leo Castelli Gallery
$ 60,000–75,000

Ed Paschke
Troika 1985 oil on canvas 42″ x 80″
Donated by the artist,
Courtesy Phyllis Kind Gallery
$ 14,000–18,000

Paul Wonner
Study: Albuquerque Studio 1985
acrylic on paper 40″ x 28″ Donated by
the artist, Courtesy Hirschl & Adler
Modern
$ 6,000–8,000

Willem de Kooning
Untitled 1977 oil on paper mounted on
canvas 41–1/2″ x 30″ Donated by the
artist,
Courtesy Xavier Fourcade, Inc.
$ 60,000–75,000

Rafael Ferrer
Gran Pina II 1983 oil pastel on paper
41″ x 29–1/2″ Donated by the artist,
Courtesy Nancy Hoffman Gallery
$ 2,000–3,000

Donald Sultan
Black Lemons July 27 1985 1985, char-
coal on paper 50″ x 38″ Donated by the
artist, Courtesy Blum Helman Gallery
$ 7,000–9,000

Lynda Benglis
Jonna Darter 1985 sand-cast black
glass 8″ x 11″ x 14″
Donated by the artist, Courtesy Paula
Cooper Gallery
$ 3,500–4,500

Gregory Amenoff
Gordian Knot 1985 mixed media on
paper 34" x 42"
Donated by the artist, Courtesy
Robert Miller Gallery
$ 2,500–3,600

Jean-Michel Basquiat
Untitled 1984 oil and oilstick on paper
41–1/2" x 29–1/2" Donated by the
artist, Courtesy Mary Boone Gallery
$ 2,000–2,500

Dale Chihuly
Untitled 1984 glass
17" x 21–1/2" x 21–1/2" Donated by the
artist, Courtesy Ericson Gallery
$ 3,000–5,000

Rackstraw Downes
Hudson River Sewage Treatment Facility Under Construction #1 1984 pencil
on paper 24" x 31" Donated by the
artist, Courtesy Hirschl & Adler
Modern
$ 4,500–6,500

Elizabeth Murray
Utitled (Drawing for Barry Lowen)
1985 pastel on two sheets of paper
31–1/2" x 66" Donated by the artist,
Courtesy Paula Cooper Gallery
$ 8,000–10,000

Keith Sonnier
Hod Vowel 1982 dry pigment,
charcoal and aluminum spray paint on
paper 81" x 50" Donated by the artist,
Courtesy Leo Castelli Gallery
$ 8,000–10,000

John Chamberlain
Tonk #8 1984 painted metal
8" x 32–1/2" x 10"
Donated by the artist, Courtesy
Xavier Fourcade, Inc.
$ 12,000–14,000

Frank Stella
Swan Engraving V 1985 etching with
relief printing, woodcut, a/p 8, ed. of
25 59–1/2" x 49–3/4"
Donated by Tyler Graphics, Ltd.
$ 4,500–5,500

Alexander Lieberman
Untitled 1982 steel, painted, ed. 9/15
30" x 28" x 24" Donated by the artist,
Courtesy Andre Emmerich Gallery

Roger Brown
Why? 1985 oil on canvas 72" x 48"
Donated by the artist,
Courtesy Phyllis Kind Gallery
$ 15,000–20,000

Jasper Johns
O Through 9 1970 lead relief, ed. of 60
30–1/8" x 23–1/2"
Donated by the artist, Courtesy Leo
Castelli Gallery
$ 8,000–12,000

David Smith
Untitled 1963 spray paint on paper
16–1/4" x 13–1/2" Donated by Candida
& Rebecca Smith, Courtesy Knoedler
Gallery
$ 9,000–12,000

Ross Bleckner
Untitled 1984 oil on canvas 18" x 20"
Donated by the artist, Courtesy Mary
Boone Gallery
$ 2,000–2,500

189

It would be impossible to even begin to analyze the price structure of all the works on this list. But all are considered "big names" in the art world today. Certainly, the choice is wide, and it involves mainly work by living artists, all professional, and all at or near the top of their careers. To give just an indication of what is required if one is to purchase from this list, I have selected just one artist, Cy Twombly. I have selected Twombly because his is a market in transition. We have from our information gathered the following: First, as we see from this list, the range of his prices for work which is apparently four years old and for works on paper is $ 18,000 to $ 24,000, and average newer oils at approximately $ 200,000 to $ 250,000.

We have had a recent sale at Sotheby's where an early Cy Twombly painting, which sold in 1973 for $ 40,000, made more than ten times that amount in 1985. This would seem to be a real market for someone who has a spare twenty thousand dollars or so to spend on a work of art that is not an oil, but a work on paper.

What is this Twombly market like? In a recent issue of *The Art Newsletter* (published by *Art News*), there was a comment on the Cy Twombly market and his prices which indicated that the pricing criteria was not based only on Twombly's fame as an artist as of today but what his fame will be in the future, taking into account certain market factors. This was accepted by the writer, at the outset, based upon the price level of the work. In the art market of today, rising prices do not drive investors away, they attract them. As a work of art increases in price, demand for it also tends to increase. This phenomenon is known as the Veblen Effect, after Thorstein Veblen, a Norwegian-American economist who first observed that steadily rising prices have a positive effect on an artist's reputation. As prices for an artist's work are increased, Veblen said, he becomes more important; when his prices rise above the going rate for the work of his peers, he is revered by dealers, critics, curators, and collectors, as well as investors.

The rule is a simple one, high price equals quality in the minds of most art buyers. We therefore have to look at the demand side of the marketplace to see if prices are more likely than not to go up in the reasonable future. The writer of the *Newsletter* described Twombly's market today as essentially European. By that is meant that demand in the United States is still quite limited because he is not particularly well-known in America. Why is this so? Americans demand, more frequently than not, pictures they can understand without having had a course in art history. The Europeans, it is said, who do buy contemporary art, are more advanced than the Americans in what they will spend their money for in contemporary art. The Americans will therefore pay a higher price for art which has a balance between originality and conformity to traditional images. An image becomes traditional in America when it has been seen, exposed, exhibited, and promoted as acceptable for that type of art. Twombly's images have not as yet been seen by Americans as acceptable.

Twombly's work for the American market is sufficiently different from the typical abstract work that the American market is used to by now. It doesn't look like the abstract work that American buyers are familiar with. According to the

reporter, the demand in America is low because of initial bewilderment in the content of the pictures.

A good example of how demand is controlled by content or conformity to well-recognized patterns is what happened with the demand cycle for the written works of both Gertrude Stein and James Joyce. Because both were unusual for the time, the demand was slow until originality and publicity for the product ultimately took over. The same can be seen with Cubist and Surrealist painting. When it first appeared it was upsetting to the collecting public. It wasn't what they were used to, especially with regard to Picasso. Initially, demand for classic Picassos was substantially stronger than for Cubist Picassos.

When Stephen Mazoh, a New York art dealer was quoted in *The Art Newsletter* as saying that "interest in this country (for Cy Twombly's work) may soon outstrip that overseas," he is saying that once America catches up with this strange work which the sophisticated Europeans do understand, demand in the U.S. will increase and prices will go up. With works of the 1960's and 1970's commanding $ 350,000 and up for important pictures, it will not take much demand for those early works to move into the onehalf million-dollar range and the newer work to move right along with it. The supply of the early work has always been limited, because Cy Twombly probably has kept most of his early work for himself. Unlike many of the other early American abstract artists, the supply of this early work is limited since he didn't have to sell early on, because he was, I understand, always rich. The newer work (with the supply controlled, I am sure) and the drawings, and the works on paper will fill the demand gap, for those who must own a Twombly.

Clearly, if a collector wants a Twombly for his collection, price will often be a major consideration in the buyer's choice of an early work over a later work, or a work on paper compared to an oil.

Standards by Which to be Guided

What we have seen in this list of prices, and the way they are presented (name of the artist, title, date, size and medium), that is unique to the fine art collectibles market is how value is coupled with the knowledge of the artist, and the medium and size, within the market and the marketplace. The key question is, who is the artist? You can pay someone for this knowledge, or you can try to find out yourself. Also, we have seen the place fame of the artist plays in all of our decisions. What is the art public's estimation of the reputation of the artist? The differential, excluding medium and size, determines comparative price within the art historical process.

Compare David Smith, an important New York School artist, with a work on paper (16–1/4 x 13–1/2 inches) at $ 9,000 to $ 12,000, with Jean-Michael Basquiat – Asher Edelman's favorite, and the subject of *The New York Times* profile – at $ 2,000 to $ 2,500 for a work on paper (41–1/2 x 24–1/2 inches). Will the David Smith increase in value faster than the Basquiat or vice versa, that is the collector's question. Knowledge of the artist, his place in the art historical process, coupled

with knowledge of the market and the marketplace, will help make that decision. This knowledge is not difficult to obtain, but it takes time, and the desire to study the artist and his market. One learns by shopping, but also by looking and reading.

David Smith is no longer alive and able to add works to the marketplace. Jean-Michael Basquiat is turning out works each year by the hundreds, if not more. The collector must remember that the big difference in the pricing of new and older work is the part the artist plays. He plays no part in older work, which is already in the market and he plays a key role in new work because it represents more than the sale of a product, it represents the artist's reputation.

Younger artists, without a track record, sell at whatever price they can get, and to some extent, what they need to get by and buy materials. These younger artists would love to be able to price on a per diem or hourly rate, but because the market for their work is non-existent or the market is overcrowded with unknown artists their prices are freely negotiable.

Once the artist sets the retail price for the new work, the gallery takes its commission as agent, usually from fifty percent of the retail price to a thirty-three percent commission. Thereafter, price depends on the demand-price relationship that changes over time. The work seldom comes down in price, it just doesn't sell. The artist may lose his gallery representation and have no means to sell at all. And this usually means he sells from his studio to friends or to others by word-of-mouth.

If the system works for the artist, the upper limit is equal to the market potential at a given price. Even the slowest painter, if he wants to, can increase production for an exhibition. In these rare cases where an artist produces few works per year, the artist has to be well-off enough to be able to live on something other than his production as an artist. In these cases the work will be more expensive because of the number of works produced. If demand skyrockets, like for Jasper Johns, and Richard Diebenkorn, and the artist owns a lot of his early work, he can become very wealthy from the sale of the new work, keeping the best of the old work for himself, and selling one or two early pictures to build his capital for his new studio, houses, wives, and divorces. Competition among artists plays the most significant role in setting the selling price, even if the work can never sell at that price. That is why bargains can be had, when one doesn't buy directly from the artists or galleries, but at auctions or at liquidations of collections. Recently a large corporate collection was liquidated at auction. The prices were ten percent of the dealer prices for the same work, and yet, as far as I could determine, not one dealer bought for stock.

For the collector, time and change of style are also two very important concerns in making pricing decisions. For full value, time is the most important determinant, unless one can participate in a short-term fashionable upswing for a group of artists.

The pricing difference between the retail and wholesale markets stems from the source of the work. Wholesale buys are rarely available from a living artist, therefore, the secondary market of liquidation auctions become the prime source for bargains. Bargains from earlier periods of art are rare, unless one has gained

such superior knowledge of the subject as to be able to pick up the bargain which the market has for some reason or other not recognized.

As an element of future investment value, pricing is a factor which tries to anticipate the future potential market demand, so that growth of the market is anticipated as a function of time and the increase in the artist's reputation, his place in art history.

"How is anything completed. And if it is not might it, and is there a choice."

Gertrude Stein

XI

Five Propositions to Remember

I remember well my own introduction to contemporary art in England in the 1970s. It was the artists, the critics and above all the dealers, including the auctions, who taught me to look and try to understand what I was looking at. Since the market in England for contemporary art was so small, even one new potential collector became important to the market.

Alex Gregory-Hood, former colonel in the Grenadier Guards, patron and dealer to English abstract art through his Rowan Gallery and gentleman above all else, would invite anyone interested in contemporary art to informal lunches in his office. Present were critics, officials, collectors and others in the art world. These Rowan rituals, existing for their own sake and without any business motive, allowed the collector to eat, drink and to discuss art and the artists. Through these contacts a collector could not help but sharpen his critical eye.

The one individual who I remember best from this period is Vera Russell, writer and curator of the Artists Market, a not-for-profit exhibition space in England's Soho. Vera Russell, in the short time she operated her gallery, did more to help young artists get started and improve the taste of collectors than anyone I have come in contact with in the art world in the last fifteen years. Our current crop of museum directors and curators could well learn from her example how easy it is to take the mystery and hype out of collecting contemporary art if the collector, artist, and critic are all integrated into a process which has as its goal improving peoples' experience in looking. Vera Russell's exhibitions combined high-priced works by artists with important reputations with lower-priced works by lesser-knowns. She understood how to educate and introduce the public to make decisions about what is worthwhile to buy at a fair price. She understood better than most that the collector will participate in this process if he has confidence in the those making the recommendations.

What I have tried to do is to give the future collector some insight into the world of art collecting from my own experiences as a collector over the last fifteen years. Quite obviously, these experiences are limited by my own interests. Since the field is so large, I have probably left out as much as I have put into this little book. But, what I have tried to do is deal primarily with those concepts (rather than the details of collecting) that integrate money and art. In the end however, to be successful you must improve your own taste and become a visually literate person. Is it easy? No. But it can be accomplished with time, energy and study. While it is true that combinations of visual forms are susceptible to multiple meanings, depending on the contexts in which they are organized, the fact that

pictures support several interpretations does not imply that art is incomprehensible. Once we accept the fact that art is another language, we raise the problem of comprehension. How do we get to understand this language? We take part as individuals in a dialogue about the meanings and values of pictures. We carry this discourse to the point where that dialogue, as well as the art objects on which it centers, becomes a significant focus of our interaction with the art. Then we start to understand the language. Let me leave you with five propositions to consider each and every time you look at a painting:

1. Ask an expert or someone whose opinions you respect to explain the work to you before you buy it. Don't be embarrassed to ask!

2. If you think it is a successful work of art, is it successful compared to other works of art you have looked at? And you must look at a lot of work, if you want to understand what is a successful work of art.

3. What do *you* think is good about the painting? What are you hoping to find? Consider the critics' views, but make your own judgments.

4. Consider the approach of the artist, the specific nature of the statement made, and how effective he has made it. Has the artist created a work of consequence? It may be small, it may be a work on paper, or even a print, but is it a work of consequence?

5. Is the price a fair one, based upon the artist's recognized position? Are you being ripped off?

Unless you are very rich, you will not be able to buy the very best, but you can buy the best you can afford. As a successful collector, you will have exposed yourself to a personal adventure of consequence based upon your own judgment and knowledge. Is that the best you can do? I believe it is. Can you also make money as a collector? The best advice on that is from my best friend, Diane L. Ackerman, *Getting Rich,* "A Smart Woman's Guide to Successful Money Management":

> "I have tried to show that money matters can be easily comprehended by any intelligent, thinking woman [or man] and that, when approached creatively, the money game can prove the most exciting and rewarding game in town. The hardest part of playing the game is learning the rules, but once you begin, I promise that you will never want to stop."

Good luck!

DICTIONARY

THE COLLECTOR'S ART HISTORICAL VOCABULARY[1]

Without the understanding of certain basic terms, trends and signposts, it is impossible for the collector to comprehend the nature of the history of art. Art history will always inform the way in which we appreciate what we are looking at whether we like it or not. Works of art are always discussed within their historical context, some call them labels, whatever they are called, the collector must be familiar with them.

[1] I have chosen a few essential sources, each of which has as its basic virtue language I could understand. The number of books available on each of these trends or subjects is virtually innumerable. See *The Image Maker, Man and His Art,* by Harold Spencer, Charles Scribner's & Sons, New York, (1920); *Contemporary Trends*, by Doris L. Bell, The Scarecrow Press, Inc., (1981); *Dictionary of Modern Painting*, by Fernand Hazan Paris Book Center, Inc., and *Looking At Art*, A Visitor's Guide to Museum Collections, by Adelheid M. Gealt, R. R. Bowker Company (1983).

A Contemporary Overview[2]

Quite obviously, hundreds if not thousands of books have been written on each historical segment, but in summary, this is how I, at least, understand some of the terms as they are applied to pictures, which the collector has to deal with.

Every picture of something which transmits information is abstract in the sense that the specifics of the subject are to some degree incomplete. I perceive every picture as communication between the artist and the spectator. Like Marcel Duchamp, I believe that the creative act is not performed by the artist alone, but is completed by what the spectator brings to the work. The spectator, representing the outside world, deciphers and interprets its meaning, and thus contributes to the creative act. This picture of something thus operates like language in that it exrpesses an image or idea. I call pictures which seem to have a definite image or idea figurative, as contrasted with abstract pictures.

Defining a picture as truly abstract is much more difficult for me. In common sense terms, "to abstract" means to withdraw or separate, particularly to withdraw attention from something or from an aspect of a thing. But in the language of twentieth century art, two different meanings of abstract have evolved. When we say that a picture of a certain object or scene is abstract rather than naturalistic, then we are using abstract in the context of a picture that has an image. The other meaning is when we describe a picture as abstract because it is not a representation of anything at all. Finding one's way between these two definitions is of constant confusion among collectors and even artists.

If a painting transmits information about some segment of the visible world it may be more or less abstract, depending on the scarcity or completeness of the information it transmits, or the details left out or played down, it is still in the world of representational or figurative art. Abstraction is best exemplified by American Abstract Expressionism for which the New York School has Sam Francis, Hans Hofmann, Pollock, Rothko, Still and Motherwell as its great exponents. In England this style was adopted by John Hoyland, and in France, we could look at that master abstractionist, Francois Arnal. I also consider Minimal art abstract. There one could look to Carl Andre, Dan Flavin, Donald Judd, and Robert Morris.

[2] This overview deals only with those contemporary artists I am interested in. It stops, as you will see, with the artists who came on-stream prior to the 1980s, and does not deal with those artists in England, France or Germany who were and are dealing with important contemporary issues.

Abstract art simply describes those works of art which are without representational significance. They do not refer to things or events outside the work of art itself and they do not result from incomplete specification, that is the elimination of detail in the depiction of natural appearances.

The word 'expression', or the term 'Abstract Expressionism' means that a work has as its primary interest expressive characteristics, whether or not they come from the emotions of the artist. The impact of the picture derives from its expressive characteristics and the intense emotional attachment to the expressive characteristics of color, as evidenced by painters from Kandinsky through Abstract Expressionism to the Color Field painters. Interesting painters in this group range from James Brooks, Arshile Gorky, George McNeil, Jules Olitski, Milton Resnick, Joan Mitchell to Paul Jenkins. Interesting work in England would include the work of Alan Davie, Patrick Heron, Peter Lannon, Terry Frost and Roger Hilton.

On the other hand, the Constructivist painter deliberately plays down these emotional characteristics of the picture's image and the physical materials. Most Constructivists use geometrical or quasi-geometrical forms to achieve this non-expressive quality. Typically Constructivist would include the English artists Anthony Hill and Kenneth Martin.

There are so many forms of so-called abstraction that the average collector is understandably confused. How about Ludwig Sander; another very good painter. Before we continue, from Abstract Expressionism, as the main source, to the 1960s and the emergence of a new conception of art drastically opposed to the Abstract Expressionist artists, we have to look at this middle period, from 1950 to 1960. This is an area about which little or nothing has been written.

Turning to the list in Appendix B of Irving Sandler's *The New York School: The Painters and Sculptors of the Fifties,* we find a range of painters who just don't seem to fit easily in this history of abstraction. The reason is that most of them were very young during that ten-year period, and the world of Pop Art and Minimal Art, which emerged in the 1960s, cut them off, before they could really stabilize their positions.

Looking at Sandler's list, we see patterns and similarities in education, exhibitions, and type of work. The Hans Hofmann School is certainly one of the dominating factors. Another is that many were self-taught, like the artists of the New York School. Certain galleries were dominant, like the Hansa Gallery, the Zabriskie Gallery, the Borgenicht Gallery, the Tibor de Nagy Gallery. But the biggest difference between them and their elders, was that some, like Joan Mitchell, Michael Goldberg, Norman Bluhm, Robert Goodnough, Paul Brach, Jan Muller and Milton Resnick remained committed in one fashion or another to abstraction; while others (like Leland Bell, Louisa Matthiasdottir, Wolf Kahn, Nell Blaine, Robert De Niro, Jane Frelicher, Grace Hartigan, Lester Johnson, Philip Pearlstein, and Fairfield Porter) moved into figurative or representational work with abstract overtones.

David Shapiro, in a recent catalogue at the Grace Borgenicht Gallery on the

work of Wolf Kahn (one of the artists on Sandler's list), puts the problem squarely:

"Kahn achieves monumentality as in a line of trees marching towards invisibility, without changing too much what he thinks of as a 'low-volume rhetoric.' He may speak of an 'absolute rightness' but has a fine sense of imprecision and the problematic of imperfection. He doesn't think of himself as a realist but as a figurative artist in the Abstract Expressionist tradition, and admires the sparse paintings of Mondrian and his search for absolute relations. Alice Neel praised Kahn's art as one of feeling, and he does think of his work as an instrumentality of release: 'I care that my pictures get you somewhere spiritually where you wouldn't have been without them.'"

Obviously, it's all shadings of degrees of a picture of something. These figurative or representational painters, in contrast with their contemporaries, were painting pictures of something that I can easily identify with. It seems to me that they were, in a sense, bridge painters between Abstract Expressionism and painterly freedom. They were painting about something identifiable in the natural world, and yet, they were following the Abstract Expressionists in deflecting attention from the non-representational part of their work.

How about the 1960s, Pop and Minimal Art? In the Pop Art field, the big names are Warhol, Lichtenstein, Johns, Oldenburg, Rauschenberg, Rosenquist, Ruscha, Dine and Wesselmann. There are others, like Peter Blake, Richard Hamilton, David Hockney, and Allen Jones, all English. For the Minimalist, we have Donald Judd, Brice Marden, Mel Bochner, Dan Flavin, and of course, Frank Stella, the most important name of the 1960s.

Though both Pop and Minimalism had antecedents in that what these artists tried to do was to break out from the apparent similarities of their predecessors. What they sought basically was an art of anonymity, where the artist stood aloof from his work, refusing to follow where he was traditionally supposed to go, and presenting art as an object among other man-made objects. These artists were fixed upon the work as an object with its own associations and problems. It is deadpan art of the literal and matter of fact. The art object itself may be banal and obviously boring, but its strength is that it is what it is seen to be and nothing else.

As Frank Stella said, in that most famous of famous quotations:

"I always get into arguments with people who want to retain the old values in painting, the humanistic values that they always find on the canvas. If you pin them down, they always end up asserting that there is something there besides the paint on the canvas. My painting is based on the fact that only what can be seen *is* there. It really is an object. Any painting is an object and anyone who gets involved enough in this finally has to face up to the objectness of whatever it is that he's doing. He is making a thing. All that should be taken for granted. If painting were lean enough, accurate enough, or right enough, you would just be able to look at it. All I want anyone to get out of my paintings, and all I ever get out of them is the fact that you can see the whole idea without any confusion . . . What you see is what you see."

This new art of the 1960s was intellectual rather than sensuous in its impact. It was an art of reduction. If all this sounds negative, it was positively and deliberately so.

John Russell and Suzi Gablik, writing in 1969 in *Pop Art Redefined*, tell us:

"Pop Art has been handicapped with a freakish and flamboyant history, partly as a result of mishandling in the public news media, so that nearly everyone, including the artists, now responds to it with ambivalence. Certain critics still exclude it from serious consideration, and a proportion of the public think it is some sort of joke. I know of only two endorsements in contemporary criticism which support the notion that Pop and Minimal art have a common denominator. The first is an essay by Robert Rosenblum, appended in this book, which was published as early as 1964 (i. e. five years ago). He states: 'Already the gulf between Pop and abstract art is far from unbridgeable, and it has become easy to admire simultaneously, without shifting visual or qualitative gears, the finest abstract artists, like Stella and Noland, and the finest Pop artists, like Lichtenstein. The development of some of the Pop artists themselves indicates that this boundary between Pop and abstract art is an illusory one.' The second article is a more recent one by Barbara Rose, entitled 'The Politics of Art (II)', published in *Artforum*.

Robert Rosenblum in an article entitled, *Pop Art and Non-Pop Art*, says:

"So sensitive are the art world's antennae to the symptoms of historical change that, in 1962, when some New York galleries began to exhibit pictures of vulgar subject matter, a new movement, Pop Art, was instantly diagnosed and the mindless polemics began. As usual, the art in question was seldom looked at very closely and questions of definition and discrimination were ignored. Instead, things were quickly lumped together into a movement which called for wholesale approval or rejection. Presumably, one had to take sides, and various critics were considered to be either vigorously for or against it. But what was it?

"If Pop Art is to mean anything at all, it must have something to do not only with *what* is painted, but also with the *way* it is painted; otherwise, Manet's ale bottles, Van Gogh's flags, and Balla's automobiles would qualify as Pop Art. The authentic Pop artist offers a coincidence of style and subject, that is, he representes mass-produced images and objects by using a style which is also based upon the visual vocabulary of mass production."

Thus artists like Lichtenstein, Warhol, Rosenquist, Indiana, Wesselmann, Oldenburg (but not Rivers, Rauschenberg, Johns, Dine, Thiebaud, Marisol) all share a style that we now accept as Pop.

The Color Field painters, from the late 1950s, like Morris Louis, Helen Frankenthaler, and Kenneth Noland, moved in a different direction, using the technique of staining unprimed canvas. These often very large-sized canvases

sought to occupy a whole field of vision when a spectator stood at ordinary gallery distance from the paintings. This encouraged the spectator to immerse himself wholly in the experience of color sensation. This tendency culminated in the more subtly modulated color expanses of Jules Olitski and Larry Poons. In effect, the color is abstracted from the forms and is presented as a perceptual object in itself. The stained canvas was itself the object, no longer the bearer of an image.

The term "hard edge" is another term of this period. The use of this term was said to refer to the new development that combined economy of form and neatness of surface with fullness of color, without continually raising memories of earlier geometric art. Leon Polk Smith, Ellsworth Kelly and Jack Youngerman, would fall into this category, as well as Al Held, Raymond Parker and Charles Hinman. A favorite of mine, Patrick Heron, tried to develop a new kind of image through the medium or a kind of space generated by color itself. It's hard to categorize Walter Darby Bahnard. Is he minimalist or hard-edge? I don't know, but he is a most interesting painter.

These artists were trying to abolish, or at any rate suppress, the image from painting. This was their innovation to the world of abstract art. The mostly large sizes of these paintings had the effect of enveloping the spectator. For these pictures to work for me, they have to be very good in stimulating the senses.

Jasper Johns seems to me to fall outside any of these groups. Johns does not seem to me to paint a picture but rather an object. Jasper Johns' flag paintings are meant to be replicas of a flag. This was possible because a flag simply is a specific pattern, and by painting that pattern to occupy his complete canvas, Jasper Johns was making a flag, not a picture of a flag. Jasper Johns is the complete master of what he does from both a technical and artistic point of view. When one talks about quality in painting, one has to talk about Jasper Johnes. For most collectors who first encounter the work of Jasper Johns, the work is very ambiguous as it doesn't fit neatly into any of the wellknown groups or words with which they are familiar. Technically, the work is a painting, but it actually is a flag, yet functionally it is intended to operate as a painting, not a flag. I am not smart enough to understand Jasper Johns completely, but I do know that he certainly is one of the most original of many original painters of our time.

Frank Stella is another artist I have trouble with, but again one of the most important original artists of our period. As I see it, Stella took the flag idea from the paintings of Jasper Johns and moved forward. In Johns, the motif of the flag coexists with the painting; when the flag ends, the picture ends. Stella's horizontals have no logical or psychological ending, but run indefinitely, beyond the picture. The motif of the picture is not closed, but is open in all directions. This at least was the feature of most of the early paintings of the 1960s, even with the shaped canvas. Today, he has moved in the direction of paintings which come out from the canvas in all directions, I suppose extending the motive into what looks, to me, more like sculpture than painting, but the idea is the same.

It is an experience to see a new Stella painting and to try to understand what is visually happening to these patterns, which never seem to end as they pop out from

the base of the structure, which have to be constructed of tough material, as canvas would never support such patterns. The horizontal, vertical, or diagonal axes of the picture are tying together the motif as a physical object. There are no centers of interest in Stella's pictures, the interest as I see it, is distributed over the whole of the picture as you look at it.

The third big name of the contemporary period after the Abstract Expressionists is Richard Diebenkorn. Still not as widely-known as Frank Stella and Jasper Johns, Richard Diebenkorn is a master artist. Since Diebenkorn is California-based, his remarkable achievements are still unfamiliar to even knowledgeable collectors of art. In large part, this neglect is due to the absence of a substantial support system of criticism and patronage in California, in contrast with New York.

Diebenkorn is an artist of keen intelligence and enormous natural gifts which he has subjected to training; learning from his peers and his own seeing, but most importantly from his own unflinching criticism. In the early years of the Second World War he moved toward abstraction. At one point of uncertainty, in Berkeley in 1955, he easily could have taken shelter in the success of the Abstract Expressionist movement and his own considerable achievements in it. He moved, instead, against the current and into figurative art. There seemed to be a need to experience the tradition of modern figuration and to explore the insights of Matisse and Bonnard, the master colorists of the earlier century. He did this with his own style of free brush-work and his own growing sense of structure and originality. By the end of the 1960s, he was back to abstraction, in what he has called the Ocean Park Paintings.

Richard Diebenkorn's paintings are deeply affected by his immediate environment. "Temperamentally," Diebenkorn once said, "I have always been a landscape painter." It was not surprising that within two years after he took up residency in Los Angeles (initially to teach at the University of California), Diebenkorn's painting had taken a distinctive stylistic turn from representational to abstract.

These richly worked linear compositions are obviously more than personal recapitulations of the landscape by the painter. These are abstract works of the very best quality. They synthesize and cross-reference the best of what can be expected without recognizable imagery. In practice, it is very hard for a collector to differentiate among types of abstract art, and it certainly is not a clear-cut distinction.

But when I look at Diebenkorn, I see a progressive abstraction from natural sources, as he tells us from his titles. True, he proceeds to the extreme limit of the landscape subject matter of the picture, so that landscape is no longer recognizable. I know a great deal about the history of this artist, and I have seen and continue to see his puzzling figurative work. I believe in understanding the subject, and when I look at his landscape paintings, I can no longer detect the landscape, but I see the emotional or expressive prospective of the theme in the pictures.

The other big name of this period is the sculptor Richard Serra. Considered by many artists as probably the most influential of his time, he has been startling the

art world for a very long time. As Serra has said, his objective is "to create a behavioral space in which the viewer interacts with the sculpture." Most people, at least in downtown New York, at Federal Plaza, hate their interaction with Richard Serra, but no matter, this is to be expected. As John Russell, in his review of the Richard Serra exhibition at the Museum of Modern Art has said, Serra has had pre-eminent success, at least with the professionals or the art historians. As a sculptor:

". . ., Serra has been one of the most inventive people around since the late 1960s, when he drew up a list of verbs that was, in effect, an inventory of the actions that he believed to be the province of sculpture. They included 'to roll, to cut, to tear, to shorten, to chip, to simplify, to support, to splash, to refer, to force.' There's not much chipping in the present show, but the other verbs have lost none of their pertinence."

There is one other form of abstract art that deserves a few lines, it is Conceptual Art. This term is applied to artists who basically present their art in the media of texts, photographs, maps, diagrams, sound cassettes, videos, etc. The term is also used to refer the spectator to happenings, events, or situations removed in time and place from what is presented in the gallery.

This type of art is said to be a logical continuation of the spectator's involvement in the process by which an artwork comes into being. The work tends to demand an ever-increasing spectator involvement, not only in the form of appreciation, but by actual participation in the process of production. In sum, the idea is that the work of art is the final product, and abstraction is carried to the last limit, to the point where the artwork as an object has disappeared.

As anyone can guess, this kind of art has not been a great success with average collectors, as it is generally a very difficult area for them to understand. The other problem for the Conceptual artists was the non-consumable nature of most of their work.

We have so far talked about abstract artists, but how about figurative or representational artists today? When a work of art is figurative or representational, it carries visual information about things in the world outside itself, their colors, shape, structure, etc.

Representational art is really more difficult for collectors because its tradition goes back further than abstract art. Nonfigurative art was still considered a novelty until the advent of the New York School. Even though Kandinsky is generally thought of as the pioneer of Abstract Expressionist work, from the collector's view abstraction in the U. S. begins with the New York School. This is a good breaking period, if we are to try to understand contemporary figurative work.

Hilton Kramer, in his *The Revenge of the Philistines,* reprints an article entitled "The Return of the Realists." "Not since the 1930s," he says, "has realist art – the kind of painting, drawing, and sculpture that appears to give us an accurate and unembellished account of what we see in the world around us – enjoyed such widespread exposure and esteem."

The important points in understanding this phenomenon, he tells us, are that

first the realist movement is not homogeneous in its style, its methods, or its ideology. Second, as a movement, it is divided in its aims and outlook; third, a large part of the movement derives from the theory and practice of Modernist art and may then be said it represents a continuation of Modernist art by other means. ("Modernist," incidentally, is a term used by the critics to describe the movement that developed after the 1900s.)

The issue within the new realist tradition, Kramer says, is subject matter. "Is the subject of primary importance to what the artist sets out to achieve?" He answers his question by saying, "an art movement that embraces so many contradictory aspirations, that flouts so many modernist pieties, and that has already, in a relatively short time, generated so much argument and controversy, even within its own ranks, does not lend itself to easy summary."

If it's not easy for Hilton Kramer, imagine how difficult it is for the average collector. The names of the artists whom he uses as examples, and his favorites over the years, are all wellknown established artists: William Bailey, Philip Pearlstein, Jack Beal, Alex Katz, and Neil Welliver. All are artists who are transmitting information about some segment of the visible world outside the art object. Bailey is a still-life painter, Pearlstein paints figures, and Welliver, the landscape, but all of these painters are also abstract in that the information they transmit is less or more complete than what they actually see. But we certainly see and understand the subject matter of the painting.

Looking for current references is not an easy task for the collector, with figurative or realist painters. Mark Strand and Robert Hughes in *Art of the Real, Nine American Figurative Painters* (William Bailey, Jack Beal, Jane Frelicher, Philip Pearlstein, Alex Katz, Lenhart Anderson, Louisa Matthiasdottir, Wayne Thiebaud and Neil Welliver) are somewhat helpful.

Robert Hughes, in his foreword, tells us:

"American art criticism has its discreet code words. One, often heard in the last few years, is 'the revival of realism.' It politely suggests that realist painting fainted, or perhaps died, for a couple of decades; whereas now it issues from its tomb like Lazarus, joyfully to be greeted by (among others) critics. This construction has one great advantage. It sidles past the embarrassing question of fashion, to which no group of people, least of all the labile crowd that constitutes the art world, is immune."

Mark Strand, in his Introduction, continues:

"In the early sixties, when public attention shifted away from experiments in abstraction and focused on pop art, representation was once again an accepted mode of painting. The nine figurative painters in *Art of the Real* owe nothing to Pop Art. Believing in the selective and psychological attributes of the human eye as opposed to the camera eye, they do not work from photographs, nor do they care about reproducing the glossy neutrality of the photographic image. They are more concerned with the manipulation of surface as it serves the creation of a

convincing illusionistic space. Thus all the *realisms* – photo, neo, allegorical, painterly, and so on – are lumped together with the implicit understanding that if the shapes seen on canvas bear some relation to objects seen in the world, a realist painting is what we are looking at."

Strand tells us that he would have liked to include more than nine, and suggests that we might add to this list, Leland Bell, Alfred Leslie, Gabriel Laderman, Jane Wilson, Paul Georges, Nell Blaine, Janet Fish, Rackstraw Downes, Paul Wiesenfeld, John Moore, William Beckman and Catherine Murphy.

For the collector who's interested in the contemporary world, this is a good source. Now, start your course of study with the Dictionary of Art Historical Terms, and hopefully you will be on your way to becoming a smart collector. The best single reference for the collector to start with is John Berger's *Ways of Seeing*, British Broadcasting Corporation and Penguin Books, 1985.

A

ABSTRACT ART – Those forms of twentieth century art that do not present the natural appearance of objects; they are often referred to as nonrepresentational or non-objective. The term "abstract" itself is an uncertain or obscure term and invites constant discussion. One could easily claim that all art is abstract, just as one might follow Picasso in declaring that there is no abstract art. Attempts to substitute other terms for it have failed.

Abstract art falls into two historically defined periods; an initial period (1910–1916) when abstraction was the result of an anti-naturalist process, and a second period that began in 1917 with Mondrian (and is still going on) in which abstraction-for-abstraction's sake is the absolute principle from which the artist starts.

Discussion of abstract, non-figurative or non-representational (as contrasted with representational or figurative) art has generally led to a continuing controversy rather than to any real clarification of the subject. Opponents and supporters reach a deadlock, because it is as useless to deny the legitimacy of abstract art as to try and impose its principles as absolute dogma. No artistic formula, abstract or representational or figurative, can be justified or condemned in itself; it must be judged by reference to the quality of the works that exemplify it.

The Houston artist Kelly Alison summarizes her view of abstraction as follows:

> "The word 'abstract' actually means that which can exist only as a conception. It involves such a vast sum of knowledge and so many different ideas that without art no man could hold it in focus of his conscious awareness. Most people think an abstract painting is done by taking concretes and abstracting them. Quite the opposite – it is taking abstractions and making them concrete."

ABSTRACT ESPRESSIONISM – A movement of abstract art that emerged in New York City during the 1940s. It attained singular prominence during the 1950s and was the first important school of American painting to declare independence from European styles and to influence the development of art abroad. It emphasized personal expressiveness and qualities of brush stroke and texture, and it glorified the act of painting itself.

ACRYLIC – A synthetic plastic resin; in solvent, used as the vehicle for acrylic paints. Fast-drying acrylic paints are often used today in place of oils. Many artists today use acrylics rather than oil. Today, whether an artist paints in oils or acrylics is of little importance in determining the value of a painting.

AESTHETICS – The term aesthetics was first used by Alexander Gottlieb Baumgarten as the title of a work published in the 1750s. This book continued the eighteenth century debate questioning the assumptions inherited from the Classical tradition. In this debate, for the first time, men as familiar with and devoted to the classics as Diderot, Voltaire, Lessing, Montesquieu and Hume questioned the assumptions inherited from the Classical tradition.

The question: Must art serve a didactic purpose and teach a moral lesson, or is its primary function to give pleasure?

Clive Bell, the writer and critic, had it correct when he said:

"It is improbable that more nonsense has been written about aesthetics than about anything else: the literature of the subject is not large enough for that. It is certain, however, that about no subject with which I am acquainted has so little been said that is at all to the purpose. The explanation is discoverable. He who would elaborate a plausible theory of aesthetics must possess two qualities – artistic sensibility and a turn for clear thinking. Without sensibility a man can have no aesthetic experience, and, obviously, theories not based on broad and deep aesthetic experience are worthless. Only those for whom art is a constant source of passionate emotion can possess the data from which profitable theories may be deduced; but to deduce profitable theories even from accurate data involves a certain amount of brain-work, and, unfortunately, robust intellects and delicate sensibilities are not inseparable."

ALTERNATIVE SPACES – The 1970s saw art and art forms begin to move out of the galleries and museums and into alternative spaces, such as cellars, lofts, outdoors (earthworks, coastal wrappings, valley curtains), and studios for video and performance. Brian O'Doherty coined the term to describe this phenomenon.

One of the most innovative at the time and most active alternative space programs in the nation was in Wichita, Kansas, where a group called Art of the Above, working with city authorities, developed the concept of the floating gallery. Another type of alternative space is Public School One in New York, organized and operated by Alane Heiss. Built in the 1890s and abandoned in 1963, it was later taken over by the Institute for Art and Urban Resources, which has spawned

successful exhibition spaces such as the Clocktower. Today, there are alternative spaces in almost every city in the U. S.

AMERICAN REALISM – The Eight and the Ashcan School – The American Academy, established in the nineteenth century, was like its earlier European counterparts in that it exerted influence and power in the art world and often helped determine the success or failure of an artist. Like Europe's academies, the American Academy was conservative, traditional, and inflexible. It established artistic traditions and standards that influenced art into the twentieth century, until a group of vibrant young painters, led by Robert Henri (1865–1929), rejected its stodgy politics and attitudes as aesthetically stifling. Consistently rebuffed in exhibitions juried by the academy, a group now known as The Eight – consisting of William Glackens, George Luks, John Sloan, Everitt Shinn, Arthur B. Davies, Maurice Prendergast, Ernest Lawson, and Henri – exhibited in 1908 to demonstrate its independence from the academy.

The Eight attempted to inject new life and spirit into painting by finding a subject matter close to the heart and experiences of painters. Life and art were thought to be the same thing, and The Eight and other associated painters observed and painted everything they saw: city slums, theater, commerce, and the whole fabric of urban life with its urchins, derelicts, and milling crowds on streets and bridges. The urban milieu in all its vast diversity and with its full cast of characters fascinated these painters. Because of the sometimes commonplace imagery, one group inherited the name of the Ashcan school. Most of the members of this group were students of Henri, the most prolific and influential teacher of this group.

Regionalism – Realist painting from the 1920s and 1930s is often called American Scene painting. During this period, America was relatively isolated – both politically and artistically – from the rest of the world, and many artists were preoccupied with purely American subjects, in whose relevance and vitality they firmly believed. American life, its cities, and more often its small towns and rural districts were the subjects of American Scene painting. In their search for quintessentially "American" subjects, the Regionalists often ended their journey in the bleak, cold, and intellectually narrow world of the small rural town.

The financial deprivation of many artists in the 1930s was to some extent alleviated by the WPA, or the federal Works Project Administration, which was established in 1935 to support artists by commissioning murals for public buildings throughout the United States. By the start of World War II, these projects had been phased out, and art schools and universities took the place of government in giving institutional financial support to artists.

AQUATINT – An intaglio printing process by which a porous ground of resin or other substance is applied to the metal plate and fused to it by heating. When immersed in acid the effect of the acid is to penetrate the tiny pores in the ground and etch a surface that, when inked and printed, creates a grainy, gray value. By controlling the length of the immersion and by "stopping out" some areas already

etched and reimmersing the plate a variety of values or tones can be developed. The term also refers to the print made from the inked plate. For the collector interested in prints, the aquatint process is one of the several methods used to make prints. The method used by the artist seldom add to value, it is the fame of the artist and the subject, rather than the process, which creates value.

ARMORY SHOW – An international exhibition of modern art held in February 1913 in New York. Coming after the first exhibitions of Matisse (1908) and Picasso (1911), both arranged there by Alfred Stieglitz in his Gallery 291, it has remained the most famous exhibition of its kind in the United States. On the initiative of an artistic avant-garde which had already got itself talked about, a number of artists such as Matisse, Picasso, Braque, Léger, Derain, Vlaminck, as well as Kandinsky, Brancusi and Marcel Duchamp, were invited to exhibit their works, under prudent cover of some paintings by Courbet, Ingres, Delacroix and several of the leading Impressionists. The works of a number of young American painters were also on exhibit, chaperoned, so to speak, by a few artists of long standing such as Whistler, Ryder and Twachtman. Thus, every trend and taste was represented: Classicism, Romanticism, Realism, Impressionism, Fauvism, Cubism, Expressionism and Abstract Art. Eleven hundred works were assembled in the armory of the 69th Cavalry Regiment, hence the name bled in the armory of the 69th Cavalry Regiment, hence the name "Armory Show." This experiment was received with scandalous demonstrations unprecedented in the United States. Amid howls of derision and laughter, the Cubist room and, in particular, Marcel Duchamp's "Nude Descending a Staircase," were attacked by a frenzied mob that threatened to destroy the canvases it considered offensive to good taste. The press, as was to be expected, endorsed the public's hostile attitude. Nevertheless, the exhibition was a great success, stirring up curiosity if nothing else. It moved to the Chicago Art Institute, where it was received with similar scenes. Boston showed the same disapproval, but with more restraint. Everywhere the exhibition provoked the same reaction. The Armory Show did, nevertheless, manage to find a few supporters and became the basis from which all serious collecting started in the U.S. From that moment on, modern art found a comparatively large audience in the United States. For most collectors, the starting point in his exhibition odyssey must be the "Armory Show."

ARTIST'S BOOK – The term artist's book is also used to describe a booklike object, closer to painting and sculpture, that is a metaphorical expression of the form and function of a book. Multiple bookworks are manufactured with mass-production materials and techniques – photo-offset, letterpress, rubber stamps, photography; but one-of-a-kind books are put together by hand – sewn, constructed, collaged, modeled – out of every imaginable material. They often stress the sensory aspect of books: imitating ancient tomes, scrolls and tablets, alluding to their cultural, historical and psychological dimensions as record-keeper, ency-

clopedia, primer, ritual object, diary, religious tract, manuscript, even musical score. Right now, the unique book is attracting growing numbers of artists, with remarkable results. Its current popularity seems to mirror the art world's renewed emphasis on individual espression, materiality, and salable objects in this neoconservative period. Book Works (3 Dragon Court, Borough Market, London, S. E. 1, England) has for sale a full range of artists' books.

As Barbara Braun tells us in "Artists' Books," Small Press, Vol 2, No. 1 (Sept./Oct. 1984):

> "Rot (a.k.a. Dieter Roth), an Icelandic artist who also lives and works in Germany and Switzerland, was one of the first to recognize and explore the sculptural, sensory, and associational possibilities of the medium. A skillful graphic artist (and also a poet), he began as early as the mid-1950s to experiment with the physical structures of books. With extraordinary inventiveness, he manipulated sequences of pages, the direction, scale, and pacing of images (which sometimes consisted of blown-up words), and played with the sound, size, shape, and binding (using spiral and ring binders, and loose pages in folders) of books. 'He took a stack of newspapers and cut them into squares and made a book. Another book of comics had holes cut into it. And he used proof sheets as part of the book, making layers of images,' says Skuta Helgason, himself an Icelandic book artist and manager of Bookworks, a Washington, D.C., artists' book outlet, in describing how Rot perforated pages with stencil cuts to produce different tactile and visual effects as the pages turned, and used found materials and printers' waste in his books.
>
> Rot has produced nearly 50 books, most of them selfpublished in small editions. But since his association with Stuttgart publisher Hansjorg Mayer in the mid-1960s, he has been publishing larger editions and replicas of his earlier books."

The range of work in this area is something special; from the best of the private presses, like Ronald King's Circle Press in Guildford, England, to the Center for Book Arts in New York, the contemporary book arts are flourishing. See *The Open and Closed Book,* Contemporary Book Arts, 1979, Victoria and Albert Museum, England and *Livres Artistes,* Centre Georges Pompidou, 1986.

The range of collecting possibilities in this area is limitless. Ruth and Marvin Sackner have built a private museum attached to their home in Miami which contains the best collection of book arts in the world. Continually searching throughout the world for old and new works, the Sackners epitomize the tradition of the great collectors of America. Although not comprised of pictures like the Barnes, The Norton Simon, the Guggenheim or the Whitney collections, the Sackner collectibles are the finest of the book arts. The famous and the not-so-famous artists make up an extraordinary melange of possibilities of future potential for the arts. Specializing in concrete and visual texts, the collection is housed in an archive open by appointment and has been recently catalogued. See: *Ruth and Marvin Sackner, Archive of Concrete and Visual Poetry,* compiled by Ruth and Marvin Sackner, 1986.

B

BATEAU-LAVOIR – In the early years of the century the poet Max Jacob gave this name to a strange conglomeration of artists' studios in Montmartre, at the top of the steps leading to No. 13 Rue Ravignan. There are all sorts of conjectures as to the origins of the Bateau-Lavoir. It has even been suggested that it was once a factory. In any case, Van Dongen, and later Picasso, came to live there, that is to say between 1900 and 1904.

Beginning in 1904, there was a change in the social status of the tenants of the place. Little by little, writers and artists began to take it over. Among those who came to live there, at one time or another, were Pierre MacOrlan, Juan Gris, Andre Salmon, Gargallo, Max Jacob and Pierre Reverdy. It became a kind of club that soon had its habitués – artists like Matisse, Braque, Derain, Dufy, Marie Laurencin, Modigliani, Laurens, Utrillo, Lipchitz, Maria Blanchard, Metzinger, Marcoussis; poets and writers like Apollinaire, Jarry, Cocteau, Coquiot, Cremnitz, Paul Fort, Warnod, Radiguet, Gertrude Stein; actors like Dullin, Harry Baur, Gaston Modot; and dealers like Vollard, Sagot, Kahnweiler and Berthe Weil; not to mention inquisitive strangers. It was with this outstanding group that Picasso first discussed Cubism. From 1980 on, daily discussions took place, either in the studios of Picasso or Juan Gris or in the neighboring cafes. This new aesthetic doctrine slowly took shape around Picasso in the course of discussions that went on night and day between Braque, Derain, Gris, Marcoussis and Metzinger, joined later by Apollinaire, Raynal and the mathematician Princet. These discussions changed art forever.

When the First World War broke out in 1914 painters left the Bateau-Lavoir and Montmartre for more comfortable lodgings, and thus ended the period of the "Bateau-Lavoir".

BAUHAUS – In 1919 Walter Gropius, one of the leading contemporary German architects, founded in Weimar the Staatliches Bauhaus (State Building House), a grouping together of the schools of fine arts and crafts. Stemming from the historical and social conditions of a defeated Germany, the Bauhaus was a reaction against expressionist individualism. Its ambition was to revive the lost unity of all the arts, in relation to modern architecture on the one hand and the concrete needs of industrial civilization on the other. The "Bauhaus" group wanted to re-establish a harmony between the different artistic activities, between craftsmanship and artistry.

The leading teachers, together with Gropius, were artists of the first rank: Lionel Feininger (from 1919 to 1933), Paul Klee (from 1920 to 1929), Oskar Schlemmer (1921 to 1929), Wassily Kandinsky (from 1922 to 1932), and Lazlo Moholy-Nagy (from 1923 to 1928). Klee taught theory, then painting on glass and tapestry. Kandinsky gave lessons in general theory, but concentrated more on abstract composition and monumental painting.

In 1929 the Bauhaus moved to Dessau where, a victim of National Socialism, it had to close down in 1933. Gropius, who gave up the management of the Bauhaus

in 1928, and Feininger settled in the United States in 1937. Moholy-Nagy joined them there, and tried to revive the tradition of the group, founding a New Bauhaus in Chicago.

BLAST – "Vorticism" was the only movement in Great Britain comparable in intention with Parisian Cubism and Italian Futurism before 1914. Wyndham Lewis was the creative pivot around which Vorticism revolved, and the publication Blast, which he edited, was the group's public platform.

The word was actually coined by Ezra Pound. (*Pound's Artists*, The Tate Gallery, 1985.) Vorticism was abstraction, often totally non-figurative, and characterized by flat, planelike systems of arcs and angles organized radially from a particular focal point (the "Vortex") which draws the spectator into a whirling recession. Like Cubism and Futurism, the movement was essentially anti-Impressionist; like the latter, it "accepted the machine world . . . it sought out machine forms." The "political" purpose of the movement was to "hustle the cultural Britannia" and "Blast" – or, to give it its full title, "Blast: Review of the Great English Vortex" – was to blow the cobwebs from her eyes as though with a flame-thrower.

BLAUE REITER – The name, derived from a small picture by Kandinsky, "The Blue Rider" is used to designate the most fertile artistic movement that arose in Germany before 1914. At the beginning of the century Munich was one of the main centers of German artistic activity. In 1902, Kandinsky opened his own school of art, and became president of the "Phalanx" group. In 1904 all the advanced groups of artists united, and exhibitions were arranged of works by Cézanne, Gauguin, Van Gogh and the Neo-Impressionists. In January, 1909, Erbsloh, Jawlensky, Kandinsky, Kanoldt, Kubin, Gabriele Munter, Marianna von Werefkin, Schnabel and Wittenstein formed the New Artists' Federation of Munich, and held their first exhibition at the Tannhauser Gallery from December 1909 to January 1910. Other artists joined the movement: Bechtejeff, Erma Bossi, Kogan, Sacharoff (1909), Girieud, Le Fauconnier (1910), Franz Marc, Otto Fischer (1911) and Mogilewsky (1912). In addition, Picasso, Derain, Rouault, Vlaminck, Braque and Van Dongen were invited to take part in the exhibitions.

This vast group, with no definite program, had no aim other than to unite all the young artistic forces. To show its importance and its variety, Marc and Kandinsky took it upon themselves, in July, 1911, to prepare a collective volume of aesthetic studies and numerous illustrations under the title of "Der Blaue Reiter." But even before it appeared, in the course of the third combined exhibition (December, 1911), differences of opinion arose over questions of jury, and Kandinsky, Kubin, Marc and Gabriele Munter left the Association. On the 18th of December, also at the Tannhauser Gallery, the first exhibition of the new "Blaue Reiter" group was held, showing forty-three pictures by Henri Rousseau, Delaunay, Epstein, Kahler, Macke, Bloch, Schonberg, David and Vladimir Burljuk, Bloe-Niestle, Gabriele Munter, Kandinsky, Marc and Campendonck. A

second exhibition, confined to drawings and engravings (in black-and-white), took place at the Goltz Gallery three months later. The circle was enlarged by the inclusion of the "Brucke" group of Dresden, the New Secession of Berlin, the French artists Braque, Derain, Picasso, La Fresnaye, Vlaminck, Lotiron and Vera, and the Russians Nathalie Gontcharova, Larionov and Malevitch. In 1912 Paul Klee, moved by the works of Marc, Delaunay and Kandinsky, joined the group and exhibited his poetic water-colors. There was no formulation of any aesthetic role, unless perhaps an aversion to academic formulas, and a faith in what Kandinsky called the "inner necessity."

The First World War dispersed the efforts and energy of the "Blaue Reiter." Macke was killed in 1914, Franz Marc in 1916. Klee and Kandinsky went back to the Bauhaus at Weimar and Dessau.

BRITISH ABSTRACT ART – The only British center for abstract art in the years immediately after the war was St. Ives in Cornwall, where Ben Nicholson and Barbara Hepworth had settled on the outbreak of war, followed shortly afterwards by Naum Gabo (who moved on to the United States in 1946). Hepworth made sculptures inspired by caves, monoliths and wave forms, while Nicholson largely abandoned pure non-figuration to make small stylised landscapes of St. Ives and its environs, as well as post-Cubist still life compositions. Their presence at St. Ives attracted various younger artists such as Lanyon, Wells, Barns-Graham, Heron, Frost and Mitchell.

A second wave began in 1948 with the conversion of Victor Pasmore to abstraction. Pasmore had become more and more interested in Cézanne, Seurat and Post-Impressionism, and had begun to experiment along these lines until he reached what he felt was an impasse. His decision in 1948 to start again with abstract art, using a basic vocabulary of forms such as the circle, square and spiral, was a turning point in post-war British art; and he was followed soon afterwards by a small group of artists who were pupils or friends of his such as Kenneth Martin, Adrian Heath, Terry Frost and Anthony Hill. See *Forty Years of Modern Art 1945–1985* (The Tate Gallery, 1986).

C

CABARET VOLTAIRE – The Dada group, founded by the Alsatian Hans Arp, the Rumanian Tristan Tzara, and the Germans Hugo Ball and Richard Hulsenbeck, first came into the public eye when, on February 8, 1916, it opened an arts club in Zurich, called the Cabaret Voltaire, with a theatre stage and an exhibition and lecture hall. On March 30th Dada inaugurated the series of entertainments that shocked the public. In the words of the Surrealist poet Georges Hugnet: "On the stage someone thumped keys and bottles to make music until the audience, nearly crazy, protested. Sernier, instead of reciting poems, laid a bouquet at the foot of a dressmaker's dummy. A voice from beneath an enormous hat shaped like

a sugar-loaf declaimed Arp's poems, Hulsenbeck bellowed his poems, while Tzara emphasized the rhythms and crescendos by banging on a bass drum."

A slim volume entitle "Cabaret Voltaire," to which Apollinaire, Cendrars, Marinetti, Tzara and others contributed, was published in June of that year. A performance, which degenerated into a brawl, was put on in the Kaufleute Halle in 1919, before an audience of 1,500. About that time the Dada movement developed in Berlin, Cologne, Hanover and, finally, Paris.

Today's equivalent of the Dada might be said to be Performance Art. Starting in roughly 1967, this art combines aspects of Performance, Process Art, and Conceptualism. Artists turn their bodies into subjects and objects as a material for creating art. Today, we have photography and videotapes to record the art and the performance. Franklin Furnace and the Kitchen in New York, and performance centers in other cities in the U. S. and Europe seem to be accelerating. For the collector who wants an experience, Performance Art is the place to be and be seen.

CAFE GUERBOIS – Situated in Montmartre, at No. 9 Avenue de Clichy, the Cafe Guerbois was the meeting-place of an artistic circle which, as early as 1866 (but especially during 1868 and 1869), was frequented every Friday by Manet and the writers and art critics Zola, Duranty, Theodore Duret; the painters Bazille, Degas, Renoir, Pissarro, Monet, Sisley, Guys, Stevens; the sculptor Zacharie Astruc, the engraver Bracquemond, and the photographer Nadar. The first principles of the Impressionist movement were laid down there. Inspired by the lengthy discussions that took place there, Zola enthusiastically launched his crusade for the movement, which he was soon to disavow. After the Franco-Prussian war these gatherings were resumed. Manet was always the central figure. It was there that Clemenceau met Monet. They were to remain lifelong friends. About 1876 the group began holding its sessions at the Nouvelle Athenes, also in Montmartre.

COLLAGE – A work produced by gluing pieces of natural or manufactured materials to a surface to produce all or part of a work of art; often used in combination with painting or drawing. This technique, as old as time itself, became a genuine art form in this century. Referred to as "Papier Collé" by the French, in America, we call it the "Art of Assemblage." What is its origin, and who was its inventor? While "collages" appeared in the work of both Picasso and Braque at the end of 1912, it is apparently the latter who first had the idea and was the first to apply it.

Braque glued pieces of printed or decorative papers or of newspaper to cardboard or canvas, and then applied either ink or pencil lines or touches of gouache or oil paint to them. Picasso's procedure was not much different. Soon both incorporated into their pictures sand, pieces of cloth or wood, odd objects like playing-cards, boxes of matches or wrappers from tobacco packages. While Picasso sought unexpected effects of contrast, Braque succeeded in revealing the relations between the elements employed and forms mentally conceived, to achieve a sort of visual poetry. The common, inert, dead substances had only to be incorporated by human ingenuity into a picture to take on artistic life.

As early as 1913 Juan Gris made harmoniously rhythmic collages of selected materials. He used pages of books, musical staves, decorative flowered papers, and old-fashioned engravings. Between 1914 and 1918 the French sculptor Laurens executed numerous compositions which mark the high point of the Cubist "papiers collé." But the experiments that Jean Arp, another sculptor, made at the same time revealed entirely different preoccupations. Arp, a deliberate and reflective artist, concerned, above all, with sobriety, if not austerity, of expression, cut out from paper with great precision plain forms that he had only to glue upon a ground to obtain simple and straightforward rhythms. Italian Futurists, in turn, experimented in the technique practiced by the French Cubists: Balla, Boccioni, Carra, Prampolini, Severini. The Dadaists made use of it also, but in a spirit that was different from, if not opposed to, that of the inventors. Whereas the latter desired to accentuate the plastic value of the image, the boisterous followers of Dada used the same technique to destroy the traditional concept of a picture, to exhibit in the most extravagant juxtapositions their contempt for logic and reason. Both Max Ernst and Schwitters used them in their art. The humor and fantasy of these artists could not fail to influence the Surrealists Miro, Tanguy and Magritte about 1928. Russian Constructivists, Germans from the Bauhaus, and the Futurist Magnelli also made uses of the collage technique.

Finally came Matisse, whose experiments were the most important since that of the Cubists. It was, in fact, Matisse who revived collage as an idiom and endowed it with an inimitable vocabulary, syntax and style. The "papier collé" was the happy culmination of his art and life. Barred by illness and age from easel painting, he gave up the brush for the scissors and paint for colored paper during his last ten years. Cut and glued paper came to be his sole medium. He mastered it so completely, made it a tool so obedient to his will, so suited to his gifts, that his "papier collé" illuminate his entire past and justify all his previous experiments. His constant effort, continued during half a century, to increase the emotional value of the arabesque and the sonority of tone, to create an increasingly acute feeling of pictorial space, could not fail to lead to the cut and glue papers to which his book "Jazz" introduced us in 1947 and is today available in a reprint form at your local bookstore. There is indeed little difference between his pencil drawings and the designs he made with scissors; indeed he said himself "scissors can achieve more sensitivity than the pencil." As he preferred to apply color on his canvases flat, he had prepared himself for a long time to substitute paper for paint. Moreover, by cutting out sheets of colored paper with scissors he could simultaneously associate line with color and contour with surface. This is why, completing the Cubist experiment, Matisse was able to make "papier collé" an autonomous medium, an idiom as authentic, as alive as the weaving, enamel and stained glass of the past.

In America, collage and assemblage became synonymous in the late 1950s and early 1960s into not only a procedure but a complex of attitudes and ideas. The fine line between assemblage and environments is often vague, and the two are sometimes considered together. Some of the artists active in assemblage are Ed

Kienholz, Louise Nevelson, Robert Rauschenberg, Simon Rodia, Joseph Cornell, and Jim Dine.

Building on the tradition of collage, futurism, and dada, William Seitz, in "The Art of Assemblage" (1961), analyzes assemblage in the context of the diverse images and intuition that come together in the immediate context and past history. He adapted the word "assemblage" from Dubuffet to describe works that are predominantly assembled rather than painted, drawn, or carved and ones that are entirely or in part made of natural or manufactured materials, objects or fragments not intended as art materials. Seitz classifies and describes phenomena, both positive and negative, that are in juxtaposition to each other in relation to assemblage, and he discusses Apollinaire and Gide in relation to his theories.

COLOR-FIELD PAINTING – This term was applied to the work of a generation of American painters who exhibited in the late 1950s and early 1960s (Gene Davis, Helen Frankenthaler, Kenneth Noland, Morris Louis, and Jules Olitski), with Barnett Newman generally considered the originator of the color-field concept. Colorfield painting is known for its monumental horizontal scale, with the whole field of vision of the spectator engulfed. It does not have the depth tradition of oil painting but has color extending beyond the confines of the canvas to infinity.

COMPOSITION – The organization of forms in a work of art.

CONCEPTUAL ART – Conceptual Art defies an exact definition, but, in general acceptance, it emphasizes rules, or sets of decisions, as the essential feature of art not the physical objects. The essential aspect of Conceptual Art is its self-reference. The artists define their intentions of their work as part of their art. Conceptual Art generally emphasizes the elimination of the art object, and that it is best explained through itself. Richard Serra, one of the leading modern-day Conceptualists says, "I do not make art, I am engaged in an activity."

CONCRETE ART – A term invented by Theo Van Doesburg in 1930 to replace the term Abstract Art. Since then Concrete Art has been used in preference to Abstract Art in the writings of certain artists such as Arp and Max Bill. The term is interchangeable with Abstract Art.

CONSTRUCTIVISM – Russian art movement founded around 1913 stressing Abstract Constructive principles which had considerable effect on Western European Abstract Art, particularly sculpture. The name given to this art movement was Suprematism. This was the name given by Malevitch to the geometrical abstractions he derived from Cubism in 1913. The elements of Russian Constructivism or Suprematism were the rectangle, the circle, the triangle and the cross. Almost simultaneously Tatlin originated the Constructivist movement and Rodchenko Non-Objectivism, both closely related to Suprematism. Later (about 1920) Constructivism was revived when Gabo and Pevsner published the "Realist Man-

ifesto" in Moscow. When modern movements were banished by the Russian authorities, Gabo left Moscow for Berlin, and Pevsner for Paris. However, it was chiefly through the activity of the painter and draughtsman El Lissitzky that Constructivist and Suprematist ideas were introduced (starting in 1922) into Germany, in the Bauhaus. The work of Mondrian was more dogmatic than Suprematism. While the work of Mondrian has more deeply affected the art of our time, it is Malevitch that must be given credit for having gone the farthest in the shortest time, by leaping from Cubism to Suprematism in the space of a few months, starting anew on an entirely different and quite simple basis: the black square on a white background.

All painting that takes as its groundwork exact geometrical forms, without any attempt at representation, necessarily descends, therefore, from Malevitch and the Suprematism of 1913. The movement may have appeared futile at that time, but from it has emerged a whole new sphere of art that is far from being exhausted today. Today there are modern-day Constructivists in he U. S. and England, and all of their painting basically takes as their starting point Malevitch.

CUBISM – One of the earliest movements in modern Abstract Art, it began in France about 1909 partly as a rebellion against Impressionism. Its exponents transformed natural forms into abstract, geometric arrangements of intersecting, overlapping, and interlocking planes. Pablo Picasso and Georges Braque were its founders.

Cubism is the name given to an aesthetic revolution and one of the most basic art forms, brought about by Picasso, Braque, Juan Gris and Leger between 1907 and 1914. Matisse and Derain also contributed to the formation of this movement, which influenced the majority of the avant-garde artists during the years that preceded the 1914–1918 war. Like Impressionism, Cubism at first encountered nothing but general hostility, or incomprehension, and was given its name in derision. In his account of the first Braque exhibition at the Kahnweiler Gallery, the critic Louis Vauxcelles picked up one of Matisse's sallies and spoke of "cubes." The following spring, in the same paper, and again on the subject of Braque, he spoke of "Cubist bizarreries." The creators of Cubism accepted the term with reserve, and constantly denied they were theorists. Picasso declared: "When we painted as we did, we had no intention of creating Cubism, but only of expressing what was inside us." Braque said: "For me, Cubism – or rather my Cubism – is a means I created for my own use, with the aim of putting painting within range of my talents." The vitality and fecundity of Cubism comes from the coupling of these two exceptional temperaments, who worked enthusiastically together, without surrendering their own personalities. Later, they were joined by Gris and Leger. The history of the development of Cubism falls into three phases: a Cézanne phase (1907–1909), an analytical phase (1910–1912), and a synthetic phase (1913–1914). A favorable climate for it had been prepared by the vogue of Negro sculpture and primitive art, the Seurat retrospective exhibition in the Salon des Independants of 1905 and, particularly, the Cézanne retrospective in the Salon d'Automne of 1907. Matisse and Derain had already disciplined Fauvism and tried to organize, method-

216

ically, the painted surface of the picture. In the spring of 1907 Picasso completed "Les Demoiselles d'Avignon, "hacked out with an axe," of which the right-hand section, violently simplified and constructed by drawing alone, without the use of chiaroscuro, marks the beginning of Cubism. He met Braque, whose natural evolution he speeded up. That autumn, Kahnweiler opened, in the Rue Vignon, the gallery that was to become the home of Cubism. The famous Bateau-Lavoir group was formed in 1908 at No. 13 Rue Ravignan, Montmartre, where Picasso, Max Jacob and Juan Gris went to live. It also included Apollinaire, Salmon, Raynal, Gertrude and Leo Stein, and others. The new aesthetic movement, intuitive with Picasso and deductive with Braque, can be clearly seen in the landscapes painted by Picasso at La Rue-des-Bois in the Oise in 1908, and at Horta de Ebro in Spain in 1909 (the latter exhibited by Vollard), as well as in the landscapes painted by Braque at l'Estaque in 1908 (exhibited at Kahnweiler's). Braque, fresh from Impressionism and Fauvism, controlled his color by an austere sense of form; Picasso, the instictive draughtsman, tried to introduce color into his work. Each on his own was striving to find the same solutions by developing whatever quality he lacked. They made a study of the fundamental problem of painting: the representation of colored volume on a flat surface. The history of Cubism is that of the successive solutions discovered to resolve this difficulty. The result was a new plastic language, lyrical and conceptual at the same time, which put an end to that respect for appearances which had been observed since the Renaissance. In their reaction against Impressionism and its visual spontaneity, Braque and Picasso discarded from their world all fortuitous appearances and atmospheric accidents. They tried to define the permanent properties of objects and their stability in a closed space, without perspective or light, through a geometrical crystallization inspired by Cézanne; hence the significant and very restrained choice of themse, which were limited to very simple things: trees, houses, fruitbowls, bottles and glasses – later, small tables and musical instruments – that could be reduced to geometric forms and easily identified by the spectator. They were less interested in making an inventory of the world than in creating, with a few characteristic "signs," a language which would renew its significance. But in this initial, groping phase, in spite of their efforts, the antinomy of object and color, local tone and volume, was overcome only by painting in monochrome, or an imitation of sculpture.

In 1910 Braque gave up landscapes for figures and still lifes. In his own words, he passed from visual space to tactile and manual space. Picasso left the Bateau-Lavoir for the Boulevard de Clichy, also in Montmartre, where he painted a series of heads and portraits. The second phase of Cubism, described as analytical by Juan Gris, because of the increasing breakdown of form, is characterized by the use of simultaneity. Several aspects of the same object are put together on a single canvas, rather as a child sees an object, as it exists in itself and in our minds. Thus, the object appears as if broken, spread out and open from the inside. This concern for complete realism differentiates Cubism from all the other Abstract movements derived from it, and separates it from the decorative tendencies of Fauvism. This

period of extreme analysis and systematic experimentation was not without a certain danger of very close or air tight which Braque and Picasso proposed to remedy by the use of "papiers colles" and real materials, such as sand, glass, newspaper and cloth, inserted in the canvas to stimulate perception. During this period Cubism was widely publicized. It also saw its division into many off-shoot movements, including Abstraction as we know it.

The First World War dispersed the creators of Cubism, each to follow the course of his own artistic destiny. But the collective exaltation of those heroic years from 1907 to 1914 will never be lost, and constitute an area basic to the understanding of Modern and Contemporary Art.

D

DADA – The Dada Movement developed between 1915 and 1922, between the dispersal of Cubism – from which it borrowed, and generalized for its own ends, the technique of collage or papier colles – and the advent of Surrealism, which succeeded it, and for which it constituted a preparatory though negative phase. Dada made its first appearance almost simultaneously in Zuric, New York and Paris, before reaching Germany and then concentrating in Paris. Switzerland's neutrality during the First World War had made it a refuge for all kinds of political exiles. Lenin was there, rubbing shoulders with artists and writers from almost every country. Among the latter were the Rumanian poet Tristan Tzara, the German writers Hugo Ball and Richard Hulsenbeck, and the Alsatian painter and sculptor Hans Arp. In February 1916 they founded the Cabaret Voltaire, a literary club, exhibition gallery, and theatre hall all in one; the name is a clear indication of its sarcastic and critical intentions. A dictionary, opened at random (this appeal to chance was to become systematic) furnished the name of the movement: Dada. Learned lectures on Klee, or Lao-tse, alternated with scandalizing or mystifying entertainments, designed to undermine by every possible means the traditional bases of culture and social order. Works by Arp, Chirico, Max Ernst, Feininger, Kandinsky, Klee, Kokoschka, Marc, Modigliani and Picasso were exhibited in a very eclectic manner at the Dada gallery in 1917. The typical artists of the movement was Arp, illustrator of Hulsenbeck and Tzara, who, with his colored papers, his woodcuts and his sculptures, organized the so-called free forms, born of fantasy and the unconscious.

The real precursor of the Dada spirit in its destructive sense was the painter Marce, Duchamp, a man of implacable logic and exceptional gifts. He settled in New York in 1915, where his famous "ready-mades," mass-produced objects arbitrarily raised to the level of works of art, created a sensation, and became the central figure of the Stieglitz group and the Review "291" (Man Ray, Picabia, de Zayas, Arensberg), an anti-artistic movement parallel to the Dada movement of Zurich. Picabia, a painter of Spanish origin, had visited New York in 1915. He went to Barcelona and founded the "391 Review there in January 1917. He turned

up in Switzerland in 1918 and contacted the Dada group. Two numbers of *Dada,* the review edited by Tzara, were published in 1917. *Dada III,* in which Picabia collaborated, appeared in December 1918, and contained the *Dada Manifesto*, in which the meaning and destructive force of the movement were confirmed. The *Dada Anthology* (number 4–5 of the review) appeared in April 1919. Tristan Tzara then settled in Paris, and was enthusiastically received by the group run by the poets Breton, Aragon, Soupault, Eluard, Ribemont-Dessaignes and Peret. A Dada salon opened at the Montaigne Gallery on June 6th, 1922, but the Parisian movement was more literary and, after a summer demonstration in the Tyrol, it dissolved in internal disputes in the autumn of 1922.

In Germany, because of its defeat in 1918, and the social crises of the time, Dada found fertile soil for expansion. With the more direct participation of artists, the movement took on a more political character. The Berlin group, created by Hulsenbeck in 1917, broke up in 1920, after a large-scale exhibition which was a triumph for Georg Grosz, ferocious caricaturist of the German feudal bourgeoisie and militarism. On the artistic plane it was, perhaps, the Cologne group which was the most interesting, as a result of the activities of Max Ernst who, joined by Hans Arp, began to make his collages. The exhibition of April 1920, held at the Winter Cafe and closed by order of the police, reached a level of scandal and provocation which has never been surpassed. The departure of Max Ernst for Paris in 1922 marked the end of Cologne Dadism. There was a movement founded in Hanover by the poet and painter Kurt Schwitters, whose collages entitled "Merz" were formed of unusual materials and all sorts of litter.

Dada was less an artistic movement than an intellectual revolt, born of the convulsions of the First World War (1914–1918). But it was necessary for the coming of Surrealism, which was to build on its ruins.

Dada had little appeal in England, and, in the U. S., existed only briefly. See *New York Dada,* Ed. by Rudolf E. Kuenzlr, Willis Locker and Owens (1986). Dada's main contribution to this century was its atirical character.

DURAND-RUEL – Paul (1831—1922). The influence of the great art dealers on the development of painting in the nineteenth and twentieth centuries has been considerable. Durand-Ruel was first a friend of Corot, Millet, Theodore Rousseau and Boudin, and gave them both moral and material support, sharing their enthusiasms and their disappointments, and disposing of their conavases for them, often with reluctance. He was one of the most important art dealers who backed the Impressionists in 1870. In 1871 he fled to London, and there made the acquaintance of Monet and Pissarro. On his return to Paris in 1872 he bought twenty-three canvases from Manet for 35,000 francs. For more than ten years Durand-Ruel did his utmost to popularize the Impressionist works, which no one wanted and everyone condemned. That is how Manet, which no one wanted and everyone condemned. That is how Manet, Renoir, Monet, Sisley, Cézanne, Degas and Pissarro became his friends, and the correspondence that he carried on with each of them contains important insights into their characters. He was them

contains important insights into their characters. He was as much a philanthropist as an art dealer, and narrowly escaped bankruptcy, because of the support he gave artists, before he succeeded in interesting America in the new school in 1886. In the history of Impressionism his name is linked particularly with the second exhibition of the group, which he arranged in his premises at No. 11 Rue Le Peletier in 1876, as a protest against the pig-headedness of the official Salon, which refused to accept the adherents of the new school. It was because of this exhibition, which came up against the most violent histlity, that Duranty wrote his famous book in support of "The New Painting." The stubborn refusal of French collectors to accept the Impressionists made Durand-Ruel decide to open galleries in London, Brussels, Vienna, and finally in New York in 1887.

In spite of all this, when Feneon congratulated him on his eventual success, Durand-Ruel replied: "It is the collectors that we have to thank for that."

DUVEEN – Joseph (Lord Millbank). Joseph Duveen was one of the most spectacular art dealers of all time. His astonishing career was built upon the simple observation that Europe had art and America money. To trade one for the other became the ruling and highly profitable passion of his life.

He told his American clients, "You can get all the pictures you want at fifty thousand dollars apiece – that's easy. But to get pictures at a quarter of a million apiece – that wants doing!" His "doing" skyrocketed the values of art masterpieces to astronomical heights, transformed the American taste in art, and, in five decades, established American collections as among the finest in the world.

E

EARTHWORKS (LAND ART) – An important movement that emerged in the middle 1960s developing out of minimal art, earthworks are closely related to Conceptual Art. Artists substitute terrain for object, and what is shown in exhibitions is the documentary evidence (drawings or photographs). Artists work with tar, gravel, mine tailings, dirt, and mud. Robert Smithson's Spiral Jetty, in Great Salt Lake, Utah, is one of the better-known examples of this medium. This process eliminates subject, object, and subject-object and tries to bypass the art gallery system, although this in the end has proved impossible. An important Contemporary artist in this group is Hamish Fulton, who says: "My artform is the short journey – made by walking in the landscape." The actual art objects consist of photographs of the artist's journey. (John Weber Gallery, New York City.)

ENGRAVING – an intaglio printing process in which lines are cut into a metal plate which is then inked and wiped.

ETCHING – An intaglio printing process by which a metal plate (usually copper) is first covered with an acid-resistant ground through which the design to be painted

is scratched. The plate is then immersed in acid, which bites into the exposed metal, transferring the scratched design into the plate. Printing ink is worked into the acid-bitten portions of the plate, and the unetched portions are wiped clean. The print is taken by placing dampened paper on the inked – and warmed – plate and running the plate and paper through the rollers of an etching press. The term is also applied to the print made from the plate.

EXPRESSIONISM – A style of art in which the natural object is distorted to communicate an inner vision or feeling.

Impressionism, Fauvism, Cubism, Futurism, Surrealism – titles adopted by the artists themselves or given them by their opponents – apply to contemporary and clearly defined groups or movements. Expressionism, on the other hand, denotes a permanent tendency in art, characteristic of the Nordic countries, which becomes accentuated in times of social stress and disturbance. Expressionism has found particularly fertile soil for expansion in our turbulent age, including the 1950s "Abstract Expressionism" and the most current (1981–1986) phase labeled Neo-Expressionism. Although the idea always existed, the term for it is a recent invention of German aesthetics, popularized by Herwarth Walden, publisher of the avant-garde review "Der Sturm," in Berlin, who classified under the heading of Expressionism – as opposed to Impressionism – all the revolutionary manifesta-tions between 1910 and 1920, including Cubism and the abstract trends. This broad definition, as confused as it is exaggerated, is to be found in the writings of nearly all those who concerned themselves with Expressionism, prior to Sheldon Cheney, an early American critic, who takes it to signify modern art as a whole and at its best. There are two conflicting viewpoints with respect to Expressionism – the one putting the accent on form and its autonomy, the other on psychological force and its impetus.

As a reaction against Impressionism and the objective tendency of Cézanne and Seurat, which Cubism continued, the first Expressionism movement, with Symbolist and Modern-style influences, came into being in 1885 and lasted until 1900. The leading figures in it were Van Gogh, Toulouse-Lautrec, Ensor, Munch and Hodler. Their subjectivism expressed itself in obsessional and dramatic themes, and not only through their intensity of color but also through the monumentality of their forms and the violence and sharpness of their drawing, which explains the return to the expressive line and simplified engraving and illustration techniques. Van Gogh, setting an example with his way of life as well as his work, was the founder and hero of modern Expressionism. Often in his letters, notably on the subject of his portraits, he explains what he is trying to do, afraid all the time lest his deliberate exaggeration be taken for caricature. Caricature is, in fact, a popular and spontaneous form of Expressionism, but with Van Gogh it acquires a very special value. Hodler, Munch and Ensor figured in the second wave of Expressionism, which arose (about 1905) in Germany with the creation of the *Brucke,* and in France with the decisive contribution of Rouault, of Picasso of the blue and Negro periods and, in some respects, of Matisse and Fauvism (Derain and

Vlaminck). The Belgian Ensor vacillated between Impressionism and an expressive symbolism which he resuscitated from Bosch. The Swiss Hodler often indulged in an allegorical and irritatingly exaggerated realism. Munch, a compatriot of Ibsen, touched by the morbid side of Kierkegaard's philosophy, was the central figure of Nordic Expressionism, and left his mark on it both in Germany and Scandinavia. His influence in those countries is eminently comparable, though in an opposite direction, with that of Cézanne in France. His first exhibition in Berlin in 1892 caused a scandal.

Expressionism in its dual aspect – social and physical – took firm root in the *Brucke* group, nurtured by Munch, Van Gogh and Negro sculpture (the most Expressionist of all the arts), and in a general way permeated the various currents in Germany on the eve of the war up to the *Blaue Reiter* of Munich. The creative fever became dramatically intensified, but without being able to assimilate the constructive lesson of Cubism. There are some outstanding names in the movement: Nolde and Kirchner, specifically Germanic temperaments openly at war with the art of Paris; Kokoschka in Vienna, who, at the very moment when Freud, in the same city, was elaborating psychoanalysis, executed a striking series of portraits which resemble flights into the subconscious. Suddenly the Jewish and Slav soul, dormant for centuries, manifested itself in painting, its expressionist tendency bringing a new ferment into art. From far away in distance and in time came men like Soutine, Pascin, Chagall, full of nostalgia and anguish, brimming over with tenderness. They settled in Paris before 1914. Expressionism penetrated to the United States about 1908 through Max Weber, also of Russian origin.

After the extraordinary outbreak at the beginning of the century, the interim period between the two wars stabilized itself in a sort of neo-classicism, interrupted by only one revolutionary movement, Surrealism. But the great masters of Expressionism, Munch, Ensor, Rouault, Nolde, Soutine, Kokoschka and Max Weber, continued on their own. In Latin America, particularly in Mexico, you had Rivera, Orozco, Siqueiros and Tamayo in the monumental and popular form of the fesco. Expressionism was expelled by the Nazis. Beckmann took refuge in Holland, where Expressionism evolved in a parallel manner (Sluyters, Charley, Toorop). Expressionism gave us Gromaire in France, Auberjonois in Switzerland, Solana in Spain, Rossi in Italy, and, after the 1929 crisis, gained many recruits in the United States, notably Rattner and Knaths. The Civil War in Spain, and the Second World War, moved Picasso to a new Expressionist style of hitherto unheard of violence, of which the masterpiece is *Guernica*. This brought in its wake a general revival of Expressionism, in Europe (1935–1950), in Latin America, and especially in the United States, as a result of the direct influence of Beckmann and the Germanic tendencies. After 1950, it was the American Abstract Expressionists, Tachism and Cobra (Nicolas de Staël, Hans Hartung, Constant and Asger Jorn) and now the so-called Neo-Expressionism of the 1980s.

F

FAUVES – "Wild beasts"; a name given to a group of French painters who explored an expressionist style characterized by bold distortion of forms and vivid color. Though a short-lived movement (1905–8), its influence was basic to the evolution of twentieth-century Expressionism.

Fauvism, based on pure color, was the first art revolution of the twentieth century. It was not a school, complete with program and theory, but the result of the temporary conjunction of a number of painters, actuated by the same motives and brought together through the kind of chance meetings that so foten create highly productive movements. In the famous Salon d'Automne of 1905 twelve colorists, grouped around Matisse and conscious of the similarity of their views, exhibited together. The explosive forces of their work provoked a scandal. They came together again for the Salon des Independants of 1906. Louis Vauxcelles, the art critic, noticing a small bronze in the Florentine manner by the sculptor Marque in the middle of the hall full of the riotous colors of those who were still called the "Incoherents" or "Invertebrates," exclaimed: *Donatello parmi les Fauves!*" (Donatello among the wild beasts). The name Fauves caught on, and by the time of the Salon d'Automne of the same year it was in general use. The history of Fauvism is a brief one, beginning in 1905 and reaching its full development in 1907. It may be useful to go over briefly the succession of exchanges and contacts that assisted in its creation and crystallized around the dominant personality of Matisse, the oldest in experience and undisputed leader of the movement. Three main groups of dierrerent origin (joined by Van Dongen, an independent) came under his sway, and rallied to his principles during those heroic years: the group of the Atelier Gustave Moreau and the Academie Carriere (Marquet, Manquin, Camoin, Puy), the Chatou group (Derain, Vlaminck) and lastly, the Havre group (Friesz, Dufy, Braque).

Matisse entered the Ecole Nationale des Beaux-Arts in 1892 as a pupil of Gustave Moreau. Rouault was already there. Marquet joined them in 1894, and Camoin in 1897. Moreau's enthusiastic and liberal teaching permitted the strong temperaments of the Fauves-to-be, who had become close friends, to develop without restraint. "I am the bridge," he told them, "over which some of you will pass." When he died, his pupils dispersed. Matisse, who already had considerable authority over his comrades, spent a year in Toulouse and in Corsica, and brought back from these two places, in 1899, a series of small landscapes violently sketched in pure tones with a Pointillist technique. On his return to paris he rented a studio at No. 9 Quai Saitn-Michel, in the same building as his close friend Marquet, and stayed there until 1907 – that is to say, for the whole period of Fauvism. He painted figures in pure blue, still lifes radiant with scarlet and orange, with the same audacious treatment as his Southern landscapes. In his researches he was closely followed by Marquet and, though more warily, by Manquin and Camoin. In 1899, at the Academie Carriere, he met Jean Puy, Laprade, Chabaud and Derain. Over all of them, and Derain in particular, he exercised a strong influence. He exhibited

at the Salon des Independants in 1901, together with Marquet. "We were the only two painters to express ourselves in pure tones," Marquet later said, adding: "Already in 1898 Matisse and I were working in what was to be called the Fauve manner." Derain and the self-taught Vlaminck, who shared a studio at Chatou, outside Paris, tried similar experiments, in an even more violent manner. It was at the first Salon des Independants, in 1901, in the midst of the famous Van Gogh retrospective, that Derain introduced his friend Vlaminck to Matisse. The years 1899–1901 marked, therefore, the first Fauve "push," one part of it led by Matisse and Marquet, under the structural influence of Cézanne, the other by Vlaminck and Derain, under the Expressionist influence of Van Gogh. This period was different from the period of happy, free expansion, between 1905 and 1907 dominated by the decorative influence of Gauguin.

In 1902–1903 Matisse and Marquet painted interiors and views of Paris, going back to the sombre workmanship of the early Manets. Derain went on military service, and Vlaminck, on his own, surrendered himself to his passion for color. A small gallery run by Berthe Weil gave some preliminary exhibitions of the works of the future Fauves from 1902 to 1904: Matisse, Marquet, Manquin, Flandrin, Camoin; then the childhood friends from Havre, Friesz and Dufy; and, later, Van Dongen, a Montmartre bohemian of Dutch origin. They exhibited again as a group a the Salon des Independants of 1903 (Matisse, Marquet, Puy, Manquin, Camoin, Friesz and Dufy), still without attracting public attention. Matisse had his first one-man show in the shop of the art dealer Ambroise Vollard, in June 1904, and spent the rest of the summer at Saint-Tropez, on the Riviera, painting in the company of Signac and, particularly, Cross, whose Pointillist technique he adopted, intensifying its force and luminosity. At the Salon d'Automne he showed thirteen pictures done in this manner, which were a revelation to Friesz. In the Salon des Independants of 1905, where Matisse exhibited his "Luxe, Calme et Volupte," it was Dufy's turn to experience a decisive shock when he saw "this miracle of the imagination at play in drawing and in color." He and Friesz abandoned Impressionism, the tradition in which they were trained, to follow the "pictorial mechanics" of Matisse. Derain came back from military service, and there were some very active exchanges between Matisse and the reconstituted Chatou group, who manipulated colors like "sticks of dynamite." During the summer Derain joined Matisse at Collioure, and from the stimulating contact between these two lucid and lively natures there, beneath the brilliant southern skies, the first real Fauvist canvases were born. They were to create a sensation at the historic Salon d'Automne of 1905, together with those of Marquet, Manquin, Puy, Valtat, Vlaminck, Friesz and Rouault, the latter exhibiting with his friends but remaining on the fringe of the movement with his sombre colors and moral passion. The year 1905 also saw the formation of a parallel movement in Germany, the *Brucke,* which, however, soon turned to Expressionism.

The Salon des Independants of 1906, in which Braque (the last of the three men from Havre to be won over) participated, and the Salon 'Automne of the same year (the Gauguin retrospective), when Van Dongen came to complete the group,

mark the peak of Fauvism. Its principles can be summed up in a few words: uniformity of light, space-construction by color, illumination of the flat surface without illusionist modeling or chiaroscuro, purity and simplification of means, absolute correspondence between expression (emotive suggestion) and decoration (internal organization) by composition. "Composition," said Matisse, "is the art of arranging in a decorative manner the diverse elements through which the painter expresses his feelings." Form and content coincide, and are modified by mutual reaction, for "expression comes from the colored surface which the observer takes in as a whole." In short, it is dynamic sensualism ("the shock to the senses of what the eye beholds"), and subject to the economy of the picture ("whatever is useless is consequently harmful"). This unity distinguishes the Fauves from their immediate successors, who superimposed color on a conventional framework, and from the Expressionists with their illustrative tendency. No doubt such a balance between order and passion, fire and restraint, could not be maintained at such a high level for long. At the end of 1907 Fauvism had already given way to Cubism. Matisse alone (perhaps Dufy too, though in a different mood) kept to the end the eternal youth of Fauvism. But for all of them this heroic exaltation remained, to quote Derain, the "trial by fire" which has purified painting, and revealed the best in themselves to a number of highly gifted temperaments.

FLUXUS – Fluxus, one of the first genuinely international movements since dada, was formed in the 1959–60 period and played a significant role in the history of SoHo in New York City. An early Fluxus publication was a set of cards, published in November 1961, of a pre-Fluxus concert organized by Nam June Paik. Other publications advertised a Neo-Dada in Musik in June 1962, and later a series of concerts in copenhagen, Paris, Dusseldorf, Amsterdam, The Hague, and Nice in 1963. By 1963, a core group of Fluxus – Alison Knowles, Dick Higgins, Nam June Paik, Wolf Vostell, Tomas Schmit, Ben Patterson, Emmett Williams, Addi Keopcke, Robert Filliou, and George Maciunas – had performed through Europe in their Fluxus Happenings.

FRENCH ABSTRACT ART – Francois Arnal, Rene Duvillier, Gerard Schneider, Jean Messagier and Jean Degottex represent the native artist reaction to the School of Paris and the Dubuffet style of naive graffiti and the art of the primitives and the insane (what we now call "art brut"). From the late 1950s these artists were producing pure painting, where the picture no longer represented anything but itself. It was an art that rebelled against French art history and was irreverent toward the art which preceded it. In the late 1950s they were all famous in France and America, but by the late 1960s their fame had almost completely faded. All of them are still working today, and they will be rediscovered as quality abstractionists. The critic Pierre Restany has said of Arnal's paintings:

"The quality of their presence is double: present in relation to us, present in themselves. Never as much as today would the judgmenet of Jean Hyppolite prefacing Arnal's exposition at Jean Larcade's in 1955

have taken its full value: Arnal's paiting conquers, for our joy, the sense through unveiling of 'the elementary'."

FRY – Roger Eliot (1866–1934). Eminent English art critic, little known as a painter; born and died in London. Fry studied Natural Sciences (taking a first-class degree) at King's College, Cambridge, but gave up this field for art. He went to Rome in 1891, where he was profoundly influenced by Raphael and Michelangelo, ant then to the Academie Julian, Paris, in 1892. He again visited Italy in 1894, and wrote essays on Bellini and Giotto. In 1905 he published a critical edition of Sir Joshua Reynolds's "Discourse." Unable to find a suitable position in England, he accepted that of Director of the Metropolitan Museum of Art in New York in 1905. (He returned to London five years later.) He wrote a study of Cézanne, published in 1906, and became interested in the work of Gauguin, Matisse, Van Gogh and Maillol. It was Roger Fry (together with Clive Bell) who aroused an interest among the English-speaking peoples in what he aptly named "post-Impressionism," with his two Grafton Gallery Shows in 1910 and 1912, the equivalent of the American Armory Show of 1913. In 1933 he was appointed Slade Professor of Fine Art at Cambridge, and died the following year.

Fry had a vast enthusiasm for, and an intellectual understanding of art, but little creative ability. As a painter he was soon forgotten. In his views on art he was elastic and always open to new ideas. His many short studies and articles on the subject of art and artists are of great interest. His honesty and lack of conservatism won him lasting respect as a sensitive, perceptive and helpful critic.

FUTURISM – Futurism burst on Paris in February 1901, when the Italien poet, novelist and essayist Filippo Tommaso Marinetti published in *Le Figaro* the manifesto of Futurist poetry, extolling the beauty of speed and aggressive movement, vowing to destroy museums, libraries and academies of every kind. Born in Egypt in 1876, Marinetti studied literature at the Sorbonne in Paris. In 1909 his play in French, *King Bombance,* was performed at the Theatre de l'Oeuvre. In the early part of 1910 three Italian painters, Carlo Carra, Umberto Boccioni and Luigi Russolo, met Marinetti in Milan and, after lengthy discussions on the state of Italian art at the time, decided to issue a call to the young artists in the form of a manifest. Carlo Carra, in his *Memoirs,* writes that "when distributed a few days later in thousands of copies, this appeal to fearless and open rebellion . . . had the effect of an electric charge." The manifesto also bore the signatures of Giacomo Balla, who was living in Rome, and Gino Severini, who had been living in Paris for several years. A second manifesto was launched in April of the same year. Like the text published in *Le Figaro,* the new manifesto extolled the dynamism of modern life, to which even the French avant-garde painters remained completely indifferent. The young signers of this program then believed blindly in the neo-Impressionist technique which Balla had taught Severini and Boccioni. A short trip to Paris gave them an opportunity of seeing the paintings of Picasso and Braque. They had really gone there with the intention of holding a first exhibition, but Severini

succeeded in convincing them of the necessity for further work before venturing to face the Paris critics. When the exhibition actually took place, in February 1912, Futurism appeared to be an attempt to introduce into Cubist composition the dynamic element. While Severini brought to Futurism the pure colors of Seurat, Carra, on the other hand, adopted the grey tonalities of the Cubists. Boccioni, the theoretician of the movement, never lost sight of the "realism" of Picasso, visible even in his Cubist compositions. Russolo, by sheer poetic intuition, was already foreshadowing the advent of Surrealism.

Form the first exhibition Severini emerged triumphant. In the following year, 1913, Giacomo Balla painted a series of masterpieces, suggested to him, it is true, by three of Severini's canvases entitled *Spherical Expansion in Space*. While the technical means of his companions was still uncertain, Balla was the only painter of the group to succeed in giving expression to the desire for power proclaimed by Futurism. Boccioni, in his sculptures, achieved results which were no less miraculous.

Futurism was more than just an impetuous rush towards the spirit of modernism, more than just a doctrine. It linked art with life. The 1914–1918 period of Futurism. By 1930 there were no longer five or six Futurist painters, but five hundred.

G

GENRE – In specific usage with painting, a type of painting or sculpture that depicts subjects from ordinary daily life.

GOUACHE – A watercolor given body and opacity by the addition of a neutral filler such as whiting (calcium carbonate), a chalky powder. A gouache-like effect can be achieved by adding white pigments such as zinc white or Chinese white to watercolor, but this is not a true gouache, Casein colors, combining pigments with a binder manufactured from soured skim milk, also have a gouache-like effect.

GOUPIL – (Gallery). In the years around 1850 the Goupil Gallery, then located in the Rue Caulaincourt, was a small shop which sold principally engravings of the works of such painters as Horace Vernet, Paul Delaroche and Ary Scheffer. In 1877, with the third Impressionist exhibition, Goupil became interested in the new movement and from then on the growth of the gallery was rapid. Van Gogh worked in the branch in The Hague in 1869 and was later transferred to the Brussels shop, where he was replaced by his brother Theo prior to his transfer to the London branch. In 1875 Vincent worked for a while at the Paris headquarters, from which he was dismissed the following year. Later, he sent some of his paintings to his brother, Theo, still employed by Goupil, who tried to place them with the Gallery, but they were rejected as "horrors." In 1893 Toulouse-Lautrec exhibited a group of his Montmartre canvases at the London shop. Another Goupil related to the founder of the firm, was the author of a book on painting which was instrumental in Matisse's choice of career.

GREENBERG – CLEMENT. Clement Greenberg is sometimes called the fahter of modern American art criticism, and has always been a controversial figure among art critics and historians. Although the American artists of the 1940s that he singled out for attention have since achieved international recognition as the first generation of abstract expressionists, the "modernist" theory of criticism by which Grennberg justified his taste and specified the significance of such artists has often provoked hostile comment.

It was Greenberg who, more than any other critic, helped American art criticism to come of age. Departing from the traditional impressionistic approach, Greenberg posed a revitalizing philosophical view to justify his actual experience of the controversial works of Pollock, Gorky, de Kooning, Motherwell, and others. This search for historical as well as aesthetic principles, and intellectual as well as intuitive methods, is largely responsible for the strength of the best contemporary American art criticism.

H

HAPPENINGS – Happenings were art at the theater. This art movement derives its name from Allan Kaprow's earliest public work, "Eighteen Happenings in Six Parts," performed in New York in 1959. The painters and sculptors who developed this 1960s experience emphasized the visual and tactile responses of the individual without the traditional plot, character, actors, and repetition of performance as in theater works. Happenings are not fixed in time or place, and their structures are a coming together of objects, actions, and environments. Performance Art of the 1980s is both similar and dissimilar to the early Happenings in that today's performance artists deal with self as a work of art. The Fluxus movement was active in happenings, as were artists Red Grooms, Jim Dine, George Segal, Claes Oldenburg, and Al Hansen. Happenings were international events.

Inasmuch as there is a great deal which has been written about Happenings, the reader is directed to the extensive bibliography in *The Theatre of Mixed Means: An Introduction to Happenings, Kinetic Environments, and Other Mixed-means Performances* (1968), by Richard Kostelanetz. Included in the bibliography are anthologies, books and articles by pracititioners, macro-criticism, and relevant background material.

HARD-EDGE PAINTING – This is a type of painting which treats the whole surface as one unit, extending across the canvas from edge to edge and has no depth effects. Colors are usually restricted to two or three hues; paint is applied evenly and is applied with sharp edges of color rather than blurred edges. Artists using this style – among them Alexander liberman, Jack Youngerman, Al Held, and Ellsworth Kelly – have influenced both American and European painters. All of these painters are active today.

In the introduction to a catalog in 1964 (Hard-Edge), Lawrence Alloway, the critic, states that "what you see is precisely what there is. Yet what you see is usually optically ambiguous in this art of exploration of geometric forms."

I

IMPRESSIONISM – A late nineteenth-century French school of painting that attempted to depict transitory visual impressions. Impressionist works were usually painted directly from nature using broken color to achieve luminosity and to represent sunlight.

From April 15th to May 15th, 1874, a group of independent young French painters who had formed a *societe anonyme* that included Monet, Renoir, Pissarro, Sisley, Cézanne, Degas, Guillaumin and Berthe Morisot, held an exhibition, apart from the official Salon, at the studio of the photographer Nadar. the exhibition caused an uproar, and a journalist named Leroy, writing in the satirical magazine *Le Charivari* of April 25th, jeeringly called the exhibitors "Impressionists," after a canvas by Monet entitled "Impression, Sunrise." This name, accepted by the painters themselves, became very popular and was soon universally adopted.

The Impressionist painters were born between 1830 and 1841 – Pissarro, the eldest, in 1830, Manet in 1832, Degas in 1834, Cézanne and Sisley in 1839, Monet in 1840, Renoir, Bazille, Guillaumin and Berthe Morisot in 1841. These young innovators from different environments, came together in Paris about 1860. It was at the Seine estuary and the Channel beaches where, between 1860 and 1870, the Impressionism movement really began. It was in that light-and-water-saturated air that Monet, in contact with the two innovators, Boudin (1824–1898) and Jongkind (1819–1891), evolved a style of painting that became more and more fluid, ethereal and highly colored. Pissarro and Sisley remainde close to Corot. Cézanne and Degas had no part in this Impressionist phase. Manet, through the modernity of his subjects became, perhaps in spite of himself, the standard-bearer of the young school that met at the Cafe Guerbois.

The Franco-German war of 1870 dispersed the group just when their experiments were taking shape. Manet, Renoir, Degas and Bazille were called up and went to war; Bazille was killed in the battle of Beaune-la-Rolande. Monet, Pissarro and Sisley took refuge in London, where Daubigny introduced them to Durand-Ruel, the dealer who was to become their chief defender. Their discovery of Turner and Constable hastened the evolution of their technique. In 1872 Monet at Argenteuil, near Paris, and Pissarro at Pontoise (Seine-et-Oise) began painting the new type of open-air landscape. Monet's work, on the grand, universal scale, dominated by the spell of water and by the phantasms of light, attracted Renoir, Sisley and manet; Pissarro's bucolic and earthy, with more stress on structural values, influenced Cézanne and Guillaumin. In 1873, with the conversion of Manet, Cézanne and, to a limited extent, Degas, to light-colored painting, the Impressionist style spread and became more generally used. The critic Armand Silvestre made a fine distinction between the three painters: "Monet, the most skillful and the most daring; Sisley, the most harmonious and the most timid; Pissarro, the most true and the most naive." Renoir led his figures into the sunlight. In 1874, with the exception of Manet, who remained faithful to the official Salon, the group as a whole faced the public, under a barrage of insults and taunts.

Seven joint exhibitions followed, at intervals, until 1886. The year 1877 was perhaps the peak year of Impressionism.

After a heroic decade of enduring contempt, and producing masterpieces, Impressionism, at the very moment that it began to gain recognition, ceased to exist as a spontaneous ideal. Each of its founders, having reached maturity, thenceforth went his own way, while retaining allegiance to the common cult that had brought them all together.

The death of Manet in 1883 – by then a new generation had arisen (Seurat, Van Gogh, Gauguin and Lautrec), nourished on Impressionism but reacting against it – coincided with the complete breaking up of the original group, despite the efforts of Durand-Ruel.

Impressionism was not a set group with a program or a master-disciple relationship; it was a question of taste, an experience, a moment of brotherhood, shared by young artists who discovered the world and found it vast enough for each of them to draw upon it without constraint. They, as a group, revolted against the old traditional "laws."

Impressionism, even in its most homogeneous period, from 1870 to 1880, showed a variety of styles. After that date, with the coming of a new generation, other tendencies and styles sprang up – Neo-Impressionism, Symbolism, Expressionism – that reacted violently against it, even though they derived from it. Nevertheless, in spite of the complexity of the various movements, from 1860 to 1900 the period which may still be called Impressionism.

J

JUGENDSTIL – The term *Jugendstil,* derived from the Munich review *Jugend* (Youth), founded in January 1896, designates in the German-speaking countries, in which it was particularly developed, the movement known in England under the name of "Modern Style," in France under that of *Art Nouveau,* and sometimes just called 1900 Style, because of its extreme vogue in Europe about that time. It was a sort of essentially decorative baroque and romantic resurgence, characterized by an exuberance of decoration based on plants and undulating forms, and was related to the fashion and taste of the time.

The hero of the Modern Style in England was Aubrey Beardsley (1872–1898), illustrator In France *Art Nouveau* played an important role in the renaissance of the decorative arts. In France, it is in the posters of the period by Lautrec and his emulators, Steinlen, Cheret and Cappiello that we can see this period best. In 1896, in the Rue de Provence, the dealer Bing opened his Galerie de L'Art Nouveau and soon exhibited the work of the Norwegian painter Edvard Munch. Munch frequented Mallarme, designed the production of *Peer Gynt* for the Theatre de l'OEuvre, and surrounded his pictures and drawings with allegorical and decorative borders in the spirit of *Jugendstil*, of which the most active centers were Barcelona, Munich and Vienna.

Barcelona the center of the Spanish cultural revival, where the fantastic architecture of Gaudi (1852–1926) was being created, with its ornamentation of plant forms, was deeply penetrated by Nordic and Germanic influences. It was in this "modernist" atmosphere that the genious of Picasso was being formed. His first drawings appeared in *Joventut* and *Arte Joven,* periodicals which were inspired by the Munich review *Jugend.* His first journey to Paris took place in 1900 and his "blue period" showed him still under the influence of Lautrec and Steinlen.

In Germany, whose two artistic capitals were Munich and Berlin, the *Jugenstil* helped to break the fetters of traditionalism and encouraged new trends. The Secession group in Munich eleven years before settling in Florence. It was presided over in 1897 by Max Klinger (1857–1920).

But it was in the cosmopolitan and fastidious Vienna of the end of the century that the *Jugenstil* found its supreme expression. Its uncontested leader was Gustav Klimt (1862–1918), who executed the decoration of the University (1899–1900), and who remained, till 1905, president of the Secession, whence the name of Style of the Secession, which is still given to the Viennese version of *Jugenstil.* The poets and musicians Hugo von Hofmannsthal, Peter Altenberg and Gustav Mahler were all part of this atmosphere of culture and aestheticism, which was evident also in the furniture, the jewelry and the objets d'art of the Wiener Werkstatte (Viennese Studio), created in 1903. Here, too, grew up the young Kokoschka (born in 1886), a fellow-pupil of Egon Schele at the School of Decorative Arts, friend and protege of the celebrated architect Adolf Loos. In 1908 Kokoschka exhibited the illustrations for his book *Die Träumenden Knaben* (The Boy Dreamers), in which can be recognized the double influence of Klimt, to whom the work is dedicated, and of Hodler, and which constitutes, by its refined sensibility of line and the decorative use of color, perhaps the masterpiece of the *Jugendstil.*

K

KAHNWEILER – Daniel Henry (born in 1884 in Mannheim, Germany). When he was eighteen he went to Paris and spent three years there before arriving in London, where his uncle began to train him for a career in banking. But his passion for art history and painting soon made him neglect his work at the stockbroker's with whom he had been placed, in favor of long hours in museums. It was not long before he threw over his banking career. On his return to Paris in 1907, when Fauvism was triumphing at the Salon des Independants, he opened a picture gallery which rapidly became famous. The first painters who interested him were Derain, Vlaminck, Van Dongen, then Braque, Picasso, Leger and Juan Gris. In 1980 he exhibited Barque's first Cubist canveses after they had been refused at the Salon d'Automne. He not only materially supported the Cubist painters but also took up his pen in their defense. In 1909 he began his series of art books with Apollinaire's *L'Enchanteur Pourrissant*, with woodcuts by Derain, then *Saint*

Matorel by Max Jacob, with etchings by Picasso. During the 1914–1918 First World War, Kahnweiler retired to Switzerland. In his absence, his belongings were confiscated and his collection dispersed at an absurdly low price, despite the efforts of his painter friends. After the Armistice he returned to Paris, and with his friend Andre Simon opened a new gallery in the Rue d'Astorg. In 1920 Kahnweiler published three works: one by Vlaminck, another by Derain, and one in German, *Der Weg zum Kubismus*. Kahnweiler's house in Boulogne became an artistic center frequented by avant-garde writers and painters. New artists were shown at his gallery: with the sculptors Manolo and Henri Laurens there were Masson, Beaudin, Suzanne Roger, Roux and Kermandec. During the Second World War, Kahnweiler sought refuge in the unoccupied zone of France, after placing the management of his gallery in the hands of his siter-in-law, Louise Leiris. During the years 1939–1944 Kahnweiler wrote his now-famous book on Juan Grist, the standard work on the artists, which was publishen in 1946. Kahnweiler is certainly to be considered one of the great art dealers of the century.

KINETIC ART – Kinetic derived from the Greek word for "moving," was first applied to art in the 1950s and "has been described as four-dimensional because it adds the dimension of time to sculpture." Frank Popper, a critic, has described kinds of movement as (1) actual movement (moving lights and machines), (2) virtual movement (a response within the spectator's eye to static visual stimuli), and (3) movement of the spectator in front of the work or manipulation of the work by the spectator.

The artists' names, mostly French, who fall within this movement, are Victor Vasarely, Jesus-Raphael Soto, Jean Tinguely, Pol Bury, and Yacov Agam. In England, Bridget Riley would fall into the Kinetic Art category.

L

LITHOGRAPH – A print produced by the planographic process of lithography which involves a surface design drawn on a perfectly smooth stone or metal plate with a lithographic (grease) crayon or tusche (a grease ink). After a chemical treatment, printing ink may be rolled on the moistened stone or plate, the water repelling the ink from the places untouched by crayon or tusche, accepting the ink where the crayon or tusche have been applied. A print on dampened paper is then taken from the inked stone or plate by running it through a lithographic press.

LONDON GROUP and LONDON SCHOOL – "The London Group" wrote Roger Fry, "has done for post Impressionism in England what the New English Art Club did, in a previous generation, for Impressionism." Founded in 1914, its origins lie a decade further back. When Sickert returned to London in 1905 he at once became the center of a group of painters – most notably Lucien Pissarro, Harold Gilman, Charles Ginner and Spencer Gore – who looked to Gauguin and

the other post Impressionists rather than to the watered-down Impressionism of the NEAC. These artists met regularly at Sickert's studio at 19 Fitzroy Street; they stood for urban and "low life" subject-matter, for a light palette and a high color key, and opposed the jury system of exhibition selection. The Fitzroy painters finally founded, in 1911 (the year following Fry's first post-Impressionist exhibition), the Camden Town Group, which held its first showing at the Carfax Gallery under the presidency of Gore. Among the original sixteen members, besides Sickert, Pissarro, Gilman, Ginner and gore, were W. Baynes, R. Bevan, J. D. Innes, A. John, H. Lamb and J. B. Manson. In 1914, under the presidency of Gilman, the Group amalgamated with several smaller groups – notably the Vorticists – to form the London Group (the name was suggested by Epstein), showing a such in the same year at the Goupil Gallery. Among the new members were D. Bomberg, Sylvia Gross, W. Lewis, J. Nash, C. R. W. Nevinson and E. Wadsworth; other names which became associated with the London Group within the next few years were those of V. Bell, D. Grant, M. Gertler, B. Meninsky and P. Nash.

There is a modern London School that derives from the artist David Bomberg (1890–1957), then on to Frank Auerbach, and then starts making contemporary modern branches to Tom Phillips in one direction and R. B. Kitaj in the other. Francis Bacon, Lucian Freud and Sidney Nolan could also be considered predecessors of one part of the modern London School.

The Kitaj direction is better known in the United States because Kitaj is the most controversial of the English painters. Although American by birth, Kitaj considers himself "London School." John Russell, *The New York Times* art critic, considers it the most intellectual and important work being produced today. The most literary of the English pop artists, Kitaj is by general admission the most intellectual of the painters working today. Kitaj enjoys a considerable audience in Europe for the protean complexity of his pictures. In his wide-ranging art he has attempted to rework the grand alliance between books, poetry and painting, seeking to accommodate historical, political and sexual urgencies within modernism. Around 1970, two even larger passions emerged: a concentration on drawing the human form – under the spell of what he was convinced was a neglected modern legacy, and, with excitement, Kitaj began to discover a Jewishness in himself. It led him to an immersion in Jewish studies and enigmas, which has changed the course of his art.

Kitaj quotes Cézanne's famous ambition (*R. B. Kitaj*, Marco Livingstone, Rizzoli, 1985), "To do Poussin over again, after Nature," and says he would like "To do Cézanne and Degas and Kafka over again, after Auschwitz." Kitaj's original and restless pictures reflect the terms of his own life to a confessional degree not often found in modern painting. His "Human Clay" exhibition in the 1970s introduced a new group of figurative artists who make ethical points and tell stories. The most important of this group is Leonard McComb, who was recently shown at Washington, D. C.'s Hirshhorn Museum.

The Tom Phillips' direction (*Tom Phillips, Works, Tests to 1971*, Edition Hansjor Mayer, London) has had no real exposure in the United States, although his work is widely known in Europe. Phillips' work is the opposite of what American critics and writers expect, in that Phillips does not aim to please confront or inform the general art public but rather a small, select audience. As Phillips says:

> "My own view (constantly under attack within my head) is that the artists can only follow the lead of his passions though it seems to point over the hill to nowhere. Since my passions are for structures, connections, correspondence, and systems which link the sensual, visual and inteelectual worlds, they are not predominantly political except when they react to the results of political acts (as in the Berlin Wall pictures). Since every extreme ideology I have in the past examined or flirted with has thrived by the organised death of its dissenters, I am left a purposely indefinite quietist/humanist/pinkish social democrat with leanings toward devolutionary anarchism: this is hardly a position in the white hot centre of political ferment.
>
> I *do* earnestly hope that what I do has some appeal and meaning for other ordinary people, but there is little I can do if it does not (though this worries me). I work hard."

M

MINIMAL ART – A term used to indicate the work developed by several artists during the 1960s, particularly in the United States, who aimed at reducing art to basic geometric forms (in sculpture) and to pure color patterns and fields (in painting), completely eliminating representational and illusionistic factors.

Minimal art is essentially sculptural, although some painters (Brice Mardin) are included within the term. A major art movement of the 1960s, its supporters claimed "that it was the first American movement to owe nothing to Europe." Barbara Rose's essay "ABC Art" in *Art in America* (Oktober–November 1965) is a virtual collage of theory, history, and critique of minimal art. She states that "the work of a number of American artists of a new young generation seems aimed at denying the emotionalism of its Abstract Expressionist predecessors and glorifying the minimum – or pure nothingness." This art, with its roots in Dada, is simple, clear, direct and immediate.

One of the major exhibitions of minimal art was *Primary Structures* (1966) at the Jewish Museum, New York. In the catalog of the exhibition Don Judd, in describing his work, demythologizes the artist's function. "If someone says his work is art, it's art." The theory of minimal art is at odds with previous ideas of art in that it deals with the surface of matter, a combining of art and science.

MODERN – A good starting point is 1883, the year in which the Danish critic George Brandes (1842–1927) published a volume of essays with the title *Men of the Modern Breakthrough*. Brandes' use of the word "modern" immediately caught on. It became a rallying cry in a fierce debate in Germany, Northern and Central Europe – What is the meaning of "Modern"? For or against? – which lasted from the 1880s to the 1900s. In Paris, London and New York, the Modern period begins later. The date of the "Modern" period is still at matter of argument, but the 1900s seems to be the middle ground.

In short, the essence of Modernism was a new consciousness, new ways of seeing man and the world, a condition of the human mind for which there was no precedent. Whether this is how it appears in the middle of the 1980s is another question: there is no doubt that it was a view held with passionate conviction by many of the most creative people of the time and that it inspired a remarkable burst of innovation in science, literature, the arts, the human and social sciences.

MORRIS – William (1834–1896). William Morris took John RuskinÅ arguments a step further still:

"Apart from the desire to produce beautiful things, the leading passion of my life is hatred of modern civilization . . . what shall I say concerning its mastery of and its waste of mechanical power . . . its stupendous organization for the misery of life . . . was it all to end in a counting house on the top of a cinderheap . . . the pleasure of the eye taken from the world and the place of Homer taken by Huxley?"

Morris agreed with Ruskin that art could not be reviewed without a fundamental reform of society, but he had no confidence that this could be achieved by preaching to a dominant middle class, incapable of its own regeneration. Morris wanted a social revolution.

"The unifying theme of Morris's extraordinarily varied career was a desire to reunite art and craftsmanship, and this in turn led to that preoccupation with functional structure and honest use of materials which has prompted Pevsner to call him one of the pioneers of modern design. If Morris seems at times to be struggling in vain to lift the visor of his basinet, we must also remember that – by a sublime paradox which he himself would have relished – his aesthetic theories point unmistakably in the direction of Gropius, Frank Lloyd Wright, and the twentieth century." William Morris, *The Ideal Book* (University of California Press, 1982).

N

NABIS – The Nabis, so baptized by the poet Cazalis with a Hebrew term meaning "prophets," met every month for dinner at l'Os a Moelle, in the Passage Brady in Paris, and every week in the studio of Ranson, who found a picturesque nickname

for each of them: Bonnard, "The Nipponizing Nabi"; Verkade, "The Nabi Obelisk"; Vuillard, The Zouave." The Nabis' doctrine was summed up, according to Maurice Denis, in the Theory of the Two Distorions: "The Objective Distortion, based upon a purely aesthetic and decorative concept, upon technical principles of color and composition, and the Subjective Distortion, which brought into play the artist's own perception . . ." They applied these principles not only to easel painting, "a plane surface covered with colors brought together in a certain order," but also to a series of decorative techniques whose spirit they revolutionized, such as painting on cardboard, tempera, stained glass, lithography, posters, theatre settings, and book illustration. The variety of their experiments and increasing exchanges between the worlds of art and entertainment characterize the end of the century, which bore the Nabi stamp in all fields.

Bonnard, Vuillard, Denis and Lugne-Poe (the latter three schoolmates at the Lycee Condorcet) shared a studio for a time in 1890, in the Place Pigalle. Then Denis, Serusier and Verkade – the latter became a monk at the famous Benedictine monastery of Beuron in 1893 – drew together in a certain neo-classical mysticism vaguely derived from Pont-Aven, while Bonnard and Vuillard, the sensitive Intimists, by far the most gifted of the group, unamenable to the theories of Serusier, soon separated from Gauguin and formed with Roussel an actual group within the group. During this period Vallotton pracitced chiefly wood-engraving in black-and-white. He made the doctrine and the art of his friends known in Switzerland, but after 1900 his tense, severe style developed into an extreme realism close to German expressionism. The Nabis exhibited together for the last time at the Durand-Ruel Gallery in 1899.

NEO-CLASSICISM – Neo-Classicism is generally regarded as a successor to the Baroque, a style prevalent during the first half of the eighteenth century. By the second half of the eighteenth century, the succession of styles from early Renaissance to late Baroque were called the Neo-Classical style and constituted the dominant tradition in European art.

NEO-EXPRESSIONISM – In its broad sense, Neo-Expressionism applies to the art of the '80s. The marks on the canvas convey a heaviness and heart, as Robert Hughes tells us, it is "turgid, lava-like floods of paint, fulgurous color, primitive and mythic imagery and the like." In its more specific sense, according to Michael Brenson, it applies at least to the Americans, Julian Schnabel, David Salle, Eric Fischl, Robert Longo, Cindy Sherman; the Germans, Anselm Kiefer, Jorg Immendorf, George Baselitz, Markus Lupertz, A. R. Penck and the Italians, Sandro Chia, Enzo Cucchi and Francesco Clemente. Brenson, in 1986, has declared it as an artistic movement that has passed.

NEO-IMPRESSIONISM – A movement whose members were Seurat, Signac and the group of painters who followed their principles, the scientific study of color and the systematic division of tone as they had been practiced instinctively by the

Impressionists. The term is supposed to have been created by the painters themselvers, in homage to their elders. The aim of these artists was to rationalize the expression of light with pure colors and to substitute a scientific method for the empirical one of the Impressionists. At the first show of the new Societe des Independants, in December, Seurat again exhibited his *La Baignade*, based on "contrasts of shades," which, in a still flexible handling, achieved his purpose: to reconcile the eternal and the fugitive, architecture and light, figure and landscape, Impressionist vibration and classical stability. Signac, four years younger, dynamic and pugnacious, himself given to the same investigations, was enthralled by this canvas and became an eager proselyte, In 1885, at Guillaumin's, he met Pissarro, whom he introduced to Seurat, and who enthusiastically took up the new discipline, which met his need for order and structure; Pissarro interested his eldest son Lucien and the latter's fellow student Louis Hayet in the movement. Between 1884 and 1886 Seurat executed his second large composition, *A Sunday at the Grande Jatte*, based upon "contrasts of tones," in accordance with his now fully established technique, the methodical fragmentation of stroke that he called "Divisionism" and carried as far as "Pointillism."

"To divide," explained Signac, the theoretician of the group, "means to secure all the benefits of luminosity, coloring and HARMONY: (1) by optical fusion of pigments pure in themselves (ALL THE SHADES OF THE SPECTRUM AND ALL THEIR TONES); (2) by separating various elements (local color, color of lighting, their reactions); (3) by balance of these elements and their proportions (according to the laws of CONTRAST, GRADUATION AND IRRADIATION); (4) by the choice of a stroke proportionate to the size of the picture."

In March 1886, the art dealer Durand-Ruel went to New York with three hundred Impressionist canvases, to which he added works by Signac and Seurat, including *La Baignade*. The same year the *Grande Jatte* was the chief attraction at the eighth and last Impressionist exhibition, May 15th-June 15th, which marked the breakup of the original group, impending since 1880, and the official appearance of Neo-Impressionism or, in Pissarro's terms, the separation of "Romantic Impressionists" and "Scientific Impressionists. Monet, Renoir and Sisley withdrew. Degas accepted the participation of Seurat, Signac and Lucien and Camille Pissarro exhibiting in the same room, but asked that the word "Impressionist" be eliminated from the poster, and rejected the works by Angrand and Dubois-Pillet as inadequate. At this time Feneon made the personal acquaintance of Seurat and his friends. He was to remain their faithful advocate and official interpreter. He devoted a series of masterly articles to them in avant-garde magazines, articles which were collected in a booklet at the end of the year. The Neo-Impressionists made an appearance as a group at the second Salon des Independants at the Tuileries (August 21st-September 21st, 1886), where Seurat showed his *Grande Jatte* again. Pissarro exhibited at Nantes in November and succeeded in getting Suerat and Signac accepted with him. These three painters were invited to exhibit in Brussels by "The Twenty," an independent group courageously led by Octave Maus. Signac and Seurat were present at the opening in February 1887. Though

admired by Verhaeren, the *Grande Jatte* attained only a *success d'estime*, but it won several Belgian artists over to Divisionism, among the Henry van de Velde and Theo van Rysselberghe. In France new Divisionists appeared: H. Petitjean, Maximilien Luce, and, a little later, Lucie Cousturier, to mention only the more important. The movement also spread to Italy, with Segantini, Previati, and Morbelli, who appeared for the first time in Milan in 1891. finally, three of the principal artists of the late nineteenth century, without belonging to Neo-Impressionism, underwent Seruat's influence and practiced Divisionism for a time: Gauguin in 1886, Lautrec in 1887 and Van Gogh during almost his entire Parisian period (1886–1888), when his relations with Signac and Seurat were particularly fruitful.

The methodical enterprise of Seurat culminated in two great compositions: *Le Chahut* (1890) and *The Circus* (1891), based upon "contrasts of lines," in which his will for style turned to stylization and touched Modern Style. He died at thirty-two on March 29th, 1891, exhausted by work but having delivered his message. Pissarro, who was asked to assume leadership of the movement, refused, chiefly because he had just given up Divisionism to return to the freer handling of his initial manner. Only Lucie Cousturier, Cross and Signac, who in 1889 published the doctrinal work that has since become a classic, "From Eugene Delacroix to Neo-Impressionism." In 1899, and even more in 1904, the Fauvism of Matisse was prepared by a Pointillist stage, through contact with Signac and Cross, at whose side he worked in the summer at Saint-Tropez, and the large Seurat retrospective at the Salon des Independants in 1905 brought on Cubism.

NEW REALISM – A revival of naturalistic images rendered in a matter-of-fact way that has developed since the mid-1960s. In a variant form called photorealism the artist documents visual experience in paintings that emulate color photography, sometimes enlarging such genre as portraiture to heroic proportions with striking effects. In sculpture, this direction has produced figural art rendered life-size and in natural colors – like habitat groups in natural history museums. The range of artists in the world who fall under this designation is infinite. See Gerard Xuriguer, *Les Figurations, de 1960*, Editions Mayer, Paris, 1985.

NINETEENTH CENTURY PAINTING – No other century except perhaps the twentieth century witnessed as many different approaches to painting as did the nineteenth century. From the traditional academic painters to the Symbolists, artists painted in an atmosphere of relative freedom, sometimes adapting ideas from the past or charting entirely new directions that were to presage the art of the next century. The differences among nineteenth-centruy artists' technique, imagery, color, and brushwork in painting and surface treatment in sculpture are astounding. During this century and for the first time in the history of art, artists who shared similar attitudes or beliefs would band together, sometimes giving formal names to their causes or movements. The public, the French Academy, and artists shared an interest in an art that served no specific purpose other than to

represent certain styles and subject matter that were considered important in and of themselves. The notion that art is created for its own sake originated in the nineteenth century and continues to influence our contemporary conceptions about art.

Unlike the eighteenth-century artist, who functioned in many ways like a small entrepreneur and adapted his art to his client's wishes and needs, the nineteenth-century artist was a lonely visionary subject to the vicissitudes of the Muses and disdainful of the demands of the marketplace. This century saw a parting of the ways of artists and patrons. Atlhough some artists still anticipated the needs of the market and tailored their work to meet them, others chose to heed only the voices of their innermost souls. The artist, not the client determined the subject matter, material, scale, color, and techniques in accordance with what was required to represent his personal vision. As artists determined for themselves what was artistically relevant, they developed new subjects and new interpretations of traditional themes.

If one could identify one subject among all others that preoccupied nineteenth century artists, it would be the landscape. In an age that had witnessed the transformation of nature by technology and its machinery, the image of nature assumed a significance that was unmatched by any other period of art. Landscape scenery evoked notions of an unspoiled environment in the midst of an urban milieu; it suggested the passage of time and hence a sense of history; it posed considerable challenges to artists who sought to record the nuances and effects of light and atmosphere. But, most importantly, it became a vehicle for expressing a profound need for spiritualism that went unfulfilled in an age that had forsaken religion for scientific rationalism and skepticism. Few other periods used landscape imagery so effectively as a means to affirm man's inexorable bond with, and separation from, the infinite and universal presence of nature. Nor was there another subject that permitted the artist so easily to impose himself on it and lose himself in it at the same time. The relationship of the nineteenth century to landscape imagery is a fascinating example of the paradox, for it both affirmed the Renaissance ideal of the celebrated individual artist who was unique in his creative spirit and prized above all others the one subject in art in which the artist's identity couls best be submerged. When we view a nineteenth-century landscape, we admire nature's work as much as we do the artist's, and the genius of this century is that we do not know, nor is it really important, where one leaves off and the other begins.

The nineteenth century art movements would include the following: Neoclassicism; Academic Art; Romanticism; The Pre-Raphaelites; The Barbizon School; The Hudson River School; Luminism; American Scene Painting; and the American Barbizon School.

NOUVEAU REALISME – As Richard Alley, in *Forty Years of Modern Art (1945–1985)* (The Tate Gallery) tells us:

> "The two most radical European abstract artists of the post-war

period have been the Italian Lucio Fontana and the Frenchman Yves Klein. Fontana, over a generation the older of the two, founded the avant-garde Spazializmo movement in Italy in 1948 and the following year began to make pictures by punching the canvas surface with holes and, later, by making rhythmical sweeping cuts with a razor blade. Klein is known above all for the completely monochrome pictures which he made from the early 1950s onwards, at first sometimes green white, yellow or red but from 1957 mainly a very distinctive blue, a deep sensuous cobalt, which he named International Klein Blue (IKB), and which for him symbolised infinite space.

Exhibitions of Klein's works in Italy and Germany prompted the young Italian painter Piero Manzoni, sometimes regarded as his Italien counterpart, to begin making series of completely white pictures known as 'Achromes', with surfaces of a variety of textures, and also led to the formation in Düsseldorf of the Zero group led by Piene, Mackand Uecker (whose sister he married). The Dutch artist Schoonhoven was another of those who collaborated in Zero.

Through Klein's friendships with two artist working in his home town of Nice, Arman and Martial Rayse, and his meeting in Paris with Tinguely and Haisn, the group Nouveau Réalisme (New Realism) was founded in 1960 by the critic Pierre Retany. The original members included Klein, Tinguely, Raysse, Arman, Hains and Spoerri, who were afterwards joined by César, Niki de Saint-Phalle and Christo. Although the group had come together around the activites of Klein, the main preoccupation of the others was to revitalize the School of Paris through the use of commercial images and consumer goods drawn from the contemporary industrialized environment (ant therefore had something in common with the aims of Pop Art). Thus Arman made 'Accumulations' of objects; Tinguely created wildly fantastic kinetic constructions out of scrap-metal parts; Spoerri fixed the plates and other objects used in a meal in the exact positions in which they happened to be left at the end of the meal; Christo began to wrap cans, chairs and so on; and César to compress car bodies in industrial machines made for this purpose.

Klein and Manzoni, who both died young, also made some works towards the end of their lives which helped lead the way to Concneptual Art."

P

PAINTERLY – Originally, as used by Heinrich Wolfflin in his *Principles of Art History*, a term designating an approach to art that emphasizes the broad effects of mass, light, and shade as opposed to linear definition; now often extended to designate any approach that involves a loose, spontaneous handling of the paint.

PARIS – (School of) "L'Ecole de Paris" was the name given to a group formed after the First World War by a number of foreign painters, brought to Paris by similar needs and united by similar affinities. Since then the name has acquired a looser meaning. Originally, the School of Paris consisted of Modigliani, Pascin, Chagall, Kisling, Soudine; an Italian, a Bulgarian, a Russian, a Pole and a Lithuanian. To these can be added the names of Leopold Gottlieb, Eugene Zak, Kremegne, three Poles; Mintchine, a Ukrainian; Max Band, a Lithuanian. All these painters were of foreign birth, and however diverse their ideas, temperaments, ways of life, they were brought together by common bonds of age and race. They belonged to the same generation, all having been born between 1884 and 1900, and they were all jews. These uprooted ones likes France and drew from French sensibility, thought, and art the elements they needed to bring their gifts to fulfillment. But as painters they did not succeed in making themselves French. Contemporary with the Cubists, they did not espouse their theories nor follow their example. They always remained lyricists, romantics, expressionists and passionate individualists. Jean Dubuffet is widely regarded as the most inventive and influential painter to have been produced by the S

PHOTOGRAPHY

Nineteenth Century – In 1826, the French physicist Joseph Nicephore Niepce produced the first photograph by exposing a pewter plate to the view from his window. by 1837, Louis Daguerre refined the process by using mercury vapor to develop the image and common salt to fix it. Photography was to find use in this early stage in portraiture.

Like other technical processes, photography challenged many and saw numerous refinements. An Englishman W. H. F. Talbot, managed to eliminate the bulky metal plates used for daguerreotype and produced the first paper negatives, calling his new process calotype. Much larger images were thus possible, making landscape and other views logical subjects for the calotype. David Octavius Hill and Robert Adamson were famous calotype photographers.

By mid-century, photographers joined or replaced the illustrator who recorded historic events, such as wars. Roger Fenton documented the Crimean War in 1855 with photographs, and Mathew Brady recorded images of the American Civil War. By 1888, George Eastman had put ghe first hand-held camera on the market, and photography became increasingly accessible to a broad spectrum of society.

In any event, photography was instantly recognized as a tool for artists working in other mediums. It was an aid to artists in understanding and interpreting the appearances of objective reality. From the beginning, however, there were photographers who sought to create artistic images unique to this new process who sometimes relied on the traditional subject matter and composition used in painting. Many of these images are regarded today as equal in artistic expressiveness to other traditional mediums.

Twentieth Century – The twentieth century story is a story of accomplishment over a span of fifty to sixty years. It is basically a study of artists who will be considered historic photographers of the twentieth century. It would be impossible to compile even a long list of the important names, but certainly the list at Chapter 5 of *The Photograph Collector's Guide*, Lee D. Witkin and Barbara London, New York Graphic Society, 1974, is a good place to start. The authors list 234 individual photographers, and I would say that all would be names that a collector could buy with confidence. Inclusion in this list indicates that these particular photographers are difficult to ignore for a collector of photography.

PHOTO-REALISM – Photo-realism, with its beginnings in the late 1960s, encompasses works closely resembling bright sunlit photographs, a double reference to both painting and an image derived from photographs. The artists were intrigued about the "technical problems of rendering tones across a surface and capturing reflections and highlights. They treat all parts of the image impartially." In *Tropics in American Art Since 1945*, Lawrence Alloway states that these painters are "engaged with the typicality of the present, the conjunction of objects that are normal in our society, not its precious monuments." Malcolm Morley paints an ocean liner; Richard Estes paints streets; Robert Bechtle and Ralph Goings paint automobiles. Photo-realists refer back to Pop art for subject matter, in Goings's words "the random order in the way reality puts itself together." These are visual reports that have no symbolic meaning.

POINTILLISM – This term refers to the technique perfected and carried to its extreme consequences by the advocates of Neo-Impressionism. It consisted in juxtaposing small strokes of pure colors on the canvas.

PONT-AVEN – (School of). Pont-Aven is a picturesque little town in Brittany, frequented since 1873 by artists drawn there both by the archaic charm of the country and the celebrated inn of Marie-Jeanne Gloanec. It won fame through Gauguin's visits and gave its name to the school of painting created around him, the principles of which were revealed to him in Brittany."When my clogs strike this granite ground," he used to say, "I hear the low, dull, powerful sound that I seek in painting." However, his first lonely stay, from June to November 1886, was merely an introduction without immediate importance. In Concarneau, in August, his friend Schuffenecker met a young painter and poet of eighteen, Emile Bernard (1868–1941), precocious, open, cultivated, full of mystical ardor and passion for the country that he explored on foot in every direction. Schuffenecker introduced him to Gauguin; but the latter's rather cold reception cut the meeting short. Gauguin's second stay in Pont-Aven, from June to October 1888, was to be decisive. Under the stimulus of Bernard, Gauguin executed some marvelous paintings; what has become known as the Pont-Aven style, consisting of vast plain surfaces of pure color, juxtaposed without transition, with sinuous, heavy arabesques. The new use of pure color – to which, he said, everything had to be sacrificed

– without the nuances of light peculiar to the Impressionists, led to a glorification of the decorative plane surface, the lifting of the horizon, and the suppression of perspective and space. In effect, the details are eliminated and only the essential form, the "idea," remains. Gauguin's genius was able to draw masterpieces and an original vision from these techniques. At the end of September, Serusier, then a pupil at the Academie Julian, staying at pont-Aven among traditional painters, was introduced to Gauguin through Bernard and painted under his direction the famous landscape of the *Bois d'Amour*, a small board covered with "pure colors assembled in a certain order," which he brought back triumphantly to his comrades, the future Nabis, as the "talisman" of the new doctrine. This was for them a decisive revelation, reinforced by the first public show of the Pont-Aven Group, held early in 1889 at the Cafe Volpini in the Place du Champ-de-Mars in Paris on the grounds of the Universal Exhibition: it bore the name "Exhibition of Painting of the Impressionist and Synthesist Group," and comprised, together with seventeen canvases by Gauguin and twenty-three by Bernard, works of Laval, Anquetin, Schuffenecker, Fauche, G. Daniel, L. Roy, all framed with white laths that made a sensation.

While "the School of Pont-Aven," according to Maurice Denis, "stirred up as many ideas as that of Fontainebleau," and renewed the aesthetic current of the end of the century, the gathering of the artists who formed it was due only to the prestige of Gauguin and hardly survived his departure.

POP ART – Pop Art, the tribute to the consumer society, uses as its sources advertising and comic strips. The techniques and vocabulary are derived from the same sources and have their roots in commercial art. The object is all important as an object and not as an emotional experience. Major centers of Pop Art were the United States and Great Britain. Andy Warhol adn James Rosenquist (both commercial artists) were early Pop Artists, along with Roy Lichtenstein, Claes Oldenburg, Jim Dine and Robert Indiana. In England, the big names are David Hockney, Richard Hamilton, Patrick Caulfield, Peter Blake, and Allen Jones. David Hockney is now the most important artist of this group, with pictures that sell at auction for $ 500,000 and up. Other artists, like Howard Hodgkin and Tom Phillips are wrongly classified as English Pop.

POSTMODERNISM – Brian O'Doherty pusblihed an article in *Art in America*, entitled "What is postmodernism" which began, "Now that the modernist era (1948–1969?) is over . . ." He complained that although postmodernism "is our diagnosis for what surrounds us, one never hears it defined" and suggested that "there is an unconscious agreement to withhold a definition partly because everyone's definition will expose the confusion the word is designed to cover." Fifteen years later, we still lack a definition of postmodernism which makes any sense. Michael Newman (*ICA Documents* –) has defined it based upon the assumptions used:

"How postmodernism is understood will be dependent upon two interrelated assumptions: the definition of modernism and a theory of history, which may be implicit in a theory of art. Confusion arises because 'modernism' and 'postmodernism' are used as both aesthetic categories and terms for cultural phenomena which coincide with epochs of history. Modernity has been understood as the period of modernization; and post-modernity as the period of consumer society within corporate capitalism; the period of fundamental technological changes; or as the period of the loss of legitimation by the great narratives of Enlightenment. Some theory of history, even if it is that of the failure of theories of history, is always involved. As Fredric Jameson has written, 'to grant some historical originality to a postmodernist culture is also implicitly to affirm some radical structural difference between what is sometimes called consumer society and earlier moments of capitalism from which it emerged.'"

Has the modern period ended? Douglas Davis, in *Artculture*, "Essays On The Post-Modern" (Harper & Row, 1977), has answered this continuing question as follows:

"All this does not mean that the modern period – as characterized by the art of 1980–1960 – has come to a definite end, but it does raise the question of whether we are not at the point of much more fundamental transitions than any which separated the various 'isms' that have followed one another in the history of modernism. Easel painting does not seem to be of interest to many of the most interesting young artists anymore. But this could change tomorrow. The situation is transitional and is very open. The appearance of a few geniuses who might renew easel painting would change one's thinking a lot. Until we have more perspective on this movement, we can only speak in terms of tendencies and directions."

POST-PAINTERLY ABSTRACTION – Post-painterly abstraction refers to work produced after Abstract Expressionism by artists Sam Francis, Helen Frankenthaler, Ellsworth Kelly, Frank Stella, and others. "Painterly" is a concept first introduced into art theory by Heinrich Wolfflin in 1915. He applied the term to baroque styles in order to distinguish them from linear, classical modes. He equated painterly with the optical sense, or pure visibility. Formalist critics, such as Clement Greenberg, have applied these concepts to contemporary painting.

PURISM – The manifesto of Purism, the work of Amedee Ozenfant and Edouard Jeanneret, who, under the name of Le Corbusier, became one of the great architects of the twentieth century. Purism wished to forbid in painting all fantasy and preciosity, with a view to restoring objects to their architectural simplicity and their authenticity. Purist works were therefore to reject every accident harmful to the architectural balance of form. Moreover, the composition of a Purist picture required absolute objectivity; any too individualistic touch was to be rejected.

However, Purism led to no development in painting, no doubt because of its excess of rigor. Only in the architecture of Le Corbusier did these theories find a valid field of application.

R

RENAISSANCE, The – This was the period of the "new learning." As the Englishmen like Thomas More called it, it was more than anything the recovery or rebirth of Classical antiquity. What historians have done is to apply this word to the new attitudes and beliefs which they associated with the revival of Classical learning and which was described as the Renaissance period. Today, the word is used as a label for a historical period in Europe between, say, 1350 and 1600.

RUSKIN – John (1819–1900). John Ruskin was a passionate art critic. He denunciated the ugliness of the nineteenth century and its neglect of beauty. He argued that this was the result, not of a defective education, but of the principle on which the capitalist society was organized, its one-sided concentration on the production of wealth, and its indifference to the production of men. For Ruskin, value, wealth and labor had to be removed from the jurisdiction of the law of supply and demand and related to wholly different, organic principles of society which he identified with Socialism.

S

SECOND GENERATION NEW YORK SCHOOL – Irving Sandler in *The New York School* deals with what he has called "the Second Generation of the New York School." Very little has been written about this era in general terms, except through monographs of individual artists. Sandler tells us that this group evolved from that of first and what it passed on to the next. To date, most of the historical work has related to abstract members of the group, not the figurative or representational. Putting the period from 1950 to 1960, Sandler in his book lists the artists he feels falls into this group at Appendix B. Some are currently very well known, like John Chamberlain, Richard Diebenkorn, Jim Dine, Helen Frankenthaler, Jane Frelicher, Al Held, Alex Katz, Wolf Kahn, Ellsworth Kelly, Philip Pearlstein and Frank Stella. Others are starting to be discovered by the public, such as Leland Bell, Neil Blaine, Norman Bluhm, Gandy Brodie, Robert De Niro and Lester Johnson.

STEIN – Leo (1872–1947) and Gertrude (1874–1946), American writers, brother and sister, born in Pittsburgh, Pennsylvania. After completing their university studies, Leo and Gertrude Stein arrived in Paris about 1900 and settled themselves in a *pavilion* at Rue de Fleurus, which shortly became the gathering place for an

endless tream of poets, critics and other writers, as well as the leading avant-garde artists. The Steins early indicated a preference for the work of Matisse and Picasso, who were still relatively unknown. Over the years, Leo winnowed out his reflections on art in three volumes, *ABC of Esthetics, Appreciation: Painting, Poetry and Prose* and *Journey into the Self*. What he had to say about art can be distilled into a single proposition – that an aesthetic accomplishment can be fully seized only if one has first learned to behold nature with the eyes of a painter. This contention, which he sustained with reasons of a highly personal character, enabled him to illuminate the basic impulse of an artist even when he did not altogether sympathize with it, and he did not, in fact, invariably cherish the most advanced men. His sister, on the other hand, never altered in her fidelity to Cubism and its exponentes – especially to Picasso and Juan Gris. Her most imposing work is a complex and original novel, *The Marking of Americans*, and her impish libretto did much to ensure the fame of Virgil Thomson's *Four Saints in Three Acts*. She particularly relished the work of Juan Gris, devoting to him several critiques, notably the one in *Transition*, in 1927. In 1933, in her *Autobiography of Alice B. Tokals*, she set forth with warmth and sharpness her account of her many contacts with artists and writers (some of whom subsequently had their complaints to make on her interpretation of history – as did brother Leo). Her name will always be intimately associated with the Cubist adventure and the formation of avant-garde taste in America. As a writer, she is now famous, of course, not only in the United States, but also in France, which she did not desert – except for brief visits – even during two world wars.

STIEGLITZ – Alfred. In the twenty years before the First World War, and up to 1917, one man almost singlehandedly changed the course of American art and photography. The man was Alfred Stieglitz. The Stieglitz name is associated as dealer, promoter, critic, and philosopher with respect to some of the great names of our time. Among others in his circle were John Marin, Mardsden Hartely, Arthur Dove, Georgia O'Keefe, Paul Strand, Charles Demuth, Max Weber, and Abraham Walkowitz, who have been labelled the Stieglitz group.

At his gallery at 291 Fifth Avenue, New York, progessive artists and critics met to discuss the urgent need for change in the culture of their time; the paintings and critical writings that grew out of these discussions belong to the first avantgarde period in American art. Stieglitz, of course, did not create singlehandedly the revolutionary talents who congregated at 291, but he provided the inspiration and the environment that welded them together in a common cuase. From 1908 to 1913, the year of the Armory Show, Stieglitz and his colleagues were virtually alone in the production and encouragement of avant-garde artistic currents in America. Stieglitz and his circle continued to work actively for the advancement of modernism until the gallery closed in 1917.

STIJL – (De) (Style). A Dutch periodical created by Van Doesburg in 1917 for the defense of the Neo-Plastic principle, and whose central figure during the first three years was Piet Mondrian. The other contributors were, besides Van Doesburg

himself, the Belgian painter and sculptor Vantongerloo, the painter Vilmos Huszar, the Futurist painter Gino Severini, the Dutch poet Antonie Kok, the architects Wils, Van't Hoff and Oud, and, fleetingly, the painter Bart van der Leck. In the second year, the architect Rietveld joined the group and later, in 1921, the film director Hans Richter. In 1923, Van Doesburg, celebrating the fifth anniversary of the review, paid tribute to Mondrian in an editorial: "Although several artists, in various countries, have worked consciously and unconsciously to evolve a new plastic expression, it was the painter Piet Mondrian who, about 1913, was first to arrive at a realization of the new plastic conception in painting as a logical continuation of Cubism. This accomplishment, which won the approval of the younger generation of artists in Holland, awakened the confidence of the most advanced painters in the possibilities of a new medium. *De Stijl* hails in Mondrian the father of Neo-Plasticism." *De Stijl* ceased to appear in 1928. However, in 1932, Mme. Petro Van Doesburg published a last issue, devoted to the memory of her husband, who had died in 1931. Among the number of avant-garde magazines, frequently short-lived, that appeared throughout Europe between 1920 and 1930, *De Stijl* exercised an unmistakable influence upon art between the two wars.

SURREALISM – A literary and art movement influenced by Freudianism which sought to express the imagination and the unconscious as revealed in dreams, free of conscious control and convention. It was founded in Paris in 1924 and was a prominent international movement that many artists of the Dada group joined.

The systematic dismantling of established values at which Dadaism had worked could lead to constructive results only by bringing into play and organizing – and this was the role of Surrealism – the host of obscure impulses which, springing from unexplored realms of the mind, called up concepts hitherto considered so many baseless fancies. It was a question of themes supplied by the unconscious, chance, madness, dream, hallucination, delirium or humor, capable of creating in the artist's imagination zones of "systematic estrangement" that he would then have to identify and populate. Dada had exhausted itself chiefly by making tracery out of the rubble of its demolitions when Surrealism undertook to experiment scientifically with the mysterious materials furnished by the unconscious. When Andre Breton published his *Manifesto of Surrealism* in 1924, the artist received an absolute directive to make a clean sweep of rational vision and to substitute for it an irrational. Accordingly, Max Ernst, in his *Treatise on Surrealist Painting* contended that "any conscious, mental control of reason, taste, will, is out of place in a work that deserves to be described as absolutely Surrealist." Every artist was to work alone at his own vision of the world, unconcerned with that of the others, even if they were themselves followers of Surrealism. Their untiring quest for the marvelous took on various aspects, according to each painter's imagination or gift for premonition. Chirico, in his first "manner," discovered the secret motives of metaphysical anguish, as it could be born in the unexpected encounter of known objects. Hans Arp caused a strange life to spring up in the very heart of objects supposedly inert. Max Ernst, both in his *frottages* and in his

paintings, endowed with real existence, elements suggested to him only by hallucination. As for Joan Miro, he created a universe inhabited by signs that his will for metamorphosis charged with symbolic values.

Ans while Andre Masson enquired into the perpetual struggle between life and death in us and in things, it was beyond the infinity of the sky or in the very depths of the ocean that Yves Tanguy sought to capture the essential mysteries. Dali, behind a front of delirious interpretations, deliberately undertook the disquieting organization of a metaphysical universe. Man Ray, who made use of photography for his rayographs, drew particularly moving poetical suggestions from the fixity of objects. finally, Margritte discovered "lyrical facts" hitherto unsuspected in the juxtaposition of familiar objects. In short, the intentions of the Surrealists stemmed for painters as well as for poets from a desire to escape the absurdity of events and the stupidity of the official literary and artistic formulae that wighed heavily upon the future of the intelligence.

SYMBOLISM – There are two fundamental modes of artistic experience: image and symbol, one a direct perception and the other an ideal interpretation. From 1885 on, Symbolism developed in literature as well as in the visual arts simultaneously. Painters and poets no longer aimed at a faithful representation of the outside world, but at an imaginative suggestion of their dreams through symbolic allusion and an apparel to the decorative form. The year 1886, with the appearance of Rimbaud's *Illuminations*, the arrival of Van Gogh in Paris and Gauguin's first stay in Brittany, was a turning point that confirmed the break with Impressionism and marked the official birth on the one hand of Neo-Impressionism, a scientific development of Impressionism, and on the other, and at the opposite pole, of Symbolism, which was first expressed in literature.

The young critic, Albert Aurier, an enthusiastic admirer of Gauguin, defined Symbolism in painting in an article in the *Mercure de France* for March 1981 as follows: "The work of art," he proclaimed, "must be: (1) *Ideist*, since its only goal will be expression of the idea; (2) *Symbolist*, since it will express the idea in forms; (3) *Synthetic*, since it will transcribe the forms in a mode of general comprehension; (4) *Subjective*, since the object will never be considered in it as an object, but as the sign of the idea perceived by the subject; (5) *Decorative*, which is a manifestation of an art at once subjective, synthetic, symbolist and ideist." These characteristics put the emphasis toward a decorative abstraction, applied in particular to Gauguin and the School of Pont-Aven, as well as to the Nabi group – Bonnard, Vuillard, Roussel, and Maurice Denis. There were also three isolated artists with whom the Symbolist generation claimed kinship: Gustave Moreau, Puvis de Chavannes, and Odilon Redon.

The most Symbolist of this group, Odilon Redon (1840–1916), was a contemporary of Impressionism, and a friend of Mallarme and the young Symbolist writers, Gide, Valery and Francis Jammes. Redon is said to have created in his work a visual plastic idiom of his dreams. He is the Symbolist painter *par excellence*. This is why the Nabis, Bonnard, Vuillard, Roussel, Serusier, Maurice

Denis, of whom he executed admirable lithographic portraits in black, bistre and sanguine, turned to him with fervor and paid homage to him in a collective exhibition at Durand-Ruel's in 1899. In the same category, and on the same level, though in a different spirit, can be placed the Belgian painter James Ensor (1860–1949), who began in the Impressionist manner, but from 1890 on discovered in masks the expression of his fantastic universe and the climate of his irony.

T

TASTE – The ability to analyze originality expressed through a mastery of craftsmanship, passion guided by reason, and an ability to understand the autonoma of art and aesthetic judgments, independent of either morality, psychology, politics or religion.

Kant, in his critique of judgement at p. 37 wrote:

"The judgement of taste cannot be anything but subjective."

But this did not apply a system of relativism. For what he meant was a standard of judgement which was accepted as universal, and which reises above personal interest or individual preference. To have good taste is something which men of reason would agree with once they fully understood or grasped it.

TEMPERA – Painting in which the color pigments are ground in egg yolk diluted with water for fluid application. Egg tempera may also employ an emulsion (in place of the egg yolk and water) consisting of the whole egg – with the membrane around the yolk removed – oil, and dammar varnish, with water added for thinning.

TZARA – Tristan. French writer, born in 1896 in Rumania. Tristan Tzara used the word "Dada" for the first time on February 8th, 1916, at the Maieray Cafe in Zurich, as he would later use the term "Abstract Art" in one of his lectures at the Kunsthaus in the same city. Coming to Switzerland from Rumania to study mathematics, Tzara met, in 1916, the German poet Hugo Ball, his countryman the painter Marcel Janco, and Hans Arp. With other writers he frequented the Cabaret Voltaire. The establishment was situated in the Spiegelgasse, where, at number 17, lived Lenin, who became Tzara's friend. They were soon exchanging both ideas and chessmen. The first event of the group at the Cabaret Voltaire was a concert of Negro music. Poems were recited by Janco, Hulsenbeck and Tzara, who had organized the meeting. In 1917, works of Picasso, Janco, Arp, Delaunay, Kandinsky, Modigliani, Macke, Prampolini, Chirico and others were exhibited there. The review *Dada* appeared in the same year. The first two issues printing compositions by these artists as well as poems, but the general tendeny of the magazine did not yet reflect Dadism properly so called. It was not until the third issue (1918) that the first Dadaist manifesto appeared, signed by Tzara.

V

VISUAL POETRY – Artists, in their quest for new art forms, have either combined poetry with their work or used it as the work itself. In some cases they have endowed an abstract image with a literary meaning. Verbal and visual meanings are combined to form a bridge between paitning and literature. Today primarily an English artform, it incorporates words and/or poetry into the visual image. The group has two distinct branches, the American form is represented by Joseph Cornell, Lucas Samaras and Robert Arenson, where the object itself is transposed or meanings and metaphors are explored. In England, words and images become a form of concrete poetry. By combining language with objects, the work of art is created. The English School, which includes at least one American, Emmett Williams, includes John Furnival, Peter Bailey, and possibly Tom Phillips. In all of these artists' works, language is visually perceived.

One of the most interesting artists of this group is Ian Hamilton Finaly, barely known outside of England or Scotland. See *Ian Hamilton Finlay: A Visual Primer* by Yves Abrioux, Edinburgh: Reaktion Books (12 Dublin Street, Edinburgh EH1 3PP), 1985, 248 pp., over 370 illustrations, 65 in full color, 19 in two-color, 24 pounds (ca. $34; so far unvailable in America). Although Ian Hamilton Finlay was 60 last year, his work is only now becoming well-known outside a relatively restricted group of admirers. This book brings together for the first time, in a kind of anthology, a great number of his printed cards and booklets, published over a 25-year period. As Mark Francis in *Artforum* (1985) tells us:

> "With the aid of this book Finlay can be seen to be working in a matrix of literary and visual modes, of cultural and ideological landscapes, like Marcel Broodthaers or Vladimir Nabokov in other contexts. To leave Abrioux with the last and certainly appropriate words:
>
> 'Does Finlay's neo-classicism produce a forced conjunction of terms (the ancient and the modern), demonstrating by the very violence of its procedures that the last threads of a tapestry going back to ancient Greece have been broken? Or does it imply structural continuity between the terms it unites? Romantic and post-Romantic irony depend on the fact that such questions cannot be finally settled.'"

VOLLARD – Ambroise (1865–1939). In December 1895, Vollard organized in his gallery the first great Cézanne exhibition, with a hundred and fifty of his most characteristic canvases. The show created a sensation. Vollard's shop, his "cellar," as it was called, became the most brilliant artistic center in Paris during the first forty years of the century. No biography of Vollard can omit a rather impressive iconography: Bonnard painted him in 1905, and then in 1915. Cézanne made, in 1889, the famous portrait of him which is now in the Petit Palais, and which took no fewer than a hundred and fifteen sittings. At about the same time Vollard figured in Maurice Denis's *Hommage a Cézanne* (1901). He sat for four canvases by Renoir, in 1905, 1906, 1915 and 1917, the last time dressed as a toreador. Picasso

painted him in the Cubist manner in 1906 and then in 1915 and 1937; Rouault in 1926, Dufy on a ceramic in 1934. But Illustrated books came to be his chief concern. In 1905 he published a collection of lithographs by Lautrec, Bonnard and Vallotton. From then on publishing was an activity that never abated until his death. There appeared successively the *Parallélement* of Verlaine (1900); *Daphnis and Chloe* (1902) illustrated by Bonnard; *The Imitation of Christ* (1903); the *Sagesse* of Verlaine (1911) by Maurice Denis; a Ronsard (1915); a Villon (1918); the *Fleurs du Mal* (1916); the *Little Flowers of St. Francis* (1928); the *Odyssey* (1930) by Emile Bernard; the *Jardin des Supplices* of Mirbeau, by Rodin; the *Chef d'OEuvre Inconnu* of Balzac (1931); the *Histoire Naturelle* of Buffon (1947) by Picasso; *La Maison Tellier* of Maupassant (1933); and the *Mimes des Corutisanes*, translated by Pierre Louys (1935) with illustrations by Degas; *La Tentation de Saitn-Antoine of Flaubert* by Odilon Redon (1938); the *Reincarnations du Pere Ubu* (1932) by Rouault; finally works by Vollard himself with engravings or drawings by Renoir, Puy, Bonnard (*Sainte Monique*) and Rouault, and other books such as the *Dead Souls* of Gogol and the *Fables* of La Fontaine by Chagall that the publisher's death left unfinished.

In 1898 Vollard organized a second retrospective of Cézanne and, in 1899, an important exhibition of the *Nabis*. The year 1901 witnessed the first showing of Picasso, from whom he bought some thirty canvases for two thousand francs in 1905. The first exhibition of Matisse also took place at Vollard's gallery, in 1904. Vollard had an opportunity to show his fondness for Fauvism by acquiring the whole of Vlaminck's studio in 1906. Having met Rouault in 1907, he directed him toward ceramics and later, in 1916, toward the illustration of books, eventually installing a studio for him in his own house, where he invited all the artistic and literary elite of Paris for his famous dinners. In addition, he brought out bronzes by Rodin, Renoir, Maillol and Picasso. His tremendous activity won him the title of the art dealer of his time. A respectful but vigilant observer, he executed protraits himself – literary ones – as an author, he wrote on Cézanne, Renoir and Degas. In 1937 he published his *Souvenirs d'un Marchand de Tableaux* (published first in English, in 1936, as Recollections of a Picture Dealer), which remains an important source for the art history of our time.

Z

ZERO (Group) – Group Zero, founded in 1957 by Heinz Mack, Otto Piene, and Gunther Uecker, considered the movement to be a reaction against Abstract Expressionism. In their search for a purer art, their works were principally involved with surfaces and figure-ground relations somewhat similar to American minimal art. The group disbanded in 1966.

BOOKS

This is a list of the sources which are in my own library. Since I did not go outside my own library there may be other sources as good or better. Calling or visiting a good art bookstore is a good way to get started. I can recommend Hackers Art Books, at 54 West 57 Street, New York, NY, 10019, where Seymour or Linda Hacker are always helpful, either on the phone or in person.

Abstraction and Artifice In Twentieth Century Art. Clarendon Press, Oxford, 1979.

A Code for the Collector of Beautiful Books. Maurice Robert and Frederic Warde, Limited Editions Club, 1936.

Action, The New Direction, Precision in New York, 1955–60. Newport Harbor Art Museum, 1985.

Aesthetics – A Study of The Fine Arts in Theory and Practice. James K. Feibleman, Humanities Press, 1968.

Alfred Stieglitz and the American Avant-Garde. William Innes Homer, New York Graphic Society, 1977.

All the Empty Palaces – The Merchant Patrons of Modern Art in Pre-Revolutionary Russia. Beverly Whitney Kean, Universe Books, 1983.

American Art Galleries. Les Krantz, Facts on File Publications, 1985.

American Artists. Les Krantz, Facts on File Publications, 1985.

American Realism, Twentieth Century Drawings and Watercolors. Harry N. Abrams, Inc., 1986.

American Pop Art. Lawrence Alloway, MacMillan, 1977.

An American Collection. The Neuberger Collection, Harry N. Abrams, Inc., 1968.

Anyone Can Make Big Money Buying Art. Morton Shulman, MacMillan, 1977.

Art. Clive Bell, Chatto and Windus, 1927.

Art and Criticism, 1976. Edited by Brandon Taylor, Winchester School of Art Press, Winchester, England, 1979.

Art and Intellect. Harold Taylor, The Museum of Modern Art, New York, 1960.

Art Books – A Basic Bibliography. E. Louise Lucas, New York Graphic Society, Ltd., 1968.

Art Collecting for Pleasure and Profit. Cornerstone Library, 1964.

Art Criticism, Vol. 1, No. 3. Co-Editors: Lawrence Alloway and Donald B. Kuspit.

Art in Britain, 1969/70. Edward Lucie-Smith and Patricia White, J. M. Dent and Sons, 1970.

Artists in their own Words. Paul Cumings, St. Martin's Press, 1979.

Art Now – Gallery Guide. A Selected Listing of Current Museum and Gallery Exhibitions. P. O. Box 219, Scotch Plains, NJ 07076.

Art of the 1930s. Edward Lucie-Smith, Rizzola, 1985.

Art of the Real – Nine American Figurative Painters. Edited by Mark Strand, Foreword by Robert Hughes, Clarkson N. Potter, Inc., 1983.

Art on Trial – From Whistler to Rothko. Laurie Adams, Walker & Company, 1976.

Art Talk. Cindy Nemser, Charles Scribner's Sons, 1975.

Beauty and the Beasts. Stephen E. Weil, Smithsonian Institution Press, 1983.

Beyond the Canvas, Artists of the Seventies and Eighties. Rizzola, 1986.

Clement Greenberg – Art Critic. The University of Wisconsin Press, 1979.

Collectors and Artists: Planning and Probating the Estate. Practicing Law Institute, 1977.

Collector's Marketplace Directory, 1981–1982. New York City Edition, Entrepreneur, Inc., 1981.

Contemporary Artists, Editors. Colin Naylor and Genesis P. Orridge, St. Martin's Press, 1977.

Contemporary Artists. Second Edition, St. Martin's Press, 1983.

Contemporary Art Trends, 1960–1980 – A Guide to Sources. Doris L. Bell, The Scarecrow Press, Inc., 1981.

Critic's Eye. Maurice Grosser, The Bobbs-Merrill Company, 1962.

Dictionary of America Art. Matthew Baigell, Harper & Row, 1979.

Dictionary of American Artists, Nineteenth and Twentieth Century. Glen Opitz, Apollo Books, 1982.

Dictionary of Contemporary Artists. Paul Cummings, St. Martin's Press, 1966.

1981 Dictionary of Contemporary Artists. Clio Press, Santa Barbara, CA, 1981.

Dictionary of Modern Painting. Paris Book Center, Inc.

Duveen. S. N. Behrman, Little, Brown & Company, 1952.

Early American Modernist Painting, 1910–1935. Abraham A. Davidson, Harper & Row, 1981.

Foundations for Curriculum Development and Evaluation in Art Education. George W. Hardman and Theodore Zernich, Stipe Publishing Company, 1974.

Freehand – An Artist's Story. Lily Harmon, Simon & Schuster, 1981.

Gertrude Stein, Lectures in America. Beacon Press, 1985.

Giacometti. James Lord, Farrar Straus Giroux, 1985.

How New York Stole the Idea of Modern Art. Serge Guillaut, The University of Chicago Press, 1983.

International Contemporary Arts Directory. St. Martin's, 1985.

Law, Ethics and the Visual Arts – Cases and Materials. Two volumes, John Henry Merryman and Albert E. Elsen, Matthew Bender, 1979.

Legend, Myth and Magic in the Image of the Artist. Ernst Kris and Otto Kurz, Yale University Press, 1979.

Lock, Stock and Barrel – The Story of Collecting. Douglas and Elizabeth Rigby, J. B. Lippincott, 1944.

Locus Select – An Artist/Gallery Listing. Filsinger & Company, Ltd., 1980.

Locus 1977/78 – An Artist/Gallery Listing. Filsinger & Company, Ltd., 1975.

Looking at Modern Painting. Leonard Freedman, Editor, W. W. Norton & Company, 1961.

Mayers International Auction Records. P. O. Box 339, Gracie Station, New York, NY 10028.

Memoir of an Art Gallery. Julien Levy, G. P. Putnam's Sons, 1977.

Memories of the Duveen Brothers. Edward Fowles, Times Books.

Modern Artists on Art. Edited by Robert L. Herbert, Prentice-Hall, Inc., 1964.

Modernism, Criticism, Realism. Harrison & Orton, Harper & Row, 1984.

Painters Painting – The Modern Art Scene, 1940–1970. Emile de Antonio and Mitch Tuchman, Abbeville Press, 1984.

Patrons Despite Themselves. Alan L. Field, Michael O'Hare and J. Mark Davidson Schuster, New York University Press, 1983.

Pop Art Redefined. John Russell and Suzy Gablik, Praeger Publishers, 1969.

Recollections of a Picture Dealer. Dover Publications, Inc., 1978.

The Aesthetic Experience. Jacques Marquet, Yale, 1986.

The Art Crowd. Sophie Burnham, David McKay Company, Inc., 1973.

The Art Dealers. Laura de Coppet and Alan Jones, Clarkson N. Potter, Inc., 1984.

The Art Game. Robert Wraight, Leslie Frewin of London, 1974.

The Artist's Dilemma. James Boswell, The Bodley Head, 1947.

The Art Newsletter – The International Bi-Weekly Report on the Art Market. ArtNews, 5 West 37 Street, New York, NY 10018.

The Art Scene. Barrie Stuart-Penrose, Paul Hamlyn, 1969.

The Arts Without Mystery. Denis Donoghue, Little, Brown, 1982.

The Case of the Baffled Radical. Harold Rosenberg, The University of Chicago Press, 1985.

The Collectors – Dr. Claribel and Miss Etta Cone. Barbara Pollack, Bobbs-Merrill, 1962.

The Cult of Art. Jean Gimpel, Stein and Day, 1969.

The Domain of Art. Sir W. Martin Conway, John Murray, London, 1901.

The Enemy – A Biography of Wyndham Lewis. Jeffrey Meyers, Routledge & Kegan Paul, 1980.

The Experience of Modernity. Marshall Berman, Simon and Schuster, 1982.

The Fifties. Douglas T. Miller and Marion Nowak, Doubleday & Company, 1977.

The Heaven of Invention. Georg Boas, The Johns Hopkins Press, 1962.

The Image Maker – Man and His Art. Harold Spencer, Charles Scribner's, 1972.

The Insider's Guide to the Art Market. Art New Assoc., 1985.

The Humanist Tradition in the West. Alan Bullock, W. W. Norton, 1985.

The Meaning of Modern Art. Karsten Harries, Northwestern University Press, 1968.

The Modern Dilemma in Art. I. J. Belmont, Bernard Ackerman, 1944.

The New Generation – A Curator's Choice. Kennworth Moffett, Rhineburgh Press, 1980.

The New York Art Review. Les Krantz, Editor, Collier Books, MacMillan Publishing Company, Inc., 1982.

The New York School – The Painters and Sculptors of the Fifties. Irving Sandler, Harper & row, 1978.

The Party's Over now. John Gruen, The Viking Press, 1972.

The Perennial Avant-Garde. Gerald Sykes, Prentice-Hall, Inc., 1972.

The Rare Art Traditions. Joseph Alsop, Harper & Row, 1982.

The Revenge of the Philistines – Art and Culture, 1972–1984. Hilton Kramer, The Free Press, 1985.

The Scene. Calvin Tomkins, Viking Press, 1976.

The Sense of Sight. John Berger, Pantheon Books, 1985.

The Sociology of Art. Arnold Hauser, The University of Chicago Press, 1982.

The Theory of the Avant-Garde. Renato Poggioli, Harvard University Press, 1968.

The Vital Gesture. Franz Kline, Abbeville Press, 1985.

The World of Abstract Art. Edited by the American Abstract Artists, George Wittenborn, Inc., 1957.

The World, The Arts and The Artists. Irwin Edman, W. W. Norton & Company, 1928.

Thinking About Art. Edward Lucie-Smith, Calder and Boyars, 1968.

This Knot of Life - Paintings and Drawings by British Artists. L. A. Lover Gallery, 1979.

Topics in American Art Since 1945. Lawrence Alloway, W. W. Norton & Company, 1975.

Toward Reality - Essays in Seeing. John Berger, Alfred A. Knopf, 1962.

What is Art History? Mark Roskill, Thames and Hudson, 1976.